American design in the
twentieth century

MANCHESTER
UNIVERSITY PRESS

STUDIES IN DESIGN AND MATERIAL CULTURE

general editor
Paul Greenhalgh

American design in the twentieth century

Personality and performance

Gregory Votolato

distributed exclusively
in the USA by
St. Martin's Press

Manchester University Press
Manchester and New York

The right of Gregory Votolato to be identified as the author of this work has been asserted by him in accordance with the Copyright, Designs and Patents Act 1988

Every effort has been made to obtain permission to reproduce copyright material/the figures illustrated in this book. If any proper acknowledgement has not been made, copyright holders are invited to inform the publisher of the oversight.

Published by Manchester University Press
Oxford Road, Manchester M13 9NR, UK
and Room 400, 175 Fifth Avenue, New York, NY10010, USA

Distributed exclusively in the USA by
St. Martin's Press, Inc., 175 Fifth Avenue, New York, NY10010, USA

Distributed exclusively in Canada by
UBC Press, University of British Columbia, 6344 Memorial Road, Vancouver, BC, Canada V6T 1Z2

British Library Cataloguing-in-Publication Data
A catalogue record for this book is available from the British Library

Library of Congress Cataloging-in-Publication Data applied for
Votolato, Gregory
 American design in the twentieth century: personality and performance / Gregory Votolato
 p. cm. — (Studies in design and material culture)
 Includes bibliographical references and index.
 ISBN 0-7190-4530-4 (cloth).—ISBN 0-7190-4531-2 (pbk.)
 1. Design—United States—History—20th century. 2. Design, Industrial—United States—History—20th century. I. Title. II. Series
NK 1404.V68 1998
745.4'4973'0904—dc21 98-12712

ISBN 0 7190 4530 4 *hardback*
 0 7190 4531 2 *paperback*

First published 1998

05 04 03 02 01 00 99 98 10 9 8 7 6 5 4 3 2 1

Typeset in Stone Serif with Sans display
by Carnegie Publishing, Lancaster
Printed in Great Britain
by Alden Press, Oxford

Contents

Illustrations

Acknowledgements

Earlier versions of several parts of this book have been delivered as lectures, and I am grateful to the many students and colleagues who have commented on their contents over the years. Chapter Seven, 'Industrial drama: the custom car myth', was presented first as a conference paper and subsequently published in a substantially different form than appears here, in *Design Review*, Issue 11, vol. 3, 1994 ('My Own Private Chevrolet'). I would like to thank the editor, David Redhead, for his advice at that time.

My thanks are due to Paul Greenhalgh for entrusting me with this subject and for giving me a good start; at Manchester University Press, Matthew Frost, Katharine Reeve, Stephanie Sloan, Rebecca Crum, Rachel Armstrong and Gemma Marren all provided continuous, much-needed support and advice; Vivienne Robertson's careful and constructive copy-editing was enormously helpful in the final stages; Buckinghamshire University College allowed me liberal helpings of time and money; Helen Rees for reading the text and her generous advice; Rhode Island School of Design Library and Museum; the following friends, relatives and colleagues who helped in ways too numerous to list: Christopher Baird, Peter Baker, Dolores Barchi, Ray Batchelor, Greer Crawley, David Creighton, Jim Draper, Rupert Hamerton-Frazer, Russ Hampton, Brendan James, Terry Jones, Terry Lelliot, Mike Luxton, Margaret Mathias, Catherine McDermott, Sylvia Quinn, Paul Springer, Lorraine Tavani, Mary Votolato; and Danuta Votolato, for her constant support and encouragement.

To my parents, Arthur (1900–88) and Mary (1906–)

Chronology

General history	Fine arts and literature	Design
1900-09		
1900: US adopts gold standard.	**1900**: Theodore Dreiser publishes *Sister Carrie*.	**1900**: Gustav Stickley launches 'Craftsman' furniture.
1901: Republican Theodore Roosevelt succeeds assassinated William McKinley as US President. Progressive era begins.	**1903**: Isadora Duncan, *Danses-Idylles*, Paris	Carnegie Institute founded in Pittsburgh. offering art & design courses
1901: Buffalo Pan-American Exhibition.	**1904**: George M. Cohan, *Give My Regards to Broadway*	Campbell's Soup can given current label.
1903: Wright brothers make first successful flight in powered aircraft.	**1905**: Edwin S. Porter, *The Great Train Robery* debuts in nickelodeons nation-wide.	**1901**: Louis Sullivan, Carson Pirie Scott store, Chicago.
1905: First neon signs.	John Sloan, *Early Sunday Morning*	**1901**: Gustav Stickley begins publication of *The Craftsman*.
1903: US implicated in Panamanian revolution – gains control of site for new Atlantic–Pacific canal.	Alfred Steiglitz founds Photo-Secession Gallery in New York (becomes '291' in 1908)	**1904**: Albert Kahn designs factory for production of Packard automobiles.
1903: First 'muckraking' articles by Ida Tarbell and Lincoln Stephens, *McClure's Magazine*.	**19C6**: Picasso, *Gertrude Stein*	**1905**: Elsie deWolfe establishes interior decorating service in New York
1907: Roosevelt establishes National Conservation Association.	**1907**: William James, *Pragmatism*.	**1908**: Model T Ford introduced.
1908: US Supreme Court limits working day for women to 10 hours.	**1908**: Marinetti's first *Futurist Manifesto*.	**1909**: Charles and Henry Greene design Blacker house, its furniture and gardens, Pasadena, CA.
	1909: New York Motion Pictures, Essenay and Selig companies begin production of movies in California.	Frank Lloyd Wright's Robie House, Chicago.
1910-19		
1912: US Post Office establishes domestic parcel post service.	**1911**: First publication of *The Masses*, magazine promotes radical ethics and aesthetics.	**1910**: Wasmuth publication of the works of Frank Lloyd Wright in Germany.
1914: Panama Canal opens.	Irving Berlin, *Alexander's Ragtime Band*.	**1912**: L. L. Bean designs Maine Hunting Shoe, begins mail order sales.
1914: World War begins in Europe	**1913**: Armory Show in New York introduces America to modern European art.	National Alliance of Art and Industry formed.
First electric assembly line at Ford Highland Park plant.	**1915**: Edgar Lee Masters *Spoon River Anthology*.	**1915**: US Post Office Rural Mailbox.
1917: US enters war. War Industries Board given dictatorial powers over industry.	**1915**: Provincetown Players founded.	**1916**: William Laurel Harris publishes 'Industrial Art and American Nationalism'.
Espionage Act establishes	**1915**: D.W.Griffith, *Birth of a Nation*.	**1917**: James Montgomery

General history	Fine arts and literature	Design

General history

xenophobia as official attitude.
1917: Bolshevik revolution in Russia.
1918: Armistice signed to end fighting on 11 November. Approximately eight million people had died.
1919: President Wilson promotes establishment of League of Nations, but America does not join.

1920-29

1920: Eighteenth Amendment (Volstead Act) prohibits the sale and consumption of alchohol. Nineteenth Amendment gives women political equality with men.
1921: Quotas imposed on immigration.
1927: Cellulose Acetate plastic available in colors
Sacco and Vanzetti executed for treason. Many believe them to be victims of xenophobia.
Lindbergh flies Atlantic.
1929: Wall Street stock market crash begins period of the Great Depression.
Kodak develops 16mm color film.

1930-39

1930: Greyhound buses enter service.
1932: Franklin Roosevelt elected President, begins 'New Deal' policies for recovery and social reform.
1933: Hitler comes to power in Germany.
Tennessee Valley Authority established.
1933-34: Chicago Century of Progress Exhibition.
1935: WPA established.
Pan American Airways begins passenger flights across Pacific.

Fine arts and literature

1917: Original Dixieland Jazz Band issues first recording.
1918: Original Dixieland Jazz Band makes first European tour, introduces jazz to Europe.
1919: United Artists film corporation founded.

1920: Sinclair Lewis, *Main Street*.
First commercial radio broadcasts by station KDKA of Pittsburgh.
1924: Gershwin, *Rhapsody in Blue*.
1925: F Scott Fitzgerald, *The Great Gatsby*.
Metropolitan Museum of Art opens American Wing.
1926: Ernest Hemingway, *The Sun Also Rises*.
1927: *The Jazz Singer,* first sound film.
Duke Ellington forms resident band at The Cotton Club
1928: Disney's first Mickey Mouse cartoon.
1929: Museum of Modern Art founded in New York.

1932: Alexander Calder, first *mobiles*.
Stuart Davis, *American Painting*.
MOMA , *Modern Architecture: International Exhibition*.
1932-33: Diego Rivera, mural at Ford River Rouge factory.
1933: Black Mountain College, experimental art community, founded in North Carolina by John Andrew Rice.
1934: Lewis Mumford, *Technics and Civiization*.
Salvador Dali exhibits

Design

Flagg, *I Want You* recruitment poster.
1917: First industrial art exhibition at Metropolitan Museum of Art.
Wallace Nutting begins manufacture of colonial reproduction furniture.
1919: Bauhaus formed in Weimar.

1924: First Harvard Advertising Awards
1925: International Exposition of Decorative Arts, Paris.
Eliel Saarinen and George Booth commence construction of Cranbrook Academy of Art, Bloomfield, Michigan.
1926: Helen Koues, *How to Be Your Own Decorator*.
1927: Model A Ford replaces Model T.
Harley Earl appointed to head GM styling section.
Buckminster Fuller's Dymaxion house prototype.
1928: 'Macy Exhibition of Art and Industry', New York.
1929: Both Raymond Loewy and Henry Dreyfuss receive first industrial design commissions.

1930: Art Center College of Design founded in Los Angeles.
1932: Norman Bel Geddes, *Horizons*.
1932: Cranbrook Academy of Arts formally established.
Philadelphia School of Design for Women merges with Moore Institute of Art.
1933: Fuller's Dymaxion car demonstrated at Chicago World's Fair.
Bauhaus closed by Nazis.
1934: Chrysler launches Airflow model.
1936: Knoll furniture

General history

1936: Acrylic plastic developed.
1937: Styrene plastic developed.
Fiberglas perfected by Corning.
1939: Germany invades Poland. Second World War begins in Europe.
1939-40: New York World's Fair.

1940-49

1941: First commercial TV stations authorized.
US 'Lend-Lease' agreement with Britain.
Japan attacks American naval base at Pearl Harbor. America enters Second World War.
1942: ENIAC, first electronic computer developed.
1945: First atomic bomb demolishes Hiroshima. Second World War ends. UN Charter adopted.
1946: Winston Churchill's 'Iron curtain' speech.
1947: 'Cold War' begins. Marshall Plan for foreign aid. House Un-American Activities Committee begins investigations of communism in America.
1948: Transistor invented in USA.
1949: Formation of NATO Alliance.

1950-59

1950: US enters Korean conflict.
1951: First electricity from atomic power plant.
1952: Eisenhower era begins. First public Cinerama theater opens in New York
1953: Korean armistice.
1954: Supreme Court abolishes segregation in public schools.

Fine arts and literature

Surrealist paintings in New York.
1935: Fred Astaire and Ginger Rogers dance in *Top Hat*.
1936: Chaplin's *Modern Times*.
1937: John Dos Passos, *USA*.
1938: Margaret Mitchell's novel *Gone With the Wind* filmed.

1941: Orson Welles, *Citizen Kane*.
1942: Peggy Guggenheim founds 'Art of this Century' gallery in New York.
Edward Hopper paints *Nighthawks*.
Breton and Duchamp, *First Papers of Surrealism* exhibition, New York City.
1943: Piet Mondrian completes *Broadway Boogie-Woogie*.
1944: Aaron Copeland's *Appalachian Spring* first performed.
1946: Eric Hodgins, *Mr. Blandings Builds His Dream Castle*.
1947: Tennessee Williams, *A Streetcar Named Desire*.
1948: Giedion, *Mechanization Takes Command*.
Thelonius Monk, *Round Midnight*.
Eliel Saarinen, *Search for Form. A Fundamental Approach to Art*.
1949: Jackson Pollock's *Composition No. 1*.

1952: Cage and Rauschenberg collaborate at Black Mountain College.
1953: First telecast of *I Love Lucy*.
The Wild One stars Marlon Brando.
1954: Arnold Schoenberg, *Moses and Aaron*.
1955: *Rebel Without a Cause* stars James Dean.

Design

company established.
Frank Lloyd Wright designs Kaufmann house, Falling Water.
1937: Russel Wright, 'American Modern' dinnerware.
Moholy-Nagy founds New Bauhaus in Chicago.
1938: Gropius and Breuer arrive in USA.

1940: MOMA 'Organic Design in Home Furnishings' exhibition.
Steuben exhibits work in glass by 27 artists including Dali, O'Keefe and Noguchi.
1941: Wurlitzer Model 850 jukebox.
Willys Jeep.
Fuller's Dymaxion Deployment Unit
Quonset Hut.
1942: Marianne Strengell heads Cranbrook Textiles Studio.
1945: Tupperware introduced.
1946: First Levittown constructed, Long Island, New York.
1947: Dior launches 'New Look' in Paris.
1948: Mies van der Rohe's *Lake Shore Drive Apartments* begun.
Lustron prefabricated house.
1949: First Cadillac tailfins.
Charles and Ray Eames, Case Study house no. 8.

1950: First MOMA 'Good Design' exhibition.
1951: First Aspen Conference on design.
Noguchi, paper lamps.
1952: Skidmore, Owings and Merrill, *Lever House*, New York.
Gibson produces Les Paul guitar.
1956: Monsanto House of the Future, Disneyland.

General history

1955: International Cooperation Administration promotes importation of foreign handicrafts
1957: USSR launches first space satellite, 'Sputnik'; space race begins.
1958: Lycra invented. Stereophonic records introduced.
First US space satellite, 'Explorer'.
1959: Hawaii becomes 50th state.
Fidel Castro gains power in Cuba.

1960-69

1960: J. F. Kennedy inaugurated as US President.
1962: Three US astronauts orbit Earth.
Telstar satellite launched.
1963: JFK assassinated.
Martin Luther King, 'I have a dream' speech.
1964: Ranger VII satellite takes close-up photographs of moon's surface.
1965: Ralph Nader's *Unsafe At Any Speed.*
Malcolm X assassinated.
US involvement in Viet Nam war escalates.
1967: 'Summer of Love'.
1968: Martin Luther King and Robert Kennedy assassinated.
1969: US lands first astronauts on moon.
Woodstock music festival.
ARPANET communications network developed by US government.

1970-79

1970: Boeing 747 jumbo jet enters commercial service.
Major anti-war demonstrations culminate with National Guard shooting four students at Kent State University.
Theodore Roszak, *The Making*

Fine arts and literature

Sloan Wilson, *The Man in the Grey Flannel Suit.*
1956: Elvis Presley appears on the Ed Sullivan Show.
Allen Ginsberg, *Howl.*
1957: First Annual Conference of American Craftsmen.
Jack Kerouac, *On the Road.*
1958: Jasper Johns exhibits *Flag.*
J. K. Galbraith, *The Affluent Society.*
1959: Saul Bass titles and graphics for *Anatomy of a Murder.*

1962: Andy Warhol, *Green Coca Cola Bottles.*
Claes Oldenburg, *Soft Sculptures.*
1963: Beatles appear on Ed Sullivan Show.
Warhol's films, *Eat, Sleep* and *Kiss.*
1964: Kenneth Anger, *Scorpio Rising.*
Living Theater perform *Marat-Sade*, by Peter Weiss.
Susan Sontag 'Notes on Camp'.
David Smith begins series of *Cubi* sculptures.
1965: Tom Wolfe *The Kandy-Kolored Tangerine-Flake Streamline Baby.*
1966: Harold Rosenberg, 'Is There a Jewish Art?'
Carl Andre, *Lever.*
1967: Arthur Penn, *Bonnie and Clyde.*
1969: 'Anti-Illusion: Procedures/Materials' exhibition, Whitney Museum.
Dennis Hopper, *Easy Rider.*

1970: Robert Smithson's *Spiral Jetty.*
Conference on Art Criticism and Art Education, New York City, Lawrence Alloway attacks 'elite criticism'.
1971: Arthur Penn, *Little Big Man.*

Design

Time cover story on Claire McCardell.
Morris Lapidus, *Fontainbleau Hotel*, Miami Beach.
GM Motorama features 'Kitchen of Tomorrow'.
1958: Frigidaire 'Sheer Look' kitchen appliances.
Ford Motor Co. launches the Edsel.
1959: Wright's *Guggenheim Museum* completed.

1960: World Design Conference, Tokyo.
GM launches Corvair car.
1961: Henry Dreyfuss, *The Measure of Man.*
1962: Raymond Loewy, Studebaker Avanti.
1963: Herman Miller, 'Action Office'.
1964: Eugene Bordinat and Staff, *Ford Mustang.*
1966: Drop City settlement in Colorado.
1967: Robert Venturi's *Complexity and Contradiction in Architecture* published by MOMA.
Expo '67 in Montreal features Fuller's geodesic American pavilion.
1968: Hobie Cat Catamaran.
1969: *Objects USA* exhibition at Smithsonian Institution.
Children's Television Workshop launches *Sesame Street.*

1970: Anti-war posters by Art Workers Coalition.
1971: Bay Area Rapid Transit system (BART) enters operation, San Francisco.
Victor Papanek, *Design for the Real World* published in Sweden.

of a Counter Culture.
1971: Intel announces microprocessor.
1972: 'Watergate' scandal breaks – forces Nixon resignation in 1974. Demolition of Pruitt Igoe apartments in St Louis.
1973: America withdraws from Viet Nam. Yom Kippur War sparks world oil crisis. Petroleum prices soar.
1974: Robert Pirsig, *Zen and the Art of Motorcycle Maintenance.*
1976: American bi-centennial celebrations.

1972: Nam June Paik: *Paik-Abe Video Synthesizer* exhibited.
Francis Ford Coppola, *The Godfather.*
1972-76: Christo's *Running Fence* project.
1975: E. L. Doctorow, *Ragtime.* Philip Glass, *Einstein on the Beach.*
Patti Smith performs at CBGB club in New York City.
1977: J.-M. Basquiat and Al Diaz paint *SAMO* graffiti in Manhattan.
Walter de Maria, *Lightning Field.*
Mary Boone gallery opens in New York City, promotes Neo-Expressionist art.

1972: *Italy, The New Domestic Landscape* exhibition at MOMA.
Venturi's *Learning From Las Vegas.*
Frank Gehry, *Easy Edges* chairs in corrugated cardboard.
1975: Design Management Institute founded in Boston.
1977: Charles Jencks, *The Language of Post-Modern Architecture.*
1978: Ralph Lauren, costumes for Woody Allen's *Annie Hall.*
1979: Philip Johnson: AT&T building, New York.
Sony introduces 'Walkman'.

1980-89

1980: Ronald Reagan becomes President – period of conservative government begins.
1981: (MDF) Medium Density Fiberboard.
AIDS epidemic revealed.
1982: Formica announces Color-Core laminate.
1984: 28th Olympiad in Los Angeles.
Gas leak at Union Carbide factory in Bhopal kills 2,000.
1985: Reagan and Gorbachev initiate glasnost/detente.
First practical ceramic super-conductors.
1986: Chernobyl nuclear disaster.
1987: Stock market crashes – period of economic uncertainty begins, recession follows.
1989: Columbia TriStar bought by Sony.

1980: John Cage, *Litany for the Whale.*
Keith Haring, magic marker paintings in New York subway.
1981: 'New York/New Wave' exhibition at P.S.1 gallery in New York.
1982: Jenny Holzer, *Truisms*, Times Square, New York.
1983: Serge Guilbert, *How New York Stole the Idea of Modern Art.*
1984: James Cameron, *The Terminator.*
1986: Spike Lee, *She's Gotta Have It*
1987: Menil Collection opens in Houston.
1988: Whitney Museum holds Donald Judd retrospective.
1989: Whitney Museum, *Image World; Art and Media Culture* exhibition, New York City.

1983: American Motors introduces Jeep Cherokee.
Design Issues journal launched.
Formica sponsors *Surface and Ornament* travelling exhibition.
1984: Apple Macintosh PC and operating system.
Venturi furniture collection for Knoll International.
1985: Quantel Paintbox computer technology.
1986: Bill Stumpf, *Ethospace* office system
Michael Graves, Alessi kettle.
1988: Mazda Miata designed at Mazda Design, USA.
I. M. Pei, Louvre Pyramid.
1989: OXO International, 'Good Grips' utensils.
Victor Margolin, *Design Discourse.*

1990-97

1990: German re-unification. USSR dismantled. Cold War ends.
1991: Gulf War follows Iraqi invasion of Kuwait.
George Holliday videos Rodney King beating in Los Angeles. Riots erupt.

1991: Bret Easton Ellis, *American Psycho.*
Lawrence Weiner installation *Displacement* at Dia Center for the Arts, New York.
1992: Jeff Koons and Ilona Staller, *Made in Heaven* exhibition.

1990: Design for disassembly (DFD).
Spike Lee opens chain of street and sports-wear shops.
1991: Pesce Ltd (USA) 'Seaweed Chair' made of recycled materials.
Venturi and Scott Brown,

1992: *Mall of America,* world's largest shopping mall opens in Minneapolis.
EuroDisney opens in France.
1993: Cult siege in Waco, Texas.
American undergraduate, Mark Andreessen, develops Netscape Web program.
1995: O.J. Simpson trial captures world media attention.
Privatization of Internet by US government.
Louis Farrakhan leads Million Man March of the Nation of Islam in Washington DC.
1996: Average salary of Boeing Aircraft Co. employees $50K.
1997: Hong Kong returns to Chinese sovereignty.

1993: Mapplethorpe exhibition indicted for indecency by US Senator and Mrs Jesse Helms.
Toni Morrison, first black woman novelist awarded Nobel Prize for Literature.
James Carpenter, *Refractive Tensegrity Ring*, dichroic glass installation, Munich airport, Germany.
1994: Martha Stewart *Home for the Holidays* Christmas TV special.
1995: Quentin Tarantino, *Pulp Fiction.*
Charles Jencks, *Architecture of the Jumping Universe.*
1995-96: *Craft in the Machine Age* exhibition, American Craft Museum, New York.

National Gallery Extension, London.
Gehry and Oldenburg Chiat/Day building, Venice, California.
1992: *Ray Gun* magazine begins publication, music + style.
1993: Nike-Air blow-moulded eurethane sports shoes.
1994: Ciba Aerospace Co. fiberglass and resin Windpower Blade.
'Aeron' office chair by Bill Stumpf and Don Chadwick, high-performance seating (mfg. Herman Miller).
1995: Victor Papanek, *The Green Imperative.*
Mutant Materials in Contemporary Design exhibition, MOMA, New York.

Introduction

During the twentieth century the way Americans housed, clothed and transported themselves, the nature of their work and the passage of their leisure time were increasingly tied both to manufactured goods and their advertised images supplied by the expanding print and electronic media. Design became an essential ingredient in the process. It also became a popular vocation.

Design in 'The American Century'

The journalist, Tom Wolfe, with only a pinch of his famous hyperbole, called the period since 1900 'The American Century'. The past hundred years was the time 'in which the young giant became the mightiest nation on earth … the richest nation in all of history, with a wealth that reached down to every level of the population … The way Americans lived made the rest of mankind stare with envy or disgust but always with awe.'[1] Americans themselves were staring – in magazines and shop windows, on TV and in the street – with envy, disgust, lust, pride, anticipation and boredom. But what were they staring at? Designed things? Designed pictures of designed things?

Wolfe described the average American family car as 'a 425-horsepower, twenty-two-foot-long Buick Electra with tail fins in back and two black rubber breasts on the bumper in front'. This was something to stare at. The American home was a suburban ranch 'with gaslight-style front porch lamps and mailboxes set up on lengths of stiffened chain that seem to defy gravity'. Inside was 'wall-to-wall carpet you could lose a shoe in, and they put barbecue pits and fishponds with concrete cherubs urinating into them on the lawn out back'. This too was something to behold.

Of course, it was not just American tastes which impressed and appalled. The Buick's tail fin could rip open a human body as effectively as the teeth of a killer shark; and the evidence was seen daily in hospital emergency rooms and on the obituary pages of the daily papers. A Smith and Wesson 'LadySmith' pistol or a Colt 'All American' Model 2000, kept in the shag-carpeted bedrooms of many homes, were 'designer' weapons styled to appeal to both the conscience and taste of the American mom. The glamorized

destructive power of these small domestic appliances was the focus of attention in countless film and TV dramas.

Yet Americans, and the rest of the world, were also staring at the intelligent screen displays of sensible Macintosh computers. They were wearing everyday, durable Levi jeans. They were going on vacation in the comfortable cabins of Lockheed Constellations and, later, in vast 747s. They were quenching their thirst out of the same, satisfyingly tactile 6.5-ounce Coke bottle that millions of other people have been drinking out of from Syracuse to Singapore for over eighty years. And they were relying on the federal government to provide safe, fast and economical highway systems, air traffic control patterns and postal services, all design to benefit the whole population.

Throughout the century, the production and acquisition of material goods were more closely bound up within the fabric of life in the United States than they were anywhere else in the world. America became the ultimate materialist culture.

While urban, rural and ethnic poverty have continuously dogged the American dream of wealth, what is amazing is how many people have had access to the incredible abundance of the economy. Intense commercial competition has undoubtedly accounted for much of the vigor of American industry. Early in the century, the rapid growth of cities boosted demand for products by putting a huge number of salaried workers with plenty of disposable income in close proximity to large numbers of shops. At the same time, companies such as Sears Roebuck were selling millions of products to rural Americans through their mail order catalogues or 'dream books'. Later, with the exodus to the suburbs, malls offered a new leisurely experience to the motorized shopper. Ultimately, buyers only needed to tune into a TV shopping channel showing non-stop infomercials and then recite their credit card numbers into the telephone to purchase just about anything. With virtual shopping via the internet becoming a reality of the 1990s, the process became even less mechanical and more private.

Perhaps the most compelling and contradictory features of American design were its uniquely democratic virtues and its shameless appeal to status. Yet serious discussions of 'class' in Europe stood in marked contrast to the light-hearted Americanism, 'classy', which was used broadly to describe high quality.

While older cultures were trying to abolish their old class hierarchies, Americans were busy defining a social structure which recognized various kinds of achievement and punished those who did not achieve. However, as in Europe, class in America was synonymous with an appreciation of tradition. The decorative weather vane on the garage roof and the wrought iron lantern over

the front door of the suburban Cape told of the residents' membership in the land-owning tradition of the republic and of their respect for conventions of taste which dated back to the Massachusetts Bay Colony. Yet, these trappings of class were found among house dwellers at all economic levels.

Recognition of the aspirational nature of goods in the American marketplace pre-dates the present century. The Commissioner of the Bureau of Labor Statistics of the State of Connecticut wrote in 1887 that 'wants have multiplied, and society demands so much in the style of living that the laboring-man finds it almost impossible to live as respectably now on his wages as his father did thirty years since upon his. That is, wages have not kept pace with the increasing wants and style of living demanded by society'.[2]

While in many ways America remained in the shadow of Europe during its entire history, design was an activity in which it went spectacularly its own way, for better and for worse. And so, what are the qualities which distinguish modern American design from design in other parts of the world? Is it the tension between what Wolfe called America's 'Hog-stomping Baroque exuberance' and its practical, utilitarian and democratic qualities?[3] Is it the independent spirit seeking expression? Is it a simple craving for novelty and sensation? Or is it the impression of ethnic or regional character which identifies American design?

Radical American thinkers of the early twentieth century, such as VanWyck Brooks and the philosopher-poet, George Santayana, held the idea that America must develop a culture which reflected its democratic nature and its particular ethnic and regional composition. These were cultural nationalists who rejected the need for European models or European approval for their work and their ideas. Their aim was shared in the first half of the century by visual artists such as the photographer Alfred Steiglitz, the painter Georgia O'Keefe, and the architect Frank Lloyd Wright, whose concept of 'Usonia'[4] inspired the design of houses and furnishings which expressed allegiance to both Native American culture and modern technology while responding to the specific qualities of the American landscape.

Correlation between independence and communication has been central to life and design in the vastness of the United States. The traditional rural mailbox was a direct design response to the permanent provision of Rural Free Delivery service by the Post Office in 1902. The sturdy, simple and capacious steel mailbox provided a tangible link between geographically isolated individuals, a link expanded also by the telephone and later by the internet, the terminus of which was the personal modem-computer.

Expressions of personal freedom, love of novelty and rejection of authority have been reflected in American design since the earliest settlers landed in Massachusetts and Virginia. North American writers from Henry David Thoreau to Witold Rybczynski have described how the spirit of independence is achieved by building a home. At a less ambitious level, the Americans' love of novelty and invention, expressed as 'Yankee ingenuity', found an outlet in the Do-It-Yourself movement which offered a partial escape from the commercially produced domestic environment. The individualistic spirit also became an export commodity represented by the rugged, independent image of the Marlboro man, by the Jeep Cherokee, usually portrayed in deep wilderness, and by Frank Gehry's eccentric and emotionally charged but functional buildings and furniture. On a more purely physical level, self-reliance was an aim of 'Good Grips' domestic products designed to enable people with arthritis to perform their own domestic chores without assistance.

In the tradition of the Shakers and other early settlers, Puritanism and practical values remained at the heart of American life and inspired some of the most characteristically American design thinking and products. The simple, efficient and sturdy Stanley Utility Knife or Revereware pots and pans belonged to a genre of products which made work easy and pleasurable. Having the correct tools and apparel for every job was of paramount interest to Americans who always want a 'better mousetrap'. In this spirit the radical inventor, Buckminster Fuller, dedicated his career to a quest for utility and economy in the design of his Dymaxion products and most notably in the spare efficiency of the geodesic dome he patented in the 1940s.

But what about Marilyn Monroe and Madonna? Sex, glamour and extravagant displays of wealth have been the flip-side of American Puritanism, and they are equally part of the country's design character. The aggressive and sensuous contours and colors of a Corvette Stingray or a Fender Stratocaster guitar are as typically American, in their ways, as are the practicality and mechanical austerity of a Kryptonite bicycle lock.

American culture has held tradition and modernity in a delicate equilibrium throughout the century, although to some observers it seemed like a war in which one set of values must triumph absolutely over the other. The domestic kitchen became one of the greatest arenas of this contest. With high-tech, Sub-Zero refrigerators and glossy KitchenAid dishwashers standing proudly between Colonial or Shaker cabinetry, American kitchens reconciled the personal need for emotional comfort with the high technical expectations of the modern family.

What was 'design'?

In 1987 John Thackara wrote that 'traditional notions of "design" are, both practically and theoretically, defunct. Reality has seen to that.'[5] His suggestion that all earlier definitions were *passé* may be arguable. But the assertion that both popular and professional ideas of design are subject to change is helpful as a starting-point in identifying a set of questions about the concept of design.

In the 1970s the addition of Gloria Vanderbilt's signature to the seat of a pair of blue jeans signaled the full-blown acceptance of design as a celebrity occupation. The status conferred on the ordinary, though well-tailored, jeans by linking them with a famous American family name suggested the distance design had moved away from its role as a means of improving products and toward the purely commercial function of adding value by fictitious associations.

In the course of the century 'design' acquired a variety of meanings, yet it remains one of the most ambiguous words in common use. Describing the early auto manufacturers' understanding of design, Stephen Bayley wrote,

> It took a while for these founders of the American automobile industry to discover design. At first the word to them meant only the matter-of-fact solution to mechanical engineering problems ... With the urge to create volume, design meant the perfecting of manufacturing processes. Soon, however, they discovered a form of beauty separate from but related to the fascinating quest for profits. When they were persuaded for the first time that appearance might have an influence on sales, they did not call this perceptual innovation design; instead they called it styling.[6]

The roots of the word design can be found in the Italian 'disegnare', meaning to draw or plan. The Renaissance painters used 'disegno' as a term to distinguish works of art which were carefully planned on the basis of line, communicating a clear sense of order, as opposed to more subjective, emotional qualities of works characterized by their expressive use of 'colore'.

According to the industrial designer and historian Arthur Pulos, in the nineteenth century 'The concept of design as a means by which a plan for a product could be conceived in the mind and laid out in detail for analysis and evaluation before it was manufactured began to expand the traditional use of the word design beyond artistic composition and decoration.'[7] Since the birth of modern engineering in the eighteenth century, design has come to be seen as the process of conceiving, planning and describing the form of an object to be made either by oneself or by someone else. The drawing became the standard means of communication

between designer and maker and also part of the legal contract between them.

But drawing is not the only language of design. Harley Earl, the head of styling at General Motors for over thirty years, did not draw; he acted as a 'critic and synthesizer', communicating his vision of a car body to draftspeople and model-makers through a vocabulary of colorful descriptive phrases and physical gestures.[8] Despite being based on his inability to sketch, Earl's method of designing was effective and became the standard system used by all Detroit car manufacturers in the 1930s and 1940s.

The acceptance of design as a professional activity in the first decades of the century was dependent on rapidly expanding mass production of consumer goods. The pioneering generation of industrial designers defined the profession during the boom of the 1920s and the Great Depression of the 1930s. Raymond Loewy, Walter Dorwin Teague, Norman Bel Geddes and Henry Dreyfus moved from careers in fashion illustration, advertising, stage design and the fine arts to establish the first industrial design practices. As self-declared professionals, they realized one of the chief aims of the Progressive movement (a social and political force in the early decades of the century), establishing the primacy of expertise in every field.

Their practices departed significantly from previous associations between artists and industry through their independence as consultant organizations, their aggressive courtship of business clients, and their declared aim of employing design to enhance the desirability of relatively standard products which were competing in a heavily saturated marketplace. Thus, Loewy's famous redesign of the 'Coldspot' refrigerator for the Sears Company in 1935 emphasized sculptural form, ornamental detailing, tactile qualities and novel interior appointments as means of attracting the attention of buyers. Using the model of the fashion industry, the new industrial designers applied ornament and color, which could be updated annually, to domestic products and cars making obsolescence an incentive to future consumption.

The changing meaning of 'design' has reflected increasing professionalism and specialization. Graphic design, fashion design, product design and interior design have, this century, joined architectural design and what were previously called the decorative arts as recognized professional activities represented by chartered organizations such as the American Institute of Graphic Arts (AIGA, founded 1914), the Industrial Designers Society of America (IDSA, founded 1938), the American Society of Interior Designers (ASID, founded 1975), and the Council of Fashion Designers of America (organized by Norman Norell).

These organizations followed the model of the American Institute of Architects (AIA) which was founded in 1857 to promote professional ethics, represent its members publicly, support professional education and registration standards, and sponsor awards for professional excellence.

The growth of higher educational programs catering to the new design professions also promoted the idea of design disciplines as related, but specific professional activities having a status approaching that of architecture, law, medicine or banking.

Alternatively, some pundits supported a broad, cross-disciplinary definition of design. The computer scientist, Herbert Simon, wrote that

> Everyone designs who devises courses of action aimed at changing existing situations into preferred ones. The intellectual activity that produces material artifacts is no different fundamentally from the one that prescribes remedies for a sick patient or the one that devises a new sales plan for a company or a social welfare policy for a state.[9]

In response to this definition one might well ask to what extent negotiation and persuasion operate within the design process? Can executive managers of design teams be considered part of the creative process, or are they simply enablers – those with the money and/or the power to get things made or organized?

Even such a broad view of design remains essentially in a professional arena. Others have gone further, reflecting a popular idea of design as an activity which can be pursued for an infinite variety of purposes by just about anyone. Victor Papanek described all people as designers. 'Design is basic to all human activity. Any attempt to separate design, to make it a thing-by-itself, works counter to the fact that design is the primary underlying matrix of life.' As in Herbert Simon's definition, Papanek retreats from the exclusivity of design as a professional skill and asserts the intuitive nature of design which makes it accessible to everyone. 'Design is composing an epic poem, executing a mural … reorganizing a desk drawer, educating a child. (It is) the conscious and intuitive effort to impose meaningful order'.[10] Papanek also insists on the communal nature of design, declaring the Inuit peoples of Alaska and Canada 'the best designers in the world'![11]

What, then, are the main functions of design? Is it primarily about making objects look good, work better or sell faster? Is it a profession or a universal activity? Is it intuitive and pleasurable, or is it a neutral, objective, scientific process? Is design an ideological instrument based on political and economic objectives? These are some of the questions that this book attempts to answer through example and discussion.

Who is a designer?

Despite a diversity of specific aims, the overwhelming weight of writing by critics, theorists, historians and designers themselves, during the final quarter of the century, viewed design exclusively as a profession practiced by trained and registered individuals in the service of commerce. The amount of professionally designed, manufactured articles surrounding the majority of Americans would seem to support this view. However, the enormous popular interest in design which has developed during the same twenty-five years, the amount of media attention on design, the number of college students choosing design as the core of a liberal education and the amount of amateur designing which is easy to find if one looks for it, all suggest a different reality. It begs the questions, 'Who is designing, and why?'. It suggests the need for a broader enquiry into the reasons why people design.

Fun is one of the basic objectives of play; and play can be defined as the exercise of imagination and experiment for personal pleasure. Could this also be a partial definition of design? If so, the pleasure and satisfaction children find in making buildings and machines from construction toys or modelling a world out of plasticine could be linked with the pleasure adults derive from proposing a solution to the difficult problem of office seating, from designing a page layout on their home PC, or in their leisure time from planning a new garden layout or creating a party costume. The craft element of making the designed object is important to most amateurs, as it is to professional craftspeople; and it may interpenetrate with the act of conception. Planning and building a tree house or a fort made of branches and odd bits of plywood has long been a popular project for groups of suburban and rural children. Should we give up experimental constructive play in adulthood? Or is there equal satisfaction to be gained from such direct and intuitive designing later on in life.[12] Some critics would argue that trial and error design wastes more time and material than adults can normally expend simply for the fun of it.

Advertisers would have us believe that ordinary people take part in design through the exercise of choice in the marketplace. Critics interested in future technologies also suggest that design is increasingly devolving to the user. In fact, computer software now enables us all to conceive and perfect graphic layouts, typography and illustrations within documents. And commercial availability of modular products, from 1950s hi-fi components to fashion separates, has enabled individuals, by the exercise of choice, to tailor their possessions to particular needs and tastes. Flexible manufacturing systems, allowing for economical short production runs,

have also enabled designers to cater more specifically to customers' requirements. Leisure time, too, has allowed us increasingly to plan and construct our own environments. But do these popular activities employ meaningful design? In what contexts can such design usefully be discussed? Does it have social, economic, political or aesthetic significance?

Time magazine announced with journalistic bravura that Raymond Loewy designed 'everything from tiepins to locomotives'.[13] And, indeed, products which appear in this study range from monumental to minuscule, from permanent to ephemeral. But there is a case yet to be made for a more inclusive definition of design. Design processes may be highly public or intensely private, individualistic or collaborative, professional or amateur. This study will concentrate on three basic areas of design - clothing, the automobile and the home - all of which share two themes, enclosure and disclosure. All three protect us, conceal us and at the same time represent ourselves to the world outside. And they also demonstrate the diversity of purposes to which design is put and the variety of ways in which it is conducted.

USA, 1900

This study begins in 1900. Inevitably, the use of such a date is arbitrary. Yet 1900 has historical significance as a moment in time when a variety of factors - technical, political, philosophical and economic - combined to change the character of life for a majority of people living in the United States. The first year of the new century also has symbolic importance as a time when there was a pervasive sense that culture was on the threshold of a rush forward toward better moral and physical standards of living for the many.

Hopes were pinned on the Progressive movement (1900–14) which attracted a following of middle-class reformers who believed that a new spirit had arisen in America which would inspire the formation of a more humane and creative society. The vigorous, young Theodore Roosevelt's accession to the presidency in 1901 signaled the political implementation of many of the movement's social aims: to rectify inadequate housing for the poor, to settle labor disputes, to improve working conditions for the laboring classes, and to rid government of corruption. Progressives also supported women's suffrage and rational dress, public health controls, consumer rights, temperance and housing reform. They put their faith in expert advice on all aspects of life and subscribed to the publishing industry's new mass-circulation magazines as a broad channel of communication between professionals and public.

The enemy of Progressivism was the emerging economic class hierarchy represented by a new generation of millionaires with flamboyant tastes and decadent habits. Thorstein Veblen's satirical *Theory of the Leisure Class*, published in 1899, cataloged anthropologically the manners and appearances of the new upper class. His concepts of 'conspicuous leisure' and 'conspicuous consumption', demonstrated mainly through the acquisition and display of clothing, yachts, elaborately furnished mansions, carriages and works of art, would remain pertinent to discussions of design for the rest of the century.

Yet the enjoyment of leisure-time activities was also becoming widespread throughout the salaried classes around the turn of the century as demonstrated by the craze for amateur photography. Its greatest stimulus was the introduction of the first Kodak Brownie camera in 1900. The simplicity of the Brownie's design and Kodak's processing service enabled the novice photographer to produce good pictures without benefit of tuition, and at a cost which put photography within the reach of millions. Through the high quality snapshot (figure 1), every-day activities of ordinary people were celebrated in a way previously unknown. Lore of families and individual experiences could be recorded easily in pictures for the first time. And the appearances of their houses, cars and clothes were frozen in time for future reference and as a pictorial means of charting progress and the evolution of taste and style.

Although the first technically successful American automobile had been driven through the streets of Springfield, Massachusetts, in 1893 by Charles and Frank Duryea, the impact of the automobile on the popular imagination was only being felt at the start of the

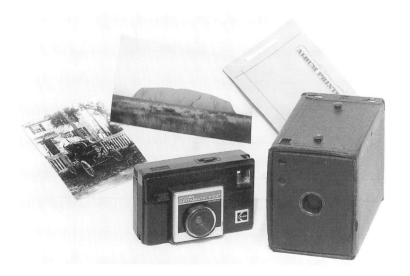

1] Kodak's Brownie, 1900, and Instamatic, *c.* 1970, cameras personalized history and generated a new folk art for the twentieth century. Their simple designs enabled millions of people with no art training to produce convincing visual images which portrayed a mythical world of their own making.

2] The automobile was more than mere transportation from the start. Collier's magazine ran this cartoon, captioned 'Jilted', in 1904 showing the depth of feeling the machine had already inspired. Women quickly realized that the car offered them a new independence.

new century, when Americans quickly fell in love with the car (figure 2).

In the 1890s the states had established highway departments for the improvement of road communication, initiating a process aimed at satisfying a variety of diverse public needs and wants. Rural Free Delivery (RFD), first introduced by the Post Office in 1891, promised farmers regular mail delivery and necessitated the improvement of country roads. The League of American Wheelmen represented several million American cyclists by 1900 and lobbied for extension of the country's paved roads for the purposes of sport and of pure, unimpeded freedom of movement. Thus an infrastructure was developing which would make automobile travel practical over the vast American continent.

Acceptance of the car was accelerated by popular events such as the first exhibition of the American Automobile Club which opened at New York's Madison Square Garden on 3 November 1900. Three-quarters of the cars shown by the thirty-two participating manufacturers were powered by electricity or steam. This reflected the crudeness of the internal combustion engine in the early years of its development. Hand-crank starting was difficult and dangerous, and an efficient muffler to silence its noise and an exhaust system to reduce its evil smell were refinements still a year or two off. Steam cars were powerful by comparison, while electrics were easy to start and operate and were clean and silent; and when paved roads reached only to the city limits, a 40-mile running distance on a single battery charge was thought to be sufficient.[14]

Prices for the 1900 models began at around $500, a modest outlay at the time, reflecting the relatively humble backgrounds of the makers and their democratic intentions for the motorcar. This contrasted with the early status of automobiling in Europe where cars were built exclusively for a wealthy, sporting clientele. In America, the commercial potential of the car was quickly understood. The 1905 Oldsmobile Model B Standard Runabout was advertised as 'indispensable to business as the telephone'.

Visitors to the exhibition were treated to colorful demonstrations of the cars on display. The pride exhibited by individual makers for their car's performance and reliability anticipated the competition which would develop later in relation to style. The names of makers quickly achieved popular currency rarely attached to the makers of horse-drawn vehicles.[15] Columbia, Winton, Waverly Electric, Stanley Steamer and Packard, all on show in New York in 1900, went on to become well-known makes. In this way, the automobile more closely reflected its ancestry in bicycle manufacture, which sold its wares on the strength of the maker's reputation, rather than its roots in carriage-making.

The increasing tempo of American life during the second half of the nineteenth century was partly the result of the rapid expansion of the United States into the western frontier and, ultimately, abroad. Both the pioneer spirit and the high cost of labor contributed to the hectic pace of technological innovation during the period. From the end of the Civil War in 1865 the annual rate of inventions registered with the US Patent Office was roughly twice that of any European country. By 1900 industrial production was twice the value of agricultural output. In the same year, output of American manufactured goods was around three times that of British goods. At the turn of the century, the United States was the world's major manufacturing nation. The country had developed means of producing goods which enabled it to make the most of both its vast natural resources and of its relatively well-paid labor force.

America also surpassed Europe as a consumer society, beginning tentatively around 1900, and getting into full swing in the 1920s with the widespread application of mass-production techniques, an immense diversity of products and services, and sophisticated advertising, marketing and payment plans.[16] Approximately twenty-five million Americans were living in cities by 1900.[17] The tall office building and the department store were established features of urban life. Around two million Americans were engaged in office work – law, accounting, engineering and clerical tasks involved in running an office.[18] To accommodate the rapidly expanding retail trades and the need for new office space, buildings such as Chicago's Carson Pirie Scott department store, designed by Louis Sullivan, and Daniel Burnham's Flatiron Building in New York were under construction in 1900 (figure 3).

The deep floor spaces of the tall new commercial buildings were made habitable and economically viable by the use of electricity to power lighting, the telephone and elevator. By the time of the Pan-American Exposition, which took place in Buffalo, New York, in 1901, the age of electricity in the home had begun. The exhibition featured an electrical hall which was considered the marvel of the event. In it were commercial displays of many of the domestic labor-saving devices which later generations would take for granted, the electric flatiron, fan, stove and toaster (figure 4).

The hall also dazzled its visitors with the artistry of its electrical illuminations. At the start of the century, technology was establishing a new role for itself in American culture. It no longer served only to ease humanity's struggle with nature and to promote the efficiency of labor. Now it was also in the business of creating magic, of entertaining[19] and of stimulating wants well beyond the dreams of people who had lived at the start of the nineteenth century.

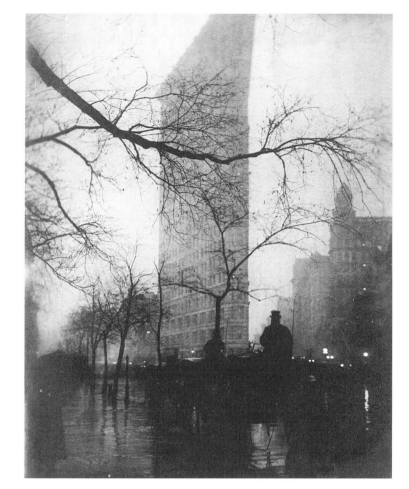

3] At the beginning of the century the skyscraper was America's supreme architectural achievement and the principal symbol of the modern city. Making money and spending it was its *raison d'etre*. The Flatiron building, New York, photographed by Edward Steichen, 1905.

4] Familiar corporate identities were formed while Art Nouveau was at its most popular. They offered elegant objects of brand loyalty, and they became global symbols of America's formidable productive capability. General Electric Company trademark.

The use of petroleum and electricity in a rapidly developed series of inventions had, by 1900, opened up the possibility of new freedoms and new aspirations for the large American middle classes, both in cities and in rural areas of the country. The motor car, electric lamp, telegraph, telephone and motion pictures were all being exploited commercially at the turn of the century and were appreciated both for their practical advantages and for the pleasure they could give. The conditions were present for design to flourish. Modern life was born.

Agents of change

In his introduction to *Mechanization Takes Command*, Siegfried Giedion wrote, 'The slow shaping of daily life is of equal importance to the explosions of history.'[20] The combination of forces, momentous or modest, domestic and international, which shaped the material face of twentieth-century America included

economics, technology, cultural trends, movements in art and literature, legislation, political currents and ethical standards. The chronology which appears at the beginning of this book lists some of the events which signaled changes in these fields.

The growth of giant companies led to new demands on design as a marketing tool. IBM and the Container Corporation of America employed versatile designers, such as Eliot Noyse and Herbert Bayer, to integrate the styling of their products, company graphics and the architecture of their buildings in order to present a coherent image to the public. Manufacturers quickly sensed the publicity value of industrial designers and employed the charismatic Raymond Loewy, Norman Bel Geddes, Henry Dreyfuss and others to style their products.

Mass production and the subsequent development of manufacturing methods form another important influence in the story of twentieth-century design. The contrast between standardization, espoused by Henry Ford, and variety within large-scale production, developed by Alfred Sloan at General Motors, reveals how methods of manufacture, the nature of work and the forces of the market influenced the appearance of products, the ways in which they were advertised and the meanings people attached to them.

Developments in technology have been fundamental to the progress of design. From the early commercial applications of electricity at the start of this century to the sophisticated micro-electronics of the 1990s, design provided the interface between people and new inventions. The global acceptance of the Mackintosh computer's screen display demonstrated how design can make the most complex technology easily accessible to an enormous number of professional and casual users.

Design also provided a link between technology and new human desires, such as the quest for speed. The introduction of Polaroid instant photography in 1947 transformed the popular attitude to taking snapshots which had first been formed by the Kodak Brownie camera of 1900. Immediate access to the finished print had a magical appeal to amateur camera users and catered to a near universal thirst for immediate gratification also delivered by inventions such as the microwave oven.

The character of designed artifacts and the ways in which they are perceived by their users have also been deeply affected by new materials. Plastics, for example, earned a chequered reputation; but if one type of material were associated in the popular mind with American design this century, it would probably be plastics. Used originally as cheap substitutes for more precious materials, the various types of plastics ultimately found aesthetics suitable to their specific physical properties. They were deemed particularly

appropriate in the kitchen, through products such as hygienic Tupperware containers and Formica laminates, in automobile and aircraft interiors, and in the light, robust and tactile casings for communication appliances such as mobile telephones and lap-top computers.

Legislation also had a profound affect on design. The enactment of Prohibition in 1920 not only drove the consumption of alcohol underground to new speakeasies, but it encouraged home-owners to construct basement 'recreation rooms', in which they could drink and entertain in security and privacy. Repeal in 1933 stimulated their construction (figure 5) and legitimized the design of cocktail equipment, bars and night clubs. In the same year, President Franklin Roosevelt's New Deal policies led to the formation of agencies such as the Tennessee Valley Authority and the Works

5] The basement recreation rooms of American homes during the 1920s offered privacy for then illegal cocktail parties. The fad of constructing them was stimulated by the repeal of Prohibition in 1933, and they continued to provide a cosy venue for home entertainment into the 1960s. This owner-built example has the elegance of a fashionable night club, 1938.

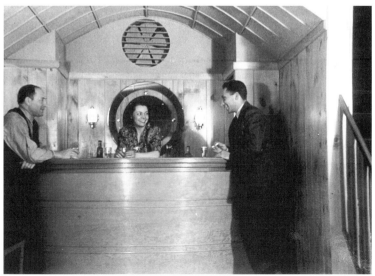

Progress Administration, both patrons of art and design in massive public works projects.

Other federal agencies became major patrons of design by mid-century. The Federal Aviation Administration employed Eero Saarinen and Ellery Husted, among others, to design buildings, signage, baggage handling systems and specialized furniture for airports. The National Park Service established an in-house graphic design staff to increase the clarity and cost effectiveness of its promotional and information literature. Similar work was done for the US Postal Service by Raymond Loewy's design office, while Marcel Breuer served as consultant architect to the Bureau of Reclamation on its Grand Coulee Dam Third Power Plant.

Political events abroad also influenced design in the United States. When the Nazi government in Germany closed the Bauhaus design school in 1933, many of its former teachers found employment in American colleges where they fundamentally altered the nature of design education. Even the establishment of an entirely new school, the Institute of Design (aka The New Bauhaus) in Chicago, by the former Bauhaus Foundation course leader, Laszlo Moholy-Nagy, was a result of German domestic politics.

In addition to the attractions of political freedom, the immensely powerful American economy was a magnet for fine artists, writers, musicians and designers from abroad. Raymond Loewy arrived from his native France in 1919 and soon made a significant impact on the way design was practiced in the United States. More recently, the Italians, Lella and Massimo Vignelli, and British-educated Ross Lovegrove have brought an international character to American design in a variety of disciplines, while hotel interiors by Phillipe Starck have introduced late-century Parisian chic to New York and Miami.

Between 1900 and the imposition of immigration quotas in 1920, the largest voluntary migration in world history brought huge numbers of Italians, Austro-Hungarians and orientals to the factory towns and ports of the east and west. By 1910, two-thirds of American industrial workers were from southern and eastern Europe. They joined the highest paid labor force in the world and were guided by advertising into their appropriate niches within the new commercial class system. But they also brought with them ethnic tastes. And when they settled in Little Italies, Jewish ghettos, Polish quarters and Chinatowns, they formed subcultures with the power to express their particular brands of creativity and invention. As both producers and consumers in the periods of mass prosperity they contributed immeasurably to the diversity of American material culture (figure 6).

Wars have stimulated innovations in all areas of design. They

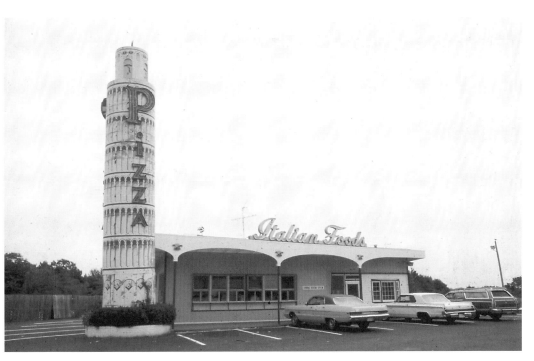

6] A topping of Italian architectural symbols is served with the pizza in a roadside restaurant also offering clam chowder.and New England boiled lobster. The interior is mainly colonial. Diversity and homogenization were the magnetic poles of American design culture throughout the century.

called for rapid advances in weapons technology. They also redirected existing industries to the production of newly developed goods, such as the Second World War Jeep, and Buckminster Fullers Dymaxion Deployment Unit, lightweight demountable houses built for airforce personnel stationed around the world. Wars have also made design a tool of propaganda. From James Montgomery Flagg's 'I Want You' recruitment poster of 1918 (figure 7) to Ben Shahn's 'This is Nazi Brutality', a sophisticated portrayal of injustice and inhumanity based on Goya's 'The Prisoner', art and mass communication techniques have combined to serve American political goals.

Fashion too has felt the influence of war. When the standard pocket watch proved unsuitable to modern military dress and activities during the First World War, the wristwatch came into common use as the standard personal time keeping instrument. Rationing of material during the Second World War drew a brisk response from clothing designers. Hems rose; cuffs, lapels and pleats vanished; and zippers gave way to non-metallic fasteners. Since the war, the G1 and A2 leather aviator jackets, first made by various manufacturers to Navy specifications in 1942, became favored attire for bikers and other fashion cults.

During the 1960s, the war in Viet Nam generated a different type of design reaction which gave a face to the anti-war protest movement. Posters such as those by the Art Workers Coalition represented widespread anger against American imperialism

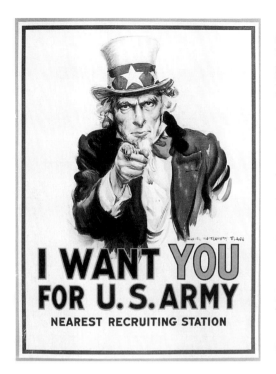

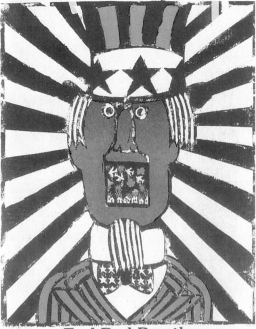

End Bad Breath.

bubbling up on college campuses during the 1960s. Logos, including the International Peace symbol and the Raised Fist symbol, often emblazoned on ex-military clothing, worn incongruously by anti-war protesters, were widely recognized statements of militant political solidarity (see figure 114).

The politically motivated style rebellion of the 1960s and 1970s, dubbed 'Radical Chic' by Tom Wolfe, responded not only to the anti-war movement, but also to the initiatives for racial advancement during those decades, culminating in the activities of the Black Panthers. With the extension of civil rights legislation from the 1950s, race became an increasingly influential factor on style and design. The recognition of a definable Black culture in America, with its own strong visual qualities, was reflected in the publication of mass-circulation magazines such as *Ebony* and through the impact of Black fashion as seen on television and in films.

Since 1969 several generations of pre-school children, around the world, have grown up with the picture of an ideally integrated urban community promoted by the teaching program, *Sesame Street* (figure 8). The producers, Children's Television Workshop, used the innovative and controversial technique of 'selling' learning by making commercial-like sequences for specific teaching objectives. They portrayed a benign world of ethnic color, enlivened by Jim Henson's 'muppets', in a streetscape and interiors which appeared distressed enough to seem homey and comfortable,

7] The malleable image of Uncle Sam, from patriarch to malevolent buffoon, reflected in both pro- and anti-government posters. 'I Want You' by James Montgomery Flagg, 1917, and 'End Bad Breath', by Seymour Chwast, 1967.

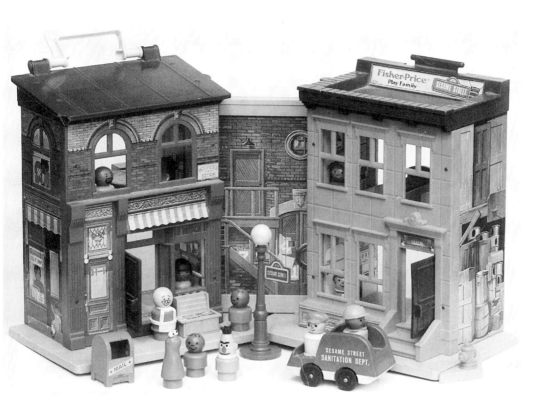

8] A benign world of ethnic color was presented in the TV learning program, 'Sesame Street'. Here, the street is presented by Fisher-Price as a set of toys attractive to children of all cultural and economic backgrounds.

without conveying an image of urban blight. *Sesame Street* was a product of the growing multi-culturalism of the late 1960s which recognized the concerns of the poor, ethnic minorities, and special age groups. [21]

During the same period the Women's movement and the changing structure of the family were affecting the nature of advertising and marketing, apparel design, and the organization and equipment of the home. The high-tech kitchen, tailored to the products of the supermarket and the fast-food industry, gave individuals, living singly or in family groups and regardless of gender, easy methods of preparing and presenting food. While the traditional table-top range of the 1930s was a woman's appliance, the microwave oven of the 1980s belonged to everyone.

Beginning with the rational dress movement in the late nineteenth century, women's apparel reflected a desire for freedom of movement and release from the dictates of high fashion. But it was the American fitness movement of the 1970s which triggered the widespread adoption of sports clothes and training shoes as street wear for both women and men. Changing ideas about health combined with increased leisure and liberation from traditional codes of propriety and gender in the formation of a fashion which had enormous consequences for the global garment industry.

Americans responded to increased leisure, afforded them by labor legislation, rising prosperity and early retirement, by taking up a wide range of pastimes and personal activities served by a staggering variety of new products. The character of home life was radically altered by the near universal addiction to radio and television. Beginning in the 1920s, design transformed domestic receiving equipment from awkward contraptions in the early radio days to the gracious cabinetry of televisions which sat imposingly in mid-century living rooms. Since the invention of the transistor at the Bell Telephone Laboratories in 1948, the Japanese took the initiative to transform television and radio receivers into miniaturized personal accessories which encouraged solitary watching or listening.

America did better with innovative designs developed to cater to popular hobbies. Surfboards and water-skis revolutionized enjoyment of the sea, while the bicycle was joined in the later part of the century by the skateboard and rollerblade as rapid and expressive means of individual, human-powered transport requiring strength and agility (figure 9).

Sports became one of the great American passions of the century, reflected in everything from stadium design to equipment, clothing and advertising. The love of sports was a locus of physical prowess, nationalism, race and money. Boat designers provided a staggering variety of recreational craft for the large numbers of weekend sailors taking to the waters in popular ChrisCraft motor cruisers of the 1950s, and ubiquitous Hobie Cat catamarans, raced world-wide since the 1960s. They also designed unique racing craft such as Nathaniel Hereshoff's J-class America's Cup boats of the 1930s and their many junior editions.

The toy industry catered to children's interest in making and building, achieving commercial success with materials such as Plasticine and with a genre of construction toys, based on a standard and expandable kit of parts. These included Lincoln Logs, patented in 1920 by John Lloyd Wright, son of Frank Lloyd Wright, and highly technical metal Erector Sets, produced since 1913.[22] Other types of toy kits, such as scale model cars, produced in plastic by Revell and others, often included accessories which offered modelers the opportunity to customize each product according to personal taste. Barbie's fashion separates offered an enormous market of adolescent girls a similar process of customization.

Demands for higher ethical standards in American manufacturing have had considerable impact on the way goods are designed, produced, advertised and disposed of. In some retail areas a sense of responsibility proved to be essential to commercial survival. In the 1960s, Ralph Nader's damning report on American car design,

9] Leisure sports spawned an enormous range of specialized equipment and clothing. Rollerblades became the ultimate rapid and expressive means of individual, human-powered transport for both men and women.

10] The down-side of automobility – safety struggled to become a design priority in America's car culture. 'Five Deaths', Andy Warhol, 1963.

Unsafe at Any Speed, pushed Detroit manufacturers to reconsider their design priorities and spurred new safety legislation (figure 10). Twenty-five years later, world-wide picketing and boycotts by 'Green' consumers provoked the redesign of McDonald's food packaging replacing styrofoam with recyclable paper.

Fisher-Price, founded in 1932, gained a high reputation for quality through the efforts of its advanced research and design departments and its rigorous testing to produce toys which were stimulating, robust and safe. Their designers also evolved a vocabulary of formal qualities which made their toys *appear* attractive, strong and safe, both to children and parents (see figure 8).

As early as the 1920s, Buckminster Fuller promoted a design ethic which gave primary consideration to the effective use of world resources. His designs met with only patchy commercial success, but his thinking remained a model for conscientious design at the end of the century. To many consumers, however, responsible design was not enough to compensate for the depredations of capitalist materialism. At its worst, design could simply lubricate the slide of humanity into a morass of mindless consumption, environmental destruction and enmity. Therefore, some North Americans supported an annual 'Buy Nothing Day', on 24 September each year.

Methods of analysis

To address such a broad subject as twentieth-century American design, I have found it necessary to use a variety of approaches, a fuller discussion of which is presented in Part III, 'Critical Approaches to Design'. The problems of identifying a national

focus to the study are aggravated by the diversity of American culture and its complex relationships with the world outside. Yet political, historical, geographical and economic links allow a discussion of design in the United States to be attempted. Inevitably, focusing on the twentieth century alone leaves earlier relevant historical events unexplained. Yet the practice of design reached a new plateau of development in America during the twentieth century. And while its next major evolutionary step may occur in the Pacific rim or in the global ether, since 1900 design innovation has been centered in the United States.

Although design is a broad activity with multiple applications and means of expression, in many respects it remains a branch of the arts concerned with the way things look. Therefore, I have selected objects and images for formal analysis. Many of the products discussed are without a design pedigree, but have been produced in such great quantities or represent such major innovations or trends that they must be included.

Much discussion of design has always revolved around 'name' designers and periods of style. And when attempts have been made to illuminate the anonymous nature of design, the emphasis has been heavily on technical developments or the history of inventions. In this volume, anonymous and popular design are considered alongside professional design primarily in their social contexts, although technology, commerce and politics also feature prominently. Individual versus collaborative design is also a theme of the chapter, 'Designers and makers'. Because designers' intentions do not always coincide with the way products are received, I have highlighted social groups to whom particular designs may have special meanings.

Due to the enormity of its subject, this book does not purport to be a comprehensive history of twentieth-century American design. Its purpose is to introduce how design evolved as an activity and as an idea. This is the story of the evolution of design from an exclusive occupation, requiring a specialized education, to a part of everyday life in which all engage as creative participants, as critics, producers and consumers, as communicants as well as receivers of ideas.

Limitations of design

Design has created misery as well as delight. It has contributed to the sense of inadequacy felt by many people who do not achieve the level and quality of consumption they are led to expect by advertising. The choices made available to consumers through the combined efforts of design, technology and marketing have

generated untold mental anguish among the insecure. In its most irresponsible forms, design has contributed to pollution, waste, injury and death. It has exaggerated the social inequities of American life. Its heroic, idealistic and materialist identity is the bar to its improvement.

But as a personal tool, design has helped individuals to organize a more comfortable world for themselves and to present preferred images of themselves to the world outside. The aim of this study is to contribute to a realistic understanding of design at the end of the millennium as part of an ongoing process of correcting and improving the environment in which we all live and of establishing a genuine place for ourselves within it.

Notes

1 Tom Wolfe, *From Bauhaus to Our House* (New York, 1981), p. 67.

2 Richard Hofstadter, William Miller and Daniel Aaron, *The American Republic*, Vol. 2: *Since 1865*; (New Jersey, 1959 repr. 1965), p. 202.

3 Wolfe, *From Bauhaus*, p. 92.

4 Usonia was a name Wright gave to his fictional, 'improved' America which was given form in his Broadacre City project of the early 1930s.

5 John Thackara, *Design After Modernism* (London, 1988), p. 8.

6 Stephen Bayley, *Design Heroes: Harley Earl* (London, 1990), p. 149.

7 Arthur J. Pulos, *American Design Ethic* (Cambridge, MA and London, 1983; repr. Cambridge and London, 1986), p. 85.

8 For a fuller discussion of Earl's design method, see C. Edson Armi, *The Art of American Car Design* (University Park, PA and London, 1988; repr. 1990), p. 27.

9 Herbert Simon, 'The Science of Design: Creating the Artificial', quoted in Victor Margolin, *Design Discourse* (Chicago, 1989), p. 3.

10 Victor Papanek, *Design for the Real World* (Stockholm, 1971; repr. London, 1991), p. 3.

11 Victor Papanek, *The Green Imperative* (London, 1995), p. 223.

12 Witold Rybczynski, *The Most Beautiful House in the World* (New York and London, 1989), pp. 32–6.

13 'Up from the Egg', *Time Magazine* (31 October 1949), p. 68.

14 Kenneth Morris, Marc Robinson and Richard Kroll, *American Dreams* (New York, 1990).

15 A notable exception was the Studebaker company, founded in 1852, which made wheelbarrows, wagons, buggies and carriages, advertising itself as 'the largest vehicle house in the world' by 1879. The company's products were easily identifiable by their characteristic green paintwork and the name 'Studebaker' emblazoned in black and gold on their sides. Studebaker began the shift to car manufacture in 1904: see Phil Patton, 'Sleek But Square – And That's Why We Loved the Studie', *The Smithsonian* (December 1991), p. 11.

16 John A. Walker, *Design History and the History of Design* (London, 1989), p. 175.

17 Hofstadter, Miller and Aaron, *The American Republic, Vol. II* p. 262.

18 *Ibid.,* p. 200.

19 The first commercial motion picture show had taken place in New York's Music Hall Theater in 1896.

20 Siegfried Giedion, *Mechanization Takes Command* (Oxford, 1948; repr, London and New York, 1975), p. 3.

21 The program, created and developed by Joan Ganz Cooney, was first aired by the Public Broadcasting System on 10 November, 1969: Jeffery Davis, *Children's Television, 1947-1990* (Jefferson, NC and London, 1995), p. 155.

22 Rybczynski, *Most Beautiful House In The World,* p. 34.

Style and design

American taste and style: beyond the cringe

<div style="text-align: right">1</div>

The nature of taste in America has been conditioned foremost by the quest for upward mobility within the middle class. The contrast between an aristocratic taste and a peasant taste in the old European monarchies was overturned by the growth of the dominant middle class in the commercial culture of North America. Snobbishness, based on family history and old wealth, was largely displaced in America by position derived from personal accomplishments, including cultivated taste. In *The Tastemakers*, Russell Lynes identified a developing 'social stratification of "high brows", "middle brows" and "low brows" who could be found at all economic levels'. What distinguished them was the degree to which their taste was informed by ideas.[1]

In America, more than anywhere else in the developed world, taste has become an expression of social mobility – usually up, but often down. It developed alongside the history of class and its opposing characteristics, ostentation and austerity, acquired meanings as fluid as the structure of American society itself. The information explosion also contributed to a highly complex picture of the nation's tastes. For example, the knowing taste for camp and kitsch in the 1960s was among the early signs that Lynes' highbrows had become aware of and interested in the kinds of artifacts which, in the late 1940s, he would have associated only with lowbrow taste. Defiance of accepted conventions of taste, an intentional breech with the decorum of the middle class, described as 'conspicuous outrage' by the English art historian, Quentin Bell, in his 1947 theory of taste and fashion, *On Human Finery*, served as a spur to the radical overhaul of taste in all fields of art and design.

In James M. Cain's novel, *Mildred Pierce*, the upwardly mobile heroine is taught a lesson about taste and style which reflects a particularly modern, American outlook (figure 11).

> Within a week, the Beragon mansion looked as though it had been hit by bombs. The main idea of the alterations, which were under the supervision of Monty, was to restore what had been a large but pleasant house to what it had been before it was transformed into a small but hideous mansion. To that end the porticoes were torn off, the iron dogs removed, the palm trees grubbed up, so the original

grove of live oaks was left as it had been, without tropical incongruities. What remained, after all this hacking, was so much reduced in size that Mildred suddenly began to feel some sense of identity with it. [Monty] seemed bent on pleasing Mildred, and it constantly surprised her, the way he was able to translate her ideas into paint, wood, and plaster.

About all she was able to tell him was that she 'liked maple', but with this single bone as a clue, he reconstructed her whole taste with surprising expertness. He did away with paper, and had the walls done in delicate kalsomine. The rugs he bought in solid colors, rather light, so the house took on a warm, informal look. For the upholstered furniture he chose bright, inexpensive coverings, enunciating a theory to Mildred: 'In whatever pertains to comfort, shoot the works. A room won't look comfortable unless it is comfortable, and comfort costs money. But on whatever pertains to show, to decoration alone, be a little modest. People will really like you better if you aren't so *damned* rich.' It was a new idea to Mildred, and appealed to her so much that she went around meditating about it, and thinking how she could apply it to her restaurants.

In what was no longer a drawing room, but a big living room, he found place for a collection of Mildred Pierce Inc.: Mildred's first menu, her first announcements, a photograph of the Glendale restaurant, a snapshot of Mildred in the white uniform - all enlarged several times, all effectively framed, all hung together, so as to form a little exhibit. At first, she had been self-conscious about them. [He] gave her a compassionate little pat,

'Sit down a minute, and take a lesson in interior decorating. Do you know the best room I was ever in?'

'No, I don't.'

'It's that den of yours, or Bert's rather, over in Glendale. Everything in that room meant something to that guy. That's why the room is good. And you know the worst room I was ever in?'

'Go on, I'm learning.'

'It's that living room of yours, right in the same house. Not one thing in it … ever meant a thing to you, or him, or anybody. A home

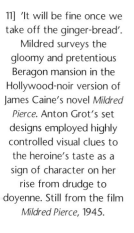

11] 'It will be fine once we take off the ginger-bread'. Mildred surveys the gloomy and pretentious Beragon mansion in the Hollywood-noir version of James Caine's novel *Mildred Pierce*. Anton Grot's set designs employed highly controlled visual clues to the heroine's taste as a sign of character on her rise from drudge to doyenne. Still from the film *Mildred Pierce*, 1945.

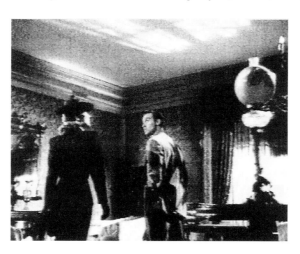

is not a museum … it (has) to be furnished with things that mean something to *you*.' From then on, Mildred began to feel proud of the house and happy about it. [2]

The message is that taste is a personal affair and that the more our surroundings reflect our true personalities, the more satisfying they will be to us and to anyone who sees them. But underlying the story is an appreciation of the mechanism by which Mildred's fluid position within the broad middle class generates her aspirations to change taste and gives her access to a higher social status.

At the start of the century, connoisseurs acquired taste from academic study and through direct examination of masterpieces. Professionally educated designers joined art connoisseurs as mandarins of taste. 'Popular taste' meant, simply, instinctive preference, and it did not figure in serious discussions. But gradually critics began asking questions such as 'whose taste is to be given priority – that of the [designer], or that of the elite group who promote good design, or that of the masses whose taste governs the vast majority of products sold?' [3]

Social mobility and the high status of working people enabled individuals to look down as well as up the economic ladder for their taste. One could choose, as Monty suggested to Mildred, not to look 'so damned rich'. Whereas before 1950 the rejection of middle- and upper-class values was limited to radicals in the arts or to political revolutionaries, afterwards it became a central privilege of middle-class Americans, evident in many of their choices. Slumming was stylish. Work clothes were worn in preference to more formal attire. A craze for pick-up trucks displaced the fashion for luxury sports cars. Peasant furnishings, including sisal rugs and oriental paper lampshades, were found where silk might have been expected. Director's chairs replaced period pieces. And rustic foods such as polenta and collard greens acquired chic.

Taste became an industry; its commercial function was the creation of demand for new products, while design was the vehicle by which manufacturers and advertisers appealed to the various tastes of their clients. The growing popular fascination with the design of everyday things, from cars to toothbrushes, greatly eroded the traditional gulf between high and low taste. Yet Lynes' highbrow still saw the choice of a toothbrush within a large framework of references including formal aesthetics and environmentalism as well as hygiene.

Taste in art, music, food or design inevitably combines two seemingly conflicting elements; the desire to be unique and the desire to belong. In the story of Mildred Pierce, the heroine is renovating 'the Beragon mansion' mainly as a route into local society.

She seeks a new group identity, and the tastefully designed house will be her badge of belonging. Similarly, her Cadillac and mink coat would be selected with deference to the preferred cars and clothes of the group to which she aspires. These carefully selected things become the sign of her new status, as her former taste is relegated to oblivion. The extent to which Mildred's home, clothes and car satisfy both her urge to self-expression and her social aspirations will determine the degree of comfort she gains from them. In the brand of upper middle-class taste to which she subscribes, comfort is one of the main constituents. Americans who do not wish to boast of their wealth tend to describe themselves as 'comfortable'. And the appearance of comfort signifies personal contentment in addition to security.

Monty approaches the job of educating Mildred as a mission characteristic of much of the literature on taste. Design is not about pomp and display. Rather its purpose is to achieve personal satisfaction by presenting an honest face to the world. In a similar spirit, the link between taste and truth was promoted at the start of the century by Arts and Crafts organizations such as the Roycrofters and later by the Museum of Modern Art (MOMA). They believed that honest values, which resided in common artifacts, formed a moral compact between maker and user, putting both at their ease.

The notion that honesty could be denoted by simple forms was a common thread in American art and design thinking. MOMA often justified its support for the International Style on the basis of its honest simplicity. However, it is evident in the passage from Mildred Pierce and in the writings of taste-makers as diverse as Edgar Kaufmann and Elsie de Wolfe that honesty and simplicity were qualities claimed for both modern and traditional styles.

Mandarins

Among the well-known individuals, architects, gallery-owners, movie stars and professional designers who have had important roles in shaping America's taste, Elsie de Wolfe (Lady Mendl) occupies a unique position as the person who transformed interior decorating from an aristocratic, amateur pastime to a commercial activity. She was significant for the Europhile aesthetic she promoted between 1905, when she first announced her services, and her death in 1950, and for the career she established for women as interior decorators. Under her guidance, taste became a professional matter.[4]

Candace Wheeler had anticipated this development prior to the turn of the century: 'there will be schools and college courses where students can be well and authoritatively trained for this

dignified profession'.[5] Elsie de Wolfe, however, did not require training. She relied on social connections for her clientele and on her knowledge of historic styles of furnishing acquired in her youth on visits to French and English country houses. She also had her own ideas and an approach to decorating which could be taught. In 1913 de Wolfe presented her thoughts in a book entitled *The House in Good Taste*. Her concept of good taste was based on two principles: 'suitability', by which she meant consistency of style - this encouraged the fashion for 'period' rooms; and 'sincerity', which encompassed both the elimination of pretentious clutter and the expression of 'the personality and character of yourself'.[6]

Elsie de Wolfe's unique personality was expressed in interiors which combined Old World charm with Tinseltown glamour; comfortable historicism was blended with distinctly modern effects, such as entire walls, including architectural mouldings, sheathed in tinted mirror. This hybrid style was particularly well suited to her later projects in Hollywood where she spent the last twenty years of her life (figure 12).

While American design innovation had been apparent throughout the nineteenth century in the development and refinement of machinery, taste remained firmly under the influence of European

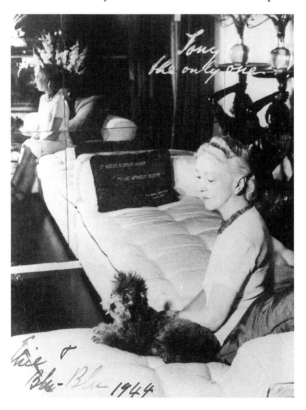

12] Elsie de Wolfe's Europhile design aesthetic adapted readily to the requirements of Hollywood glamor in the 1940s. She is seen here in the mirrored living room of her Los Angeles home.

models at the turn of the century. Men's and women's fashions were determined by decisions made in London and Paris. Homes and public buildings were designed and decorated in styles reliant on the antique, and there was still snob appeal in a French-style interior by de Wolfe. The idea expressed by Malcolm Cowley that 'They do things better in Europe' was to remain a persistent force.[7] And some Americans had the wealth to acquire almost anything they wanted from Europe.

William Randolph Hearst's architect, Julia Morgan, imported entire rooms from European palaces for installation at San Simeon, Hearst's castle in central California. At Ocean House in Santa Monica, built for Hearst's mistress, the film star Marion Davies, architect William Flannery continued the practice of importation, eliciting the comment that 'going from one room to another was somewhat like an abbreviated tour of grand European houses'.[8] This manner of building and furnishing homes of *nouveau riche* Americans was parodied by Orson Welles in his 1941 film, *Citizen Kane*, yet it also provided a model for citizens of ordinary means.

Seeing the American home of the 1920s as a rag-bag of various historical 'tastes', Lewis Mumford quoted a 'government bulletin which suggested that every American house should have at least one "early American" room' and went on to speculate about the future of the fad; 'every year I tremble lest a distinguished collector of antiques in Detroit should attempt to turn out an "early American" motorcar'. Mumford lived to see half-timbered station wagons with classical ornaments *and* futurist tail fins. Referring to the eclecticism of the houses of the period with scorn, he wrote 'Is it an accident that we so often have twentieth-century kitchens, eighteenth-century dining rooms, and sixteenth-century studies?'[9]

For aspiring American artists and architects at the start of the century, study abroad at the Academie des Beaux Arts in Paris or the American Academy in Rome was a means of acquiring the highest level of sophistication in taste. Many more continued to take the traditional Grand Tour, visiting the cathedrals, museums and palaces of England, France and Italy to acquire direct knowledge of European art.

Yet it was not only the glittering traditions of European culture which fired the imaginations of Americans between 1900 and 1950. They were also swept up in the glamour of European modernism. The radical art pioneered in the School of Paris before the First World War was reinvigorated after the Armistice and quickly influenced architecture and design. André Breton and the Surrealists, Gropius and Mies van der Rohe of the Bauhaus, Van Doesburg and the De Stijl movement, Picasso and the second wave of Cubism, Le

Corbusier and Purism: all innovative movements and styles were
seen in terms of the progressive social ideals of the artistic left.

The image of a brave new society, emerging from the ruins of
war and stirred by a proud ambition to ennoble the masses
through art and technology, impressed the younger generation of
American artists and intellectuals who travelled to the Continent
on the strength of the post-war dollar. Many went in search of legal
alcohol and the *vie bohéme*. But some were genuinely stimulated
by the radical ideas emerging from the intellectual avant-garde in
Holland, France and Germany. The Grand Tour of European mod-
ernism was taken between the wars by Louis Kahn, Louis
Skidmore, Philip Johnson and many others. In a bleak world,
ravaged by war and decimated by the unspeakable epidemics of
influenza and tuberculosis which followed, the courageous spirit
of the Modern movement evoked a romantic response among
idealistic young Americans who, on their return home, tried to
adapt the appearance of European modernism to the very different
circumstances of American life.

America had emerged from the First World War as the strongest
and richest nation on earth, but a culture still cringing in the face
of European sophistication in aesthetic matters. As a result, no
American designs were shown at the Paris Exposition of Decorative
and Industrial Arts of 1925. The New York decorator Paul Frankl
wrote at the time, 'The only reason why America was not repre-
sented at the exhibition of decorative industrial art held in Paris
in 1925 was because we found we had no decorative art.'[10] Frankl's
attitude was typical of American intellectuals of his time. The
expatriate writer, Gertrude Stein, describing a western stop on her
US lecture tour in 1934, echoed Frankl in her famous remark which
seemed to apply to the whole of American culture, 'there is no
there there'.

Like Stein, the pioneer of kinetic sculpture, Alexander Calder,
went to Paris and joined the European Modern Movement. In the
late 1920s Calder found inspiration for the forms of his innovative
wire and sheet steel 'mobiles' in the paintings of the Spanish Sur-
realist, Joan Miro (see figure 48). Even the car designer, Harley Earl,
borrowed the styling of an exclusive Spanish marque, the Hispano-
Suiza, for the 1927 LaSalle, his first major design project at General
Motors.

An official taste for European modern design was proclaimed in
February 1932 with the *Modern Architecture: International Exhibi-
tion* curated by Henry-Russell Hitchcock, Philip Johnson and
Alfred Barr Jr, director of the Museum of Modern Art. The curators
outlined the history and characteristics of a new style which, be-
cause of its simultaneous development in several countries, they

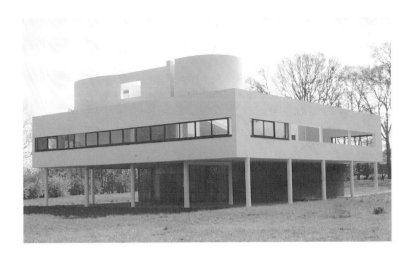

13] An orgy of austerity began with the importation of the European steamship style around 1930. Its simplicity suited both the Puritan strain in American taste and the social climate of the Depression, when showing off wealth was distinctly bad form. The Museum of Modern Art presented European-inspired Machine Art to Americans as hard, cold and, above all, ideological. It stated a 'position' and was meant to appeal to the intellect rather than to the G-spot or the funny bone. Villa Savoye, Paris, architect Le Corbusier, 1930.

dubbed the International style (figure 13). Barr's introduction to the show's catalogue emphasized the importance of the four European contributors, Walter Gropius, Le Corbusier, J. J. P. Oud, and Mies van der Rohe, whom he called the founders of the style. Barr's rationale for asserting the primacy of the four was based on their theoretical and sociological approaches to the creation of a new architecture as well as their 'sensitive and disciplined taste'.[11] Frank Lloyd Wright was given a special place in the exhibition due mainly to his early influence on the four. Yet it was clear that the organizers preferred the Europeans' formal language of smooth white surfaces, flat roofs and complete absence of decoration to Wright's textural and ornamented work.

The MOMA exhibition and a series of books, published during the 1930s by Henry-Russell Hitchcock, Lewis Mumford and others, prepared the ground for the arrival in America, by the end of the decade, of both Gropius and Mies. These imposing figures moved to the United States as political refugees bathed in an aura of tragic glamour due to the political circumstances of the time. Many other European modernists also emigrated and built outstanding careers in America. From the Bauhaus came Marcel Breuer, Sybil and Laszlo Moholy-Nagy, Anni and Josef Albers, and Herbert Bayer. The painters Fernand Leger, Piet Mondrian, Max Ernst and Yves Tanguy all arrived before the Japanese attack on Pearl Harbor. The surrealist writer André Breton, composer Arnold Schoenberg, choreographer George Balanchine, plus many more of Europe's top creative talents arrived on a wave of culture which swept over America between 1935 and 1945.

Barr, described by the *New York Times* as 'the most powerful tastemaker in America', supported the European modernists throughout his long tenure as director of MOMA.[12] His support could be seen as another episode in the process, as practised by

Hearst, of purchasing and importing culture from the Old World. Yet in the 1930s what was being imported was a current taste. Like some exotic plant specimen, it could be brought back alive and planted firmly in American soil. However, the American climate of middle-class capitalism transformed the European Modern Movement, and what grew was a hybrid.

Breaking free

Despite the continuing dominance of European taste in late nineteenth-century America, the United States showed signs of developing a more mature sense of its own culture by 1900. McKim, Mead and White had led a revival of colonial architecture, popularizing a variety of domestic styles including Queen Anne, Shingle Style and Palladian Colonial. The colonial style was given a further boost by the opening in 1925 of the American Wing of the Metropolitan Museum of Art. But while national pride may have been satisfied, some American modernists were not pleased. Lewis Mumford wrote scathingly, 'Taste is not something that can be cultivated … in a museum … it has roots in the myths of religion, the needs of social life, the technic of industry, and the daily habits of a people.'[13]

Arts and Crafts designers had looked for inspiration from sources unrelated to European or American history. They learned of the subtleties in Japanese architecture and crafts from a large display of Japanese artifacts at the Philadelphia Centennial Exhibition of 1876. Frank Lloyd Wright also came under the spell of the orient. His Ward Willetts house in Spring Green, Wisconsin, completed in 1902, reinterpreted the structure and space of the Japanese house; and his renderings of the period owed their linear simplicity to his study of Japanese prints.

Others adapted aspects of American vernacular furniture to the purposes of the Arts and Crafts movement. Gustav Stickley, who developed from Morris' philosophy an essentially American style of design, edited a highly influential magazine, *The Craftsman*, which promoted a simple and 'wholesome' taste in design and in all things related to domestic life.[14] Stickley was, foremost, a commercial furniture-maker, launching his first collection at the Grand Rapids Furniture Fair in 1900. The next year, at the Pan American Exposition in Buffalo, he unveiled his Craftsman line of solid and unornamented native oak tables and chairs. Their rectilinear forms and expressed joints satisfied the puritanical requirements of Stickley's aesthetic. *The Craftsman* ensured their commercial success by spreading a taste for the plainness of the so-called Mission style which has been credited with anticipating Functionalism.[15] In the

1990s, the revived interest in both Mission and Shaker furniture helped to reconcile the aesthetic and moral purity of modernism with a strong tradition of simplicity in American taste.

Paradoxically, true recognition of the aesthetic vitality of the American scene only appeared real to Americans when European artists began to use American life as a model for their creative work. Much of the advanced taste which Americans found in Europe in the 1920s was, itself, inspired by New World innovations. Europe was dancing the foxtrot and charleston to American jazz. In Berlin Herr Sommerfeld's house, designed in 1921 by Walter Gropius and colleagues from the Bauhaus, was like an American log cabin crossed with a Frank Lloyd Wright prairie house, including Wrightian geometrical decorative patterns in some of the leaded-glass windows and wall paneling.[16] When Lorelie Lee, the heroine of Anita Loos's novel, *Gentlemen Prefer Blondes*,[17] made her pilgrimage to the fashion houses of Paris, she might have bought a 'little black dress', of which *Vogue* quipped in 1926, 'Here is a Ford signed "Chanel"'.[18] Futurists idolized New York as the greatest symbol of modernity. Francis Picabia said in 1913, 'Your New York is the cubist, the futurist city. You have passed through all the old schools. You are futurists in word, deed and thought'.[19] Fernand Leger sang the praises of American jazz, movies and the chorus line. And Le Corbusier based many of his aesthetic ideas of the 1920s on American standardization: 'Type-needs, type-functions, therefore type-objects'.[20] In the 1950s the London-based Independent Group used American popular culture as a corner-stone in the foundation of British Pop Art. Europeans as diverse as the Czech novelist, Franz Kafka (*America*), and the Italian film director, Sergio Leone (*A Fistful of Dollars*), interpreted American themes and exported them back to America, validated as a legitimate cultural field within which new kinds of taste could grow.

The traditional idea of taste as informed appreciation of the fine and decorative arts gradually began to give way to a definition better suited to the commercial realities of life in twentieth-century America. In the catalog of a 1939 exhibition, Fine Prints for Mass Production, Rockwell Kent wrote 'To live by art is to depend on a market ... Prints have always been intended as a product for the many ... and in the past were readily consumed by them'.[21] Thus, the 'art of multiple originals' is portrayed as a true art of democracy, an art of communication through technological advances – the power press, photo engraving, color separation processes, commercial offset lithography, silk screen and computer graphics.

Middle-class taste was increasingly associated with everyday things, such as cars, and domestic appliances which, like furniture

and clothing, were mass manufactured. Clear evidence of a true American style which crossed all barriers of personal taste could be found among a vast range of small manufactured goods, designed before the Second World War, which bore the mark of native functionalism. This was unrelated to the Functionalist style of the Bauhaus, but derived instead from the evolution of manufacturing technologies, commercial imperatives, and a tradition of fitness for purpose which grew up with the American technocracy. Products such as the copper-bottomed Revere cookware, designed by Archibald Welden in 1939, had a simple, curvaceous shape derived from streamlining, but without stylistic affectations. Revereware offered excellent heat conductivity, was inexpensive, easy to clean and unobtrusive in appearance. The Zippo cigarette lighter (1932) belonged to the same genre of product, retaining its popularity due to its technical efficiency and practical styling. Apparel design also reflected the American penchant for timeless design, as in the wide-brimmed Stetson fedora hat, first produced in the 1920s.[22]

Between the wars, some designers and artists, including the industrial designer, Russel Wright, Frank Lloyd Wright and the painter Edward Hopper, actively rejected European values and styles. Stuart Davis, Charles Demuth and Charles Sheeler painted precise, abstracted images of modern America, filled with signs of the popular culture of the time, the rhythms of jazz, the poetic

14] The talents of fine artists and graphic designers entered millions of homes through the popular art of mass-produced record album covers. (Clockwise) 'Jazz Samba', cover Olga Albizu; 'Thelonius Monk', cover R. K. Miles; 'Best of Cream', cover Jim Dine; 'Cheap Thrills', cover R. Crumb; 'Persuasive Percussion', cover Josef Albers; 'Herbie Mann at the Village Gate', painting Abidine, design Norman-Slutzky Graphics. Like the jazz and rock music they represented, these small, mechanically reproduced artworks portrayed a pluralistic American culture which assimilated a multitude of diverse influences.

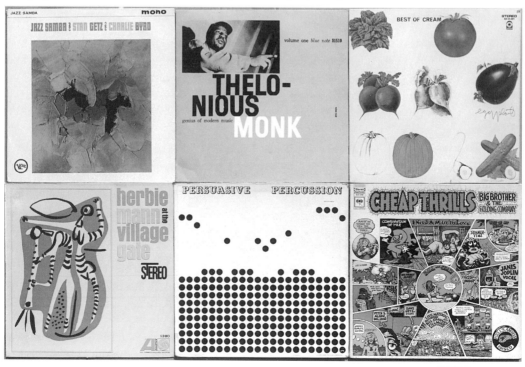

lyrics of Tin Pan Alley, illuminated billboards and common manu-
factured objects. They reflected a new aesthetic appreciation of
urban commotion and the classical grandeur of the industrial land-
scape. This was evidence for the existence of an American culture.
Gertrude Stein was being proved wrong. In fact, there were lots of
different 'theres' there (figure 14).

Susan Sontag's article 'Notes on Camp', published in the *Partisan
Review* in 1964, identified subcultures as a major factor in the break-
down of the monolithic concept of 'taste', with its modifiers, 'good'
and 'bad'. In Camp taste, what had been bad was good, and what
had been good was open to question, criticism or demolition. Sin-
cerity was replaced by style. Taste no longer came out of a rule
book; it was made up as you went along, and it was fun.

Along with Camp came a new, sophisticated appreciation of
kitsch. Defined in 1925 by Fritz Karpfen, *Der Kitsch* refers to a design
in which form does not relate to purpose. The offensiveness of
kitsch to people of refined sensibilities was first put to use by the
avant-garde. Dada and Pop Art used kitsch references to question
the function of art, its relation to popular culture and official ver-
sions of good taste (is it a Brillo box, or is it sculpture?). The advent
of a critically sanctioned, synthetic 'bad' taste, adopted by Post-
Modernists such as Michael Graves and Jeff Koons, eventually
blunted the edge of authentic kitsch and camp.[23] And while these
are not originally American ideas, the commercial culture of the
United States provided the most fertile medium for their growth
(figure 15).

New freedoms to express diverse sexual inclinations helped to
release a variety of fashion and decorating tastes from the closet.
Bondage gear and other fetish garments, such as those sold through
the Frederick's of Hollywood catalogue in the 1950s, reached the
catwalks of America in the 1980s. Madonna brought a polymor-
phous eroticism into the arenas of rock performance and
mainstream film. Her stage costumes by Jean-Paul Gaultier and her
photography, inspired by Robert Mapplethorpe, also set high
standards of 'bad' taste for the *fin de siécle*.

Andy Warhol was a pioneer taste-breaker. In the 1960s Warhol
assaulted established views of style and taste and reconfigured the
relationship between art and commerce, bringing it a new irony.
Warhol was a subject of his own art and, like a kitsch mantle clock,
he could take any form. Warhol the fashion illustrator, trans-
formed himself into Warhol the painter and sculptor, then into
Warhol the film-maker, Warhol the rock impresario, Warhol the
magazine publisher and man of letters, and Warhol the collector.

In the cultural ferment of the 1960s, the ability to shock and
amuse simultaneously was, perhaps, the most potent weapon an

artist could use in establishing a career. And so, Warhol became the embodiment of conspicuous outrage. His silkscreens based on car crashes, assassination and execution challenged the traditional reticence of the wider art public to engage in a visual dialogue with horrible subjects. And the sexual aberrations, drug taking and movie queen histrionics in his films were also highly confrontational in an age of Doris Day movies. His insistence on the virtue of boredom was perhaps his most daring challenge to a public conditioned by the expectation of constant excitement.

Warhol's legendary Factory was the rough and ready setting for his creative work and for his much publicized social life. A disused industrial space in Manhattan, its walls covered in aluminum foil,

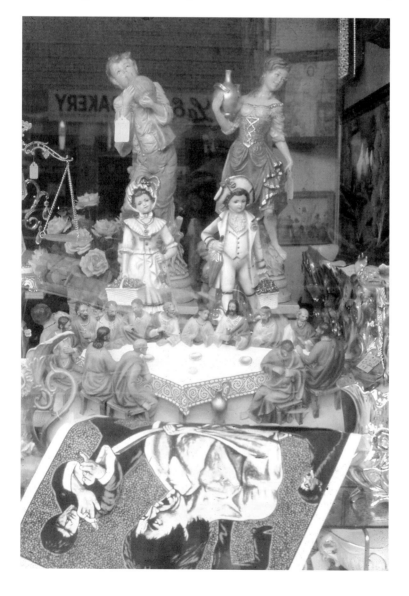

15] Bruce Lee meets Jesus and Little Bo-Peep in the window of a Latino gift shop, Brooklyn New York, c. 1975. Bizarre coincidence is a trait shared by Surrealist art, popular kitsch and Post-Modernist tastes.

furnishings sprayed silver, his first Factory became the model for 'loft' living which has become the preferred type of habitation for artistically inclined urbanites over the past thirty years, and an early lesson in functional re-use and fashionable ad hocism (figure 16). Warhol's personal image was regularly updated and photographed for publication. Beginning in the early 1960s with full black leather gear, Warhol progressed to a mock bohemianism, wearing worn workman's clothing with expensive Gucci shoes. Late in his life he became a freakish socialite in white tie and tails topped by an explosive silver wig. Like his loft, Warhol's manner of dress was widely imitated by the young.[24]

Because of his pluck and self-deprecating humor, which disarmed much criticism, Warhol flourished and simultaneously imparted to a large audience a taste for High Camp and for the rough underbelly and artificial glamor of the urban environment. His eclecticism contributed to the extraordinary breadth of American modernism.

This diversity was explored in a 1948 article by Alfred Auerbach, entitled 'What is Modern?', which identified ten types of modern

16] Disused commercial premises became the preferred homes of artists and other space-loving urban sophisticates during the period of de-industrialization. They signaled the beginning of a taste for ad hocism and recycling.

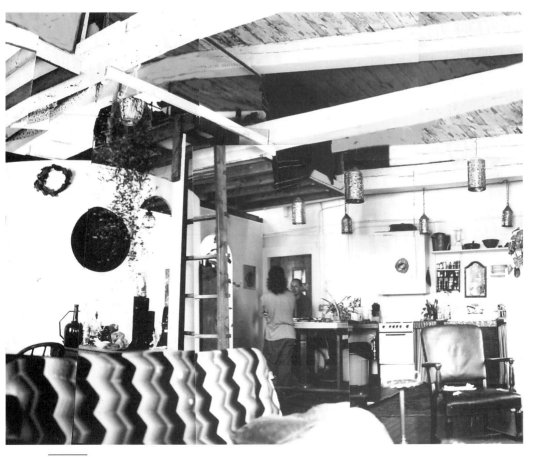

American interior and furniture design. These included 'Unrelenting Modern' (essentially Bauhaus), 'Nostalgic Modern' (a streamlining of historical styles), 'Floradora Modern' (a luxurious style like de Wolfe's common to hotel lobbies and professionally decorated living rooms), and 'Juke Box Modern' (also known as 'borax' and highly popular).[25] Auerbach's satire perceptively acknowledged 'an alive, mobile, many-faceted modern movement'; it also recognized a specifically American appreciation for a combination of comfort, luxury and utility. What he called 'Nostalgic Modern', for example, was demonstrated during the 1950s in furniture designed by Edward Wormley for Dunbar. Wormley's sleek, commodious chairs and sofas suggested traditional quality in a manner which was unmistakably contemporary (figure 17).

But none of Auerbach's categories described anything like Charles Eames's furniture, which achieved a uniquely American synthesis of Apollonian and Dionysian qualities. His iconic lounge chair and ottoman, first produced in 1956, though uncommonly sophisticated, reflected a characteristically American union of technical ingenuity, ergonomic comfort and sumptuousness (see figure 61).

American modernism embraced austerity only when it was clearly chosen over more luxurious options or when quality

17] Edward Wormley's substantial contemporary designs for Dunbar furniture typified an American synthesis of formal purity, physical comfort and visual warmth. Dunbar furniture was often photographed, surrealistically, out of doors.

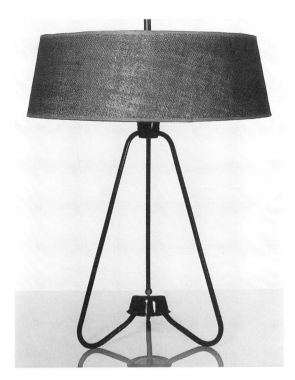

18] Dressing down the home was a prerogative of intellectuals which eventually spread through the social classes. Cheap materials in chic designs – this tubular steel lamp with burlap shade, designed by Kurt Versen, was typical of sophisticated contemporary taste in the 1950s.

materials and workmanship was evident.[26] For example, the fashion for burlap as a furnishing fabric during the post-war economic boom was a typical manifestation of chic asceticism in the midst of an orgy of consumption. With opulent goods everywhere, the simplicity of burlap in a well-made object was meant to demonstrate intelligent restraint (figure 18).

Dissemination of taste

The growth and consolidation of the United States of America was propelled by technology. Since the time of the philosopher/statesman Benjamin Franklin (1706-90), whose accomplishments included experiments with electricity and the development of a revolutionary cast-iron convection stove, interest in technology has been central to the nation's economy, culture and physical unity. By the beginning of the twentieth century this interest, transformed by the domestication of machines and the commercial competition this generated, was becoming a matter of taste. The same criteria applied to the selection of an automobile or a toaster as to the choice of a painting, a suit of clothes or a sofa. Extravagant, restrained, modern or traditional, the looks of new products catered to all preferences; and choices would be based on the personal tastes of the buyer. As reliability became less of an issue and products of each type grew more alike technically,

selection was increasingly determined by branding, signified by advertising logos and ornamental emblems. Brand loyalty quickly became an expression of taste. 'I am an Arrow shirt man – *Vogue* reader – Coke drinker – Dodge driver' (figure 19).

Admiration for new products in the garage and kitchen encouraged adaptation of their appearances to furnishings and decorative art objects. Americans visiting the 1925 *International Exposition of Decorative Arts* in Paris (from which the term 'Art Deco' derives), brought home an appreciation for hard-edged mechanical forms which they had seen applied throughout the exhibition from its pavilion architecture to household ornaments and cosmetics packages (figure 20). Two years later a *Machine-Age* exhibition was held in New York offering museum-goers a sample of authentic machine forms, including an aircraft propeller, gears and a crankshaft, shown alongside photos of industrial buildings, mechanistic sculptures and hand-crafted decorative arts objects which conformed to strict geometries emulating the precision of machine parts.

Among the first generation of industrial designers to establish

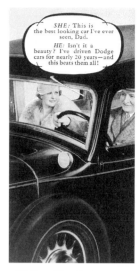

19] Brand loyalty became as important to personal identity as political or religious affiliations in the American consumer culture.

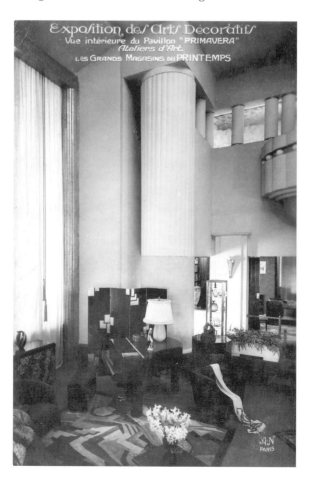

20] The Art Deco taste was brought home from Paris in stylish souvenirs. Exposition Internationale des Arts Decoratifs, Paris, 1925.

consultancies in the late 1920s, Norman Bel Geddes became the most closely identified with the first popular machine-based styling innovation, Streamlining, which he applied to everything from small kitchen gadgets to major building designs. Bel Geddes discovered that streamlining lent objects of utility a drama which was entirely metaphorical. At the 1933–34 *Century of Progress Exhibition* in Chicago Streamlining signified a future of ease and excitement made possible by the humane application of machine technology. The Streamline style dominated everything about the fair, from the turnstiles at the entrance to Buckminster Fuller's Dymaxion car which was demonstrated from the garage of George Fred Kecks 'House of Tomorrow', a steel and glass marvel of high technology. The fair linked modern design with everyday life and made it look like fun.

The extravagant use of mechanistic imagery at the fair contrasted sharply, in its strong appeal to the senses, with the Museum of Modern Art's austere and didactic *Machine Art* exhibition, held in New York the same year, in which formal purity and abstraction were the main themes. At the Chicago fair, the streamlined design of the new Airflow car, unveiled in the Chrysler pavilion, was linked in the public mind with jazz, newly legalized alcohol and eroticism personified by the fan-dancer, Sally Rand, who was another major attraction at the fair.

Streamlining became the first internationally recognized, all-American style and Bel Geddes was its impresario. He had gained experience communicating ideas to large audiences through his earlier work in theater design and department store display. He wrote, 'The window is a stage and the merchandise the players'.[27] He also believed that machine production defined the spirit of the age and that popular taste should reflect that spirit. During the 1930s, Bel Geddes attained a celebrity status which enhanced his promotion of Streamlining as the true American public taste. But unlike earlier design mandarins, such as Elsie de Wolfe, Bel Geddes appealed straight to the middle market with no trace of snobbery. The success of Streamlining depended on the receptiveness of upwardly mobile people to any idea which represented progress, a clean slate on which they could draw the image of their new position in society. The appearance of a fresh taste provided those recently arrived in the middle class an alternative to the traditions of White Anglo-Saxon Protestant taste which, in theory, would have been cultivated over several generations of wealth and privilege.[28]

Bel Geddes's book, *Horizons*, published in 1932, delivered in words and images a fantastic view of the near future in which streamlined houses, cars and airplanes would provide a frictionless

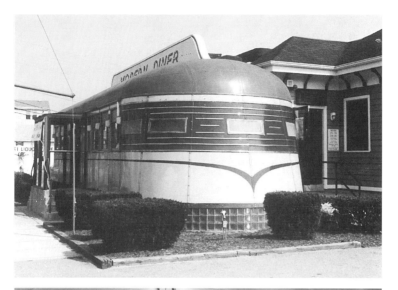

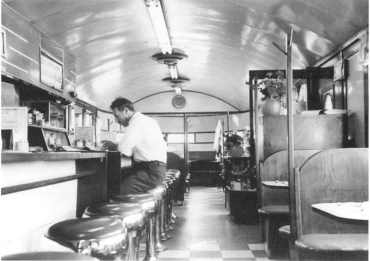

21] This modern approach to dining was typically American in its combination of efficiency and fantasy. The roadside diner pictured is a Sterling Streamliner, factory-built in 1935. Its sweeping forms realized the exhilarating, speed-driven fictions of Norman Bel Geddes' book, *Horizons*. The Streamline Style signified hope in a time of desperation.

environment where the majority of Americans would exercise their democratic rights to open space and perpetual movement (figure 21). Bel Geddes and the other leading industrial designers of the time had an opportunity to bring the images from *Horizons* to life as a complete model of 'The World of Tomorrow' for the New York World's Fair of 1939–40. Streamlining was the official style of this utopia which portrayed an imagined America of 1960 through the spectacular technical effects of Bel Geddes's *Futurama*, an aerial view of the motorways and cities of the future, Henry Dreyfuss's *Democracity*, 'a futuristic metropolis pulsing with life and rhythm and music', and Loewy's *Rocketport*, a simulated trip to outer space.

For the millions who could not visit the fair, access to a stream-lined fantasy world was available for the price of a movie ticket.

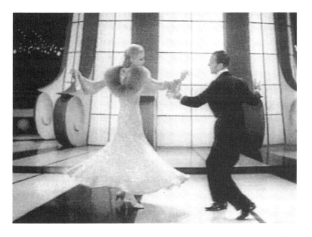

22] Fred Astaire and Ginger Rogers, still from the film *Follow the Fleet* (1936). Art Direction Van Nest Polglase, Caroll Clark. Streamlined girl, streamlined boy, streamlined music and streamlined architecture – the first truly American aesthetic appealed to all the senses. It was smooth and harmonious.

The dynamism of Streamlining complemented smooth 'swing' music and the fluid dance movements of the Astaire-Rogers partnership who graced a string of popular Hollywood musicals during the 1930s. The swank settings in which the pair danced - ocean liners, night clubs and penthouse apartments - were designed under the direction of Van Nest Polglase with sweeping lines and polished surfaces echoing and reflecting the graceful, athletic movements of the dancers and the close harmonies and syncopated rhythms of the music (figure 22).

Ginger Rogers and Fred Astaire both epitomized the streamlined human form which had become fashionable in the 1920s. Rogers's slim, athletic figure, in sleekly contoured dresses by Bernard Newman, corresponded to the slender, elongated proportions of contemporary motor boats and aircraft. By cutting new synthetic materials, such as rayon, on the bias, Newman made her costumes cling to the body and drape in parallel folds accentuating her graceful movements.[29]

The early Hollywood moguls, Zukor, Mayer, Goldwyn and Warner, all had worked in the garment industry. And so it was logical that they would wish to dress their stars lavishly and that they should find ways of capitalizing on public interest in the stars' costumes. Their taste, however, was as brash and new as the medium in which they made their millions. According to the Paramount designer, Howard Greer, 'New York and Paris disdainfully looked down their noses at the dresses we designed in Hollywood. Well, maybe they were vulgar, but they did have imagination … There I wallowed in rhinestones, feathers and furs and loved every minute of it.'[30] So did the film-going public.

Stars imposed their own tastes and became the models for particular styles. Joan Crawford's worldly look (see figure 59), derived from Schiaparelli, was interpreted for the screen by her studio designer, Gilbert Adrian, and then copied for sale to the public

through department stores such as Macy's which opened the Cinema Fashion Shop in New York in 1930. Its success spawned 2,000 similar stores across the country.

The luxurious and fantastic settings of many films were echoed in the extravagant Miami hotels designed by Morris Lapidus during the 1950s. Lapidus wrote,

> What were the tastes of the vast majority of affluent Americans? Were Americans accepting ... Gropius and Breuer and Mies van der Rohe? The answer was an emphatic 'no'! ... American taste was being influenced by the greatest mass media of entertainment of that time, the movies. So I imagined myself the set designer for a movie producer who was doing a film ... in the most luxurious tropical setting and who wanted to create a hotel that would really make a tremendous impression on the viewers. [31]

The Eden Rock, Fontainbleau and Americana hotels were despised by architectural critics, but loved by the guests, who included

23] Camp Ralph. Lauren's 'Country Collection' of apparel and home accessories, 1995, evoked a strong regional flavor while making high fashion of America's native roots.

makers of both feature films and TV commercials – the leading media taste-makers (see figure 50).

Movies also turned the issues and ideas current in the design discourse into the material of high drama. Modernism was presented as a visual metaphor for urban sophistication, moral decadence, feminism and social mobility in the sleek interior settings designed under the art direction of Cedric Gibbon's for Garbo in *Susan Lennox, Her Fall and Rise* (1931).[32] In Woody Allen's *Interiors* (1978) a designer's austere good taste, portrayed in settings by Mel Bourne, communicated the spiritual bankruptcy of highbrow culture. The uncompromising attitude often associated with modern architecture was celebrated in the film of Ayn Rand's novel, *The Fountainhead* (1949), which was loosely based on the career of Frank Lloyd Wright. Similarly, *Executive Suite* (1954) dissected the moribund Grand Rapids furniture industry and dramatized a need for integrity and innovation in design. After the Second World War, *Mr Blandings Builds His Dream House* (1948) asserted traditional American values and tastes through its conservative, anti-urban theme and neo-colonial sets executed under the art direction of Albert d'Agostino.

Films and advertising both exploited the distinctly different landscapes, climates, ethnic compositions and historical backgrounds of America's regions, promoting a variety of local styles as national or even global tastes. They have constructed a vocabulary of symbols through which individuals could express local allegiances and family backgrounds, or create entirely fictitious identities.

The romantic image of the West, its freedom and the open life of the plains, were given tangible attributes through movies such as *Stagecoach* (1940). The appeal of John Wayne's cowboy look was reflected in brisk sales of Levis and Stetson hats, while western settings helped to prepare the nation for the mass construction after the Second World War of Ranch houses which were often decorated with wagon-wheels, cracker barrel tables and rustic fencing. The western style also characterized promotions for high fashion clothing and furnishings. Ralph Lauren's Fall 1995 'Country' catalog illustrated chic and expensive designs based on traditional clothing and artifacts associated with the corral and bunkhouse, seen against backgrounds of the Grand Canyon and the interior of a Navajo 'tepee' (figure 23).

In his work for the 1938 film, *Gone With the Wind*, the production designer, William Cameron Menzies, gave the South a nostalgic glamour which spawned a long-lasting fashion in domestic architecture and decoration (figure 24).[33] Menzies controlled all visual aspects of the movie including sets, costumes,

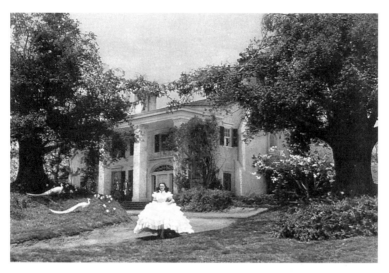

24] *Gone With the Wind* comes to suburbia. Hollywood's vision of Scarlet O'Hara's homestead, Tara (above), had an immediate impact on American taste when the film was released in 1938. A New England home, *c.* 1940 (below), is presented as a Southern colonial mansion, scaled down and winterized. Nostalgia influenced design throughout the century. Only the preferred historical moment and the manner of representing it changed.

color, lighting and the composition of shots, producing a coherent image of the Old South which continued to stimulate emotions in several generations of audiences. Like a portrait still from the movie, the packaging and advertising for Aunt Jemima Pancake Mix also brought a fantasy of the South into millions of American kitchens for decades until changes in the acceptable representation of race and gender demanded an updating of the product's image.

Beginning in 1912, the *L. L. Bean Catalog* employed vivid illustrations of its products and evocative cover art to spread the traditional image of Down East seafaring, rural values and resourcefulness embodied in the lobster-pot coffee tables, Sno-Shu furniture, sports equipment and outdoor apparel sold by mail order from the Freeport, Maine, company (figure 25). The image of a benevolent pilgrim father, a personification of trust, shown on all

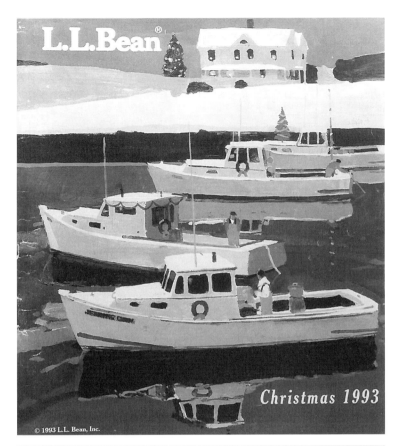

Christmas 1993

© 1993 L.L. Bean, Inc.

25] Native American dress inspired designs for popular sportswear commonly available through mail order catalogs such as L. L. Bean of Freeport, Maine. Their moccasin was an evergreen type of casual footwear while Bean's catalog cover art evoked an idylic rural image of northern New England.

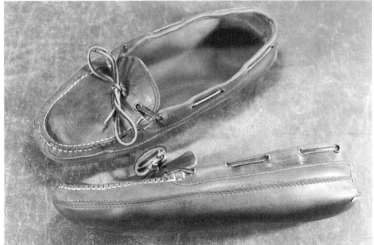

Quaker Oats packaging also recalled early New England settlements, as Aunt Jemima did the Old South (figure 26).

Regardless of growing public scepticism, the promotion of taste through advertising became one of the country's biggest businesses. Robert Sarnoff, the President of NBC, wrote in 1956, 'The

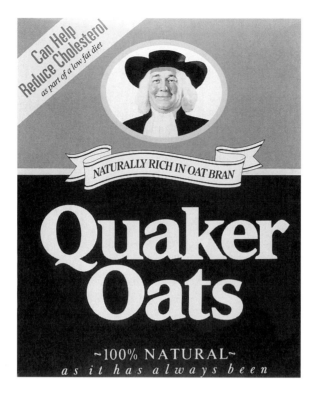

26] Regional themes abound even among products with a global market. Quaker Oats was the first cereal commercially packaged in the United States, and has been trading on its regional image since 1877. This was the package current in 1997.

reason we have such a high standard of living is because advertising has created an American frame of mind that makes people want more things, better things, newer things.'[34] Both packaging design and product styling generated desire and required customers to exercise their taste by choosing.

Ultimately, television provided the widest platform for the promotion of taste and added a new intimacy and realism to the process. Jacqueline Kennedy's informative and entertaining tour of the newly refurbished White House, broadcast nation-wide in 1962, acquainted an enormous audience with her highly refined taste and demonstrated to the nation the results of the charismatic First Lady's work on the decoration of what is perhaps the most symbolically important home in America. By glamorous association, the program revitalized interest in the restoration of lesser historical interiors and antique furniture, later encouraged by the long-running WGBH TV series, *This Old House*. The formal rooms of the White House have become increasingly familiar to television viewers as the setting for official state occasions and attract over a million and a half visitors a year. While they retain a stately continuity, the interiors of the building change to reflect the tastes and preferences of each successive First Family (figure 27).

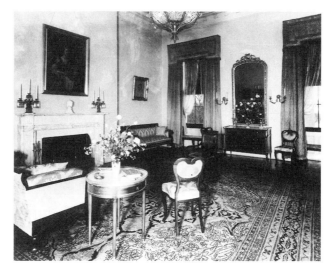

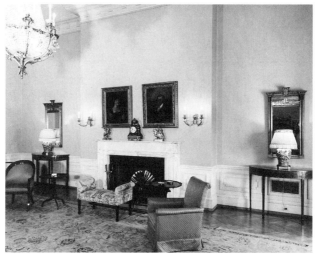

27] America's ultimate symbolic house, the White House, represents national values and aspirations dating back to the Federal period. Each presidential family has redecorated, adjusting its character to suit theirs. The Treaty Room, adjacent to the Oval Office, as it appeared during the administrations of Presidents Hoover (top, *c.* 1928), Eisenhower (middle, *c.* 1952) and Kennedy (bottom, *c.* 1962).

Educating taste

Museum design collections were assembled first as resources for industry. And their aim was to improve the aesthetic standards of manufactured goods by encouraging designers to model their products on the great historical relics in the museums' collections. Faithful copying of Colonial furniture, for example, provided a guarantee that the new product was in 'good taste'. For specifically modern products such as an electric lamp or a phonograph, a Renaissance lantern or a medieval chest would be a suitable model.

Richard Bach, the curator of industrial art at the Metropolitan Museum of Art in New York was among the first to hold an annual public exhibition of American industrial products, beginning in 1917, through which he intended to tap 'the most intimate feelings of the people, reaching them through their home furnishings, their utensils, their objects of personal adornment, their clothing'. As a result, Bach's department earned the soubriquet, 'The Workbench of American Taste'.[35] He also intended to establish contemporary design over traditional styles.

Following the Met's example after the Second World War, New York's Museum of Modern Art instituted a policy of design exhibitions aimed at elevating consumers' taste in domestic products. Their 'Good Design' shows began in 1951 and continued for five years in an effort to secure public approval for the modern style as defined by the curator, Edgar Kaufmann Jr, and selected jurors. They were not alone. A similar exhibition, entitled *20th Century Design: USA*, organized in 1959 by the Albright Art Gallery of Buffalo, New York, selected its exhibits on the basis of 'design maturity ... standard criteria - performance, durability, form - that most design exhibit judging comes to rest on'.[36] The Walker Art Center in Minneapolis opened its Everyday Art Gallery in the belief that 'anyone can learn to discriminate between good and bad design, given opportunity'.[37] These and many more museum- and gallery-sponsored exhibitions strove to educate the public to the virtues of formal simplicity and to convince them that this was a cardinal feature of good design.

More recently, institutions such as the Smithsonian Institution's Cooper-Hewitt Museum in New York exhibited designed objects as cultural artifacts and addressed taste as a product of social conditions rather than as a personal accomplishment. In 1986, the *High Styles* exhibition at New York's Whitney Museum of American Art presented the evolution of design fashions in a context of twentieth-century history. It also introduced relative values to the public discussion of taste and affirmed style as the matrix for choice, the primary mechanism of modern taste. *Crafts in the*

Machine Age: 1920–1945 at the American Craft Museum (also in New York) in 1996 suggested that challenging questions, about the relation of taste and decoration to larger cultural forces such as mechanization and handcraftsmanship, could be asked in popular exhibitions. It also demonstrated a surprising congruence of tastes between designers and craftspeople during the period of high modernism.

By the time genuine American Indian culture was nearly obliterated, a style cult was forming around the ornamentation of utilitarian and ritual objects made and used by Native Americans. The sculptor Gertrude Vanderbilt Whitney, founder of the Whitney Museum, collected aboriginal and folk art and design in the 1920s and popularized it as a national treasure through her museum. Native Americans, themselves, continued designing and making both traditional and modern artifacts, encouraged by the formation of organizations such as the Institute of American Indian Arts in Santa Fe, The Southern Plains Indian Museum and Crafts Center and the Gilcrease Museum, both in Oklahoma. These and other institutions provided an educational context for the promotion of authentic Indian styles of design.

Shops also took part in the education of their customers' taste. If New York was thought of as the commercial capital of America, Boston, or more precisely Cambridge, Massachusetts, was its intellectual hub. There, with Walter Gropius, the architect Benjamin Thompson had founded The Architects Collaborative (TAC) in 1946; he would become chairman of the Department of Architecture at Harvard in 1963. And in the rarefied atmosphere of Harvard Square, Thompson established his Design Research shop (DR) in 1953.

DR was a stylish enterprise aimed at a highbrow clientele for whom a varied selection of internationally produced domestic goods was presented as if in an art gallery.[38] Many of the items sold through DR also belonged to the design collection of the Museum of Modern Art or had appeared in their 'Good Design' exhibitions, both of which classified exhibits by origin, emphasizing named designers in their presentations. At DR some prominent items, such as Marimekko fabrics and dresses, were identified by manufacturer. But designers were given high prominence – 'Jacobsen cutlery' and 'Breuer chairs'. Other items were simply identified by country of origin, reflecting DR's sophisticated global consciousness. Thompson's shops were an educational experience for customers who were beginning to want information about common household artifacts which would unlock their understanding of these things as cultural icons. Designers' names and other attributions were the keys.

Popular magazines including *House Beautiful, Ladies Home Journal* and *Good Furniture*, 'The Magazine of Good Taste', also campaigned for refined taste and commented critically on what they considered to be its opposite (figure 28). They minutely detailed the characteristics of particular styles, chronicled their rise and fall from favor, paid homage to their creators and champions and suggested many ways of expressing individuality within the broad arena of conventional appearances. Like de Wolfe's *The House in Good Taste* or MOMA's 'Good Design' exhibitions, popular magazines offered principles or rules for the cultivation of taste. But instead of 'suitability' or 'functionalism', the general characteristics of magazine taste were comfort, charm, informality and variety.

Specialist periodicals, such as John Entenza's *Arts & Architecture* (edited by him from 1938-62) treated taste as a subject of critical debate and maintained a high-minded concern for the elevation of standards. Entenza promoted modernism out of 'a sincere belief in the goodness of technology, and a faith that design could solve many of society's problems'.[39] *Arts & Architecture* also put California on the cultural map, identifying its relaxed style and asserting that the most advanced taste of the nation was to be found on the West Coast. *Arts & Architecture* addressed various brands of modernism; and when it looked at art and design from abroad, its gaze was cast south to Mexico or out over the Pacific rim, rather than east to Europe. Using the most sophisticated modern layout and typography, the magazine's image was chic, eclectic and socially aware.[40] *Arts & Architecture's* long-running feature, the California Case Study Houses, and the furniture, ceramics, jewellery, textiles, music and film reviews that appeared in its pages were bathed in its elan (figure 29).

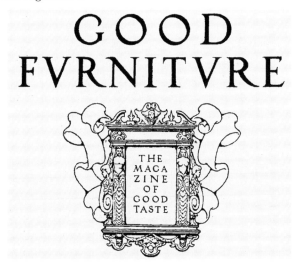

THE
MAGA
ZINE
OF
GOOD
TASTE

28] Magazines dedicated to informing public taste have flourished throughout the century identifying and promoting a succession of modern and traditional styles. *Good Furniture, The Magazine of Good Taste* declared in 1916, 'the time in which we live is one of eclecticism'. Accordingly, its editorials offered general principles of decoration applicable to any style of design. In its pages the word 'modern' was synonymous with 'American'.

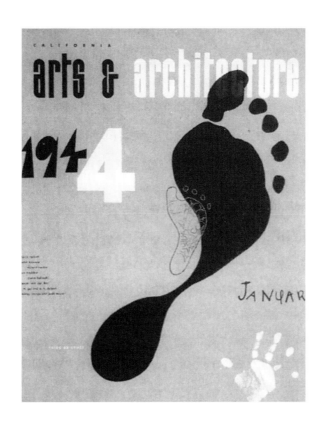

29] *Arts & Architecture* magazine helped to put California on the cultural map and extended the westward march of cultural innovation. Its covers by sophisticated designers such as Ray Eames communicated the magazine's breadth of interest in all types of avant-garde art.

While secondary schools took little interest in the cultivation of their students' taste in any branch of the arts other than literature, finishing schools traditionally taught young ladies, destined to manage upper middle-class households, the fine points of decorating and decorum. Liberal arts colleges aimed to produce graduates who were sophisticated in matters of taste by offering music and art appreciation courses as standard options in the curriculum. By the 1980s cultural studies was added to the liberal arts, placing design and popular taste in a more theoretical context. At the end of the century It was possible for anyone with a degree in liberal arts to consider themselves as well educated in the subject of taste as they were in mathematics, astronomy or political theory.

Design schools all eventually (by around 1950) fell in line with some form of modernism. However, as students everywhere were encouraged to be 'original', their personal tastes were allowed expression within the larger orthodoxy. By the last quarter of the century, stylistic pluralism was widely acknowledged in design education, and a proliferation of deconstructivist, and historicist styles appeared alongside modernism, freeing design students to explore a much wider stylistic range in their work.

In the 1970s, cultural critics, such as Tom Wolfe, were calling educated taste itself into question. Two of Wolfe's best-sellers, *The*

Painted Word of 1975, and *From Bauhaus to Our House*, published in 1981, attacked elitism which he associated with both modernism and postmodernism. His diatribes were based on the idea that the true national taste had been overrun by phonies and con-artists who succeeded, through support by major institutions and charismatic publicists, to establish cranky, foreign, minority tastes (abstract art and the International Style) at the center of American material culture.

Although manuals of taste were a publishing tradition, 'style books' became a late-century publishing bonanza recognizing the multitude of tastes functioning in America. Slesin and Kron's *High Tech*, which appeared in 1980, signaled the arrival of a new interest in domestic interiors with industrial character, gave the style a history and a name, and presented seductive photographs of real examples. Also, by providing lists of material and equipment suppliers, it invited both the professional and amateur reader to participate in the design process. *Santa Fe Style, Caribbean Style* and *American Country* were among many other books which presented new packaged tastes. Similarly, magazines such as *Architectural Digest, Adirondak, Home Furniture, Do-It-Yourself, Metropolis* and *Ray Gun* provided detailed information, discussion and advice on a broad spectrum of tastes and styles.[41]

In 1990s' America the ultimate singular authority on matters of taste pertaining to home decoration, cooking, sewing and garden planting is Martha Stewart, whose face has become as familiar to a vast and attentive audience as are her books, articles, videos and Internet website. Dubbed the 'Empress of How-to', Stewart raises mundane issues of domesticity to a level of moral and aesthetic prominence not seen since the early years of the century. Her magazine, *Martha Stewart Living*, presents an ideal of excellence in matters of taste which is chic and, at the same time, aware of issues such as personal health and the impact of domestic consumption on the natural environment. Stewart redefines the design process as a combination of rules and intuition; like gastronomy, the art of fine cooking and eating, visual taste requires the blending of tangible materials with philosophical speculations, inspiration and rules of logic to give maximum pleasure.

Finally, one of the most important influences on taste this century was travel. From the advent of motoring holidays in the early years of the century to the development of jet air transport and package holidays, Americans have been the most mobile people in history. Travel for many purposes, military service, private business or tourism, widened individuals' horizons and expanded their capacity for enjoyment of exotic customs, food, fashion and architecture. Back at home, it changed the ways in which they

constructed their personal appearances and their home environments (figure 30).

Alternative cultures

The existence of ethnic tastes has remained a fact little recognized by the cultural establishment. Music and dance were the clearest signs of the vitality in Black culture from the period of New York's Harlem Renaissance in the 1920s to the hip-hop era. But from the mid-1940s, John H. Johnson's *Ebony*, *Jet* and *EM* magazines presented dress fashions and other products of taste developing within the Black community. In the 1950s, Harlem hosted on average 300 fashion shows per year, all with paying audiences. The clothes on show were mainly church outfits, designed and made by individuals working in their homes, outside the rag trade of 7th Avenue. These events became known to the general public through photographs by Eve Arnold published in *Life* magazine. By the 1970s, monumental New York subway graffiti drew public

30] Travel greatly expanded modern taste. While foreign tastes have been brought home, American regional tastes have been exported to every part of the world. Between the two world wars Dude Ranches were a popular holiday destination where cowboy styles prevailed. Many dudes brought their jeans and bandannas back to the city and suburb. Advertisement for the Santa Fe Railroad, 1928.

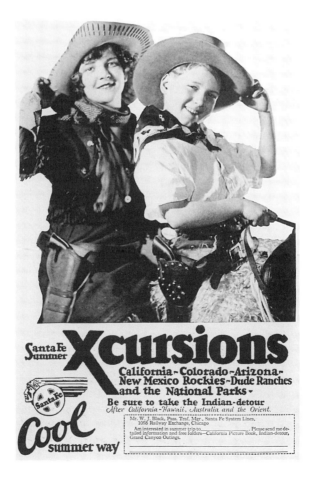

attention to the fact that ethnic urban tastes arose from a complex of factors totally out of the control of cultural institutions. Yet most innovations of Black taste ultimately had wider influence through the music industry, publishing and film.

The powerful African-inspired fashions of the 1960s, which represented a new historical consciousness and gravity in African–American culture, included 'natural' hair-styles, African textile prints and clothing forms such as the dashiki, all of which were quickly absorbed by mainstream fashion. The baggy shorts and 'jams' worn first by Black city kids in the 1980s became standard sportswear in the 1990s. Black taste became widely known and influential through film. Beginning in the 1960s with Gordon Parks' *Shaft* and *Superfly* and later in the films of Spike Lee, the tastes of urban Black society reached a general public and were imitated widely. According to Kevin Chapell, Black people 'defined America and put their stamp on the the country's music, dance, dress, walk and talk so much so that the term "Black culture" is a misnomer. It is, in reality, genuine American culture.'[42]

From the beginning of the century, artists and designers looked to the ordinary and the ugly for their imagery and transformed

31] Teacher and disciples. The charismatic photographer and gallery-owner, Alfred Stieglitz, found converts to modernism among the class of urban professionals who visited his Gallery 291 in New York (c. 1932).

those images for consumption by art collectors. The Ashcan School painters dwelt on scenes of the urban poor at work and leisure, and sold their pictures to the well-off through the chic gallery '291' of Alfred Stieglitz (figure 31). WPA artists of the 1930s, such as the photographer Dorothea Lang, had shown American poverty as a temporary phenomenon resulting from the Dust Bowl and the Great Depression. The mass media, however, portrayed an America which was predominantly white and middle class. With the recognition in the 1960s of poverty as a permanent condition in the United States, through books such as Michael Harrington's *The Other America*, a whole new world of alienation and potential insurrection became a public preoccupation. With it came a deepening awareness of urban decay and of what the world and the people in it looked like outside the white, middle-class stereotype portrayed on TV in *Leave It To Beaver* and *Father Knows Best*. Gradually, artists and designers responded to this 'other' America, creating works which reflected a growing consciousness of social breakdown and environmental decay. For example, the sculptor Edward Kienholz constructed tableaux from genuinely dilapidated material to describe the grim situations of people trapped by circumstances of race, age, illness or poverty.

In the 1970s SITE Projects employed themes of distress and decomposition in the 'Indeterminate Facade' of a Best Products Company store in Texas which appeared as a partial ruin, bricks cascading from its crumbling parapet. A taste for the worn, the broken and the abandoned was also evident in advertising photography, interior design and fashion in the wake of films such as *Blade Runner* (production design by Lawrence Paull) and Terry Gilliam's *Brazil* which portrayed romantically decaying urban environments of the future (figures 32 and 33).

A growing preference for the disreputable over the distinguished raised the question of whether taste must always trickle down from the mandarins into the domain of ordinary people or if it could also bubble up from anonymous innovation into 'official' culture. Some tastes were initiated by non-professional individuals or groups with a desire to declare their identity or to demand recognition. The hippie fashions of the 1960s brought authentic Third World textiles on to the streets of America for the first time, then into the wardrobes of middle-class college students, and finally into the ready-to-wear collections of name designers.

While mandarins tugged at public taste from above, an opposing, counter-cultural taste enjoyed growing vitality. When 'highbrow' became too boring or common, the avant-garde moved down into the gutter of taste. The metamorphosis of a rich but unfulfilled suburban housewife into a fabulously tacky magician's

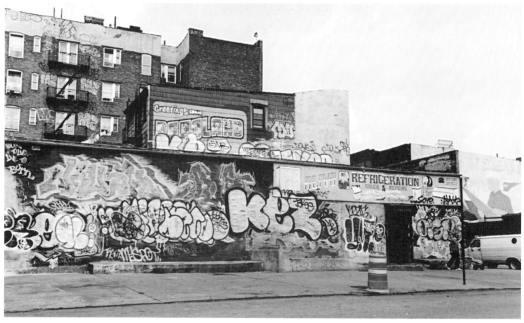

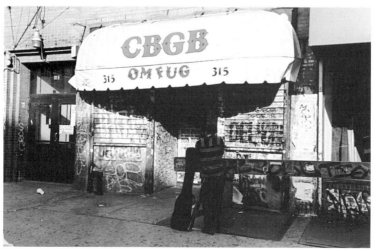

32 and 33] Commercial and industrial decay were familiar to Americans throughout the century. In the 1980s, however, the condition was dramatized and glamorized in films such as Ridley Scott's *Blade Runner*. Urban dilapidation invited a new type of renegade public art, graffiti, which quickly became chic, as in the spray-painted front and neon interiors of the Punk music mecca, CBGB's.

34] Playing in the gutter of taste. An unappreciated suburban housewife becomes a fabulously tacky magician's assistant in Susan Seidelman's film, *Desperately Seeking Susan.*

assistant in Susan Seidelman's film, *Desperately Seeking Susan*, was just such a rejection of economic privilege (figure 34). The fashion for moving down the social scale influenced a broad range of popular choices. The phenomenal success of the Volkswagen 'beetle' among motorists who could afford a Buick was one example. Torn and faded Levis was another.

Street style

'Street style' gained a place in the discussion of popular design due mainly to the importance of youth as a cultural force. Beginning in the 1920s, the novelist F. Scott Fitzgerald and the illustrator John Held glamorized a 'lost generation' whose attitudes and fashions were emerging increasingly from their own inventiveness, rather than from the traditional bastions of taste. The emphasis on youth increased further with a big change in the demographic profile of America caused by the baby boom after the Second World War. By the mid-1950s children and teenagers were major consumers and had become formidable influences on the nation's tastes.

Likes and dislikes of developing youth cults, such as bikers and Bobby Soxers, began to be picked up by the media and confirmed as fashion. Youth heroes such as James Dean and Marlon Brando, shown in leather and denim in their films and publicity, cultivated a tough, outsider's image which already had wide currency in diners, motor-cycle clubs and pool halls. Unlike pre-war stars who popularized either elite or historical styles, the 'method' actors of the 1950s endorsed existing popular tastes. By doing so, they helped to create a place for anonymous street-styles in the history of fashion.

And there was Elvis Presley. A dedicated daily shopper at the height of his rock and roll stardom in the mid-1950, Presley combined the elements of his costumes with an almost surrealist sense of unlikely juxtaposition. Pink trousers with a multi-colored cowboy shirt worn under a black tuxedo jacket was the sort of outfit that earned him the title, 'Memphis Flash'. Elvis acted as a liberating force on the wardrobes of countless young fans who watched him, albeit in black and white, in his early television appearances.[43]

That many of his exotic outfits were known to have been purchased from Lansky Brothers of Memphis, which catered mainly to a young Black clientele, fueled the critics' outrage over Elvis's erotic stage persona. The conservatism of White, middle-class Americans in the 1950s provided a suitable backdrop for the rise of a wise-guy, like Elvis, who exploited the most *outré* street fashion in a gesture of conspicuous outrage which would provoke a generation, bored by Eisenhower and grey flannel, to cross tired boundaries of class, race and gender.

One lively strand of the aesthetic free-for-all which followed in the 1960s, described by Tom Wolfe in The *Electric Kool-Aid Acid Test*, arose from the activities of the novelist, Ken Kesey, and his retinue known as The Merry Pranksters. The Pranksters signified their hip, druggy way of living through a fashion and graphic style inspired by the visual effects of the hallucinogen LSD. The key icon of the Pranksters' image was an old International Harvester school bus which had been adapted for group travel with bunks, a kitchen and a powerful music system. In it they drove relentlessly over the United States spreading the message of sex, drugs and rock and roll. The destination board said 'FURTHER', suggesting psychological as well as geographical progress.

The most outstanding attribute of the bus was its paint job, 'with everybody pitching in a frenzy of primary colors (it) was sloppy as hell, except for the parts Roy Seburn did, which were nice manic mandalas'.[44] The lurid mural expressed the shifting proportions and intense colors of the acid experience. It was also a wild affront to all conventional standards of taste. The bus was eventually photographed for *Life* magazine, and its impact was quickly felt in the 'psychedelic' decoration of countless hippie apartments and the home-made paint jobs of innumerable VW micro-buses. Despite the fact that the Pranksters were genuinely anti-establishment and avant-garde, their style was soon absorbed into the commercial system, as in the flamboyant graphic designs of Peter Max, its message lost in the process. Yet the Pranksters demonstrated vividly how to make an environment which was genuinely expressive of personal and communal values.

Fin de siècle

The picture of American taste and style which looks most plausible at the end of the century has altered considerably from the one which characterized its beginning. The number of influences on popular taste has multiplied fantastically: travel, movies, color magazines, TV and internet advertising have enlarged the taste industry to vast proportions. The extent of choice has become a misery as well as a blessing. Some styles, such as Streamlining, were commercial in origin while others emerged from individual invention or as statements of group identity, without immediate commercial motives. But the fact that the whole population has become interested in expressing individual identities through art collecting, fashion, home decoration, product selection and leisure activities make taste an essential element of the nation's economic well-being.

The concept of style dictated from abroad has been widely discarded, while the American cultural establishment has grown in strength and influence around the world. Although traditional styles have retained their importance, innovative popular taste has attracted the interest of critics and theorists. Americans are becoming more inclined to learn by looking and reading, picking and choosing. Values have come to be seen as relating to individuals' experiences, cultural backgrounds, expectations and quirks.

It is a simple law of history that each generation must dismantle the beliefs of the previous generation and construct a new set of ideas in their place. In the second half of this century, the process has been greatly accelerated by the speed of electronic communication. Styles and tastes have become more accessible, more disposable and more localized, and 'generations' have grown shorter. Design critics in the 1990s speak of a new tribalism in taste, describing subcultures which quickly form a bond of interests, like a secret language, and abandon it as soon as it becomes known outside the group. All this flies in the face of growing globalization of tastes defined mainly in America.

'Authorized' design still constitutes a major force in the design world, with each year seeing hundreds of monographs published and exhibitions mounted about 'design heroes'. And museums continue to expand their canon of revered objects. But, ultimately, each stage in the development of twentieth-century taste has been a move away from the traditional standards of connoisseurship. Modernism repudiated class; the Beat movement discarded materialism; Pop celebrated vulgarity; and Post-Modernism rejected authenticity. Recent interest in the street, the closet, the ordinary

and ugly, echoes traditional American respect for the primitive and the rebel. Outsiders join the elite as purveyors of taste.

Finally, although the picture of taste in America has become ever more complicated, we find ourselves subject to the same basic pressures to express ourselves and to conform, although the balance may have shifted in favor of the former in the post-Freudian age when confidence counted more than deference, when the novelist/philosopher, Ayn Rand, had introduced us to 'the virtue of selfishness,'[45] when we had been through what Tom Wolfe called the 'Me' decade (the 1970s), and assertiveness training is now a common leisure pursuit. But the need to belong is still a constant pressure. In the absence of objective standards of worth, taste has become the main system of evaluating the material world. And the commercial tools of branding and designer labels still operate as powerful symbols of shared taste and individual identity, as reflected in the following passage from the novel, *American Psycho* by Brett Easton Ellis, in which obsessive concern for taste and style is a metaphor for social pathology.

> At eight-thirty, the two of us are sitting across from each other in Barcadia. Evelyn's wearing an Anne Klein rayon jacket, a wool crepe skirt, a silk blouse from Bonwit's, antique gold and agate earrings from James Robinson that cost, roughly, four thousand dollars; and I'm wearing a double breasted suit, a silk shirt with woven stripes, a patterned silk tie and leather slip-ons, all by Gianni Versace.
>
> 'Jayne Simpson's wedding was so beautiful' she sighs.'And the reception afterwards was wild. Club Chernoble, covered by Page Six. Billy covered it. *WWD* did a layout … Weddings are *so* romantic … It was a sit-down dinner for seven hundred and fifty, followed by a sixteen-foot tiered Ben and Jerry's ice-cream cake. The gown was by Ralph and it was white lace and low cut and sleeveless. It was darling. Oh Patrick, what would *you* wear?'
>
> 'I would demand to wear Ray-Ban sunglasses. Expensive Ray-Bans.'
>
> 'I'd want a zydeco band, Patrick … Or mariachi. Or reggae. Something ethnic to shock Daddy.'
>
> 'I'd want to bring a Harrison AK–47 assault rifle to the ceremony,' I say, bored, in a rush, 'with a thirty round magazine so after thoroughly blowing your fat mother's head off with it I could use it on that fag brother of yours. And though personally I don't like to use anything the Soviets designed, I don't know, the Harrison somehow reminds me of …'
>
> Stopping, confused, inspecting yesterday's manicure, I look back at Evelyn.
>
> 'Stoli?' [46]

Notes

1 Russell Lynes, *The Tastemakers* (New York, 1949; repr. New York, 1954), p. 310.

2 James M. Cain, *Mildred Pierce* (first pub. New York, 1941; repr. New York and Toronto, 1978), pp. 209-11.

3 John A. Walker, *Design History and the History of Design* (London, 1989), p. 190.

4 Philip Core, *The Original Eye* (London, 1984), p. 49.

5 Lynes, *Tastemakers* p. 182.

6 *Ibid.*, p. 185.

7 Malcolm Cowley, quoted by Tom Wolfe, *From Bauhaus to Our House* (New York, 1981), p. 9.

8 Anne Edwards, 'Marion Davies' Ocean House', *Architectural Digest* (April 1994), p. 170.

9 Lewis Mumford, *American Taste* (San Francisco, 1929, limited edition), pp. 9-32.

10 Martin Battersby, *The Decorative Twenties* (London, 1969; repr. London, 1976), p. 166.

11 Alfred H. Barr, in Henry-Russell Hitchcock, *Modern Architecture: International Exhibition* (New York, 1932; repr. New York, 1969), p. 16.

12 'The Reluctant Tastemaker', *Time*, 10 October 1960, p. 81.

13 Mumford, *American Taste*, pp. 9-32.

14 Lynes, *Tastemakers*, p. 187.

15 Leslie Greene Bowman, *American Arts & Crafts, Virtue in Design* (Los Angeles, 1991), p. 70.

16 Gropius and Meyer were assisted in this design by Bauhaus apprentice Joost Schmidt, who carved Wrightian reliefs, and by Breuer and other Bauhaus journeymen responsible for furnishings, lamps and hardware.

17 Anita Loos, *Gentlemen Prefer Blondes* (first pub. New York 1925), chapter 4.

18 Peter Wollen, *Raiding the Icebox* (London and New York, 1993), p. 44.

19 Gerald Silk, *Automobile and Culture* (Los Angeles and New York, 1984), p. 78.

20 Le Corbusier, *The Decorative Art of Today* (first pub. Paris, 1925; rep. London, 1987), p. 67.

21 Rockwell Kent, *Good News for Printmakers, Fine Prints for Mass Production* (Brooklyn, 1939), p. 6.

22 Revereware cookware, Zippo lighters and Stetson hats remain in production and unchanged in appearance at the time of writing.

23 Stephen Bayley, *Taste* (London, 1983), p. 29.

24 Core, *Original Eyes*, pp. 157-69.

25 Alfred Auerbach, 'What is Modern?' (*A&A*, March 1948), in Barbara Goldstein, *Arts & Architecture, The Entenza Years* (Cambridge, MA and London, 1990), p. 94.

26 The 1908 Model T Ford, for example, was very well made and did not look cheap. Its brass radiator and tufted leather upholstery lent the car a refined character which was maintained throughout the car's production period.

27 Arthur Pulos, *American Design Ethic* (Cambridge, MA and London, 1986), p. 321.

28 See Lisa Birnbach, *The Official Preppie Handbook* (New York, 1980).

29 Donald Albrecht, *Designing Dreams* (New York and London, 1986), p. 86.

30 Peter Wollen, 'Strike a Pose', *Sight and Sound* (March 1995), p. 14.

31 Martina Duttmann, *Morris Lapidus: Architect of the American Dream* (Basel, Berlin and Boston, 1992), pp. 114–15.

32 Gibbons was the head of MGM's art department from 1924–56. In his professional capacity, he became a dedicated promoter of modern taste in architecture and interior design.

33 Michael Webb, 'Designing Films: William Cameron Menzies', *Architectural Digest* (April 1994), p. 64.

34 Robert Sarnoff, President of NBC, quoted by Donna Braden, 'Selling the Dream', from Henry Ford Museum exhibition catalog, in Fannia Weingartner, *Streamlining America* (Detroit, 1956), p. 37.

35 Pulos, *American Design Ethic*, p. 272.

36 James S. Ward, '20th Century Design: USA', *Industrial Design*, vol. 6, no. 6 (June 1959), p. 46.

37 Arthur Pulos, *American Design Adventure* (Cambridge, MA and London, 1990), p. 71.

38 Steven Bayley, *Commerce and Culture* (London, 1989), p. 85.

39 Goldstein, *Arts & Architecture*, p. 13.

40 Ray Eames designed 24 covers for *Arts and Architecture* magazine between 1942 and 1944. Her technique of composition included photo-montage, painting, drawing and inventive type specifications.

41 For a more detailed discussion of the 'Gastronomic Analogy' to architecture, see Witold Rybczynski, *The Most Beautiful House in the World* (New York, 1989), p. 50.

42 Kevin Chapell, 'The New Generation', *Ebony* (November, 1995), p. 194.

43 Karal Ann Marling, *As Seen on TV; The Visual Culture of Everyday Life in the 1950s* (Cambridge, MA, 1994), p. 170.

44 Tom Wolfe, *The Electric Kool-Aid Acid Test* (New York, 1968), p. 61.

45 *The Virtue of Selfishness* is the title of a book written by Ayn Rand and published in the 1960s.

46 Bret Easton Ellis, *American Psycho* (New York, 1991), pp. 123–4.

2 Utopia and the mall: theories and movements

There has always been controversy in America about the import-ance of theory to art and design. Clement Greenberg wrote that the development of modern art has been 'immanent to practice' and 'never a matter of theory'.[1] In other words, doing generates ideas, not vice versa. One could make the same claim for design, conditioned as it was by technical and commercial factors. But technology and commerce have their own theories, and these have had their affect on design. Theories drawn from the fine arts, manufacturing, science, sociology, anthropology, linguistics, psy-chology, economics, and politics have influenced the production of all types of artifacts, images and systems, from sculptures and sofas to aircraft landing patterns (figure 35). They have also in-fluenced the ways in which individuals understand their environments.

The purpose of this chapter is to introduce some of the ideas which most significantly influenced the practice and perception of design in the USA during the twentieth century. The theories presented here fall into two categories. The first category consists of design theories drawn from practice, education and criticism. The second category includes broad philosophical positions, such as nationalism or modernism, which influenced all areas of culture. Discussion of products, themselves, will follow in the next chapter.

35] Ideas filled the ether. Worldwide communications ensured that theories and philosophies emanating from all parts of the world influenced the material culture of America and vice versa: *History of Communications*, Stuart Davis, 1939.

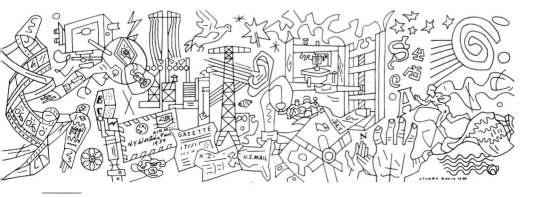

Theories of design

Design theories, like notions of taste, have been thought to come from Europe. Indeed, at the turn of the century the most coherent and convincing theoretical position on design in America was drawn from the ideas of William Morris; and the English Arts and Crafts Movement. Although Thorstein Veblen denounced the English reformer and his contemporary, John Ruskin, for their 'exaltation of the defective, the obsolete, the primitive', their ideas were championed by prominent academics such as Charles Eliot Norton, Harvard University's first professor of fine arts, whose support helped to convey the ideals of the movement across the Atlantic.[2] The importance of Morris's theory is found in its assertion that design must have a social purpose and that its practice is a political act aimed to benefit the majority of people.

In America, however, the political fervor of Morris was tempered by the entrepreneurial spirit of those individuals and companies who formed the American Arts and Crafts Movement. Morris' rules of honest construction, handcraftsmanship and suitability to purpose were made commercially viable by thinking entrepreneurs such as Gustav Stickley who in 1900 'began to promote and to extend the principles established by Morris, in both the artistic and socialistic sense'.[3] Elitist aspects of the English movement which irritated Veblen[4] were mainly eliminated from its American offshoot due to the relaxed attitude towards theory taken by Stickley and his contemporaries. Unlike their English forebears, they were pragmatic idealists, willing to use up-to-date mechanical equipment and marketing techniques to sell their goods widely at affordable prices. This set a pattern which became typical of the way American commercialism transformed high doctrines emanating from Europe throughout the rest of the century.

Aesthetic theories, originating in the fine arts, have always influenced design thinking. In the mid-1920s, European avant-garde movements such as Cubism and Futurism were joined by a new set of modernist theories coming from Holland, France and Germany which included De Stijl, Purism and Surrealism. These ideas were imported in the form of artefacts, such as the paintings and sculptures exhibited in the Armory Show, and also as published manifestos. They were also brought to America personally by their originators, Duchamp, Breton, Le Corbusier and Mondrian. On arrival, however, these ideas were all subjected to the commercial and institutional forces which controlled every aspect of life in America. Among design theories, the transformation of doctrinaire Functionalism to 'The International Style' is a prime example.

Theoretical writing on design was taken in a new direction by

the founders of the industrial design profession in the 1930s. The emphasis in books and articles by Norman Bel Geddes, Henry Dreyfuss and others of their generation was on an orderly approach to design practice and on design as a tool of business management. Despite a strong tendency to romanticism in the heroic imagery of many of their pre-Second World War products, their ideas were based in logic and clarity of purpose. They maintained the American traditions of pragmatism and liberalism in their view of design as a vehicle for social progress and for the enrichment of the common man, woman and child. The structured methodology they initiated became a kind of gospel after mid-century, when design theories such as ergonomics came to be seen as guarantees of design quality and professional responsibility.

Systematic approaches to design became increasingly important with the advent of computers and their application to highly complex problems such as aeronautical design and transport networks. In response to the perceived need for a corrective to traditional, Dionysian views of creativity based on inspiration and intuition, the Design Methods movement began in the 1960s to promote a structured theory of design which could be taught easily. Among the most articulate spokespeople for design methodologies was the mathematician and architect/designer, Christopher Alexander, whose book, *Some Notes on the Synthesis of Form* (1964), laid the foundation for the movement. The Design Methods Group, located in Berkeley, California, where Alexander taught, was part of a growing interest in the nature of practice within diverse areas of activity ranging from drama (Method acting), literature (stream-of-consciousness writing), and fine art (action painting), to management (operational research) and education (distance learning).[5] Design Methods theory classified varying approaches, old and new, to the practice of design. It then analysed each approach by separating its procedures – such as data research, brainstorming, design-by-drawing, user participation – into separate stages or elements which could be described clearly through diagrams and tables derived from mathematical graph theory. Ultimately, the movement portrayed design as both a logical professional process and, more broadly, as a way of living.

In the 1960s, another group of artists, designers and writers on design introduced to their discourse an appreciation of popular culture and commercialism as the basis of a new design theory which concentrated on the meanings attached to the appearance of products as an essential element of design process. Lawrence Alloway, Reyner Banham[6] and Richard Hamilton, three of the founders of British Pop Art, discussed enthusiastically the nuances of American commercial culture and provided a theoretical

framework for its analysis as well as a virtual encyclopedia of source material for artists and designers. Meanwhile, their American contemporaries, Jasper Johns and Robert Rauschenberg, were making art based on commercial images of the modern material world. Pop Art demonstrated the first stirrings of Post-Modernism, which could also be detected in a variety of other home-grown propositions of the period.

Robert Venturi, Denise Scott Brown and Steven Izenour's dissection of Las Vegas and the 'commercial strip' (*Learning From Las Vegas*), Jane Jacobs's denunciation of comprehensive city planning (*The Death and Life of Great American Cities*), Charles Reich's celebration of the community of youth (*The Greening of America*), and Marshall McLuhan's writings on media (*Understanding Media*) all pointed to a new view of social reality and a resulting change in public consciousness which would affect the theory and practice of design for the remaining decades of the century. Venturi's teaching methods, in particular, included new techniques for the analysis and communication of messages implanted in a design which would be open to a variety of interpretations by the end users. His approach to architectural education infiltrated other areas of design teaching (for example, industrial design and furniture design) as studies of 'product semantics'. This approach became identified particularly with work emanating from the Cranbrook Academy of Art.

Populism

Liberal democracy and basic faith in the autonomy of the individual are the fundamental political and social ideas which have conditioned American life throughout the country's history. These, coupled with a firm belief in the progressive improvement of the human condition, shaped the economic, political and cultural life of the country, particularly during the first half of the century. Pragmatism, the evaluation of ideas on the basis of their practical consequences, also contributed to a rationale for the advancement of social equality through the relentless progress of science and technology, mass production of goods, growth of a consumer culture and expansion of objective mass communication. Shortly before the turn of the century, the philosopher William James wrote that the pragmatist '... turns away from abstraction, towards facts, towards action and towards power'. James declared that the purpose of thinking was 'to help change the world'. According to James's down-to-earth philosophy, power resided in the community, an attitude which had wide appeal during the period of industrial expansion in America and which

was used as an instrument for social reform through public education.[7]

The spirit of Populism, a political movement of the so-called Progressive Era (1901–16), was devoted to social reform for the benefit of common people, an idea reaffirmed by the elevation in status of popular culture during the second half of the century. This anti-elitist viewpoint was expressed in writing on Pop Design by new journalists such as Tom Wolfe. That the popular culture under discussion was almost exclusively American confirmed that nationalism remained an important issue in late-century design thinking.

Nationalism and regionalism

It has always seemed to me a rare privilege, this, of being an American, a real American, one whose tradition it has taken scarcely sixty years to create. We need only realise our parents, remember our grandparents and know ourselves and our history is complete.[8]

Many American artists, writers, architects and craftspeople, working in the early years of the century, expressed their intention that America should produce a culture that reflected its youth, landscape, democracy, industry, local traditions and the diversity of its people. In the nineteenth century, Walt Whitman had promoted the notion of American cultural independence from Europe, and writers such as Van Wyck Brooks and George Sanatyana kept the idea fresh in the first two decades of the twentieth. The establishment of American cultural theory became increasingly important when many of the population no longer shared a European ancestry. Their shared past included Asia and Africa, the Caribbean and South America, each with its own traditions of thought.

The city was where new Americans from all over the world came together; it became the chief meeting place for their disparate ideas and a fertile breeding ground for radicalism. It was also where their cultural differences and ethnic tastes were most quickly homogenized, or 'Americanized'. Along with linguistic differences, national costumes were quickly disposed of in favor of Americanized English and 'modern' forms of dress such as the shirt-twaist for women and the tailored, solid color suit and tie for men. This process continued throughout the century in spite of a rising climate of respect and even veneration for the cultural traditions of successive generations of 'new' Americans. Eventually, Kowalskis, Votolatos, Riveras, Chings, Goldbergs and Obutus all expressed themselves through Levis, ranch houses and Buicks, while still enjoying their salsa, pierogi or won ton.

While demanding cultural conformity of its newcomers, the city inspired its intellectuals to independent thought. From 1911 through 1917, *The Masses*, a magazine published in Greenwich Village, promoted socialism, feminism and any other idea or issue which challenged the conventional thinking of the day. Articles by writers such as Max Eastman, John Reed and Eugene O'Neill were illustrated with drawings and cartoons by members of the 'Ashcan School' of painters, a group of artists including George Bellows and John Sloan, whose aim was to represent modern city life in all its forms. The stark graphics and simple typography of the magazine's covers contrasted with the warmth and wit of many of the illustrations exploring the sidewalks, roof tops, bar rooms and tenements, fashion trends, political theories and aesthetic eruptions of New York City at the time. Meyer Shapiro wrote of them,

> In proposing a realistic urban imagery rendered with boldness and verve, they introduced a vernacular note into American painting, an ideal of directness and independent spirit which were close to the emerging 20th century values in other fields; they were the parallels in painting to the writings of Dreiser, Norris and Crane and to the liberal political ideas of the time. Their conception of individuality and freedom were sustained by a faith in American social life and new opportunities offered by the growth of the city. [9]

The modern city was was an American product, the locus of a cosmopolitan spirit which fostered independent thought, individualism and a new vernacular imagery. Photo-journalism and satirical illustration were essential vehicles of mass communication in the high circulation newspapers and magazines in the period preceding television. The graphic art of *The Masses* and later *The New Yorker* and *Esquire* illustrated the close relationship which existed between advanced political, social and economic thinking and the most up-to-date aesthetics in graphic design and illustration at the time. Their setting was the rising metropolis of skyscrapers, docks, elevated railways, automobiles and mass apartment housing portrayed in a style which was accessible to the entire readership. In contrast, when John Sloan reviewed for *The Masses* the Armory Show, which he helped to organize, he was amused, tolerant and ultimately dismissive of the radical European abstraction which he saw as inaccessible to the majority of people. He called his own experience, 'A slight Attack of Third Dimentia Brought on by Excessive Study of the Much Talked of Cubist Pictures in the International Exhibition at New York'. [10]

Outside of cities, nature was the great national treasure, and the Romantic consciousness was located firmly in the epic wilderness

of prairies, forests and mountains, described by Walt Whitman as
'that vast Something, stretching out on its own unbounded scale,
unconfined, which there is in these prairies, combining the real
and the ideal, and beautiful as dreams'.[11] Since the colonial period,
artists and architects had been looking to the virgin landscape for
ideas and inspiration.

The transcendental spirit embodied in the limitless expanses
and dramatic spectacles of the landscape provided the source for
artists and designers to address the spiritual essence of America. But
by the end of the nineteenth century, Frederick Jackson Turner
had declared, with grave concern, that the previously open frontier
land had now been closed by the development of towns and trans-
port, by the telegraph and telephone. To Turner, this threatened
the independent nature of American culture:

> The advance of the frontier has meant a steady movement away
> from the influence of Europe, a steady growth of independence on
> American lines. And to study this advance, the men who grew up
> under these conditions, and the political, economic and social re-
> sults of it, is to study the really American part of our history.[12]

While the process of civilizing and, thus, closing the western fron-
tier was still going on, design thinkers were becoming increasingly
concerned with preserving, symbolically, the idea of the open
landscape and the freedom it offered. This interest in the landscape
was expressed by Frank Lloyd Wright in a rationale for the ground-
hugging profiles of his prairie houses:

> the great rolling prairies where every detail of elevation becomes
> exaggerated; every tree towers above the great calm plains of
> flowered surfaces as the plain lies serene beneath a wonderful un-
> limited sweep of sky ... And I saw that a little of height on the prairie
> was enough to look like much more ... All unnecessary heights have
> for that reason been eliminated. More intimate relation with out-
> door environment and far-reaching vista is sought to balance the
> desired lessening of height.[13]

A growing appreciation of vernacular design also contributed to
the development of design nationalism. In an age steeped in the
notions of progress and disposability, hero-worship and brand loy-
alty, the simple qualities of vernacular artifacts made by
anonymous craftspeople came to represent the purest motives of
design; they combined utility with spiritual gratification and were
often held up as symbols of 'the American spirit'. In 1910 Wright
wrote on the functional and moral value of indigenous designs.
'Though often slight, their virtue is intimately related to environ-
ment and to the heart-life of the people. Functions are usually

truthfully conceived and rendered invariably with natural feeling. Results are often beautiful and always instructive.'[14]

Against an environmental background of increasing commercial sameness, vernacular products also offered a strong sense of local character. Regional handicraft traditions contributed to the formation of a composite national design identity which could be shared by everyone. California landscape, the natural materials it offered and the craft traditions of the Spanish settlements there had a profound influence on the products of the local Arts and Crafts Movement.[15] The California artist Ernest Allen Batchelder published a series of books, beginning with *Principles of Design* in 1904 and *Design in Theory and Practice* in 1910 and many articles for Stickley's magazine, *The Craftsman*, which explained his symbolic use of Mayan and Spanish motifs for ceramic decorations as a means of perpetuating a local vernacular.[16]

Another staunch regionalist, Mary Sheerer, wrote of her intention to found a school of crafts for the production of pottery which would express the character of the local culture and landscape. 'The whole thing was to be a southern product, made of southern clays, by southern artists, decorated with southern subjects.'[17] Yet when such products were published, exhibited or sold, as they usually were within the huge national marketplace, they came to be seen as 'American'.

Among the early industrial designers, Russel Wright was an outspoken advocate of design nationalism, with specific regional variations, particularly during the later 1930s when he saw the influence of European modernism threatening to dominate native innovations and accomplishments. In 1938, Wright and his wife, Mary, conceived a line of products which they called American Way, consisting of hand-crafted and machine-made domestic wares of all types. They enlisted industrial designers, craftspeople, department stores and manufacturers to develop and market such products which would confirm the richness and vitality of indigenous American design.

Traditionalism

A 'new American', Sibyl Moholy-Nagy, who emigrated from Germany in the late 1930s, advocated the study of indigenous artifacts as sources for design innovation: 'Every creative effort is a metamorphosis of the spirit that must be fed on the admired precedent.'[18] Throughout the century, the most 'admired precedent' among the artifacts of America was its colonial dwellings and their contents. The revival of interest in colonial design had been driven by a desire among reformers to inspire nationalistic

pride and offer an alternative to Victorian eclecticism. Reformers saw the craft products of the early colonial period as representations of pragmatism and democratic virtue.

As Robert Peabody wrote in *The American Architect*, '... we too have a past worthy of study ... our Colonial work is our only native source of antiquarian study and inspiration'.[19] These were relics of the original American Dream, products of self-sufficient families living in simple houses on their own plots of land. And land ownership was at the heart of the civil rights of the new nation as envisioned by Washington and Jefferson. Buildings such as George Washington's home at Mount Vernon and Thomas Jefferson's Monticello carried, in their form, proportions, detailing and furnishings, the image most closely associated with the aspirations of the young democracy, a reminder of which was welcome in the turbulent twentieth century. Even in the closing decades of the century images of the Colonial and Federal periods were revived in designs by Robert Stern and other Post-Modernists.

Ironically, the mythical re-creation of early America was promoted vigorously by a number of the country's wealthy industrialists who carried a great burden of responsibility for undermining the ideals of the early republic. John D. Rockefeller, who became the richest man in the world on the profits of his Standard Oil Trust, supported a hugely ambitious restoration and reconstruction of colonial Williamsburg in the 1920s. This was an impeccably detailed outdoor theme park with an ideological purpose. A tightly edited version of eighteenth-century Williamsburg was presented by costumed 'residents' performing for visitors daily activities of the pre-industrial past. Upper-class planters and the spirit of free enterprise were the subjects of homage. No evidence of southern slavery was to be found there until much later.[20]

Henry Ford also honored the colonial past. His restoration in Massachusetts of the seventeenth-century Wayside Inn served as a preamble to the most ambitious project of his later years, the construction of an outdoor museum dedicated to the common people and celebrating the self-made inventors and industrialists of America. Set in Dearborn, Michigan, Greenfield Village was established as an automotive museum which also exhibited thousands of other artifacts. Whole buildings, including Orville Wright's cycle shop and Thomas Edison's laboratory, were taken from all over the country and arranged as a village portraying Ford's personal vision of the history of American industry as a 'synthesis of the home-spun and the high-tech'.[21] Among his favorite displays on the site was the cosy interior of the colonial Plympton House where work and domestic life were carried out in unity and 'Yankee ingenuity' was expressed in many features.

The success of Williamsburg and Greenfield Village as national shrines led to imitation by other colonial theme parks such as those constructed, mainly from scratch, at Mystic Seaport in Connecticut, and at Old Sturbridge Village, Massachusetts, where planners followed Ford's method of importing antique buildings from their original locations and installing them around a newly arranged village green. These places were highly influential in fostering a sense of national identity, and they created wide interest in the preservation and re-creation/evocation of early American values. From suburban living rooms, to shopping malls and the cars in their parking lots, references to colonial design promoted a newly formulated myth of Americanism.

The concoction of fictitious 'histories' persisted throughout the twentieth century in the promotion of new American enterprises such as the city of Los Angeles. There, the Arroyo Set, a group of intellectuals led by the journalist, Charles Fletcher Lummis, created a historical mythology of southern California which

> inserted a Mediterraneanized idyll of New England life into the perfumed ruins of an innocent but inferior 'Spanish' culture. In doing so, they wrote the script for the giant real-estate speculations of the early twentieth century that transformed Los Angeles from small town to metropolis. Their imagery, motifs and legends were in turn endlessly reproduced by Hollywood. [22]

The so-called Booster Era of southern California history represented a past in which happy Indians were enlightened by benevolent Franciscans operating from graceful missions under an endlessly blue sky. Lummis's magazine, *Out West (Land of Sunshine)*, promoted the Mission Revival in architecture and design, local archaeology (he founded the Southwest Museum), and a brand of physical culture linked with Anglo-European racial superiority guaranteed through eugenics. Local missions, such as San Gabriel Arcangel, were restored and reconstructed as western theme parks. And the Arroyo aesthetic found its greatest outlet in the Craftsman bungalows which combined Navaho motifs with 'Mission Oak' interior furnishings. A similar project based on seventeenth-century adobe architecture of New Mexico led to the formation of a spectacularly successful tourist environment in the town of Santa Fe, which in turn created a national interest in 'Santa Fe Style'.

The Gene Autry Western Heritage Museum in Los Angeles, founded by the popular cowboy singer, also presented traditional regional culture through elaborate displays of artifacts associated with the Old West: Colt guns, Spanish and native American products, and film clips from old Hollywood Westerns.

Modernism

> Nationality is a good thing to a certain extent, but universality is
> better. (Henry Wadsworth Longfellow)

To many people the twentieth century was the Modern period.
Although historians and critics are likely to trace the roots of mod-
ernism back to the Enlightenment and to the beginnings of the
Industrial Revolution, a recognizable modernity in art and design
began in earnest around 1900. And while it was often portrayed as
a monolithic theory leading to artifacts with a particular look,
modernism in America encompassed a number of generally op-
posed ideas reflected in objects with widely varying appearances.
Rationalism/the irrational; socialism/capitalism; objectivity/sub-
jectivity; internationalism/regionalism; individuality/anonymity
all belonged to the concept of modernism. American culture was
far too diverse to be represented by a singular design ideology, and
so its brand of modernism was by nature multi-faceted.

American modernism encompassed widely divergent and seem-
ingly contradictory ideas combined in complex new theories. Lewis
Mumford, writing in 1940, described the purpose of design in what
he referred to as the new 'biotechnic age'. The designer, he wrote,
should aim 'to effect a synthesis of nature, the machine, and human
activities and purposes'.[23] Thus, to Mumford, like William Morris,
design was part of a larger matrix of concerns, not essentially an
aesthetic pursuit, but an instrument of social improvement, a pol-
itical act aimed at ending alienation and confrontation. He
continued optimistically,

> Taken together, modern form, modern architecture, modern com-
> munities are prophetic emergents of a biotechnic society; a society
> whose productive system and consumptive demands will be di-
> rected toward the maximum possible nurture ... of the human
> group, and the maximum possible culture of the human person-
> ality.[24]

Only four years later, during the dark days of the Second World
War, he developed, in a more somber tone, his philosophy of social
integration, here including history in his unity of factors,

> In an attempt to control the disintegrating forces that are at work
> in our society, we must resume the search for unity; and to this end,
> we must explore the historic nature of the modern personality and
> the community, in all their richness, variety, complication, and
> depth, as both the means and the end of our effort.[25]

The alienation and confrontation which culminated in the
catastrophe of war was thought by Mumford to stem from the

excessive rationalism of the industrial world, typified by Ford's production line and by the time and motion studies of the industrial efficiency expert, Frederick Winslow Taylor. Similarly, the use of dubious, 'universal' human measurements and other 'average' statistics, stripped of cultural, social and psychological factors, tended to dehumanize the ergonomic design studies carried out by Henry Dreyfuss in his effort to transform industrial design into a science. Mumford saw the alienation from human values produced by misapplication of science and technology to all aspects of modern life as an important factor in the rise of militarism and totalitarianism during the 1920s and 1930s.

> Modern civilization has been arrested in mid-flight: its technical advances in saving labor, perfecting automatism, mechanizing the daily processes of life, multiplying the arts of destruction, and dehumanizing the personality have been responsible for this arrest. The rise of the machine and the fall of man are two parts of the same process: never before have machines been so perfect, and never before have men sunk so low. [26]

While plenty of evidence exists to support this view, other modernists saw mass production as a cause for celebration, despite its dehumanizing effects on the individual worker. It had released the democratic potential of industry to produce high quality goods at such a low price that most people had access to them. In many industrializing countries, Ford became the god of material progress, a force rather than a human being. Fordism, a term originally coined in Italy and taken up in Germany, Japan and the Soviet Union, meant modernization and Americanization. Modernism in the 1920s was gauged by mobility, and the Ford car was the means by which millions moved. Fordism spread the American system of industrial organization internationally and became synonymous with American commercial ideology.[27]

Functionalism

Fordism was in part a product of the anonymous, American vernacular design tradition which, according to Sibyl Moholy-Nagy, fulfilled an 'ideal standard', meaning an optimal solution to need, executed in an efficient manner using available technology, while enhancing the spirit of the user.[28] Thus, by providing a suitable solution to the demand for mass motoring during the first quarter of the century, the Ford car demonstrated the ideal of functionalism. Its utilitarian form became a symbolic presence on the roads of the country, a mobile advertisement for the virtues of rational

production and functional design in the service of personal freedom (see figure 90).

The individual most often credited with constructing a theory of functionalism is the Chicago architect Louis Sullivan. But the roots of his ideas can be traced back to the early nineteenth-century sculptor and natural philosopher Horatio Greenough, who proposed that beauty arises as a direct response to the solution of a problem. He saw this relation between utility and aesthetics as a law of nature. 'Beauty as the Promise of Function; Action as the Presence of Function; Character as the Record of Function.'[29]

At the turn of the century abstract representations of organic forms became essential to design for two reasons. First, in keeping with the progressive spirit of the time, they offered a vocabulary of images and qualities which had limited historical associations. Second, they provided design with an emblem for an organic analogy which became the core of American modernist thinking. Sullivan developed Greenough's ideas, themselves drawn from earlier writers dating back to Vitruvius, in his article, 'The Tall Office Building Artistically Considered'. He wrote,

> all things in nature have ... a form ... that tells us what they are, that distinguishes them from ourselves and from each other. Unfailingly in nature these shapes express the inner life, the native quality of the animal, tree, bird, fish ... It seems ever as though the life and the form were absolutely one and inseparable ... form ever follows function, and this is the law. [30]

Sullivan allied the principles of nature with pragmatic responses to modern problems to form a theory of functionalism which was in keeping with the ideas of natural selection, survival of the fittest, promoted in the late nineteenth century by social Darwinist thinkers such as the grim Yale sociologist William Graham Sumner. His dictum, 'root, hog, or die' was used as a justification for *laissez-faire* economics, but could also be seen as analogic to the evolution of new product types. (see p. 262)

Sullivan applied his definition of natural law to the arts of design, first through a rational analysis of need, then to the matter of construction technique, and finally through abstraction of form and the application of ornament, based on florid plant motifs which represented his organic design theory. In his later essays and books, including *Kindergarten Chats* (1901) and *The Autobiography of an Idea* (1924), Sullivan breathed new life into the old Vitruvian triad, strength, utility and beauty, employing these qualities in the quest for a standard solution to a particular modern design problem - the tall office building. Sullivan was an architect of great importance for the technical and aesthetic innovations of his

buildings; but his legacy to the twentieth century was his dictum, 'form follows function', which became the slogan of one of the main currents in modern design thinking.

Later, his method was used by other design theorists including Frank Lloyd Wright. Le Corbusier also drew from Sullivan a justification for what he saw as the inevitable evolution of an ultimate object type for each particular modern problem (the skyscraper, the automobile, the vacuum cleaner, and by further extension the cocktail glass and the running shoe), a logical outcome of functionalist thinking. Raymond Loewy, too, employed the Darwinian aspects of functionalism to explain the evolution of particular products and the development of style. His Evolution Chart of Design [31] described the formal development of telephone, automobile, house, high-heel shoe and other familiar objects in terms of inevitable simplification and progressive streamlining.

Sullivan and Ford approached design as a means of addressing social, technical and commercial problems specific to the time and place. In its early years of development, the automobile, like the skyscraper, called for a design which would tap a huge, potential demand and which would make the most efficient use of the available technology in its production and construction. Henry Ford, like Ransom Olds and a number of their contemporaries, realized that the democratic potential of the automobile could be fulfilled only through the development of mass-manufacturing techniques which would bring the price of automobiles within reach of a vast, potential car-owning public.

Ford's design philosophy was, therefore, conditioned by available industrial production techniques and the economic realities of the market for automobiles between 1900 and 1925. The Fordist concept of a universal product was analogous to Sullivan's typical floor of office space in the new skyscrapers. But the flaw in Fordist thinking was its failure to see that his 'final solution' to the question of the automobile was only good as long as the market and technology remained stable. Changing circumstances demanded new responses. Similarly, the standard office had to become differentiated in quality and size in relation to the needs and status of its occupant - corner offices on upper floors attracted higher rents.

Le Corbusier, designers of the Bauhaus and other European modernists active in the 1920s became known in America for an approach to design which was heavily reliant on Sullivan's ideas, although stripped of their organic analogy in favor of machine symbolism. The Europeans had developed a philosophy and a style which paid homage to technology, functionalism, internationalism, humanism and abstraction. Philip Johnson and Henry-Russell Hitchcock's book and exhibition, *The International Style:*

Architecture Since 1922 (1932), gave the European Modern move-
ment an American name, provided a theoretical and critical
testament in its support, and ensured its acceptance in the United
States by emphasizing its stylistic identity over its theory. The
Modern movement's main idea was functionalism: to produce
buildings and furnishings as utilitarian as the Ford car, as unpreten-
tious in appearance, as affordable, and as suitable to the needs of
people all around the world. Thus, the ideas which Ford drew
together in a theory of production around 1910 had been assimi-
lated by Europeans after the First World War and imported back
across the Atlantic beginning in 1932. We might well ask, how
useful were they to Americans by that time?

In 1925, Ford's Model T (1908–27) began encountering stiff com-
petition in the market which forced its replacement by the more
fashionable Model A in 1927, five years before the International
Style had a name. That the classic, universal consumer product
had had its day was obvious to American manufacturers, who
turned to industrial stylists for an alternative. Thus, by 1927 For-
dism, itself, was commercially past its prime. But the European
avant-garde, who had not yet much direct experience of either
the fruits or evils of Fordism, remained ideologically attached to
it and under its influence stylistically. Their American supporters
were blinded to the naivety of this position by their firm belief
that 'they do things better in Europe'. Meanwhile, indigenous
American design got on with giving the customers what they
wanted.

As a whole, the ideas of the Modern Movement, formulated in
the 1920s, did not transplant well to America in the 1930s, despite
the efforts of Europhile patrons and articulate promotion of the
International Style. The commercial culture of the United States,
even in the leftist atmosphere of the Great Depression, was far too
strong to take very seriously the social engineering attached to
European modernist thinking. Thus, Ideology drained out of the
International Style when it became a surgical tool in the American
corporate facelift of the 1950s.

The inventor-architect Buckminster Fuller pointed out that the
International Stylists' belief in technology was 'superficial', 'illuso-
ry' and contributed little to the advancement of living conditions
for the majority of people. The Modern Movement's claim to func-
tionalism was always more imagined than real and retained only
a shadow of Sullivan's original thesis. The most ardent functional-
ists, such as Hannes Meyer, Walter Gropius's successor as Director
of the Bauhaus, asserted that utility is the only important consider-
ation in the design process and that beauty will naturally flow
from the satisfaction of utilitarian demands. But Meyer was highly

critical of his predecessor's regime at the Bauhaus under which, he said, 'art strangled life everywhere!'. [32]

The former Bauhauslers who came to teach and practice in America, became part of the American International Style, leaving pure, theoretical functionalism back in Germany with Meyer.[33] This development had been anticipated in 1934 by the Museum of Modern Art's *Machine Art* exhibition, which showed parts of machinery as if they were abstract sculptures. According to George Marcus, MOMA

> established its own set of requirements for design – an aesthetic (simplicity, purity, geometry, and also austerity), a method of production (Machine manufacture, actual or implied, using modern materials), and an iconography (the machine, as selectively defined) – which it constructed as functionalism.[34]

Thus, functionalism achieved a role and status distinct from practical service.

Progressivism

Modern thinking has been driven by a belief in the upward movement of culture from a sordid and confused condition. This view was proposed by nineteenth-century utilitarian thinkers, including Marx, who anticipated that an improved society could only be achieved through material progress. In America, Social Darwinism and Manifest Destiny saw material progress, achievable through scientific and technical developments and physical expansion, as the dominant force in American culture.

Thus the twentieth century began with the idea of progress celebrated as the saviour of modern society. The Progressive Movement, personified by President Theodore Roosevelt, was a political philosophy aimed to foster a rapid improvement in American culture through a policy of general reform which had considerable implications for design. Reorganization of the American home was central to Progressivism, which promoted a form of architectural determinism founded on the idea that healthy surroundings would encourage an improved society. Such an environment would be based on design principles related to the informal nature of American life; it would be aesthetically classless, structurally direct, open in arrangement, and efficient through rational uses of technology. And, above all, it would be affordable.

Progressivism reawakened confidence in democracy. Like pragmatism, it was a down-to-earth philosophy which asked basic questions about how society worked, who made decisions, what were their costs, and what would be their consequences? Machines

served as an almost irresistible model for progressive thinking. They demonstrated so rapid and glamorous a state of evolution from crudeness to sophistication, that the rest of culture, including art and design, became captivated by their mystique. Europeans, devastated by political turmoil and vast epidemics of disease during the first quarter of the century, took this particularly to heart. American writing rarely exhibits anything to rival the rhetoric of Europeans on the necessity of progress in the arts.

> We who insist that a masterpiece must be burned with the corpse of its author ... against the conception of the immortal and imperishable we set up the art of the becoming, the perishable, the transitory and the expendable.[35]
> The activity of the mind continues unendingly, in an ascending curve; it creates its implements; and this we call progress ... Each piece of mechanism would be more beautiful than what had preceded it and would inevitably be surpassed by its successors. And so we should get an ephemeral beauty, soon out of date and despised.[36]

But, unlike Europe, America in the early part of the century was a nation without an ancient tradition to provide a canon of 'masterpieces'. It was striving to define its culture, rather than trying to unload it. In America, there would be no revolution, as demanded by Marx or Marinetti. Commercial motives, not ideology, would determine the rate of change.

As a result, on its arrival in America, the European Modern Movement lost its movement. Its leaders were canonized by the American star system; its ideas were declared final by the promoters of the International Style; and its products were quickly commodified and institutionalized as 'classics' in the new permanent home of the Museum of Modern Art. Progress was put on a pedestal and kept under guard.

Thus one of the central paradoxes of American modernism revolves around the concept of progress. Commerce and technology ensured perpetual change and promised continuous improvement in all material things. Yet the desire for a genuinely American culture demanded that all new design be assessed for permanent inclusion in the museums of the future.

Organicism

By the 1930s, even leading modernists saw unbridled progress as the engine of social degradation. As he had done with the machine, Lewis Mumford linked blind faith in progress with the rise of facism,

Faced with the need for revising their faith in the smooth curve of
progress, which automatically gave to the latest institution the title
of being the best, the apostles of progress blandly closed their eyes
to the facts that contradicted their faith. And the progressive's re-
treat hastened the barbarian's advance.[37]

Mumford proposed an alternative version of modernism based on
a philosophy of progressive humanism which emphasized the de-
velopment of the human spirit. Like others of his generation,
Mumford had a utopian vision in which technology would be
harnessed to an enlightened, democratic government. Its purpose
would be to improve society as a whole by creating a level of
material wealth that would provide physical security and comfort,
support education and foster the pursuit of creative leisure. Like
Renaissance Humanism, Modernist Humanism recognized the
need for stability in many aspects of life ranging from population
control to aesthetic stabilization.

> Once the organic image takes the place of the mechanical one, one
> may confidently predict a slowing down of the tempo of research,
> the tempo of mechanical invention, the tempo of social change,
> since a coherent and integrated advance must take place more
> slowly than a one-sided unrelated advance.[38]

His holistic view of culture balanced organic, human and envi-
ronmental values with those of technology and defined design as
an instrument in the process. Mumford pointed out the paradox
of the organic analogy which resides in the difficulty of harnessing
technology both to the public good and to the development of
individual human values.

> our capacity to go beyond the machine rests upon our power to
> assimilate the machine. Until we have absorbed the lessons of ob-
> jectivity, impersonality, neutrality, the lessons of the mechanical
> realm, we cannot go further in our development toward the more
> richly organic, the more profoundly human. [39]

The Museum of Modern Art joined Mumford in promoting the
organic analogy in design through their exhibition, *Organic Design
in Home Furnishings*, organized in 1941 by Eliot Noyse. The catalog
described organic design clinically as 'harmonious organization of
the parts to the whole, according to structure, material and pur-
pose'.[40] But entries by Charles Eames, Eero Saarinen, Ralph Rapson
and others included expressive references to forms in nature, made
possible by the three-dimensional forming of laminated wood pro-
ducing compound-curved shells. These products, though abstract
and unornamented, revived the idea and spirit of organic design
set out by Louis Sullivan four decades earlier.

Coupled with the advance of organicism was the rise of anti-

rationalism in the arts. Jackson Pollock's famous comment 'when I am in my paintings, I don't know what I am doing' was echoed in the ambitions of numerous designers who, beginning in the 1930s, set out to find an alternative to the apparent objectivity, sobriety and aesthetic austerity of the International style. This direction appeared particularly in the fields of advertising, furniture, fashion and design for stage and film. These fields were quickest to assimilate the ideas of Surrealism, popularized in America during the 1930s by Salvador Dali, and communicated to a critical and theoretical audience by the mute presence in New York of the movement's 'father', André Breton (as a war refugee, he never learned English).[41] (figure 36)

As European Surrealism was absorbed by American culture, it combined with the theory of organicism which had been present in American design thinking since the nineteenth century. The combination of these two ideas resulted in the birth of a new and specifically American alternative to rationalism, a brand of

36] Surrealism was an imported system of thought which richly complemented the rational tradition in American culture with its insistence on the unruliness of the natural world and the human mind. The movement's founder, André Breton, was pictured by Joseph Cornell in 1966.

modernism which emphasized individual, sensuous and tactile qualities of objects.

This fertile approach to design was fostered notably at the Cranbrook Academy of Art in Bloomfield Hills, Michigan. Founded in 1925 by George Booth as a school of art and design, an atelier and an art colony, the campus was designed by the Finnish *émigré* architect, Eliel Saarinen, who also planned the school's educational programs. Cranbrook was conceived to provide a humane and efficient environment in which the arts and day-to-day life could flourish together. The community was intended to elevate midwestern culture and improve design standards in American industry. For a very small institution, its impact has been considerable.

During the first twenty-five years of its existence, Cranbrook design fostered the organic principle alongside the ideas of functionalism. Its openness to different theoretical positions demonstrated the possibility of what Eliel Saarinen called an 'organic unity' arising from the combination of subjectivity and objectivity in design thinking and the inseparability of art and design. Thus Cranbrook provided a venue for both theoretical speculation and practical accomplishment, for a hybrid American modernism which found a large popular following and also enjoyed critical support from the cultural establishment.

Pluralism

Since the Second World War a growing awareness of the multi-culturalism of America has had a great impact on design theory. Loss of faith in internationalism brought about by the Cold War and the Viet Nam debacle, the devastating effects of industry and technology on the environment, disaffection with the 'melting-pot' society, and breakdown of faith in religion, law, medicine and the family all have contributed to a cynical view of modernism and its central notion of progress.

The formation of a 'counter-culture', recognizable since the Beat movement of the 1940s, established a tradition of questioning authority in all fields. Respect for expertise, initiated by the Progressive movement early in the century, came under suspicion from the 1960s onward. The design profession did not escape the accusation of neglecting the wants of social classes two and three, ethnic minorities, women, children and all others with hopelessly bad taste. Bitter controversy and cries of elitism, ageism, sexism and racism have peppered the design discourse as they have discussions in every other profession.

However, if we accepted that most people were capable of making their own decisions about their political affiliations, financial

affairs, medical treatment or education, then why should they not select a table lamp with the same confidence? Brass-and-glass, matt-black, fringed-and-tasseled, all came to have equal validity in the democratic order of design. Kitsch and Camp existed on the same plane with Good Form. Sloanism recognized the importance of customers' preferences around 1925. Since then design theorists have been alert to the varied tastes of American consumers.

The big opportunity to go beyond monotheistic arguments over design came with the information revolution, heralded by Marshall McLuhan in the 1960s. Through the electronic media, images have come to dominate late-century culture as goods did the earlier period. The study of images as texts, which are open to interpretation, has led to a widespread interest in the way people understand the elements of material culture: signs, objects and environments. This new attitude supported a shift from the objective orientation of design to an approach which emphasizes the myth-making function of design and its subjective interpretation by its users. In *Understanding Media* and *The Medium is the Massage* (with Quentin Fiore, 1967), McLuhan envisioned the end of rationalism in a new and exciting vortex of intersecting realities, combining inputs from all areas of human activity in all parts of the world – thus, the 'global village', but a village made up of distinct 'families' and 'individuals'. If rationalism suggested linear order in time and space (for example, Ford's assembly line), the electronic media would form a web conveying many visual and auditory experiences simultaneously, demanding instinctive rather than reasoned responses.

McLuhan's idea, that the environment we create for ourselves is our medium for establishing our own identity in society, was not new. What he added, however, was the concept that global communications would provide universal access to the available stock of images and identity models and encourage a closer relation between thought and action: the possibility for greater equality, individuality and intimacy (as in the pre-industrial village), but on a world-wide scale.[42]

Like McLuhan, Charles Jencks was concerned with signification and understanding. Basing his method on the French linguistic and sociological analyses of Roland Barthes and others, Jencks formulated a semiotic approach to design which was constructed to supersede the theory and styles of modernism. He coined the term 'Post-Modern' and applied it to a theory of pluralism in art, architecture and design, stating, 'The present situation tolerates opposite approaches'. And he stressed the need for local responses to local conditions. Through his books, *Adhocism* (1972) and *The Language of Post-Modern Architecture* (1977), he called for design to be 'a continually renewed improvisation on themes coming from every

possible source', to become 'personal and small-scaled', to 'humanise and individualise'.[43] According to Jencks,

> A purpose immediately fulfilled is the ideal of adhocism; it cuts through the usual delays caused by specialization, bureaucracy and hierarchical organization ... a new mode is emerging, the rebirth of a democratic mode and style, where everyone can create his personal environment out of impersonal subsystems, whether they are new or old, modern or antique'. 'the individual creates, sustains and transcends himself. Shaping the local environment towards desired ends is a key to mental health. (*Adhocism*, p. 15)

In fact, Jencks advocated schizophrenia as a healthy attribute for a designer. And American art had been displaying psychotic tendencies since the days of Jackson Pollock. Surrealism and organicism had injected a destabilizing influence in to several areas of design. But Jencks put these acts in a broader theoretical context when he declared that the artist and designer should always 'be looking two ways with equal clarity' in order to take into account the various meanings which might be attached to a product by different users or groups of users. Thus symbolism and ambiguity of meaning entered the debate as central issues.[44] Their entrance signaled a turn away from the notions of consensus and singularity of purpose in society and, by implication, design. If society was not one thing, but many, then design must take many forms, a key principle of Sloanism. The information revolution would take the atomization of society beyond groups to the unit of the individual and then further still to the individual's multiple personalities.

In this vein, Robert Venturi set out the principles of 'complexity and contradiction' as the guides to a new direction established in opposition to the apparent singularity of earlier twentieth-century design conventions. His deeply American perspective was pluralistic, anti-heroic, full of irony, essentially populistic and focused on individuality. His often quoted declaration, 'Main Street is almost all right', signified a wry appreciation of the ordinary, the popular, the common and confused elements of mass culture and townscape – Gopher Prairie as well as Gotham City.[45] These ideas related closely to themes being explored by the Pop artists of the 1960s.

Post-Modernism assumed that historical understanding is at the heart of popular culture and therefore must be acknowledged in any act of communication between maker and user. How we use things is conditioned by how we have used things in the past – our collective and individual experience of life is what enables us to function effectively in the world. This assumption required designers to accept and exploit the value of common knowledge and popular symbolism.

Such a view inevitably compromised the notion of originality and the position of the designer as the originator of aesthetic concepts. Postmodern theory released judgements of taste and value to individual users or viewers, allowing free interpretation of the object or environment according to their particular experiences, cultural backgrounds, expectations and quirks. The emphasis in the postmodern discourse was, therefore, on reception rather than on the process of conception, realization and production.

With beauty and desirability no longer seen to reside in objects, but rather in our reactions to them, universal standards and 'good taste' came into disrepute for failing to reflect and respond to social reality. 'The customer is always right', would be an apposite injunction to designers in the theoretical climate of the 1990s.[46] The re-focusing of attention on end users rather than on creators of products led to the growth of interest in the field of research known as 'product semantics'.

Deconstructivism

In the 1980s and 1990s design theory was also responsive to ideas which were emerging from new discoveries in science and mathematics which were collectively called Chaos Theory: the name given to a system of thought which arose from evidence of irregularity, disorder, abnormality and turbulence – phenomena for which classical science could not account – in the worlds of biology, mathematics, chemistry and physics. Computers used in these fields were turning up a previously unknown family of shapes with tangled, jagged, twisted and broken characteristics just as astronomers and human physiologists were finding similarly unexpected patterns in their own researches. Benoit Mandelbrot's work in fractal geometry suited the emotional and intellectual climate of much late twentieth-century art and design. 'Fractal' diagrams, 'diffeomorphisms' and 'smooth noodle maps' slipped out of the scientific journals and on to designers' VDUs and the painted canvases of artists such as Frank Stella.[47]

> Simple shapes are inhuman. They fail to resonate with the way nature organizes itself or with the way human perception sees the world ... by the harmonious arrangement of order and disorder as it occurs in natural objects – in clouds, trees, mountain ranges or snow crystals. The shapes of these are dynamical processes jelled into physical forms, and particular combinations of order and disorder are typical for them.[48]

The abandonment of philosophical, cultural and scientific certainty and clearly ordered social patterns (religion, democracy,

marriage, medicine), represented abstractly in design by Platonic geometry, increasingly influenced the American consciousness since the political assassinations of the 1960s, the war in Viet Nam, global warming and the failure of antibiotics. If classical scientific theory seemed increasingly inappropriate as a model for contemporary design practice, the new science of disorder fell in behind relativity and atomic theory as another source of inspiration for art and design in the later years of the century. As 'go with the flow' became the motto for a popular attitude of the time, then an approach to design which suggested fluid physical relationships, instability, confusion and conflict as its central themes appeared an appropriate response.

The revelation of hitherto unseen patterns and layers of complexity in nature provided a background for the development of literary, social and aesthetic theories collected loosely under the heading of Deconstructivism, which became part of the design discourse in the late 1980s. Deconstructivism challenged accepted conventions in all areas of culture. The novel, the house, the human personality were all challenged as entities with particular form and meaning. Deconstructivists disassembled the structures of those conventions, re-forming them in looser, more tentative arrangements and diverse configurations. They also challenged the conventions of modernism, particularly the architecture of the International style, and the retrospective obsessions of postmodernism, such as contextualism, ornament and classicism.

Consumerism

Both surrealism and organicism demanded subjective valuation – they ended in question marks rather than exclamation marks. Functionalism and nationalism, on the other hand, shared the idea that objects embodied fixed concepts and established values requiring little or no interpretation. The tension between these two positions was demonstrated by developments in commercial design beginning in the fashion and automobile industries.

In the 1920s, the executives of General Motors (GM) realized that a) they had the flexible manufacturing capabilities to diversify their product and to constantly update it, and b) customers would choose products on the basis of style. As a result, they simultaneously shifted the emphasis of car design from satisfying need to creating desire, and gave the customer an opportunity, unprecedented in mass marketing, to exercise personal taste. The formula was a commercial success, and Sloanism (after GM President, Alfred Sloan) entered the canon of twentieth-century design theories.

Sloanism was a corporate ideology supported by the machinery of political bureaucracy and capitalist democracy. Companies following the example of GM used style as a means of promoting their prestige, enhancing their stock values and selling more products. Thus the logic of capitalism ensured the conditions in which streamlining was developed as a style.[49] According to William Pretzer,

> Streamlining was the visual aesthetic design manifestation of a corporatist attempt to draw science, technology and the future into the support of private enterprise. It heralded the advent of image over reality. It proclaimed that what was important was how something looked and not how (or how well) it worked. [50]

Recognition of the importance of the customer eventually also gave rise to an ethical theory of design. The pioneer industrial designer, John Vassos, declared, 'Design can only succeed if guided by an ethical view.'[51] The 'ethical view' has been discussed intensely by professional organizations and promoted widely by individuals such as Buckminster Fuller, Victor Papanek, Ralph Nader and Vance Packard in his best-selling indictment of American manufacturing, *The Waste Makers* (1960).

Design ethics has also been the work of the independent, non-profit Consumers Union, founded in 1936, to test products and inform customers. Their magazine, *Consumer Reports*, is published monthly, and the organization regularly publishes and updates books which analyze and rate the performance of a wide variety of products and services. Inevitably, design features prominently among the criteria applied to their assessments.

Universal Design, which aimed to ensure that products were usable by everyone, including those with special needs, has also arisen from a combination of design ethics and pluralism. This concept was promoted in publications such as *A Comprehensive Approach to Retrofitting Houses for a Lifetime*, a guide to specifications and products intended to make life easier for everyone, including children, elderly people or individuals with particular physical requirements.[52]

Environmentalism

Another late-century set of beliefs, environmentalism, grew out of a new realization of widespread environmental and ecological damage caused by the growth of modern technological culture. The design response to environmentalism has been characterized by the slogans 'small is beautiful' and 'green' design which advocated immediate, ad hoc responses to local problems and

decentralization, rather than universal or international solutions to design problems. Green design thinking also addressed problems, such as pollution and waste, which exist on a global scale. In America, environmentalism related to earlier philosophical and romantic concerns for the natural landscape, to the conservation movement initiated by Theodore Roosevelt at the start of the century, and to the environmental and resource concerns of the 1930s promoted by individuals such as Buckminster Fuller and Lewis Mumford.

Fuller's 'Dymaxion' principle (a synthesis of 'dynamism', 'maximum' and 'ions' which suggests gaining the greatest effect from the least expenditure of energy and materials) was an engineering-based equivalent of Mies van der Rohe's famous aesthetic dictum, 'Less is More'. Fuller proposed the efficiently coordinated use of available world resources to enrich the lives of the whole planetary population. His main initiative was to apply high technology to the problems of shelter and transport. He set up a study of global resources at his World Resources Inventory Center in Illinois and published many books developing and promoting his theory. Fuller's *Operating Manual for Spaceship Earth* set out 'the basic housekeeping rules for human life on the planet earth'.[53] And his ideas influenced several younger generations of design theorists/practitioners, including Victor Papanek and Stewart Brand, who published *The Whole Earth Catalog* from 1968 to 1972 as a means of empowering individuals to shape their own environments.

The main current of environmentalism at the close of the century has been most directly influenced by the writing and teaching of Victor Papanek, who developed a philosophy of design, distinct from both modernist and postmodernist systems of thought, based on an attempt to address the worst problems of human need facing designers. In this, environmentalism inherits the spirit of sociological and ethical values last associated with the technological humanism of the 1930s.

Like Mumford, Papanek sees design, at its most useful, operating outside the commercial sphere, independent of the competitive demands of packaging and styling, an element in the process of desirable social change. Unlike Post-Modernism, the pluralism of 'green design' is relatively unconcerned with aesthetics or the narrative language of design; but its philosophy is founded on a similar interest in cultural anthropology and adaptability. The input of the user is crucial to the successful solution to problems of need, according to Papanek. Therefore, design is seen as a collaboration between designer and user, relying on the designer's technical expertise and the user's understanding of specific requirements and habits, local knowledge and personal values.

Notes

1 Charles Harrison and Paul Wood, *Art in Theory 1900-1990* (Oxford and Cambridge, MA, 1992), p. 3.

2 Leslie Greene Bowman, *American Arts & Crafts: Virtue in Design* (Los Angeles, Boston, Toronto and London, 1990), p. 33.

3 Bowman, *American Arts & Crafts*, p. 34.

4 Morris confessed late in his career to have succeeded in serving only a wealthy minority with his expensive, hand-crafted products.

5 J. Christopher Jones, *Design Methods* (London, New York, Sydney and Toronto, 1970), p. xi.

6 Typically, in 'A Throw Away Aesthetic' (*Industrial Design* (March 1960), p. 93), Banham argued that design studies should address content before form, and analyse the relationships between style, representation and the consumer. This article compares the 'Platonic' aesthetic of a Bugatti engine with the 'exciting display' of a Buick V8, linking the glitter and casual extravagance of the Buick power-plant with the ephemeral nature of popular art.

7 Richard Hofstadter, William Miller and Daniel Aaron, *The American Republic*, vol. 2 (Englewood Cliffs, 1959; repr. Englewood Cliffs, 1965), p. 298.

8 Gertrude Stein, *The Making of Americans* (New York, 1934; repr. New York, 1962), p. 3.

9 Quoted by Hofstadter *et al., The American Republic*, p. 471.

10 William O'Neill, *Echoes of Revolt, The Masses 1911-1917* (Chicago, 1966; repr. Chicago, 1989), p. 115.

11 Walt Whitman, quoted by Robert Hughes, *The Shock of the New* (London, 1980; repr. London 1991), p. 311.

12 Hofstadter, *et al., The American Republic*, p. 301.

13 Frank Lloyd Wright, *An American Architecture* (New York, 1955), p. 193.

14 *Ibid.*, p. 41.

15 For a fuller discussion of both the real and synthetic relationships which developed between southern California history and design regionalism see Mike Davis, *City of Quartz* (New York, 1990; repr. 1992), p. 18.

16 Bowman, *American Arts & Crafts*, pp. 135-7.

17 *Ibid.*, p. 160.

18 Sibyl Moholy-Nagy, *Native Genius in Anonymous Architecture in North America* (New York, 1957; repr. New York, 1976), p. 34.

19 L. M. Roth, *McKim, Mead & White, Architects* (New York, 1983), p. 44.

20 Spiro Kostoff, *America By Design* (New York and Oxford, 1987), pp. 249-52.

21 Correspondence with Helen Rees, 1 September 1996.

22 Davis, *City of Quartz*, p. 20.

23 Lewis Mumford, *The Culture of Cities* (London and New York, 1938; repr. London, 1940), p. 408.

24 *Ibid.*, p. 414.

25 Lewis Mumford, *The Condition of Man* (New York and London, 1944), pp. 14-15.

26 *Ibid.*, pp. 391-2.

27 For a detailed discussion of the Model T's performance in a foreign market,

see Ray Batchelor, *Henry Ford, Mass Production, Modernism and Design* (Manchester and New York, 1994), pp. 72-4.

28 Moholy-Nagy, *Native Genius in Anonymous Architecture*, p. 12.

29 Horatio Greenough, quoted by Arthur Pulos, *American Design Ethic* (Cambridge, MA and London, 1983; repr. Cambridge, Mass and London, 1986), p. 106.

30 Sullivan, quoted by Susan Lambert, *Form Follows Function?* (London, 1993), p. 6.

31 Raymond Loewy, *Industrial Design* (London and Boston, 1979), p. 74.

32 Frank Whitford, *Bauhaus* (London, 1984), p. 180.

33 George H. Marcus, *Functionalist Design* (Munich and New York, 1995), p. 115.

34 *Ibid.*, p. 122-3.

35 Marinetti, quoted by Reyner Banham, *Theory and Design in the First Machine Age* (New York and London, 1960; repr. New York and London, 1972), p. 122.

36 Le Corbusier, quoted by Banham, *Theory and Design in the First Machine Age*, p. 250.

37 Mumford, *The Condition of Man*, p. 368.

38 Lewis Mumford, *Technics and Civilization* (London, 1934), p. 372.

39 *Ibid.*, p. 363.

40 Pulos, *American Design Ethic* p. 411.

41 Breton made his presence felt primarily through exhibitions such as the *First Papers of Surrealism*, with Marcel Duchamp, a string cobweb installation which filled the main gallery space of the Whitelaw Reid Mansion in New York, 1942.

42 Peter Wollen, *Raiding the Icebox* (London and New York, 1993), pp. 64–6.

43 Charles Jencks and Nathan Silver, *Adhocism, the case for improvisation* (New York, 1972).

44 Charles Jencks, *The Language of Post-Modern Architecture* (London, 1977), p. 97.

45 Gopher Prairie was the fictional mid-western town created by Sinclair Lewis in his novel, *Main Street. Gotham City* is the home town of the comic strip super-hero, Batman.

46 Colin Campbell, *The Romantic Ethic and the Spirit of Modern Consumerism* (New York and Oxford, 1987; repr. New York and Oxford, 1989), p. 156.

47 James Gleick, *Chaos: Making a New Science* (London, 1987; repr. London, 1989), p. 116.

48 Gert Eilenberger, quoted in *ibid.*, p. 117.

49 William Pretzer, 'The Ambiguities of Streamlining: Symbolism, Ideology and Cultural Mediator', in Fannia Weingartner, *Streamlining America* (Detroit, 1986), p. 88.

50 *Ibid.*, pp. 90-1.

51 John Vassos, quoted by Victor Papanek in The *Green Imperative* (London, 1995), p. 7.

52 *A Comprehensive Approach to Retrofitting Houses for a Lifetime* is a publication of the National Association of Home Builders Research Center.

53 Victor Papanek, *Design For the Real World* (Stockholm, 1971; repr. London, 1991), p. 304.

3 Ideas into objects

Every object is, at its most basic level of use, a mediator between individual and environment. A shoe cushions the sole of the foot from hard ground. A drinking glass carries water from its source to the drinker's mouth. A personal computer makes the Internet intelligible to the browser.[1]

One consequence of such a basic view of the material world is to establish equality in the order of things. However, among the things that we make, painting and sculpture have been seen traditionally as the primary conveyors of 'great' ideas: classicism, romanticism, humanism, transcendentalism. Architecture also has been thought to embody grand ideological messages such as nationalism, tradition and progress. Yet, in the twentieth century ordinary goods such as clothing and furniture have been accepted as embodiments of the same ideological forces as were historically the sole preserve of the fine arts and architecture. The purpose of this chapter is to introduce how theories of design and philosophical positions, themes addressed in the previous chapter, have been manifest in objects.

Theory to practice

While the first important episode this century in the American search for a national style of design came, ironically, from the ideas of the English Arts and Crafts movement, it is instructive to see how American craftspeople, designers and manufacturers, working in a variety of fields, adapted the movement's ideas and ideals to ends which were significantly different from those pursued in England. The ideas of William Morris which initiated the American Arts and Crafts movement were transformed by conscientious business people who saw a hole gaping in the middle-class market for domestic furnishings and decorative artifacts in metal, ceramics and glass. They required a simple style which shunned the elaborate European historical fashions recently adopted by the American new rich.

Craftsman furniture made by the New York firm of L. and J. G. Stickley,[2] featured massive, geometrical forms, straight lines,

repetition of standard elements and exposed mortise-and-tenon joinery. The high quality of these furnishings was signaled by the expressed riven grain of quarter-sawn oak, preferred for its great strength and resistance to shrinkage. Gustav Stickley had justified these qualities ideologically and morally as

> the primitive structural idea: that is, the form which would naturally suggest itself to a workman, were he called upon to express frankly and in the proper materials, the bare essential qualities of a bed, chair, table or any other object of this class. [3]

Declarations such as this appealed directly to the fundamental American belief in hard work, honesty and unpretentiousness. The visual similarities of Craftsman furniture to the plain furniture of the old Spanish missions of the south-west added to their association with traditional morality. While the simple lines and undecorated surfaces of the Stickleys' 'American settle' (figure 37) made it highly suitable to machine cutting and other mechanically assisted work in preparation for hand finishing, the same formal qualities also identified it as a classless, democratic product. Additionally, however, the settle's elegant proportions, refined finish, thick cushioning and sumptuous leather upholstery made it comfortable and fetishistic, similar in its simple luxury to Le Corbusier's tubular steel sofas of the 1920s, but without the machine imagery. Thus an unassuming sofa conveyed a resonant bundle of seemingly contradictory meanings and references.

The Stickleys knew that standardized product ranges, use of machinery and division of labor in production, and effective national marketing were the keys to commercial success. Gustav Stickley's magazine, *The Craftsman*, served as a prime marketing tool, establishing a wide popular interest in Arts and Crafts products as representations of the the virtues of democratic life. In the heyday of the Craftsman movement, the Stickleys were operating highly successful businesses creating and fulfilling the wants of a broad middle class, while maintaining an allegiance to the ideals

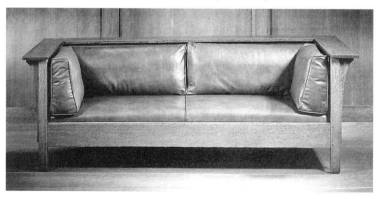

37] The solid proportions, undecorated surfaces and superb craftsmanship of L. & J. G. Stickleys' oak and leather 'American settle' signified both sumptuosity and classlessness. This 1912 design was revived by the firm in the 1990s.

set out by Morris. However, they democratized his ideals, both through the appearance and common availability of their products, and they created a true American design style appropriate to middle-class values.

The archetypal simplicity and careful construction of Craftsman furniture continued to represent the strongly held American ideals of the work ethic and the simple life long after the Arts and Crafts Movement ended.[4] The Stickley settle was produced from 1912-17, and then reintroduced by the firm, along with other original Arts and Crafts designs, in the early 1990s. Its renewed popularity at the end of the century attests to the endurance of a native American functionalism which resurfaced in the wake of the machine aesthetic. In the 1990s the settle represents a 'type' object which, through its essential anonymity and unobtrusive sumptuousness, addresses the American aspiration to mass luxury.

Similarly, the appropriation of functionalism by manufacturers of high volume domestic products in the 1950s popularized the most ascetic European design theory. Beginning in 1954, the annual General Motors Futurama presented to a vast national audience a regularly updated 'Kitchen of Tomorrow'. The fittings of the dream kitchen embodied a set of aesthetic values to which the entire middle class of home-owners would aspire. These were descended from the aesthetic of the Bauhaus: pure abstraction based on simple geometrical forms (details, such as cabinet handles and hinges, which might interfere with purity of form were concealed), absence of ornament, modern synthetic materials and a dramatic display of high technology appliances (this last part the Bauhaus never got quite right).

The enthusiasm of Americans for new kitchen designs resulted partly from the innovative layouts of post-war houses which emphasized the display of domestic gadgetry in the open-plan living/kitchen as a sign of affluence. The kitchen replaced the parlor as the showplace of the home and the 'Kitchen of Tomorrow' promised a cornucopia of glamorous hardware. When the style of the Futurama kitchen was adopted in 1958 by the GM domestic appliance line, Frigidaire, its hard-edged minimalism was advertised as the 'Sheer Look' (figure 38). The advertising spoke of its 'stunning beauty', 'America's most wanted, most imitated styling'. This was self-fulfiling hyperbole. Within a remarkably short time, the entire white goods industry was producing imitations of the 'Sheer Look'.

The 'Sheer Look' was subjected to one of the smartest advertising campaigns of the period. The Kudner agency coupled a hard-edged, black and chrome refrigerator with an elegant woman, dressed in a simple floor length gown by Oleg Cassini, her black gloved arms

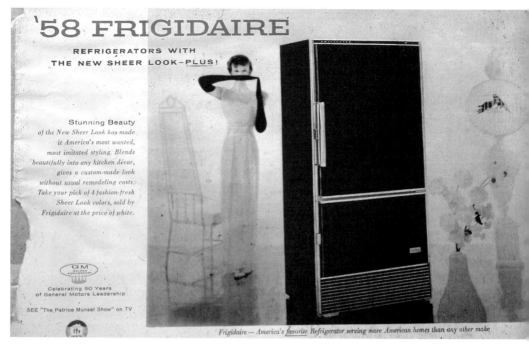

Frigidaire — America's favorite Refrigerator serving more American homes than any other make

demonstrating a sharp right angle.[5] The finishing touch in the transformation of austere functionalism into a high style of intense desirability was the addition of color to the range of Frigidaire products. Everyone knew that 'white goods' were white due to the hygienic requirements of food storage and preparation. Hygiene was also the (real and symbolic) reason why the cubic European housing of the 1920s was white. Now, the GM designers seemed to be saying, hygiene is so thoroughly reliable in a modern American kitchen, that refrigerators could quite safely be painted black, avocado or pink without jeopardizing the health of the family. Their colored rectangular surfaces now served as abstract art works in the advanced kitchen, which became like a gallery of 'machine art'.

The Frigidaire kitchen represented the latest technology, it was mass produced, and it signaled the arrival of a type form which has lasted forty years. In all these respects, it conformed to the functionalist theory from which it was drawn. But it was plangent functionalism. American corporate design and marketing subtly departed from the theory to create a product which had about it a sensuousness and luxuriousness which excited desire in an affluent public. Like being seduced by the parish preacher, as played by Burt Lancaster, the public embraced the blend of purity and physicality in the Stickleys' Craftsman furniture and in 'Sheer Look' appliances. These love affairs were genuine - body and soul.

The formation of an American national character was promoted

38] Bauhaus perfected. Austere functionalism was transformed into a high-style of intense desirability. It found a welcome place in the kitchen where geometrically precise mass-produced furniture and appliances contained an unparalleled abundance of food and lesser gadgets. The colored rectangular surfaces of the new appliances turned the kitchen into a gallery of abstract 'machine art'.

by the 'melting-pot' theory at the turn of the century and celebrated by the song writer George M. Cohan. But the sentiment of his 'Yankee Doodle Dandy ... born on the Fourth of July', wore decidedly thin in the multi-cultural United States of the late twentieth century. It became increasingly difficult to identify any clear set of characteristics which penetrated the barriers of ethnicity to define an American, a citizen of the United States. And this was without taking into account the Canadians and Mexicans, who were certainly Americans, but who had their own ideas concerning culture and nationality.

Nevertheless, the concept of national identity had potency as an impetus to design. And it left a plentiful legacy of objects made before reality sunk in. The picture was something like this: an American was democratic, highly mobile, free-thinking, outspoken, ingenious, comfort seeking, forward-looking (but with a sense of the past), athletic, informal, at once urbane and countrified – Gary Cooper in *Mr Deeds Goes to Town* or Katharine Hepburn in *The Philadelphia Story*.

One of the most influential solutions to the question of how best to provide the appropriate physical setting for such people came from Frank Lloyd Wright. His concept of the Usonian house (a name he coined to describe his idea of an American utopia) was perfected during the 1930s when the Depression and the exodus to the suburbs caused him to think seriously about the need for small inexpensive houses for young families. He advocated a semi-rural community as the best place for families. 'Because we have the automobile, we can go far and fast and when we get there, we have other machines to use – the tractor or whatever else you might want ...' (figures 39 and 40).[6]

His design for the small Usonian house, on its own acre of land, welcomed the automobile. Its carport doubled as a *porte-cochére*. From there, the main entrance led straight to the 'Work Space' (aka the kitchen), a fully applianced open bay, and into the dining area of the large living room. In another wing, also approached from the main entrance, lay the bedrooms and bathroom – a 'zoned' living plan. The house would be built of brick, timber and large areas of glass; it would have a flat roof with broad overhangs and no cellar, rather a slab containing ductwork for plumbing, electricity and under floor heating.

The living room would be dominated by a ceremonial hearth, the symbolic center of family life. Its ceiling would be low and probably made of wide planks of hand-rubbed timber. And it would extend out beyond the glass walls providing sheltering eaves and focusing the views to the landscape outside. Any furniture which was not built into the fabric of the house would also

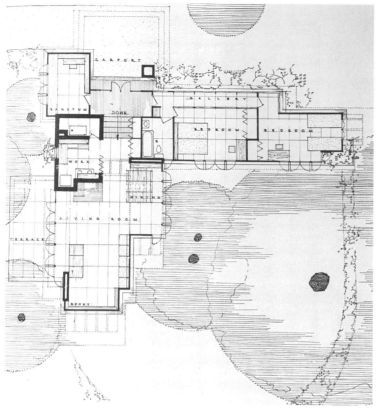

39] Wright's Usonian theory reflected the new informality of family life and a new interpretation of townscape. Modern centrally heated and air-conditioned houses retained a ceremonial hearth as the symbolic center of family life. Self-finished materials provided natural warmth, suggested 'honest construction' and offered the practical advantage of low maintenance. Typical Usonian plan and living room of Lewis House, Libertyville, Illinois, designed by Frank Lloyd Wright, 1940.

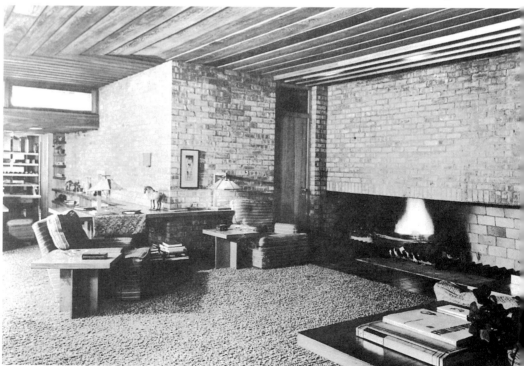

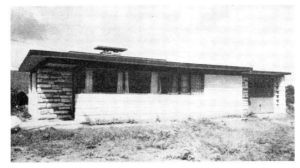

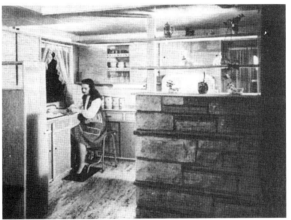

40] Wright's open-plan houses were meant to provide a model for the standard American family home of the future. The inexpensive, modern house illustrated takes its cues from Wright, but is the work of Pennsylvania architect, Raymond Viner Hall.

be low, informal and easily movable, as Wright's Americans, like cowboys and Indians, were more comfortable sitting cross-legged on the floor than in a straight backed chair - except when dining. No overt signs of wealth would be displayed; the free-flowing plan and vehicular entrance implied freedom of thought and movement and the connection with urban society; the hearth provided a focus for family discussion and hospitality; technical marvels satisfied the love of ingenuity and provided a high level of physical comfort; most important of all, the views of the land provided a reminder of the position of the family in relation to nature. Consequently, the long, low-ceilinged, glass-walled living rooms of many of Wright's houses, with ornamental fires burning in their open hearths, have the informal quality of sheltered camp sites.

Dramatic landscapes of North America inspired naturalism and nationalism in the arts ranging from the early nineteenth-century Hudson River School paintings by Thomas Cole and Alfred Bierstadt to the billboard images used to advertise Marlboro cigarettes. Rustic leisure activities, such as camping and picnicking, have also become part of the canon of American modernism. They were elevated to a theme of high Romantic art by Frank Lloyd Wright in his 1936 design for a weekend house, Fallingwater, at Bear Run, Pennsylvania. Here, the rocky terrain and rushing waterfall were

dramatically incorporated into the fabric of the building as constant reminders to the occupants of the outdoor pursuits which originally drew them to the site.

Rural values could also be detected in unlikely quarters such as automotive design. The simulated wood panelling on the sides and rear panels of Ford's Country Squire station wagons evolved from the genuine, hand-crafted timber body construction of capacious vehicles used for country trekking until the change to all-steel bodies around 1950. Since then many car manufacturers used wood-like exterior trim as a symbol for a way of life which revolved around the activities of families living in a country setting. It was meant to conjure up images of rural abundance, country fêtes and cultural stability and was the automotive equivalent of the 'farmhouse' kitchen.

Some of the most sophisticated product design at the end of the century caters to the popular desire to spend leisure time outdoors. Backpacks, tents, camping stoves and sleeping bags help to realize both a genuine and mythical communion between urbanites and the natural landscape. Sports equipment, kayaks, hiking boots, snorkelling gear and, dubiously, off-road vehicles provide sports people with modern rural pursuits which serve as alternatives to the traditional hunting and gathering of our pre-industrial ancestors.

Wright's Usonian principles helped to inspire an exodus to the country by offering a compelling rationale for the construction of countless speculative builders' houses which went up in post-war tracts, catering to both middle- and lower-income families. Their emphasis on family accommodation assumed a certain type of use – working father, home-maker mother and two-point-two children. This formula yielded a standard design differentiated only by the occupants' incomes.[7]

The Usonian house type became fused with a regional ideal emanating from the West Coast, the California Ranch house. These low, one-story, open-plan structures gave form to the image of relaxed West Coast living. With the addition of central heating and air-conditioning systems, the 'ranch' was adapted to use in all climatic zones and became one of the two most popular types of house being built during the 1950s (figure 41).

The other standard house type of the period also bore strong allegiance to a well-loved regional prototype – the colonial Cape Cod cottage. The 'Cape' had deep symbolic connections with the traditions of American life, and its simple box-like form, with a steeply pitched roof, clapboard walls and small-paned, sash windows served as a symbol of home as would be drawn by a five year old. The Cape also lent itself readily to modern internal planning;

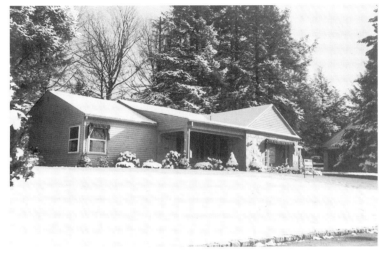

41] The post-war Ranch house had its origins in a rustic Western vernacular, but adapted easily to all regions of the United States. Typically, this New England example was dignified by granite facing around the main entrance, avoiding the need for 'period' ornaments.

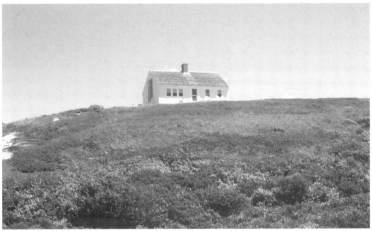

42] The painter Edward Hopper spent summers in this simple shingled cottage on Cape Cod. Except for its large studio window, it is typical of the early American house form replicated by the millions during the twentieth century. The 'Cape' had deep symbolic connections with the American tradition of free thinking.

and its simplicity of design was suitable to mass production (figure 42).

In the late 1940s Alfred Levitt applied the rational approach of Fordism to the mass production of houses (one completed every fifteen minutes). As Ford had done, Levitt and Sons paid high wages to non-union workers. They controlled their raw material supplies, manufactured their own building components and pre-fabricated major building elements using assembly-line techniques. Site work was mechanized and standardized for efficiency. The final product was inexpensive, well planned, fully equipped and was available in two styles, Cape and Ranch.

In later developments Levitt expanded the range of styles and used the marketing philosophy of Sloanism to sell them to clearly identified and targeted income and social groups. The two-story Colonial recalled the more affluent urban settlements of the early American past, unlike the humbler, rural Cape. The addition of

decorative shutters, columns, pedimented porches and American Eagle motifs enhanced the mythological value of the Colonial as a modern-day realization of the Jeffersonian ideal.

By covering the market from blue-collar to upper middle class, Levitt emulated the GM marketing theory – a product for every pocketbook, ultimately housing a population of more than seven million by the late 1950s in single-class, family communities. Houses were sold fully equipped with fireplaces, kitchen appliances and even built-in television sets. They offered their owners, who bought with the assistance of government-insured mortgages, an opportunity to decorate and landscape to achieve individuality through the expression of their own tastes, although choosing the color of the living room walls would be among the few obvious chances for self-expression.

As part of the interest in regional and historical design references, vernacular design continued to feed the idea of American nationalism. Rustic but commodious furniture, mountain ski lodges and lakeside boathouses with unique rough stone and bark-covered log construction, became symbols of the Adirondak resort area in up-state New York. Yet the curvaceous, slatted wood Adirondak chair has been a standard porch and yard furnishing in all regions of the United States throughout the century (see figure 112).

Another all-American product which dominated its market for over fifty years was the Harley-Davidson motorcycle (figure 43). Its powerful V–2 engine and substantial construction suited the long-distance travel requirements of American bikers and the needs of highway patrolmen until intense competition from more high-tech Japanese motorcycles threatened to put the company out of business. In response, Harley-Davidson played its trump card by producing a line of new, technically sophisticated bikes which exploited the company's past stylistically.

Their Softail Classic and other Heritage models of the 1980s emulated the appearance and evoked the mythology which had made Harley synonymous with American culture in the period between the First World War and Viet Nam. These products were advertised in texts emphasizing words such as 'heritage', 'classic' and 'tradition'. According to a 1989 company history, 'Harley-Davidson is a uniquely American institution and its products are an outgrowth of American thinking'.[8] Yet the thinking was less about engineering design than about street-cred as portrayed in Hollywood films such as *The Wild One* (1954), *Easy Rider* (1969) and *The Loveless* (1982). Therefore, as the only remaining American manufacturer of motorcycles at the end of the century, Harley-Davidson re-wrote its past according to a fantasy of rebellion, sex and youth which resided exclusively in an imaginary American tradition.

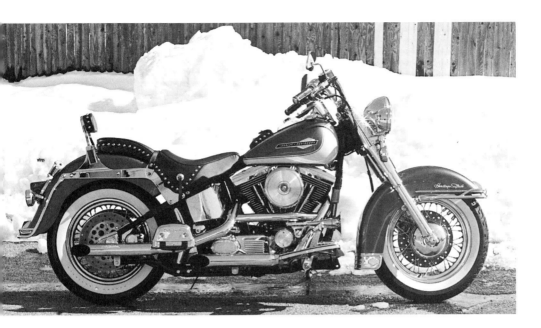

43] Harley-Davidson capitalized on its history and associations when defining a protective niche for its products against the overwhelming popularitry of the Japanese motorcycle. The classic design of the company's 1997 Heritage Softail model masked its advanced technology.

The aboriginal culture of America has been exploited as a design motif at all levels of sophistication. Romantic reminders of the Native American tradition could be found among early twentieth-century works such as the art ceramics produced by the Rookwood Pottery of Cincinnati. Among their more popular designs at the turn of the century was a tall, simple vase of oriental character, decorated with a vivid portrait of the Nez Perces tribes' Chief Joseph. The dignity of the portrait recalls the massive series of documentary photographs of Nez Perces and other Indian tribes taken by Edward Curtis and published in a monumental portfolio of 1906 with a foreword by President Theodore Roosevelt. Such elaborate homages to a people only recently subjugated by the most brutal means touched a chord in Americans which found a wide variety of outlets in literature, the fine arts and design.

Jackson Pollock wrote of his admiration for Indian culture, 'their vision has the basic universality of all real art'. His drip paintings of the 1940s and 1950s emulated techniques he discovered in south-west Indian sand paintings. The 'Navaho' series of opaque, blown-glass cylinders, conceived in 1975 by Dale Chihuly, demonstrated a modernist respect for the abstract patterns of traditional American Indian crafts. Chihuly's collection of simple forms decorated with brightly colored warped grids were based on patterns of authentic Navaho blankets which were shown alongside the cylinders when they were first exhibited (figure 44).

More familiar adaptations of Indian artifacts ranged from variations of the traditional soft-soled moccasin designed and marketed by the L. L. Bean mail-order company, of Freeport, Maine,

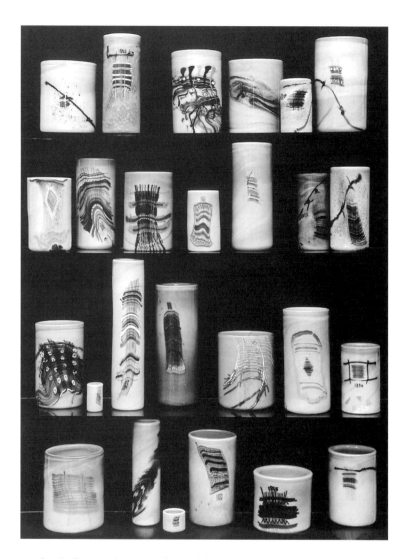

44] Native American references have found their way into a wide range of products and environments, from the top end of the fine and decorative arts to the crudest commercial designs, but all appealing to a broad interest in the native roots of American culture. The blown glass 'Navaho Blanket vases' by Dale Chihuly belong to the former category, *c.* 1980 (see also figures 25 and 45)

to the Indian-style tipis, also sold by post from Goodwin-Cole of Sacramento, California. A Sew-it-Yourself-Tipi-Kit was marketed in the 1970s by the Oregon-based Nomadics Company for those wishing to move in physically to the rural mythology of a nomadic Indian life. As in Levittown, final decoration (painting symbols on the tipi's skin) was left to the purchaser. These articles formed part of the symbolism of the environmental movement, expressing a desire of some Americans to learn how to live closer to the land and in harmony with indigenous traditions.

More commonly, however, commercial design caricatured traditional Indian imagery and symbolism for amusement. Tee Pee Motor Lodges and Wig Wam Diners formed the stock identities of motorcourts and roadside restaurants between the two world wars. By mid-century, the popular taste for Indian artifacts was reflected

in industrial design, as in the decorative emblem, in silver (read chromium) and turquoise enamel (plastic resin), which identified the Ford Thunderbird.

In a similar vein, a 1949 advertisement [9] for General Motors' Pontiac juxtaposed a rendering of a sleek coupé with an illustration of Philadelphia's Independence Hall and an encircled profile (a replica of the car's sculptural hood ornament) of the Indian Chieftain Pontiac, for whom the car was named. The copy read, 'You are … looking at something … to ponder … this coming Fourth of July. You are looking at a truly luxurious American product which is so low in price that its ownership may reasonably be aspired to by the normal American family.' Thus, the car is presented as a composite of diverse American traditions; the nobility, independence, resourcefulness and integrity of native American culture is mingled with the colonial spirit of independence, patriotism and the family values of the 'common man', and finally, the benefits of mass production and free enterprise to all ('normal') Americans.

By contrast, in the same campaign GM's advertisers exploited the concept of modernism to sell the slightly more up-market Oldsmobile.[10] On a page with layout, artwork and typography matching the Pontiac ad, the 'Futuramic' Oldsmobile was placed beside a perspective rendering of a ribbon-windowed, flat-roofed International Style house. The copy read, 'Architect George Fred Keck built tomorrow's way of living into this new home … just as tomorrow's way of driving is built into the Futuramic Oldsmobile!' Proud tradition is replaced here by the promise of a future made effortless and exciting through technological progress – the 'thrill of tomorrow' (figure 45).

Among the most ambitious and well-integrated design undertakings which fulfilled the criteria of American modernism were

45] General Motors stable mates, Pontiac and Oldsmobile, shared bodies, mechanical components and advertising agencies. Here, the 'Futuramic' Oldsmobile (right) is pitched at modernist tastes, while the Pontiac (left) is aimed at a patriotic buyer with traditional preferences.

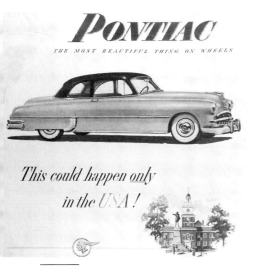

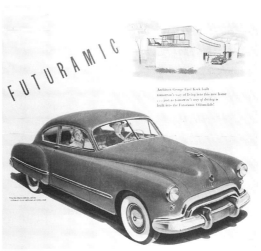

major public works projects achieved during the 1930s. With the stock market crash of 1929 and the ensuing Great Depression, Americans felt betrayed by *laissez-faire* economics and disillusioned with the personal greed and profligacy evident in the culture of the 1920s. Following his election in 1932, President Franklin Roosevelt devised a New Deal policy initiating programs to put the economically depressed and demoralized country on a path toward recovery and greater social equality.

Of the many new government agencies which employed art and design, the Tennessee Valley Authority (TVA) was among the most ambitious in its scope of works and in the standards it set. Dam building in the Tennessee Valley was initiated after the First World War as part of an effort to establish national self-sufficiency in production of nitrates used to make explosives. After a dormant period the TVA was revived in 1933 as America's first attempt at comprehensive regional planning. It was involved in the 'wide fields of flood control in the Tennessee Valley, soil erosion, afforestation, the promotion of leisure and tourism in the region and, most importantly, promoting the use of cheap electricity from hydroelectric plants for agricultural, domestic and industrial purposes'.[11] In its wide scope of activities, TVA became the first major public building program undertaken in the spirit of environmentalism.

TVA projects included twelve dams with hydroelectric power stations built along side them, parklands and tourist amenities such as visitors' centers and yacht clubs along the river and reservoirs, public buildings for local communities, permanent housing and demountable (mobile) houses for peripatetic building workers, and structures such as refrigerated river barges to encourage the fruit and vegetable freezing industry in the valley. All were intended to achieve the highest standards of design and technology in the service of society.

From 1933 to 1945, Roland A. Wank was the chief architect of TVA, coordinating the work of architects, engineers, landscape designers, industrial designers and Works Progress Administration (WPA) artists. TVA made use of design 'as one of the instruments of policy in building up a sounder, more vital civilization in the Valley'.[12] And it was not just for the Valley; every visitors' building erected by the Authority bore the inscription 'Built for the people of the United States'.

The image of TVA design was dominated by its massively sculptural engineering structures. And while functional considerations were the basis of their forms, an overall aesthetic concern was apparent in their composition, surface and detail. Julian Huxley wrote, 'Here is architecture on a scale dictated by the age.

Democratic government, engineers and architects, skilled and un-skilled labour, active citizens, all participate ... a unifying philosophy ... has brought about unity in design'.[13]

Interiors of powerhouses and generator stations, finished in glazed tiles or enameled metal, were epic spaces. Outside, concrete surfaces of the structures revealed alternating vertical and horizontal rectangular patterns of timber form-work, lending the monumental structures a human scale – this, nearly twenty years before Le Corbusier began experimenting with similar effects in 'beton brut'. The integration of all the structures in the gigantic ensemble, within 'reconstituted' natural settings, created dramatic visual effects which have helped to attract a steady flow of visitors to the area since the 1930s. According to Spiro Kostoff, 'Wank's dams for the TVA ... created an American architecture as native and appropriately elegant as Sullivan's skyscrapers and the motor-car factories of Albert Kahn' (figure 46).[14]

Community buildings, shopping centers, restaurants and other recreational facilities, and thousands of houses were built along with the engineering structures of the TVA in the 1930s and early 1940s. The aesthetics of these buildings, which departed from the heroic modernism of the engineering architecture, showed that the unified character of the age was not as simple or singular as critics such as Huxley painted it. The smaller buildings of the TVA carried very different messages concerning vernacular tradition.

Houses in the new town of Norris were sited in a picturesque manner, their traditional forms and details responding to local methods of stone and timber construction. The interiors of public buildings, in a mixture of modern and traditional styles, made extensive use of unpainted timber, giving them a rustic character. This technique was also used to make the many rural tourist cabins of the Authority reminiscent of the humble cottages which were the main traditional housing type of the region. During its first decade, the TVA employed design to appeal to a wide variety of public tastes in an equally wide variety of circumstances. TVA design neither preached nor condescended, but treated its users to an uncommon degree of respect.

In addition to titanic engineering projects, major exemplars of rationalism and universalism were to be found in designs for mass transport. Millions of people achieved previously unimagined levels of mobility through both public and private modes of transport designed as optimal solutions to practical problems.

A classic instance of pragmatic and rational design was demanded by the military build-up preceding America's entry to the Second World War. In 1940 designers from the American Bantam Company collaborated with a team of military engineers to

produce a prototype four-wheel drive, multi-purpose command and reconnaissance vehicle for the US Army. Named the Jeep, for General Purpose vehicle, the original Bantam prototype was quickly refined by the Willys Corporation which (with the Ford Motor Company) went on to produce nearly 700,000 of the sturdy, spartan cars described by General George Marshall as 'America's greatest contribution to modern warfare'.[15]

The original Jeep was a four-wheel-drive utility car capable of traversing rough terrain carrying four passengers and a 500-pound goods load. Its power-weight ratio made it a spirited performer, while its rugged proportions and aggressive, no-nonsense detailing expressed its fitness for purpose and attracted both its users'

46] Utopia goes native. A heroic industrial aesthetic was devised for the great public works of the Tennessee Valley Authority. Yet its housing and tourist accommodations often followed local traditions o combined modernism with rusticity. These examples are from the period 1933–41: (clockwise) generator room, gantry, restaurant, tourist cabin.

affection and the admiration of design critics. The Museum of Modern Art included it in a 1951 exhibition of 'modern automotive masterpieces' which included such svelte designs as Gordon Buehrig's 1937 Cord and the Raymond Loewy/Virgil Exner Studebaker of 1947.

The post-war history of the Jeep revealed the adaptability of the original design to changes in social and commercial conditions while remaining faithful to the universal ideals of the prototype. When Henry J. Kaiser bought the Willys company in the early 1950s, he concentrated on marketing the Jeep as transport for farmers and other rural occupations. Willys also built the first all-steel, Jeep-derived station wagon which converted easily to a commercial van. When American Motors bought out Kaiser in 1970, the Jeep began a gradual transformation to a sport and leisure vehicle. The CJ, Wrangler and Renegade models, which closely resembled the original military Jeep, generated an off-road sub-culture which took up a new sport known as 'jeeping' and celebrated its relief from urban anxiety at parties called 'jeep jambories'.[16] The introduction of the Cherokee in 1974 established the jeep as an executive sports vehicle for the urban and suburban middle classes, completing its evolution from warhorse to work-horse to hobbyhorse. Throughout its history, and no matter what its actual purpose or market niche, the Jeep has stood for the practical values of standardization, affinity to untamed nature, and robust independence.

In the field of air transport, similar 'classic' status was achieved by the Douglas DC3 passenger aircraft of 1935. High performance, safety and comfort were the basis for its design. The stressed aluminum skin and all-metal monocoque structure were the product of wind-tunnel testing and advances in material technology and construction methods resulting in a sleek form which was the highest expression of the science of aerodynamics at the time. The DC3 enabled millions of individuals to go further, faster than they had ever gone before. The combination of its simple beauty and its historical success established the plane as an outstanding symbol of functional design.

As the airliner was outside the realm of consumer products, its form did not need to attract attention but only satisfy the demands of utility in the most direct and enduring manner. DC3s which are sixty years old remain in use and still look viable as aeronautical transportation. Standardized corporate hardware, such as planes and trains, were sold as part of a service to travellers through advertising. And it was in that ephemeral field that design appealed to mass desire in the effort to win custom for competing airlines and railroads.

Even more important in extending mass global transportation than the DC3, the Boeing 747 jumbo jet was capable of carrying 320 passengers when it entered commercial service in 1970. Like its ancestor, the jumbo appeared what it was, a transport machine; its external form, derived exclusively from aeronautical technology, was purely functional. It became perhaps the most ubiquitous global product of the last quarter of the century and spawned an international architecture of terminals, access passages and mobile lounges based on specific standards relevant to the characteristics of the plane. The unmistakable shape of the 747 has not changed significantly since the day of its launch.

Yet the design was firmly a part of the commercial world. While advertising was the first point of contact with a potential traveller, the plane delivered the service. And so, it was part of the process of selling seats, which it did through reliability, comfort and an efficient appearance which inspired confidence. The body also served as a mobile advertisement for airlines by carrying logos and decorative graphics suggesting national or regional associations. Graphic insignia, such as the Qantas kangaroo, were identifiable from miles away and easily recognized around the world.

747 interiors were designed by many different firms working for the airlines. But it was the long-standing relationship between the manufacturer, Boeing, and the Walter Dorwin Teague agency that established some of the basic features of the 747 interior, such as seat design and the arrangement of screens for in-flight movies, which have remained throughout its life. Interior decorations, however, were often related to the country of origin of a specific airline and conveyed its national identity to long-haul passengers.

In the age of mass leisure, the most common medium of popular art was the snapshot. Nearly everyone had a camera to record family life, and many people achieved results which rivaled the work of professionals in terms of subject interest and composition. Since their announcement in 1947, Polaroid cameras have exhibited qualities of originality and functionalism in a continuously refined series of models. Change of appearance always resulted from a significant advance in the technology of instant photography or represented a widening of the market toward both the top end professional user and the low-cost mass market.

Typically, the SX-70 model, designed by the Henry Dreyfuss agency in 1972 and announced in a Polaroid promotional film made by Charles and Ray Eames, had a radical, collapsible design which minimized its size for carrying and gave it excellent ergonomic qualities which facilitated its use. Yet the camera body was also enriched by elegant finishes and detailing including leather surfaces and chromium bezels which lent the instrument

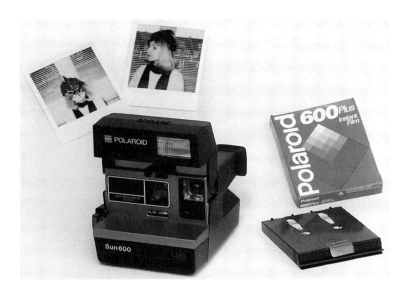

47] Polaroid photography satisfied the American craving for instant gratification. The company provided cameras which were unique and practical in appearance yet easy and fun to use. Polaroid 'Swinger' Model 600, c. 1985.

satisfying visual and tactile qualities. Polaroid cameras' ingenuity and simplicity descended from a tradition of pragmatic American design, while their universal design qualities suited the poly-morphous character of the domestic and global markets for products (figure 47).

These markets also responded to the combined rationalism of the machine and the world of natural forces when they were united through the amorphous concept of streamlining. While some streamlined designs, such as Loewy's Pennsylvania Railroad S1 locomotive, had a strongly mechanistic character, other designs, the 747 for example, appeared closer to the slippery shapes of birds and fishes. As early as the mid-1930s, with the development of new materials and production methods, designers began to explore a visual language which had the potential for reconciling the look of technological efficiency and machine production with the soft, irregular shapes of nature.

The influence of theoretical positions like Mumford's and Frank Lloyd Wright's began to be felt in American product design at around the same time as the consolidation of the International Style. What Mumford called 'biotechnics' was expressed tenta-tively in the designs of streamlined aircraft and more poetically in the mobile sculptures made in the 1930s by Alexander Calder. These precisely engineered kinetic structures in wire, sheet metal, wood, glass and other industrial materials synthesized the traits of the finest machines with the poetic, mutational qualities of nature. Their suspended, amoeboid shapes responded to the slightest change in the atmosphere around them, just as in nature plants and animals respond to environmental changes. And, like organ-isms, their forms were in permanent flux. Organicism in the fine

arts quickly influenced the thinking of leading designers such as Russel Wright, Ralph Rapson, Charles Eames and Eero Saarinen as well as craftspeople such as Leza McVey and Harvey Littleton, both associated with the Cranbrook Academy.

The immense popularity of the biomorphic 'American Modern' dinnerware, designed in 1937 by Russel and Mary Wright, was an early instance of unity between large-scale production and sensuous forms with warm tactile qualities. It also represented a rare unity of appreciation among the public and critics. The shapes of the earthenware bowls and pitchers had the transient quality of curling leaves, reinforced by the subtly speckled earth colors of the glazes. Yet there was also a dynamic element in the forms which endeared them to the futuristic and speed-happy American public.

More exotic biomorphic qualities appeared in the 'Articulated Table' made by the sculptor, Isamu Noguchi, in 1939. The inscrutable forms of the timber base, joined together by a knuckle-like sphere, contrasted with the transparent amoeba-shaped glass top, creating an organic tension typical of Surrealism. In 1944 Noguchi modified the table for production by the Herman Miller Company. It became an icon of 1950s style and was produced again in the 1990s, demonstrating the persistence of organicism in design.

In saturated markets for most relatively standard goods, the subjective appeal to personal taste through design has played a major role in a product's success or failure. The influences of organicism and anti-rationalism filtered down from the work of artists such as Calder and Noguchi to influence the full range of consumer products (figure 48). *Industrial Design* magazine wrote in 1959,

> The turn from the rationally constructed form to organically-grown and irrational shapes is becoming more and more evident, especially in the work of young designers and artists everywhere. Reason and science, which in any case have already pushed on to the borders of the irrational, are beginning to lose the basilisk-like attraction which they have exercised for so long a time. [17]

During the 1980s and 1990s interest in organicism took on a new color from the emergence of Chaos Theory, Deconstructivism and the Complexity Theory developed at the Santa Fe Institute in New Mexico,[18] all of which considered the balance between order and disorder evident in both nature and culture. The increasingly organic qualities of computers and robots, advanced prosthetics equipped with microprocessors for sensitivity, and genetic engineering all suggested a new human-machine-nature relationship which began to influence fundamental aspects of design and to find expression in 'smart' appliances, user-designed fabrics and graphics, and mutational motorcars.[19] Chaos Theory

quickly affected the styles of work produced by architects such as Frank Gehry, Peter Eisenman and James Wines (with SITE).

Gehry's projects, in particular, displayed an ingenious capacity for reconciling the technical and organic synthesis demanded by Complexity Theory. For example, a curving, ribbed timber structure, functioning as a conference room within the open-plan

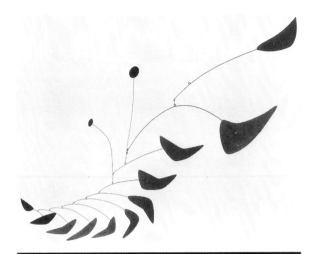

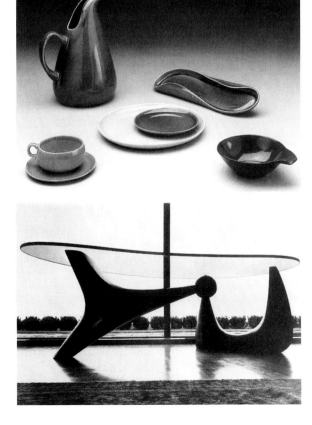

48] Nature abstracted. Alexander Calder's mobiles, first constructed in the 1930s, combined biological and mechanical qualities with the quirkiness of Surrealist Art (see ch. 6). American Modern ceramics, designed by Russel Wright in 1937, and samu Noguchi's articulated table (1937) also employed 'biotechnic' imagery in a style of domestic artifacts which became enormously popular in the 1950s. Interest in 'organic' design revived in the 1990s with the rise of 'Green' concerns and new developments in bio-technology.

offices of his Chiat/Day building, resembled the interior of Jonah's whale; it also suggested the nave of a gothic cathedral, its indirect illumination creating the impression of a celestial glow. The space was at once organic and technical, businesslike and playful, crude and sumptuous. Similarly, Gehry's stacked corrugated cardboard 'Little Beaver' chair used cheap, natural-looking packaging material in subtle, irregularly curving forms, exquisitely crafted to look as if it had been gnawed away by a talented beaver. The scaly, fish-shaped shade of his Ryba lamp, speared at the top of a loosely structured pedestal, transformed an organic cliché into an enig-matic totem, impelling its user to reconsider previously held expectations of lamp, light and fish. The considerable influence of Gehry's designs resulted from their simultaneous appeal to the human intellect, senses and emotions.

Film-makers in the 1990s also engage the use of organic imagery in set designs and special effects. Softly contoured, biomorphic interiors of director Steve Barnett's film, *Mindwarp* (production design by Kim Hix), provided a canvas against which electronically induced fantasies of Virtual Reality were played out.

No one exploited the consumer appeal of emotive design more aggressively than General Motors. Their Cadillac of 1958, designed under the supervision of Harley Earl, was appreciated as a symbol of status by the officials of the New York State government who bought them for personal use at the taxpayers' expense, unleashing a minor local scandal. In the same year, they could be seen gliding through the streets of Havana where the local population, on the brink of communist revolution, identified the gaudy cars with capitalist imperialism and American support for the incumbent dictator, Batista. If evidence were needed, more than one com-pound-curved, panoramic windshield was smashed in the *coup d'état* that followed.

Detroit cars of mid-century, their designs combining literal representation with a high degree of abstraction, became favorite subjects of analysis by historians as they offered such rich material for interpretation. Many of the Cadillac's design references were oblique, open to a variety of readings. Its jet-age symbols were taken out of context and mingled with anthropomorphic ele-ments of the bodywork. Eyes, breasts, mouth, and the more ambiguous curves suggesting shoulders and hips were treated in a hard, geometrical and mechanistic manner.

Their ambiguity and complexity of meaning related to the tradition of robots or automata represented in the arts since the Middle Ages. This interest continued during the Enlightenment when the mechanistic side of our nature began to excite philo-sophical curiosity, while in the twentieth century the Dadaists and

Surrealists became fascinated by the paradox of the machine/man or woman.[20] And like a Duchampian gender-transforming robot, the Cadillac featured both aggressive female and macho-mechanistic attributes in a manner seductive to both men and women.

The hardness of the metal, its razor-sharp edges trimmed with chromium for emphasis, were softened by subtle, muscular swellings of fender and door surfaces and by the the luxurious tactile qualities of the interior. There, richly colored carpets, brocaded upholstery and soft leather produced a lush, enveloping and womb-like atmosphere which isolated the occupants from the external environment. The driver was physically lulled in the fully automated and climate-controlled cabin, but the senses were continually stimulated. A muffled burble from the massive V8 engine, multiple speaker high-fidelity radio, whirring of motorized appliances, light glinting on chromium-plated ornaments and emanating mysteriously from dashboard instruments, all kept eyes and ears working in a pleasurable symbiosis with the machine.

In the language of Charles Jencks, the Cadillac was 'multivalent';[21] it could suggest, simultaneously, an F104 fighter plane, the anatomy of Jane Russell or Rock Hudson and a jewellery chest, filled with gold, silver and precious gems; sex, power and wealth, transformed through the ego of the driver into a charisma which came with the car as added value (figure 49). When Reyner Banham and Robert Venturi established the importance of popular thought in the discussion of art and design, they were only tuning in to what Detroit's stylists never doubted, that the aims of commercial design, in its context, are as valid as the aims of civic design or ecological design in theirs.

Popular desire for the fabulous was also expressed in the architecture and interiors created by Morris Lapidus, who opened up a world of fantastic luxury to millions of people through his shop designs and especially in the series of hotels he built during the 1950s in Miami Beach – the Fontainbleau, the Eden Roc and the Americana (figure 50).

Lapidus has been called 'the architect of the American Dream', and his work was labelled the 'Architecture of Joy' in an exhibition at the Architectural League of New York in 1971.[22] When, in 1953, he designed the Fontainbleau Hotel in Miami Beach, Lapidus responded to his client's demand for 'real luxury Modern French Provincial' by using sweeping reverse curves in both the main forms of the building and in details such as interior planting troughs and seating arrangements.[23] The lobbies featured gigantic glass chandeliers suspended within deep gilded domes and fluted oval columns which, instead of supporting the ceilings, pushed up through them into brilliantly lighted recesses. The *tour de force,*

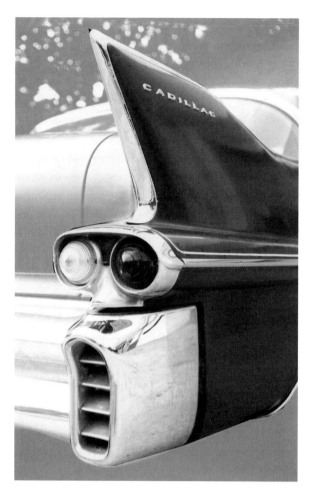

49] 'How like a Mohawk warrior', the painter Benjamin West's comment on first seeing the classical statue Apollo Belvedere, could equally apply to this detail of the 1958 Cadillac. Automobiles of the period combined rocket and jet forms with anthropomorphic bulges and curves in bombastic compositions which appealed to the emotions and the imagination. A more dramatic contrast with European functionalism could hardly be imagined. Acquiring this sort of 'hollow, rolling sculpture' was art collecting, middle-class American style.

resembling a set in a Busby Berkeley Hollywood musical, was a sweeping, white marble cantilevered staircase which led nowhere. The composition of modern streamlines and historical motifs was contrived for effect rather than utility. But such an effect!

Lapidus wrote of the hotel many years later, 'Here ... I could enlarge upon all the theories I had been developing about human nature and the emotional hunger that the average man had for visual excitement and personal adornment ... The guests want to find a new experience - forget the office, the house, the kids, the bills. People wanted fun, excitement, and all of it against a background that was colorful, unexpected - in this case to buy the tropical luxury of a wonderful vacation of fun in the sun.' 24

Another hotelier, commissioning Lapidus, told him 'I don't care if it's Baroque or Brooklyn, just get me plenty of glamour and make sure it screams luxury!' 25 He did. And the result was what a great many northerners, driving their new Cadillacs or Fords down to Florida for a winter vacation, wanted to see when they arrived. In

50] 'I don't care if it's Baroque or Brooklyn, just get me plenty of glamour and make sure it screams luxury!'. Clients enjoined the architect Morris Lapidus to pull out all the stops in his designs for hotels such as the Fontainbleau and Eden Roc Miami Beach, 1950s. Yet these spectacular holiday destinations were built to a budget and always turned a profit.

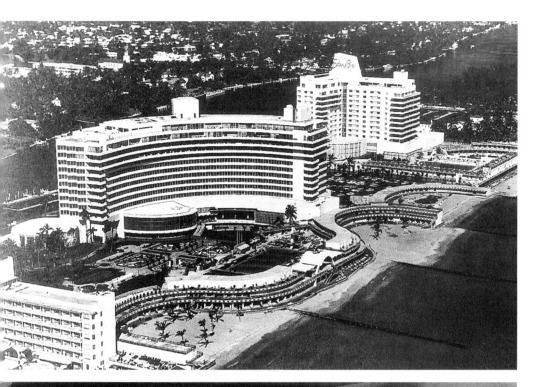

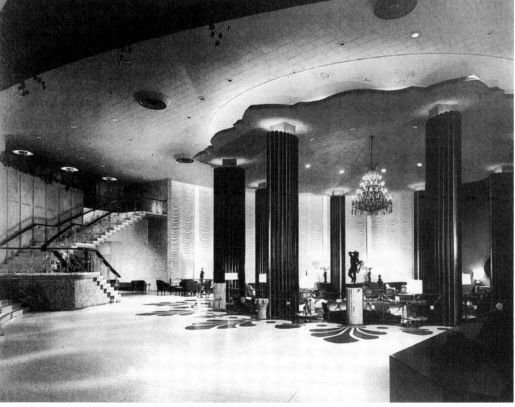

the 1990s, similarly lavish and fanciful interiors, presented as theater sets, entertained the guests in a series of hotels, clubs and restaurants designed by David Rockwell including sixty Planet Hollywoods, the Mohegan Sun Casino and Magic Underground, for magician David Copperfield, where electronic and mechanical technologies animated imagery drawn from Piranesi, Weimer decadence and native American culture to induce what Rockwell called 'The Big Wow'.

Americans' love of mobility and of the fabulous have, at times, been justified on the basis of practicality and even received government support. Such was the case of flying cars. The 1930s saw a New Deal initiative to stimulate designs for road vehicles which could be adapted for powered flight. Harold Pitcairn's AC35 autogiro-car was intended for use by the US government. Other practical, cheap flying automobiles meant for civilian use included the Fulton Airphibean and Moulton Taylor's Aerocar, designed in the late 1940s, which sported a distinctive Y-shaped tail incorporating the propeller. The Aerocar used a light fiberglass body, stored its wings in a purpose-designed trailer, and could be converted from car to plane in under ten minutes. The actor Bob Cummings had one and used it in his popular TV sit-com of the mid-1950s. Taylor's Aerocar IV, a kit adaptable to any small hatchback car, was in the works in the 1990s, sustaining the quest for a practical solution to a highly fanciful old idea.

The fanciful nature of commercial design has consistently overshadowed designing for need (figure 51). Nevertheless, need and conscience have become increasingly important issues in design

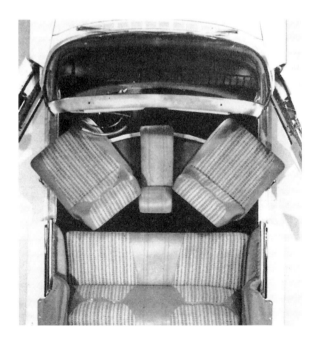

51] Chrysler's novel swivel seat, 1959, was a marketing gimmick touted to ease entry and exit from the low-slung cars of the late 1950s. But it threatened the ankles of rear seat passengers and could eject its unbelted occupant overboard in a crash.

education and publishing, perhaps as much a result of the Puritan ethic as a response to particular conditions of time, such as the oil crisis of the 1970s. Among the pioneer designers who attempted to provide a rationale for design which would address the most basic problems of shelter and mobility, Buckminster Fuller invented a range of startlingly original solutions. His geodesic domes, patented in 1947, transcended conventional aesthetics, but often achieved a strong visual impact due to their platonic form and gem-like faceted surface. Domes were one part of Fuller's utopian plan for revolutionizing the man-made world. His prototypes for pre-fabricated and mass-produced Dymaxion houses and the Dymaxion car, of which he built three examples in the early 1930s, formed the other two corners of the Dymaxion world triangle.

The Dymaxion car was devised as an extension of Fuller's proto-type Dymaxion house and was intended to use the same production technologies and materials. Both designs resulted from radical reassessments of the conventional house and car of the time although, as Lewis Mumford pointed out, the Dymaxion house retained the conventional status of the American home, standing permanently on its own plot of land. Nevertheless, Fuller's Dymaxion design theory achieved celebrity and notoriety as a direct challenge to the commercial design imperatives of the construction and automobile industries – it declared war against the concept of MAYA design (Most Advanced Yet Acceptable), a word coined to describe the acceptance of commercial constraints on progressive and radical design. MAYA, the critical point at which progressive design should stop before it reaches too far beyond prevailing tastes, was described by Raymond Loewy in the early 1970s:

> not only the designer but also the manufacturer frequently has problems by introducing a product that leapfrogs either a need or an aesthetic development. It is, therefore, risky for a manufacturer to … be too far ahead of either his competitors or the consumers' threshold of acceptance. [26]

The radical engineering and aesthetics of Chrysler's 1934 Airflow went beyond MAYA and led to failure in the showrooms. Fuller's innovative Dymaxion car never stood a chance of commercial success for similar reasons.

Yet its synthesis of the characteristics of yachts, airplanes and contemporary abstract sculpture proved enormously compelling to contemporary observers. Fuller's development of the Dymaxion car from 1927 through 1933 involved the talents of the aeronautical and naval designer, Starling Burgess, and the sculptor, Isamu Noguchi. Powered by a Ford V–8 engine which could take the large car to over 100 miles per hour, the vehicle carried up to eleven

passengers, boasted unprecedented maneuverability, and achieved high fuel economy due to its lightness and aerodynamics. And although it lost its war against Detroit, never reaching commercial production, the Dymaxion car remained a paragon of radical design ethics.

A subsequent design which came closer to production was Preston Tucker's Torpedo, a post-Second World War car which employed many of the innovative engineering and safety features of the Dymaxion design, including a rear engine. The Tucker was billed as 'the safest, most aerodynamic car in the world'. It boasted sixty-seven safety features including a perimeter chassis, four-wheel independent suspension, shock-insulated steering wheel, padded dash and pivoting third headlight. Fifty-five Tuckers were built in a massive demobilized war production plant, later used to build Lustron all-steel homes, and a major advertising campaign launched before the company was forced to liquidate.

Whereas Fuller's concerns had been primarily economic, the ethics of automobile design turned increasingly toward safety with a serious rise in accident statistics in the 1950s. A wish to lessen the causes and effects of accidents led to the design of two experimental vehicles conceived outside the automobile industry during the late 1950s. The 'Sir Vival' car, an articulated vehicle with an elevated turret-like driver's compartment, was designed and constructed by the inventor, Walter C. Jerome.[27] The better-known Cornell-Liberty Safety Car, a $250,000 laboratory on wheels, was produced and widely publicized by the Cornell Aeronautical

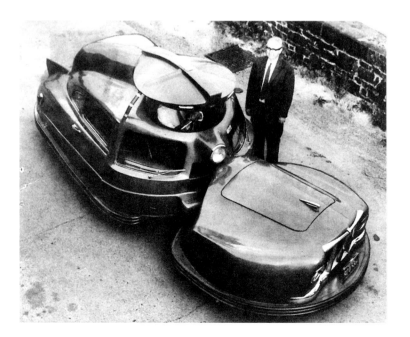

52] Independent conscience. The Sir Vival car, 1958, was a privately financed experimental vehicle meant to demonstrate accident avoidance features. Such designs have provided an outlet for the ideas of singular, crusading idealists throughout the country's history.

Laboratory and the Liberty Insurance Company of Boston (figures 52 and 53).[28]

The principle of the Jerome car was active avoidance of accidents by improving vision and maneuverability, while the more influential Cornell vehicle took a passive, defensive approach to passenger safety. Its innovations included anti-burst, accordion doors, inertia-reel passenger restraints, impact absorbing frame, and a fully padded interior with all potentially dangerous protuberances eliminated. Although both designs were quite ungainly and the Cornell prototype lacked an engine, many of their features were eventually incorporated into the products of the major

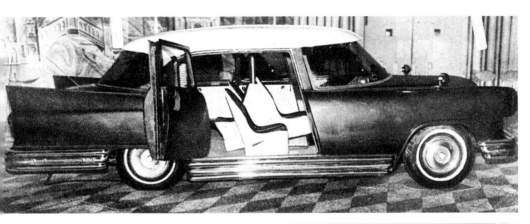

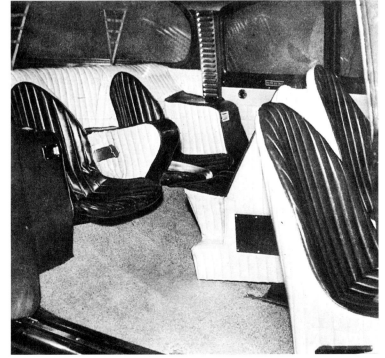

53] Institutional conscience. The Cornell-Liberty Safety Car, 1958, was an 'ideas vehicle' with no engine, but it boasted a host of passive safety innovations, many of which became standard on later production cars. A university and an insurance company collaborated on this project.

manufacturers. And the idea they promoted, of passenger and pedestrian safety, became a more significant aim of mainstream car designers from the 1970s onward.

Safety in the event of hurricane or earthquake, in addition to economic efficiency, was an advantage of Fuller's design for the geodesic dome. Emulating the structure of the atom, the Fuller dome was a section of the surface of a sphere defined by a three-way grid of circles whose intersections formed a pattern of triangles, the edges of which comprised a rigid truss. In geodesic structures, tension and compression were balanced against one another to provide maximum strength with the lightest and thinnest materials, such as tubular steel, sheet metal and plywood. Geodesic structures could be built to any size, from the scale of the hand to the size of a city, without the benefit of any internal supports, such as columns or beams.

Whereas the 39-foot diameter dome residence Fuller built for himself and his wife in Carbondale, Illinois, exhibited dubious spatial and aesthetic qualities, his larger domes, such as the United States Pavillion for the Expo '67 World's Fair in Montreal, were visually and spatially impressive while also demonstrating the

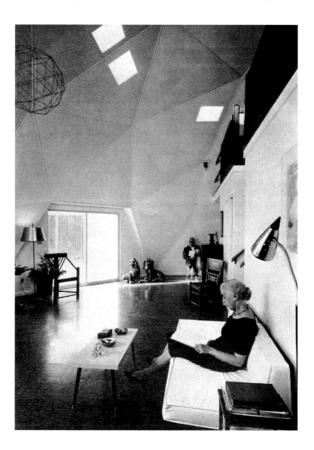

54] Idealism and eccentricity. The unusual spatial qualities of Bucky and Ann Fuller's dome house, c. 1960, did not suit conventional expectations of 'home', limiting its potential as a model for mass housing.

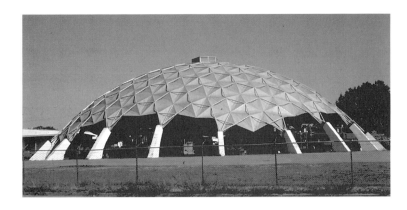

55] Modern products in the utilitarian tradition, Buckminster Fuller's geodesic domes were built by the thousands around the world as efficient shelters for people and equipment. The one above houses airport firetrucks and snow removal vehicles, allowing easy access and circulation for large vehicles within its uninterrupted floor area. Geodesic structures had greatest aesthetic impact when constructed on a monumental scale. The United States Pavilion at Montreal's Expo '67 exhibition (below) earned world-wide admiration for its poetic beauty resulting from a synthesis of organicism and high technology.

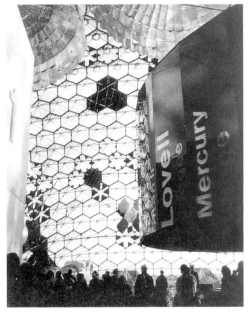

efficiency of Fuller's design principles. The US pavilion was a three-quarter sphere 'Geodesic Skybreak Bubble', 250 feet in diameter and 137 feet high, with a lightweight transparent structure and electronically operated system of glazed skin panels providing optimal atmospheric control.[29] The multi-story internal architecture was independent of the outer skin, demonstrating the flexible design potential of geodesic structures. A dramatic entrance for visitors was provided by a monorail train which penetrated the bubble at high level, a witty reference to fertility in a mechanistic environment. Within a decade after the first dome was built for the Ford Motor Company in 1952, thousands of Fuller domes had been constructed in forty countries. They served all purposes, from minimal housing to vast aircraft hangers and stadium roofing (figures 54 and 55).[30]

In the 1960s, Fuller's ecological theories influenced design in the

emerging counter-culture of hippy 'drop-outs'. The mathematician and designer Steve Baer developed from the geodesic principle a new structural geometry which he called the 'zome'. In the Colorado desert, he orchestrated the construction of a self-sufficient community called Drop City (figure 56). Baer's zomes were irregular, dome-like buildings with skeletal frames of two-by-four timbers sheathed in steel panels, mostly cut from the roofs of junked automobiles. Windows and doors recycled from demolished buildings, solar water heating systems made from disused oil drums, and ad hoc furnishing produced a look which represented a striking alternative to the ubiquitous, professionally designed and manufactured home environment. They also departed significantly from the ideal platonic forms of Fuller's domes. The battered, colorful, partially rusting surfaces of the zomes and their studied informality lent a romantic aura to the buildings and connected them with the long tradition of vernacular American housing.[31] They also anticipated the fashion for industrial decay, later applied to the influential designs for the film *Blade Runner*.

Fuller's ideas were also perpetuated and developed by Victor Papanek whose first book, *Design for the Real World*, promoted design responsibility and social action through design. Whereas Fuller, influenced by Fordism, proposed universal solutions to global needs based on mass production, Papanek advocated unique, small-scale solutions to local problems. His designs for carved and turned wooden furniture and other domestic artifacts, such as candlesticks, to be made in the cottage industries of southern Appalachia, was a typical response to a specific set of conditions. The inexpensive objects made use of existing local skills and catered to the needs and economic resources of the local consumer group (which included tourists).[32] Yet Papanek also advocated the

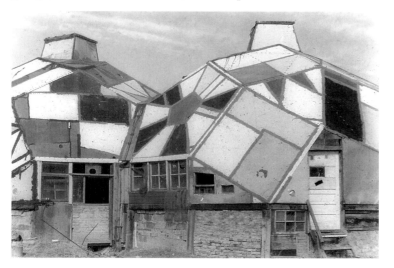

56] The zome concept, originated by Steve Baer in the mid-1960s, offered the counter-culture self-builders of Drop City, in Colorado, an easy structural system and a radical aesthetic expressive of their social agenda.

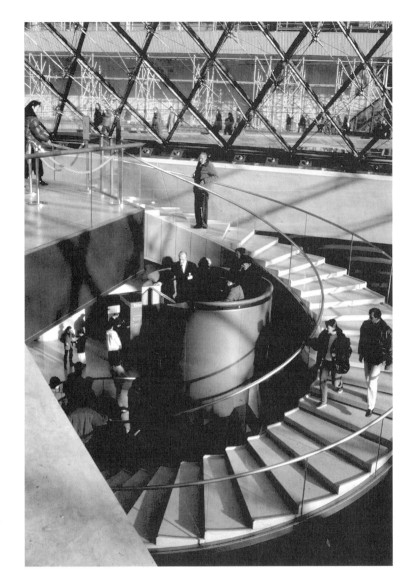

57] I. M. Pei's design for the disabled persons' elevator in the reception pyramid of the Louvre (1989) provided an entrance so dignified it could make ambulatory visitors envious. Social concern mingled with sybaritic luxury and formal purity. This example of American minimalism found a central place among the very Parisian Grand Projets of Francois Mitterand.

principle of Universal Design exemplified in products such as OXO's corkscrew and jar-opener, designed with high regard for their appearance and ease of use by people with arthritis.[33]

Another rare marriage of high aesthetics and social concern was the combined spiral stair and elevator, for visitors who could not negotiate stairs, designed by the American architect I. M. Pei for the Louvre pyramid entrance in Paris (figure 57). As the large cylinder in the center of the stair disappeared magically into the floor, it carried the occupants of its luxurious passenger platform, with uniformed attendant, ceremonially to the lower ground floor level in a spirit of grandeur compatible with the noble sweep of the stairs.

Unfortunately, toward the end of the century, the growth of environmental concern and design for need has reached little further than college classrooms and small-scale manufacturing of equipment for people with disabilities. Public sector design has deteriorated with a loss of confidence in design as a tool for social integration. The crafts have moved increasingly into the fine arts, intentionally denying their primary use functions. And commercial design has remained staunchly in the business of serving the affluent individual's appetite for fantasy and his or her sense of self-importance.

Yet ideas are still fueling design responses. Humanism and democracy have been redefined through an increasing emphasis on process over product as conveyed by graphic and software design. Progress is ever present in the design of communications hardware and software. The rapid development of realistic yet inventive imagery, if not content, of computer games is a popular example. In America modernism continues as a powerful ideological force in the design of consumer hardware. Newest means best. And the idea of living in consort with nature continues to exert an enormous influence over designs for leisure activities. The independent conscience also remains active as a motive for small-scale design solutions to genuine human problems (figure 58). As the United States becomes an ever more diversified society, consideration of national, regional, ethnic and subcultural ideas and issues contribute increasingly to the shape of its material culture.

58] Independent conscience. A home-owner's concern for the security of pedestrians negotiating the treacherous sidewalk in front of this hillside house led to an elegant and timeless public gesture.

Notes

1 Richard Padovan, *Dom Hans Van der Laan: Modern Primitive* (Amsterdam, 1994), p. 132.

2 L. and J. G. Stickley were brothers of Gustav Stickley.

3 Leslie Greene Bowman, *American Arts & Crafts: Virtue in Design* (Los Angeles, Boston, Toronto and London, 1990), p. 71.

4 *Ibid.*, p. 42.

5 Arthur Pulos, *American Design Ethic* (Cambridge, MA and London, 1983; repr. Cambridge, MA and London, 1986), p. 136.

6 Frank Lloyd Wright, *An American Architecture* (New York, 1955), p. 170.

7 A. Friedman, 'The Evolution of Design Characteristics During the Post-Second World War Housing Boom', *Journal of Design History* vol. 8, no. 2 (1995), p. 144.

8 Quoted by Peter Stanfield, 'Heritage Design: the Harley-Davidson Motor Company', *Journal of Design History*, vol. 5 no. 2 (1992), p. 142. Stanfield gives a detailed account of the process used by H-D to reinvent its product as uniquely American.

9 'Pontiac, The Most Beautiful Thing on Wheels', advertisement in *Saturday Evening Post*, 2 July, 1949.

10 'Futuramic Oldsmobile', advertisement in *Life*, 22 November, 1948.

11 Hon. John G. Winant's Foreword to Julian Huxley, *TVA: Adventure in Planning* (London, 1943), p. 5.

12 *Ibid.*, p. 75.

13 *Ibid.*, p. 77.

14 Spiro Kostoff, *America By Design* (New York and Oxford, 1987), p. 318.

15 Arthur J. Pulos, *American Design Adventure* (Cambridge, MA and London, 1990), p. 18.

16 Network Enterprises Inc., *Classic Wheels, The Jeep*, first broadcast 1995.

17 Dieter Oestreich, 'Some Modern Approaches to the Problem of Form', *Industrial Design*, vol. 6, no. 7 (July 1959), p. 74.

18 Complexity theories, and their origins in computer science, mathematics, meteorology, architecture and sociology, are discussed at length by Charles Jencks in *The Architecture of the Jumping Universe* (London, 1995).

19 Kevin Kelly, 'The Future is Organic', *Observer Life* 18 June 1995, p. 24.

20 K. G. Pontus Hulten, *The Machine* (New York, 1968), p. 20.

21 Jencks, *The Language of Post-Modern Architecture* (London, 1977), p. 96.

22 Martina Duttmann and Friederike Schneider, *Morris Lapidus: Architect of the American Dream* (Basel, Berlin and Boston, 1992), p. 6.

23 *Ibid.*, p. 90.

24 *Ibid.*, pp. 102-3.

25 *Ibid.*, p. 109.

26 Raymond Loewy, *Industrial Design* (Boston and London, 1979), p. 34.

27 Donald B. Fouser, 'They're Built to Save Lives', *Providence Sunday Journal*, 26 April, 1959.

28 'Safety', *Consumer Reports*, vol. 23, no. 4 (April 1958), p. 194.

29 R. Buckminster Fuller, *Ideas and Integrities* (Toronto, 1963; repr. Toronto, 1969), p. 192.

30 *Ibid.*, p. 278.

31 Victor Papanek, *Design For the Real World* (Stockholm, 1971; repr. London, 1991), p. 12-13.

32 *Ibid.*, pp. 303-5.

33 The line of 'Good Grips' products resulted from a collaboration between Betsy Wells Farber of OXO International and Peter Stathis and Stephan Allendorf of 'Smart Design', an industrial design consultancy based in New York.

4 Materials and technology

'I just want to say one word to you ... just one word.'
 'Yes sir?'
 'Are you listening?'
 'Yes sir.'
 'P-l-a-s-t-i-c-s.'
 'Exactly how do you mean that?'

When Mr McGuire issued that famous word of advice to Benjamin Braddock in the 1968 film, *The Graduate*, he drew a perplexed reply typical of the public reaction to plastics during the past hundred years. Their alchemical origins, ability to take any shape, color or texture, their other-worldliness in all respects, has evoked bewilderment and every other conceivable reaction, from deification to loathing. But if one type of material were associated in the popular mind with American design, it would probably be plastics. Plastics have become a necessity, even an addiction.

The trade names of the early plastics formed the language of the new chemical age: 'Bakelite', 'Lucite', 'Vinylite', 'Rayon' and 'Nylon' were the magical substances of the first half of the century. And part of our ambivalence to them results from their early use as cheap substitutes for expensive natural materials such as ivory, tortoiseshell, silk, leather or crystal. By the outbreak of the Second World War, Bakelite production had reached 50,000,000 pounds a year, much of it used to imitate wood; five times more Rayon was used than genuine silk by the American textile industry; in all, half the world's supply of synthetics was produced in the United States. And initially, most of their visible uses were ersatz.

At the start of the century, we lived in a world of objects made of substances for which most people felt some affinity. Materials were thought to embody specific sets of values and feelings; wood was warm and tactile; glass and ceramics were delicate and fragile; metals were cool and precise. And these associations could be translated into a set of forms appropriate to each material alone. Trees, as the source of timber, formed a well-loved part of our natural habitat; and the techniques of making wooden objects were often visible, as in Craftsman furniture; sawing, tenons and dovetails could be seen and were appreciated as products of human craft

skills. Similarly, metals were mined, smelted and cast; then they were hammered, riveted and screwed, polished or painted. All these processes were reflected in the appearance of common objects from bracelets to locomotives.'Truth to materials' was a maxim of conscientious design which filtered through to popular attitudes and tastes during the first half of the century – or as long as the domestic environment seemed to be made up primarily of materials taken, more or less, directly from nature. And our sentimental attachment to trees and the earth's clay was transferred into objects made from them.

By contrast, plastics were bewildering in their range and variety of type. Their origins were mysterious to the ordinary person and the means of fashioning them into useful artifacts showed no trace of human involvement. Chemical compounds derived from coal, petroleum or cellulose were manipulated by injection molding, compression molding, blow molding, vacuum forming, or extrusion to produce objects which might be clear, translucent or opaque, soft or hard, smooth or patterned. And, before long, they were available in any color of the rainbow. Even the word, 'plastics', did not mean much. It referred to a highly disparate species of materials subgrouped into families on the basis of their chemical compositions or their method of manufacture (e.g. thermosetting or thermoplastic). From the public perspective, what united them as a single phenomenon was their origin in modern chemistry and their promise of an entirely new world of material plenty, achieved cheaply and instantaneously out of nothing.

The transformation of our surroundings by synthetics required design to find ways of making the new materials acceptable and attractive. Fashion textiles provided the lead. In a fashion illustration published in 1939 entitled 'A Living Symbol of the Chemical Age', a model is shown in an elegant interior setting wearing an up-to-date, but conventional costume. The caption under the Kodachrome photograph reads, 'She wears no silk, wool, linen, cotton or leather – no jade, ivory or pearls. All is synthetic. From cellophane hat, rayon dress and gloves to plastic pearls and bracelet, patent-leather shoes with plastic heels, and a handbag with a "Lucite" plastic frame, her outfit is all of laboratory origin.'[1] But the fiction was plausible.

In the second half of the century designers and the public learned to appreciate the aesthetic possibilities of new materials mainly as a result of commercial pressure. The refinement of synthetic furs offered manufacturers and retailers the opportunity to open up a youth market for furs by dramatically undercutting the prices that genuine pelts were commanding. In the early 1960s 'fun-furs' were dyed in extravagant colors and cut to youthful

patterns which distinguished them from the serious, classically cut minks worn by well-heeled matrons. Flaunting the chemical origins of its product, one company advertised its fur-like coats with the aggressive slogan, 'It's Not Fake Anything. It's Real Dynel!' (figure 59).

The position of plastics in relation to natural materials was gradually brought into focus. In the 1950s Buckminster Fuller wrote about the early, post-First World War, attitude towards the new chemical materials.

59] Synthetics were linked with youth by the post-war fashion industry. Comfort, ease and unpretentiousness, enhanced by modern materials, became significant characteristics of American clothing design. Inexpensive 'Fun furs' of the1960s rejected the awesome seriousness of genuine furs. In the 1980s and 1990s, the animal rights movement led to a revival of interest in fashionable fake furs.

many of these substances were as yet called 'substitutes' ... Even today ... we speak erroneously of 'artificial' materials, 'synthetics', and so forth. The basis for this erroneous terminology is the notion that Nature has certain things which we call natural, and everything else is 'man-made', *ergo* artificial. But what one learns in chemistry is that Nature wrote all the rules of structuring; man does not invent chemical structuring rules; he only discovers the rules. All the chemist can do is find out what Nature permits, and any substances that are thus developed or discovered are inherently *natural*.[2]

Designers eventually found aesthetics suitable to the specific physical properties of the various new materials. Plastics were quickly found to be particularly useful in the kitchen, through products such as the hygienic Tupperware containers and Formica laminates, in automobile and aircraft interiors, and in the light,

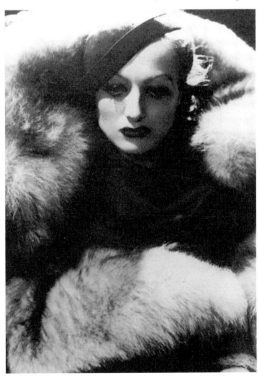

robust and tactile casings for communication appliances, ranging from telephones to lap-top computers.

The initial growth of the American chemical industry in the 1920s and 1930s was accelerated by political motives: American isolationism and fear of dependence on politically unstable foreign countries for materials. The withdrawal of German coal-tar dyes from the American textile and printing industries during the First World War had demonstrated the problems of material dependency: 'everybody remembers how the submarine *Deutchland* sneaked into Baltimore with dyes that sold for dizzy prices. We had so few dyes, and such poor ones, that our coat collars turned our necks blue and green, and Uncle Sam couldn't even properly color his postage stamps'.[3]

Following the Armistice, the American government promptly confiscated German coal-tar patents and assigned them to domestic chemical companies. They also placed high import duties on foreign-made chemicals. The effect of these two measures was to foster the growth of companies such as Union Carbide and DuPont. In the early 1920s, the DuPont chemical company spent over $40,000,000 on experiments and on the construction of factories for the production of synthetic substitutes for materials such as chromium, silk and rubber which had to be obtained abroad. By 1929, the American chemical industry produced plastics and other synthetics worth over $3.75 billion.[4] In this way plastics, as the great imitators, provided considerable freedom and security to American manufacturing. And they were among many other new materials assimilated into the everyday environment.

Light-weight aluminum, magnesium and stainless steel became familiar substances providing the benefits of lightness to increase speed and economy in all types of transport equipment. Plywood, sheet steel, foam rubber, partical boards and a bewildering variety of composites lightened, strengthened and simplified interior furnishings, while carbon fiber, ceramic-metal composites, dichroic glass and various polyesters made 'high-performance' a term applicable in all areas of design from sports clothing to the external cladding of office buildings.

Thus control over economics, production and technical performance has been one of the primary motivators for the development of new materials. While the urgencies of war radically stimulated material innovations, peacetime investment in 'defensive' weapons, space exploration and other well-funded government programs also promoted the development of lighter and stronger materials. Their commercial applications and the realization of their aesthetic potentials followed these larger demands as sophisticated new materials came into private use.

60] From early plywood versions in the 1940s to later aluminum semi-monocoque models, Al Mooney's practical and distinctive looking sport aircraft (1980 model, right) achieved high performance from low-powered engines due to their lightness, efficient aerodynamics and unique tail configuration which also made them instantly recognizable. Another of the most efficient and characterful private planes of the second half of the century was the Beechcraft Bonanza (designed 1945), easily identified by its unique 'butterfly' tail (left).

The durability of plastics made them ideal for applications free from the pressures of market forces. The standard desk telephone designed by Henry Dreyfuss Associates for Bell in the mid-1930s was made in a high quality moulded plastic casing intended for a long working life. Similarly, its appearance, relatively immune to changing fashions, was meant to remain viable for an equally long time.

Alternatively, the use of synthetics for disposable dinnerware, cheap and easily broken toys, casings of small appliances with short lifespans, textiles for fashion garments and material for packaging has made possible a throwaway culture. The cheapness and ephemeral quality of many synthetics was exploited in designs such as the short-lived inflatable chairs and pillows, sold cheaply in hip boutiques during the late 1960s. Such carelessness, born of the post-war economic boom, was seen as the central reality of modern life by Reyner Banham and other celebrants of 'expendability' in American consumer culture.[5]

The lightness, flexibility and ease of manipulation common to many of the new materials enabled designers to raise the performance capabilities of products. Advanced aluminum alloys, lightweight moly steel-tube frames and the conception of the monocoque construction technique enabled aeronautical designers to realize the full potential of streamlining in designs ranging from the Douglas DC-3 of 1935 to small, private aircraft such as the Beechcraft Bonanza and the Mooney M20J. Their smoothly contoured, stressed-aluminum skins had a tautness and fluency which simultaneously contributed to and expressed the planes' overall technical excellence (figure 60).

Expressive use of laminated plywood for lightweight and space-saving furniture was pioneered in the designs of Charles and Ray

Eames which were produced by the Herman Miller company from
the late 1940s. Eames's experiments with laminated wood coin-
cided with technological advances spurred by military uses for the
material during the Second World War, resulting in a sophisticated
state of the art after the war. The range of Eames's furniture began,
at its simplest, with side-chairs whose 'floating' plywood seat and
back were lightly supported by spidery, resilient-looking steel rods.
The thin sections of plywood curved subtly like leaves or shell
forms found in nature, an imagery which appealed directly to a
well-established American taste for the organic.

At the top end of the Eames range was the lounge chair and
ottoman named for the film director, Billy Wilder – a classic in-
stance of product promotion through a glamorous association. The
lounge chair's sectional, cherry- or rosewood-laminated plywood
shells were connected by cast-aluminum struts and supported by
a five-legged pedestal base. Thick, leather cushions nestled in the
shells, making the chair look as womb-like and comfortable as it
was (figure 61). Charles and Ray Eames unveiled the chair to the
public on prime-time television in 1956, and since then hundreds
of thousands have been sold in both authorized versions and
cheaper imitations. The price of the Herman Miller version in the
mid-1990s was over $3,000, placing this chair in an exclusive mar-
ket. Ironically, the Eames-designed furniture made in proletarian
plywood has become restricted, by careful hand assembly and
other quality considerations, to the contract or luxury markets.
Eames's designs using fiberglass are also found at the top end of the
contract market.[6]

Eames's use of new materials for furniture was coincident with
the wide application of concrete, steel and glass in architecture. And
for their own *Arts & Architecture* case study house in California,
Charles and Ray Eames made innovative use of off-the-peg

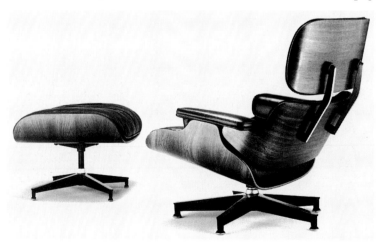

61] Charles and Ray Eames'
experiments with plywood
shell forms during the
1940s led to the creation
of a new vocabulary of
furniture forms in the
1950s. Their lounge chair
with ottoman is the most
opulent example (see
chapter 6).

industrial components including steel framing members, light-weight lattice beams, metal-framed windows and high-performance cladding panels, demonstrating the economy and elegance which could be achieved through the artful use of standard components (figure 62). Also dependent on plastics and other advanced materials were the modular bathroom and kitchen assemblies pioneered by Buckminster Fuller and made widely available by industry

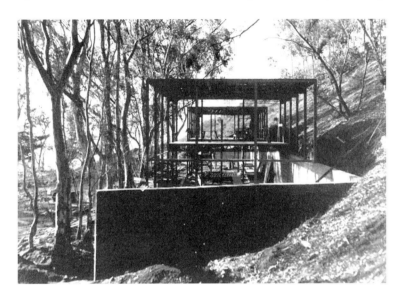

62] The Eames' house was an early exercise in the use of visible steel framing in domestic architecture. It also pioneered the use of stock components, bought from catalogs, in a design which was as aesthetically considered as it was practical. It represented a development from the traditional American timber 'balloon' frame which, nevertheless, remained the preferred method of building individual houses in the United States.

from the 1960s onward. Heating, ventilating and air-conditioning
systems, perfected for both commercial and domestic applications
between 1930 and 1950, made American buildings the most com-
fortable, if not the most economical or healthy buildings ever
constructed.

Recreational sports equipment proved to be a highly fertile area
for both experimentation and commercial applications of new
materials. In the 1990s, footwear was revolutionized for both high-
impact sporting activities and for general walking comfort by the
introduction of blow-molded urethane cushioning in a range of
shoes made by the Nike corporation. The implantation of gas-filled
bladders in the lightweight, multi-layered rubber soles of Nike-Air
sports shoes provided a new level of protection against the re-
peated forceful impact caused by jogging, a major national
recreation of the period (figure 63). The air soles also improved
comfort for court sports and for ordinary walking.[7]

The jointed, polyurethane shell and glass-reinforced nylon
frame of the 'Aeroblade' in-line skates, manufactured from 1993 by
Rollerblade Incorporated, comprised a sleek, lightweight and
highly rigid armature for the foot. Within the expressively
sculpted and ventilated boot, foams and air cushioning bladders
provided comfort for the wearer, while its row of wheels trans-
formed the wearer's body into a high-velocity sporting vehicle.[8]
Although performance specifications were the fundamental deter-
minants of their forms, the appearance of both Nike Air-Wear and
Aeroblades strongly suggested the romantic science fiction imag-
ery of films such as *Robocop* and *Tron*.

In the 1980s and 1990s, designers continued to evoke poetic
images of nature in the most advanced synthetic materials, as they
had done with Bakelite, aluminum and plywood earlier in the
century. The liquid-cast, heat-cured polyurethane used in the
making of divers' fins, designed by Bob Evans in 1994, were based
on his close observations of fish fins. The 'elastic memory' of the

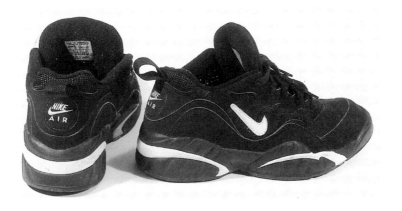

63] Nike have been
consistently at the
forefront of design
innovation linked with the
use of new materials to
achieve comfort and high
performance. The company
has contributed to the
spread of American sport
clothing styles around the
world. Nike Air Trainer,
c. 1995.

material responded, as a fish's fins would, to the thrusting, propellent movements of the body in water. As the swimmer kicked down to move forward, the fin opened to provide maximum thrust; as the leg returned, the fin folded to facilitate the upward movement. The delicate translucency of the jelly-like flippers and the fluency of their attachment to the foot further enhanced their reference to sea-life. And so the amorphousness of plastic materials ensured their continued use for emulation and imitation.

By the outbreak of the Second World War, the diversity of the compositions and technical qualities of plastics began to dislodge the idea that materials had their own innate truth. More recently, the vast proliferation of new synthetic and hybrid versions of 'natural' materials, whose capabilities and visual properties are constantly changing in response to new practical demands, has thoroughly undermined any attachment of immutable values to them. And while postmodernist thinking has freed design from any finite relationship between material and aesthetic, other ethical concerns have grown, globally, along with the new substances.

As early as the 1930s, a large quantity of patent leather was being made from discarded motion picture film stock.[9] This was a matter of simple economy prior to the development of a full-blooded 'throwaway' culture. But the question of recycling has taken on an entirely different importance in the last quarter of the century, when the depletion and pollution of the earth's resources and the ominous degradation of the ozone layer have inspired a new crusade regarding materials, technology, design and consumption. The debate has now shifted from the integrity of aesthetics to the ethical manufacture, use and disposal of materials for which the world's demand is growing exponentially. Both 'Design for Disassembly' and 'Design for Recycling' are ideas which recognize the danger and potential value of waste materials derived from redundant products. The designed-in ability to dismantle products made from a limited number of materials and components now on the agenda of large companies, such as General Electric, is recognition of the strategic function of design.

The development of new materials would not have been possible without vast reductions in the cost of electricity achieved between the 1920s and the 1960s. High-power machines, constructed from tough metal alloys, made possible the economical manufacture of materials such as plywood, Nylon and Formica. Electro-chemical technology significantly cheapened and improved gasoline, making large and powerful cars relatively practical. It also improved the quality of steel from which auto engines were made, increasing their efficiency. The combination of chemistry and electricity

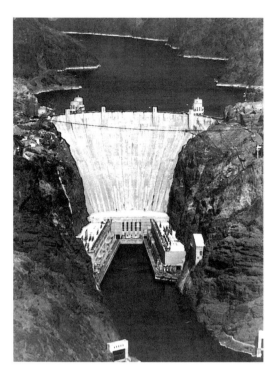

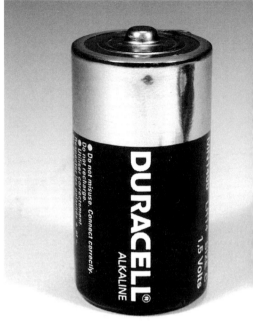

contributed to major improvements in the manufacture of electrical appliances, as well as providing a supply of power cheap enough to run them in households of nearly all economic levels. Electric lamps, kitchen equipment, laundry machines, vacuum cleaners and radios were brought into common use by the growth of the power industry during the first quarter of the century.

Sources of power ranged from the gargantuan to the minute (figure 64). Massive coal or oil fired generating plants, hydroelectric and nuclear generating stations provided ever cheaper (until the 1970s) electricity to homes and factories. The establishment of high-voltage networks transmitted electricity over long distances to factories which could be located away from their traditional sources of power, the river and the coal mine. As a result, new town planning strategies were implemented separating industry from commercial and residential settlements.

Efficient zinc carbon and alkaline batteries provided portable power sources for flashlights and other small appliances. In 1925, RCA hawked its latest model radio to a national audience promising, 'There's a Radiola for every purse', offering '*comfort*! jokes, speeches, songs, dances … *fun!* Everywhere – city, suburb, and far-away farm … *on dry batteries.*' Even after the mass electrification of homes, there were numerous uses for batteries in portable appliances which could be used out-of-doors, especially the miniaturized radios which made use of the transistor, invented by the Bell

64] Mega-power and mini-power. Monumental hydro-electric plants such as Hoover Dam (1931–36) represented the clean new world of regional power generation for what Lewis Mumford called the 'Neotechnic phase' in the history of technology. Among the tiny zinc and alkaline batteries which powered untold millions of individual, portable appliances, Duracell (*c.* 1965) offered particularly high performance and long life. These qualities were effectively communicated by the minimalist design of its casing.

Telephone Laboratory in 1948. Electricity from gigantic structures such as Hoover Dam and from millions of tiny Duracell batteries led us into an age of universal power. By the late 1950s, America was generating and consuming half the world's electricity.

The problems associated with producing so much power have called forth radical initiatives during the second half of the century. When it was generally recognized that fossil fuels would not last forever at expected rates of consumption, nuclear power generation seemed to be a logical solution. A by-product of the armaments industry, atomic power promised a new age of cheap electricity as well as a clean new source of propulsion.

The first nuclear-powered submarine, Nautilus, was commissioned in 1955 and, in the aggressive climate of the Cold War, quickly spawned a large fleet of similar craft; twenty-seven were in operation by the early 1960s. Conventionally-powered submarines, due to their large fuel storage tanks, heavy electric motors and batteries, and as many as four bulky diesel engines, had been nightmarishly cramped and unsanitary environments, even for the relatively short periods of submersion their power plants could sustain. Nuclear power changed all that.

In the Nautilus, only a modest amount of space was required for the processing of fuel; and the small reactor provided considerably more power than the diesel engines and electric motors of earlier ships. Because the nuclear ship could cruise underwater almost indefinitely, or as long as food supplies lasted, interior space and comfort gained a new importance. One of the original Nautilus crew members described its interior accommodations as being, 'like the Queen Mary' – an exaggeration, no doubt. But, in fact, the ship was spacious enough to provide an internal 'grand staircase', a large dining room which doubled as a cinema, and ample sleeping accommodation for all crew members. The large, efficient interiors were humanized by the decorative use of wood veneers, pastel laminates and bright upholstery textiles, vastly improving conditions for the entire crew.[10] The expansion of usable interior space also made possible the accommodation of a larger, lethal cargo of nuclear missiles, which was the business of the submarines.

The nuclear fleet came to include other types of ships beginning with the nuclear merchant ship, *Savannah*, commissioned in 1960 to the US Maritime Administration to demonstrate more publicly the potential of nuclear propulsion. Its sleek white form, adorned with the increasingly familiar graphic symbol of spinning electrons, appeared on the sea as a shining example of all that was progressive in American technology and design and was an impressive advertisement for the nascent nuclear energy industry.

However, in a 1958 article, entitled 'You and the Obedient Atom', Allan C. Fisher Jr wrote cautiously of the problems associated with atomic power.' Some persons fear that, as vast stores of waste build up, their safe disposal may prove a limiting factor in atomic development.' [11] Early fears, of lethal radiation leaks and genetic damage to anyone exposed to even small doses, have not been quelled by the past fifty years of research.[12] And a shocking, near-meltdown at the Three Mile Island nuclear generating plant in Pennsylvania in the late 1970s led to a widespread reappraisal of the 'friendly' atom as the power source of the future. According to E. F. Schumacher, 'The danger to humanity created by the so-called peaceful uses of atomic energy may be much greater (than the atom bomb).'[13]

Alternatives to nuclear power and the traditional, monumental forms of power generation have been proposed, and experiments have been conducted, throughout the last twenty-five years. Solar power was harnessed to millions of pocket calculators during the 1980s and 1990s, but found few larger-scale applications. Exceptions were the huge concentrations of solar mirrors generating power locally in the south-western sunbelt. Extensive clusters of high-tech wind-turbines, their efficiency enhanced by microprocessor technology, were also constructed, most prominently in California, to generate electrical power.[14]

These wind farms contributed a bold new feature to the built environment, as characteristic of its time as were the great concrete dams of the 1930s and the nuclear reactors of the 1960s. Visually, the (200-foot) tall structures, arranged in 'farms' of up to 5,000 towers, combined a primitive grace with streamlining in a novel manner which became symbolic of New Age technology. Yet they too were not without problems – in addition to power, the early wind farms generated high levels of noise which, depending on their position, could make this local power source a nuisance to neighbors who would be their main beneficiaries. At the close of the century, sun and wind power generation are still in their infancy (figure 65).

Design has also provided a link between new technologies and new human desires, such as the quest for speed. The introduction of Polaroid instant photography in 1947 transformed the popular attitude to taking snapshots which had been formed by the original Kodak Brownie camera of 1900. Immediate access to the finished print had a striking psychological effect on amateur camera users, catering to a near universal thirst for immediate gratification also delivered by inventions such as the microwave oven. But the technology which had the most profound affect on American life was the mass-produced automobile.[15]

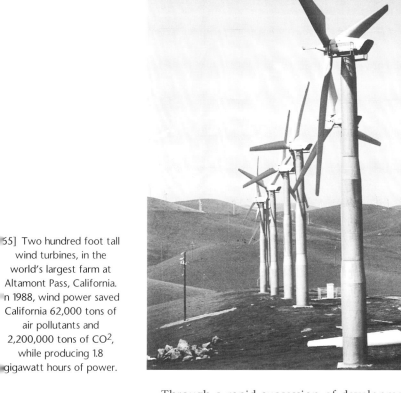

55] Two hundred foot tall wind turbines, in the world's largest farm at Altamont Pass, California. In 1988, wind power saved California 62,000 tons of air pollutants and 2,200,000 tons of CO_2, while producing 1.8 gigawatt hours of power.

Through a rapid succession of developments, beginning with the abandonment of the plannishing hammer in favor of power presses, the efficient use of labor as advocated by Frederick Taylor, the electrification of the hand-drawn conveyor belt, and the construction of a factory designed by Albert Kahn according to the new principles of production, the process of car assembly was revolutionized by Ford. Henry Ford's definition of mass production, was published in the *Encyclopedia Britannica* as 'the focussing upon a manufacturing project of the principles of power, accuracy,[16] economy, system, continuity, speed, and repetition'. These were all parts of a tradition in manufacturing which had been evolving for many decades before they were brought together for the production of the Model T.[17]

Ford's great contribution to the process was the moving assembly line applied to final production in 1913. According to the industrial historian, James Flink, this was less attributable to Henry Ford alone than to a team of highly motivated production engineers and managers Ford gathered around him in the period from 1908 to 1915. They came from a variety of manufacturing

specializations and each brought useful knowledge which, when combined, unlocked the key to true mass production. The economics of mass production had, at its core, the concept of a standard product for which there was huge demand in a domestic market with special characteristics. According to Flink,

> The Model T was the archetype of a uniquely American mass-produced gasoline automobile. Compared with the typical European touring car, the American-type car was significantly lower priced, was much lighter, had a higher ratio of horsepower to weight, and was powered by a larger-bore, shorter stroke engine. In addition to the increasingly greater emphasis that American manufacturers gave to producing cars for a mass market, these characteristics of the American car resulted from the lower price of gasoline and the absence of the European horsepower taxes. [18]

A similar approach to production was applied in the radio industry during its first phase of expansion in the 1920s. But with

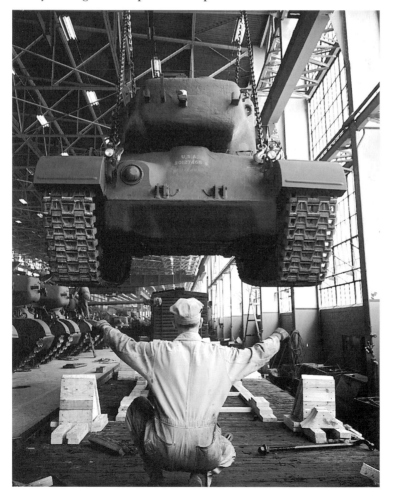

66] Among the big ideas of the century, the moving assembly line has probably had the greatest effect on the living standards of the First World. It also established the military supremacy of governments who used it most effectively.

saturation of the first-time buyer market for both cars and radios and the consequent growth of competition among manufacturers, flexible methods of production superseded Fordist methods in the major industries. The major exception to this rule came with the mass production of military hardware during the Second World War (figure 66). The intensive manufacture of standard products for which there was an insatiable, albeit temporary, demand exploited the ultimate efficienty of the Fordist system. By April 1944, Ford's Willow Run factory was producing a new B24 Liberator bomber aircraft every hour. This was mass production as a weapon in the arsenal of democracy, or how the production line won the war.[19]

From large-scale industrial processes to small-scale domestic tasks, electric motors were the main agents of change in the way jobs were done. The steady pace of Ford's moving assembly line, ensuring efficiency, was made possible by electrification. Around the same time, magazines such as *Electrical World* promoted the domestic applications of electricity for cooking, food storage, house cleaning, laundry and personal grooming. Compact and light-weight electric motors were powering practical equipment such as fans, vacuum cleaners and washing machines by 1910, when 10 per cent of American homes were wired for electricity. By 1930, this figure was up to 70 per cent. In 1917, the Edison Company intro-duced a range of phonographs equipped with 'electrical motors, electrical automatic stops, and complete electrical lighting systems', demonstrating the role of electricity in domestic leisure.[20] Comfort and ease were the hallmarks of American house design, and its equipment was designed to appeal to the same desires.

Before style had significant impact on the design of appliances, simplicity was their major selling point. Potential first-time pur-chasers of new appliances required reassurance that the equipment would not be difficult to use or dangerous in operation. The Atwater Kent radio of 1925 was advertised as providing 'Simplicity and ease of operation'. As a sign that they could afford leisure, American consumers took pride in their laziness; and manufac-turers pandered to it shamelessly. In the later 1920s, the words 'automatic' and 'simplicity' were used to sell every kind of ap-pliance: the Bryant Automatic Gas Furnace, the Frigidaire Automatic Refrigerator (General Electric claimed 'Now a far sim-pler type of Electric Refrigeration for your home … Planning of meals is greatly simplified'), the Graflex camera, ('Perfectly Simple – Simply Perfect'). And in 1933 Philco advertised its Lazy-X radio with electrical remote control for 'The easiest, laziest way in the world to spend a glorious evening!' (figure 67).

The application of technology in American design has consist-ently aimed to facilitate operation, often through the introduction

New! Different!

PHILCO LAZY-X

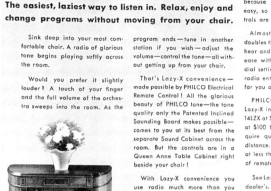

The easiest, laziest way to listen in. Relax, enjoy and change programs without moving from your chair.

Sink deep into your most comfortable chair. A radio of glorious tone begins playing softly across the room.

Would you prefer it slightly louder? A touch of your finger and the full volume of the orchestra sweeps into the room. As the program ends — tune in another station if you wish — adjust the volume — control the tone — all without getting up from your chair.

That's Lazy-X convenience — made possible by PHILCO Electrical Remote Control! All the glorious beauty of PHILCO tone — the tone quality only the Patented Inclined Sounding Board makes possible — comes to you at its best from the separate Sound Cabinet across the room. But the controls are in a Queen Anne Table Cabinet right beside your chair!

With Lazy-X convenience you use radio much more than you ever did before. You listen to a far greater variety of programs — because changing stations is so easy, so simple, and all the controls are right beside your chair!

Almost automatically Lazy-X doubles the number of stations you hear and enjoy — by doubling the ease with which you change the dial setting. A whole new world of radio entertainment is opened up for you and your family!

PHILCO offers the great new Lazy-X in two models — the superb 14LZX at $150 and the smaller 19LZX at $100 for those who do not require quite so much power and distance. The height of radio luxury at less than half the previous cost of remote control!

See Lazy-X at the nearest PHILCO dealer's. Hear it. Buy it. Relax and enjoy the last word in radio performance and convenience.

PHILCO · PHILADELPHIA · TORONTO · LONDON

Sound Cabinet

GLORIOUS TONE HERE

TUNE HERE

Control Cabinet

The glorious tone of the PHILCO Inclined Sounding Board X Models is available also in conventional cabinets.

15DX	$250
23X Radio Phonograph	$195
15X (Illustrated)	$150
91X	$100
43X All Wave	$100
47X Direct Current	$100
71X	$ 80

Federal Tax Paid

PHILCO REPLACEMENT TUBES IMPROVE THE PERFORMANCE OF ANY SET

$18 75 to $250
FEDERAL TAX PAID

A musical instrument of quality

67] American consumer goods are characterized by their promise of comfort and ease. Whether gimmicks or genuine conveniences, many products trade on their labor-saving potential. Philco's armchair radio tuning, introduced in 1933, had long-term design implications, but cloaked its new technology in familiar-looking cabinetry.

of motorized gadgets. The six-way, electrically adjustable front seat, available on nearly all Detroit cars since the early 1950s, is typical of the way in which motors have been used to achieve individual, ergonomic comfort with absolute precision (figure 68). Many such devices which added convenience to the operation of appliances – television and video remote controls for example – have also included in their designs an element of play to increase their attractiveness. Experimental gadgets, such as a robotic, self-motivated vacuum cleaner and floor polisher featured in the RCA Whirlpool 'Miracle Kitchen' of 1958, had limited practical advantages, but signified the ease of the modern ideal home. Indeed, many of the multi-functional vacuum cleaners and complicated looking,

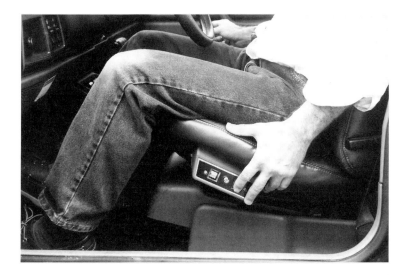

68] Remote-control audio/video tuning and 6-way power seats, standard conveniences for many decades, have contributed to Americans' expectations of environments adaptable to personal specifications of comfort.

69] American consumers considered excessively complicated domestic apparatus a joke, as in the cartoons of Rube Goldberg, 1920. Apparent simplicity is the ideal.

automatic furnaces of the 1910s and 1920s could have provided inspiration for the crazed inventions of Professor Lucifer Butts, himself an invention of the cartoonist Rube Goldberg (figure 69).

After the Second World War, the electric motor was widely adapted to a new combination of home-based work and leisure, the hobby. Many leisure pastimes, ranging from gardening to model railways, became motorized. Do-It-Yourself was one of the fastest growing industries during the great American nesting binge of the 1950s. With rapid house building increasingly reliant on standardization, new home-owners were often left with the job of 'finishing' attics and basements and of customizing their lookalike homes with built-in furniture, shelving and decorative features such as wood panelling, 'cornices' to hide curtain railings, garden structures and the ubiquitous basketball hoop over the garage door.

The Black and Decker company produced, for domestic users, a range of portable electric tools based on heavy-duty equipment employed in the construction industry since the 1920s. By 1952

over a million of their ¼-inch utility drills had sold at around $20 each. A range of Home-Utility accessories was available for sanding, grinding, polishing and sawing, using the drill's motor as the basic component of an electrified home workshop. For this reason, the Black and Decker system falls into an American design tradition of versatility and convertibility. The drill's smoothly sculpted, satin aluminum casing, reminiscent of the streamlined, muscular bulges of a P-51 fighter plane, took the form of a science fiction Ray-gun, its pistol grip and barrel embellished with serious looking ventilation holes and slots (figure 70).

The technology of sending and receiving sound waves and images through the ether was dependent, until the 1950s, on instruments made up of delicate and cumbersome valves and soldered wire circuits which were prone to failure. Nevertheless, by mid-century 93 per cent of homes had radios and 7.5 million televisions had found their place in American living rooms.[21] Radios had evolved from functional contraptions toward a standard set of type-forms. These included the console model, large floor-standing furniture pieces in period styles, often including record players and, later, televisions to become 'home entertainment centers'. The table model, usually with a plywood or plastic cabinet, was designed to function as a minor decorative element of a room. Finally, there was the small and relatively lightweight portable (at around five pounds), with strap handles, encased in bright colored plastics for the beach, or styled as airline luggage for travellers.

The invention of the transistor in the late 1940s, however, began a revolution in the design of audio-visual equipment which made the traditional types of receiving sets obsolete within a decade. The replacement of valves and copper wires with the silicon-based technology of transistors and printed circuits, combined with the universal move to lightweight metal and plastic casings, meant that radios and televisions became relatively shock-proof and, thus, safely transportable. The miniaturization of all their elements, except for the larger television picture tubes, liberated audio-visual appliances from their traditional positions in the home and allowed their users increased freedom of movement. The introduction of cassette tapes and compact discs further personalized the experience of listening and watching.

But although American manufacturers had pioneered micro-electronics in the 1940s and early 1950s, they lost the initiative to Japanese and other Pacific-rim makers who increasingly dominated the mass market for audio-visual goods from the 1960s onward. However, one area of electronics in which American manufacturers remained leaders was the growing computer industry. The

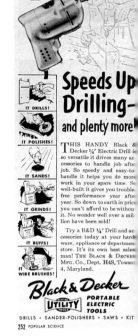

70] Work as fun. The home workshop, equipped with an ever-expanding range of useful gadgets became a play room for adults. The design of power tools often included an element of fantasy as in the Ray-gun shape of the Black & Decker electric drill

relentless drive toward miniaturization, portability and simple visual presentation of highly complex equipment and processes summoned up some of the most characteristically American design responses in the latter decades of the century. IBM (International Business Machines) pioneered the development of computer technology from its beginning in the 1940s. The consistently high standards of design set in the 1950s and 1960s by their Consultant Design Director, Eliot Noyse, ensured that a coordinated aesthetic evolved with the fast changing technology of computer hardware. The large, rectilinear grey boxes which concealed the inner workings of the RAMAC computers of the mid-1950s conformed to the spare International Style aesthetic of buildings which Noyse commissioned to house offices of the complex IBM corporation itself. Their eminently rational forms also symbolized the faultless logic of the computing process.

The domestication of computing was accomplished by Apple Macintosh personal computers in the 1980s and 1990s. Enormously increased speed and weight reduction of computers brought about by advances in superconductivity, price reductions achieved through global production and distribution, and the design of visually clear and easy-to-use screen displays led to the wide popularity of the 'Mac' among domestic and professional users. The original Macintosh, launched in 1984, was a compact, one-piece unit. With its keyboard and mouse attached, it took up little desk space and could be transported easily. The Mac resembled the then current generation of white plastic-bodied portable televisions. This familiar association, combined with the simplicity, robustness, pleasant tactile qualities and refined detailing of the unit, eased the technophobia of many new computer users.

The Macintosh PowerBook lap-top computer, announced in 1990, extended the qualities of ease and convenience which had made the earlier Mac attractive; and its matt grey plastic casing was moulded in geometries reminiscent of the toy space ships and land vehicles produced to accompany the *Star Wars* films of the 1980s. Although the PowerBook's wide popularity resulted mainly from its practical virtues, its toy-like scale and playful imagery had the added advantage of making work seem like fun (figure 71).

While IBM design turned a raw, memory-machine into the core of a cool and superior environment for the exercise of supreme logic, Macintosh created a powerful system for performing everyday tasks which was friendly and human-centered. The computer, like a Black and Decker drill, was the ergonomically-shaped tool at the center of an extensive range of accessories, including scanners, printers, modems and video, which allowed users to build a customized workshop to serve their personal requirements. In

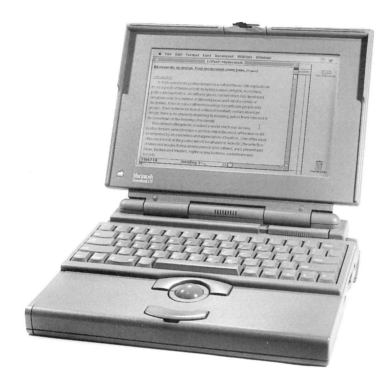

71] Robust forms, akin to the space hardware of the Star Wars films (and their spin-off toy models), made the Macintosh Powerbook lap-top computer (1990) appear advanced, dependable and playful. Modern electronics have put massively powerful design tools within the reach of millions of users.

addition, standardization of the product made it the Model T equivalent of the silicon age.

The Mac's user interface was designed to make its awesome capabilities easily accessible. The screen display, designed by Susan Kare, was devised to emulate the qualities of books and the processes of manipulating words or images in traditional published form. Indexes and dictionaries were presented in pull-down menus, while electronic processes such as cutting and pasting or highlighting text related to traditional operations using paper, pens and scissors.[22] Calendar, calculator, notepad and other amenities, represented by familiar icons, appeared on screen at the touch of a button. The personal computer enabled individual users to store and rapidly manipulate vast amounts of information and to work with it anywhere and at any time.

Computer aided design (CAD) and computer aided manufacturing (CAM) techniques also contributed to increased efficiency in the conception and production of goods. Earlier developments in mass-production technology, such as the introduction of flexible machine tools by the General Motors Corporation in the 1920s to provide for product differentiation, were augmented by computerization in the last quarter of the century. Computers increased the potential of flexible manufacturing systems (FMS) to produce small, but economically viable production runs of goods for special

markets. These innovations were particularly useful to the textiles and automobile industries which superficially update their products on a seasonal or annual basis.

Computers also fundamentally altered the design process. Modelling of three-dimensional designs on the screen superseded the use of architectural study models and clay modelling of car bodies. In graphic design and typography, the technique of 'layering' opened up new relationships between text, images and symbols, exploring complexities of meaning, previously suggested through the medium of montage. Computer technology, informed by deconstruction theory, has freed graphic communication from its traditional central aim of clarity. Youth culture and music magazines, such as David Carson's *Raygun*, and graphic work emerging from Cranbrook Academy have exploited the distorting potential of the computer, through stretching, blurring and other means of typographic customizing, to create text/images in which poetic resonance and the evocation of subjective interpretations are the primary objectives.[23]

Changes in attitude toward the techniques of production have led to a more pluralistic concept of manufacturing at the end of the century. In the period of high Fordism, a single system for making a standard object was seen as the most efficient means of providing a high standard of living to the greatest number of people. As manufacturing technology became more sophisticated and, hence, more flexible, products could be tailored to customers' specifications or targeted at particular segments of a market. Yet manufacturing economy was still the dominant factor in determining what goods were available in the mass marketplace. Hand-made luxury goods were always there for those who could afford them. But the majority of people who wanted something unique were reliant on their own skills to create it: hence, the growth of do-it-yourself tools and materials.

An insatiable thirst for uniqueness was watered liberally by easy-to-use materials and power tools which enabled millions of people to customize their homes, clothes and cars. In effect, this allowed them to take control of the design and production processes, making economically things which previously could only be made by skilled craftspeople, at a price. Carpentry and metalwork joined traditional domestic activities, such as sewing and gardening, due to the ease of manipulation and availability of new materials and tools and the encouragement, general technical instructions and advertisements provided by mass-circulation magazines such as *Fine Woodworking*, *Popular Mechanics* and *Custom Car*.[24]

Along side the amateur craft activity of the post-war period, there arose a revival of professional craft practice. The development of

low temperature glass technology by Domenic Labino, research director in the early 1960s for John S. Manville Fiber Glass company, enabled craftspeople, such as Harvey Littleton, to exploit glass in new ways and to new purposes. Originally a potter, Littleton saw glass as an alternative material with greater expressive potential than clay due to its liquidity and transparency. Labino's technical innovations in glass formulae and kiln construction made possible the establishment of small glass studios specializing in the production of absolutely unique objects intended to appeal to the senses.[25] This way of working was distinctly different from the methods employed in the great glass factories such as the Corning Glass works in New York. To express the distinctiveness of his approach, Littleton adopted an aesthetic of immediacy, communicated through melting, irregular forms and accidental effects of color, which set the objects apart from the pure geometries and tightly controlled colors favored by large manufacturers of high quality glass. Through exhibitions, teaching and publications, Littleton achieved a reputation as 'the "father" of American studio glass' (figure 72).[26]

Like the Arts and Crafts Movement of the 1900s, the studio crafts upheld a belief in the inherent nature and value of materials.

72] Ambitious new approaches to crafts have come to require collaboration and teamwork. Here glass-blowers are seen working under the direction of Dale Chihuly – a modern ballet often accompanied by loud, rhythmical music. 1990s.

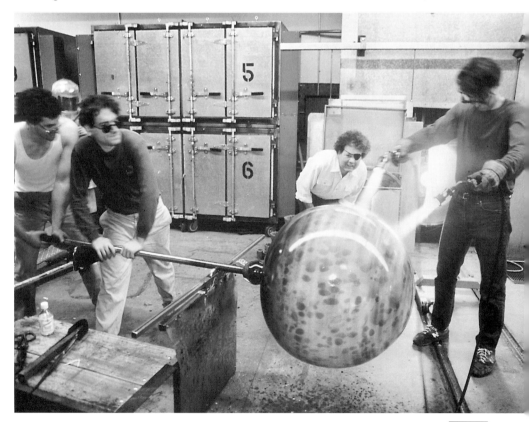

However, in the spirit of modernism, studio craftspeople sought new potentials for materials, whether they were natural materials, reformulated versions of traditional materials worked in new ways, or entirely new, synthetic substances, such as the plastics increasingly favored by jewellers and weavers. Their experimental approach to materials and techniques and their aggressively anti-rational aesthetics created an alternative to both commercial manufacturing and the traditional culture of crafts.

New types of craftwork also developed in areas of design far removed from the making of chairs, pitchers and knitted textiles. The substance and technology of cinema, telling a story through connected images and sounds, with artificial settings and costumes, placed design in an ephemeral context of light, shadow and time. Collaborative professional film-making and individually produced home-movies both provided the historical and technical basis for new interactive media which involved their viewers in creating personal audio-visual experiences. Late in the century software design has come increasingly to rely on traditional craft techniques such as trial and error, selection, correction and polishing up. Thus the interactive craft of the information era parallels the DIY world of tangible materials.[27]

Describing the nature of manufacturing materials at the turn of the millennium, William Duncan has written, 'The single most important material used by manufacturers in the future will be data … the raw materials will be chemical "slurries" … that can be instantaneously designed, manufactured and customized for and by the end user'.[28]

Given the widespread celebration of consumer choice offered by new technologies, and the continual increase in the production of goods, discussions were raised regarding the ethical issues this choice implied. Over time, two approaches surfaced to the problems of waste, pollution and imbalanced distribution of resources and technology. One was direct, the other indirect; both were utopian in character.

The direct approach was motivated by social concern and sought coordinated solutions to problems brought about by the run-away effects of technology. Lewis Mumford declared that 'All thinking worthy of the name must now be ecological.'[29] His sentiment reflected the ideas promoted by Buckminster Fuller beginning in the 1920s. Fuller's student and friend, Victor Papanek, sustained and developed the ecological argument into the 1990s through his design practice, writing and teaching.

The initiatives promoted by the ecology movement, 'green' design and other contributors to the debate over design ethics were based on a revision of the notion of progress. The nineteenth-

century concept of technical progress relied on vast scale in all aspects of technics: big locomotives, huge steamships, massive factories, the weight and mass of the iron and steam technology and the crude use of mass labor. The twentieth century inherited the idea of 'biggest is best' in Fordism. Traditional definitions of progress also emphasized the increasing dominance of machines. However, more recently Schumacher, Papanek and others declared that progress could mean small, rather than big, and that it could be achieved through individual initiative as well as through comprehensive action and legislation. Like Mumford, they advocated 'soft' technology, sophisticated and efficient. The emphasis of the ecology movement was to find technologies and materials which would satisfy human wants, but do less harm to the environment than current means. Their slogan was 're-use, recycle and dispose responsibly'.[30]

Papanek pointed out the development of thermoplastics and elastomers which are easy to recycle. He cited biodegradable polyesters (PHBVs), 'manufactured' by micro-organisms, which could replace many petroleum-based plastics used in packaging. He also advocated initiatives related to the technology of production; design for disassembly to facilitate recycling of materials; adaptive re-use of products which have outlived their original function; and self-assembly of products by their users to save energy in production and delivery.

Self-assembly has been a hall-mark of American consumption for generations, but has remained at the periphery of design consciousness. The owner-built home is an American tradition. And in modern industrial and commercial terms, the post-Second World War period saw a boom in house kits. During the early 1950s Sterling Ready-Cut-Homes advertised extensively their 'cut-to-fit homes' for self-builders or self-contractors. Sterling's color catalog showed a choice of fifty-seven designs. Their kits included 'easy to follow plans', all lumber, roofing, nails, glass, hardware, paint, doors and windows. The prices, from $2,150 in 1952 including delivery to the building site, were made possible by economies in quantity production and bulk purchasing of components.[31]

In the atmosphere of cooperation carried over from the Second World War and Korean War years, members of the Hickory Hill cooperative built thirty-two homes in Tappan, New York, during the early 1950s. Mostly young professionals recently demobilized from the armed services, the owner-builders contracted out around 75 per cent of the work to professionals and collaborated on the rest, including design, producing a small community built to their own specifications, with the investment of their own labor yielding significant cost savings.[32]

They were the same people who, once they had moved into their new homes, would have constructed their own Heathkit radios, amplifiers or televisions. These were popular high quality products supplied in kit form for home assembly by amateur enthusiasts. They offered as much as two-thirds savings in cost and gave their builders useful knowledge about the workings of the product. They also embodied the cachet of the builder's cleverness and his (these were mainly toys for the boys) seriousness about music reception and reproduction.

Since the 1950s, knock-down delivery of domestic and office furniture has been a common way for manufacturers to keep down costs, but it requires the participation of the buyer in the production process. As Papanek pointed out, the furniture industry commonly delivered its products with the caution 'some assembly required'; this is also true of toys and bicycles. And many purchasers of high quality products for niche interests, such as harpsichords or gliders and sport aircraft, would expect to assemble the product themselves (figure 73).

The second, indirect, approach to the use of materials and technology in the late twentieth century predicted the replacement of physical goods by 'information goods', a McLuhanesque concept which saw imagery and text as the new commodities. A parallel tendency in the development of technology was predicted in 1934 by Mumford who wrote of the diminution of machines:

> The machine has proved to a great degree self-eliminating: its perfection involves in some degree its disappearance. The old machines will ... be replaced by smaller, faster, brainier, and more adaptable organisms, adapted not to the mine, the battlefield and the factory, but to the positive environment of life.[33]

73] DIY goes high-tech. The builder of this Glasair II airplane kit designed and constructed the overhead and between-seats consoles, containing flight controls and the CD music system, to his personal requirements, c. 1995.

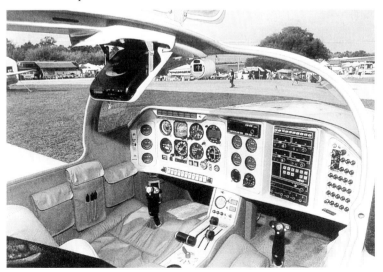

His prophesy was consistent with the general trend throughout the century towards dematerialization in all things: the replacement of books by movies, radio and TV; the overthrow of the art object by 'concepts' and events; the importance of software over hardware. 'Culture now has a software dimension equally as important as its hardware. Processes which were at one time as real as bricks and stucco are now, practically speaking, invisible. Electric cables, telephone lines and radio waves carry a huge proportion of what makes modern environments work.'[34]

Like Papanek, many late-century designers took up the idea of re-using the existing fabric of the material world to new and unexpected purposes. The decaying fabric of lower Manhattan warehouses became the preferred accommodation of artists and other space-loving creative people in the 1970s and 1980s, as disused car-tops had been transformed by advanced design to provide extraordinary shelters for hippy drop-outs in the Colorado desert during the 1960s. (see figures 16 and 56) Whereas Papanek's worthy ideas were focused mainly on the ecological benefits of re-use, avant-garde amalgamists exploited its poetic nature. Their recycling was undertaken primarily for dramatic purposes by tuning into the unstable historical resonance of the usable fragment.

At the end of the century an 'ideal contemporary material was meant to be lasting, easily recycled, reusable, non-invasive, and more flexible'.[35] The design world looks forward to responsible and diversified production including improved large industries for mass manufacturing, small-scale factories for flexible production, craft workshops, and user-makers undertaking design as well as production. There is a widely expressed urge to end or limit expendability in an effort to conserve resources and energy.

A most promising material late in the century is refuse, associated with the process of bricolage. The poetry of an old technology transposed into a new and unexpected context is better than the latest, purpose designed product. In jumble sales and swap-meets and junk yards full of architectural and automotive salvage all over the country are found the materials of the *fin de siècle*. The chic designs of the avant-garde and the homes of ordinary people are composed of the found and the fabricated, inventive combinations of old and new materials, of high technology and low technology (cottage-computer work), of the advanced and the archaic, of the rational and the romantic and, on the Internet, of the public and the personal.

Notes

1 Frederick Simpich, 'Chemists make a New World', *The National Geographic Magazine*, vol. 76, no. 5 (November 1939), p. 601; 'Plastics in 1940', Fortune, vol. 22 (October 1940), p. 91.

2 R. Buckminster Fuller, *Ideas and Integrities* (Toronto, 1963; repr. Toronto, 1969), pp. 75-6.

3 Simpich, 'Chemists make a New World', p. 608.

4 Richard Hofstadter, William Miller and Daniel Aaron, *The American Republic*, vol. 2 (Englewood Cliffs, 1959; repr. Englewood Cliffs, 1965), p. 453.

5 The aesthetics of 'expendability' was introduced by Banham as a central concern of the Pop Art movement in the meetings of the Independent Group in London during the mid-1950s. Quoted by Lawrence Alloway, in Lucy Lippard, *Pop Art* (London, 1966), p. 32.

6 'Fiberglas' (TM) was first produced by Corning Glass Works in 1937. It is composed of resin reinforced with glass fibers.

7 Paola Antonelli, *Mutant Materials in Contemporary Design* (New York, 1995), p. 73 (figure 63).

8 *Ibid.*, p. 36.

9 Simpich, 'Chemists make a New World', p. 625.

10 *Nautilus*, BBC TV (London), broadcast 4 October 1995.

11 Allan C. Fisher Jr, 'You and the Obedient Atom', *The National Geographic Magazine*, vol. 114, no. 3 (September 1958), p. 344.

12 E. F. Schumacher, *Small is Beautiful* (London, 1973; repr. London, 1975), pp. 112-15.

13 *Ibid.*, p. 112.

14 Around 17,000 high-tech wind-turbines are operating in California as of 1997.'The Great California Wind Rush', *The Independent on Sunday*, 27 October 1996, p. 44. See also James Corner, *Taking Measures: Across the American Landscape* (New Haven, 1996).

15 For an assessment of mass production as 'a peculiarly American art', see Christy Borth, *Masters of Mass Production* (Indianapolis and New York, 1945), a technological history set in a social context and told through a series of portraits of individuals, mainly associated with the car industry, who contributed significantly to the development of mass production.

16 Accuracy in the production of automobiles was pioneered by Henry Leyland, President of Cadillac, who introduced the use of Johansen gage blocks to ensure precision manufacturing of fully interchangeable parts.

17 James Flink, *The Car Culture* (Cambridge, MA, 1975), p. 75.

18 *Ibid.*, p. 52.

19 For a fuller account of aircraft production during the Second World War, see Borth, *Masters of Mass Production*.

20 David Gebhard, 'Traditionalism and Design: Old Models for New', in Whitney Museum of American Art, *High Styles: Twentieth-Century American Design* (New York, 1986), p. 52.

21 Arthur Pulos, *The American Design Adventure* (Boston and London, 1988; repr. Boston and London, 1990), pp. 296-9.

22 Richard Sexton, *American Style* (San Francisco, 1987), p. 51.

23 Mark Kemp,'*A Technological Discourse*', unpublished dissertation, Grays School of Art (Aberdeen, 1996), p. 27.

24 According to Victor Papanek, four thousand million dollars a year are currently being spent on car customization in the United States: Victor Papanek, *The Green Imperative* (London, 1995), p. 65.

25 Harvey Littleton's redefinition of glass as a medium of expression is recorded in his book, *Glassblowing: A Search for Form*, published in 1971.

26 Martin Eidelberg, *Design 1935–1965: What Modern Was* (New York and Montreal, 1991), p. 384.

27 Tom Mitchell, 'The Product as Illusion', in John Thackara (ed.), *Design After Modernism* (London, 1988), p. 211.

28 William L. Duncan, 'Manufacturing 2000' quoted in Antonelli, *Mutant Materials in Contemporary Design*, p. 19.

29 Lewis Mumford, quoted by Papanek, *The Green Imperative*, p. 17.

30 *Ibid.*, p. 47.

31 Advertisement for Sterling Ready-Cut Homes, *Popular Science* (January 1952), p. 34.

32 Arthur Bartlett, 'How to Help Build a House', *Popular Science* (April 1952), p. 151.

33 Lewis Mumford, *Technics and Civilization* (London, 1934), p. 428.

34 Nigel Coates, 'Street Signs', in Thackara, *Design After Modernism*, p. 99.

35 Antonelli, *Mutant Materials in Contemporary Design*, p. 18.

5 Designers and makers

Since Vasari's *Lives of the Most Eminent Painters, Sculptors and Architects* and the notorious autobiography of the Florentine goldsmith and sculptor, Benvenuto Cellini, both written in the sixteenth century, artists and their biographers have crowed about the importance of their patrons (popes and princes in Cellini's case) and have presented their achievements as fruits of their personal genius. Following this tradition, Raymond Loewy made good use of his dapper appearance, luxurious lifestyle and 'friendships' with VIPs, including André Malraux and John F. Kennedy. While establishing his role as leader of the emerging industrial design profession, he linked the products of his design consultancy with his personal charisma.

The industrial designers of Loewy's generation modeled their professional images most closely on architects, whose working practices and professional organizations they also emulated. The architect Stanford White was a flamboyant personality whose life and work were linked in the public mind. And the best-known American architect of this century, Frank Lloyd Wright, maintained a consistently high public profile throughout a very long career. His colorful life and pithy phrases provided rich material for the image of the modern design genius as celebrated in Ayn Rand's novel, *The Fountainhead*, which sold nearly half a million copies within five years of its publication in 1943, spawned a film starring Gary Cooper, and is still read today.

Like architecture, industrial design practice was about communicating intentions to others; business people, engineers and end users. And this was Loewy's special talent. The appearance of his offices, the renderings and clay models he produced to explain his proposals, and his practical statements on the functions of art communicated trustworthiness to his corporate clients. His Gallic charm, elegant looks and sophisticated lifestyle attracted a popular audience who would buy the things he designed in the hope that a bit of his glamor would rub off. He also communicated well with product engineers and, indeed, with his own staff, who were generally loyal to him despite his unflinching occupation of the limelight with work which was often theirs.

Beginning as a freelance fashion illustrator, Loewy soon established a consulting agency which would take on any sort of design problem, from one-offs such as the interiors of NASA's Skylab orbital vehicle, to designs produced by the millions, including the Lucky Strike cigarette package of 1940. Despite their diversity, projects such as these reflected the social and collective nature of his work. Loewy gathered around him a team of specialists including architects, engineers, market researchers, model-makers and illustrators. His talent lay in orchestrating their efforts. In his 1979 memoir, *Industrial Design*, Loewy wrote

> Design work, even when it emerges from a specific vision, is often a collaborative experience, and I trust the reader understands this. It is culturally and historically affected and has its influence on later periods – it obviously exists within a continuum … not only within my career, but, much more important, within the time.[1]

The goal of his work was to make modern life more comfortable, convenient and attractive for the greatest number of people. And his own life was paraded as evidence of the realization of that goal. He and his elegant wife, Viola Erickson Loewy, who administered his European agencies, were seen to live in a world of beautiful things; and their extravagant homes and cars, major corporate clients, impressive fees and contribution to company turnovers were news. Even the toothpaste he used, squeezed from a Loewy-designed tube, was notable (figure 74).

Time magazine honored him in 1949 as the first member of his profession to appear on their cover. The pensive cover portrait was surrounded by ghost images of his most familiar designs, the cars, buses and locomotives seeming to emerge directly from Loewy's handsomely coifed head. Although the cover article attributes

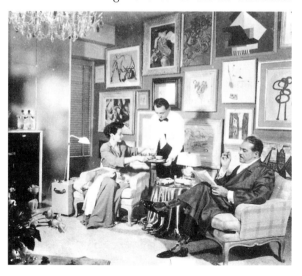

74] Raymond and Viola Loewy at home. In the 1940s, this designer's sophisticated image, his Charles Boyer Frenchness, imparted glamour to product designs which were mostly aimed at the low-priced end of the consumer market. His was an inspirational as well as an organizational talent.

some of the credit for the products to clients and to Loewy's 143 staff members, the overwhelming impression is of the creative genius from whose mind and will masterpieces flow.[2] In such a large consultancy with major offices in London, Paris, New York and South Bend, Indiana, structured under divisional heads who were responsible for specific types of work, the importance of Loewy's personal contribution to individual projects is questionable. But like Cellini's *Life*, Loewy's colorful autobiography, *Never Leave Well Enough Alone*, published in 1951, provided readers with the opportunity to identify with a fascinating central character and to become immersed in a dramatic narrative of struggle and success.

Although the group who pioneered the industrial design profession included such towering figures as Walter Dorwin Teague, Henry Dreyfuss, Harold Van Doren and Russel Wright, Loewy became the most widely known.[3] Yet he was not alone in the belief that self-promotion was the quickest route to increased sales and higher profits. Norman Bel Geddes was, if anything, an even more flamboyant character. His theatrical connections and background in stage design had led him to view design as a visionary act, and his methods of selling the vision earned him a reputation as 'the P. T. Barnum of industrial design'.[4] Henry Dreyfuss had also been a theater designer, while Harold van Doren had starred in *La Fille de l'Eau*, an early silent film by the French director, Jean Renoir.[5] These men all scented the entertainment potential of design which was demonstrated most convincingly in their ambitious collaborative endeavor, the New York World's Fair of 1939.

The fair was the culmination of the first stage in the development of a profession which had been conceived in the boom of the 1920s and consolidated in the deep economic depression of the 1930s. The major theatrical set-pieces of the fair dramatized an optimistic vision of the fully mechanized American future: a streamlined world of unlimited mobility where everything was new and clean. The World's Fair gave the showman-designers their greatest single opportunity to entertain a massive public, many of whom were first seduced by the modern style at the fair. At the same time, the chief priority of these designers was to promote their biggest clients: General Motors, Ford and Chrysler.

The fair was the apex of the pioneering phase of industrial design. And although the large pre-war consultancies continued to flourish after the Second World War, a younger generation of college-trained industrial designers took up less visible positions in agencies which increasingly specialized in graphic design, packaging or product design. Many large corporations set up their own in-house design teams which served the needs of corporate

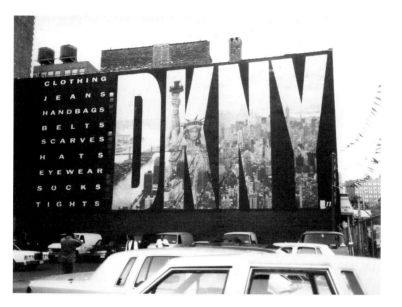

CLOTHING
JEANS
HANDBAGS
BELTS
SCARVES
HATS
EYEWEAR
SOCKS
TIGHTS

75] Donna Karan's monumental reputation as a high-fashion superstar designer is expressed through architectural supergraphics which communicate the aggressive American chic of her products, increasing their desirability in a global market. This wall advertisement was designed by Peter Arnell.

identity, architecture and product development. While there is some evidence that this trend to narrow disciplines or corporate isolation is being reversed late in the century, the multidisciplinary character of the Loewy practice remains less the standard. At the end of the century, architects, fashion designers and graphic designers still have names (figure 75). The public know the theories and buildings of Robert Venturi, the casual cashmeres of Donna Karan, and the New Wave graphics of April Greiman. Ralph Lauren's face is as easily recognized as his 'classic' clothing.[6] Most American industrial designers, however, have become relatively anonymous team members working in design practices with witty names: Frogdesign, Smart Design, Lunar Design, M & Co (figure 76).

Whereas Loewy was keen to play the art card by suggesting that designs 'came to him' and that he sketched concepts 'on the back of a cocktail napkin', after the war industrial designers increasingly emphasized the methodical nature of their working process. The emphasis was shifting from intuitive styling to more pragmatic and scientific systems of analysis such as ergonomics. The focus of research for Henry Dreyfuss, for example, was the human-machine interface. Dreyfuss gathered statistics on the proportions of the human figure and established them as the starting-point for any design. His human measurement studies were published in 1960 as *The Measure of Man*.

One of the most successful and widely used products of the Dreyfuss method of human-factors design was the standard desk telephone, commissioned by the Bell Laboratory in the late 1940s. As telephone service was free of competitive pressures, the design

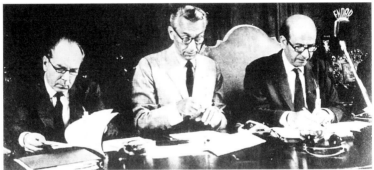

76] Members of the Politburo? The monochrome world of design consultancies in the post-war period saw middle-aged, middle-class, White men working anonymously in teams. A corrective to the superstar image of designers also implied a rational, businesslike approach to design as problem solving. The parallels with politics were overt.

of new instruments responded more to advances in technology and manufacturing than to stylistic considerations. The telephone had to be efficient and comfortable to use in any situation, hygienic, inconspicuous, pleasantly tactile, and durable both physically and aesthetically. The Model 500 desk telephone resulted from a reported 2,000 hours of design research, development and testing by the Dreyfuss agency, eventually becoming the universal American desk telephone.[7] It continues to be produced, in push-button form, having achieved an iconic status, signifying telephonic communication universally. Since its introduction in the mid-1950s, the Model 500 has functioned as a wonderful object, with its combination of geometric and organic forms, capable of holding its own on a pedestal in any museum as well as making a significant contribution to the system of global communication.

In his practice, Dreyfuss reconciled the need to create well-styled products with an objective design process and a modest recognition of the enormous network of concerns in which his designs played a part. His 'science' of ergonomics based on 'average' human factors, worked best, however, when applied to a product which had a universal application. Late-century critics have tended to see Dreyfuss's method as too blunt to deal adequately with varying cultural and individual factors. Yet the scientific approach to design which he initiated remains influential. Peter Dormer has pointed out that while 'design as methodology and design as research are practical concepts, they are also part of a fashion, and

part of a general *zeitgeist* fascination with logic, science and problem solving' also used in the fine arts during the post-Second World War period.[8] The Equa office seating system, designed by William Stumpf in 1984, is an example of the continuing interest in ergonomics as a basic approach to design and as a means of communicating seriousness of purpose to potential customers, particularly those in the contract market.

Unlike Dreyfuss and the other commercial industrial designers of his generation, Buckminster Fuller was uninterested in the public taste, aesthetic dogma, corporate profits or product semantics; his were larger aims. Fuller declared himself a Comprehensive Designer whose ambition was no less than to change the world. He undertook a mission to save humanity through the judicious application of technology to the major global problems of shelter and transport. Wherever he lectured, he drew large crowds and held them in the grip of his enthusiasm and optimism. Fuller's fierce critique of the *status quo* in all things endeared him particularly to the young who could share his vision of utopia (figure 77). He believed that reliance on ideological solutions to the world's problems (overpopulation, undernourishment and inadequate housing) was a mistake. And he condemned to failure all specialist

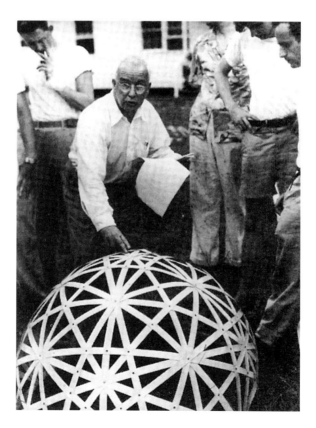

77] Genius at work. Buckminster Fuller's radical ideas breathed hope into the architecture and industrial design professions, both spiritually exhausted by commercialism. Fuller is seen here teaching in Carbondale, Illinois, *c.* 1960.

initiatives, scientific, economic or political, due to their isolation from the Big Picture. The Comprehensive Designer, he wrote, 'is an emerging synthesis of artist, inventor, mechanic, objective economist and evolutionary strategist ... the designer must provide new and advanced standards of living for all peoples of the world'.[9] Thus Fuller saw design as the central initiative in a life and death struggle against ecological disaster and human folly and the designer as a significant link in the processes of material change which could effect a real improvement in the situation of humankind.

Comprehensive Design relied on global communications. Fuller's book, *Operating Manual for Spaceship Earth*, established a perspective for design which was so broad as to transcend the considerations of political dogma or corporate concerns. Interest shown in Fuller's ideas by both the American government and the Soviet Union during the Cold War encouraged him to think that national political divisions could be overcome by significant design initiatives which would ensure sufficiency for the world's masses. He wrote 'Political leadership in both world camps has announced to the world of potential consumers their respective intents to up the standard of living of all world peoples by "converting the high technical potential to account through design".'[10]

The legacy of Comprehensive Design has been pursued through the ethical and ecological design initiatives of Victor Papanek and the design-for-need movement. Papanek wrote in Fullerian tone, 'design is bound up with the key role of synthesis between the various disciplines that make up the socio-economic-political matrix within which design operates ... an ecological world view'.[11] From this position, design was about the survival of habitats, species, cultures. It was also about the poor, in addition to making life more convenient for the rich. Like Fuller, his successors took the view that the commercial, formal and semiotic preoccupations of the design profession and its critical offshoots were at best trivial and resulted in a product culture destructive both to the environment and to the human spirit. For this reason, 'green' designers were treated as marginal eccentrics by the profit-oriented design profession and in the consumer-fixated critical and historical literature on design.

Interest in the study of consumption coincided with the development of design management as an academic discipline and a professional specialization during the last quarter of the century, when it became a common component of MBA courses in American graduate schools.[12] The Design Management Institute was founded in Boston, Massachusetts, in 1975 to address the

requirements of business people and students interested in the management role in design. The institute aimed to develop a body of literature to aid research and education in the subject, published a regular newsletter, *DMI News*, and the *Design Management Journal*. By collecting case studies, conference recordings and books such as Alfred Chandler's *Visible Hands: The Management Hand in American Business* (1977), the Design Management Institute established a field of study intended to raise awareness of design issues and methods among managers in all fields.

Since Henry Ford applied the human efficiency studies of Frederick Taylor to the design of the mechanized production line, design and management have been inextricably linked in industry. Managers in industry have been seen to make critical decisions about potential markets for the goods or services their companies provided. They set production schedules, organized teams of workers with various specializations, targeted prices and so on, to enable products to be made.

They may or may not have been trained designers and they usually did not draw, but their influence over the nature and form of the things we bought and used could be very strong. In design literature these contributions were sometimes considered as patronage, as in Eric Larrabee's *Knoll Design* (1981). Company memoirs also gave a picture (though subjective) of the design roles played by management figures, for example Alfred Sloan's *My Years With General Motors* (1965).

The combination of design and management roles has been reflected in the accomplishments of successful business people such as Elbert Hubbard. Hubbard was an early twentieth-century entrepreneur whose organizational and promotional skills enabled him to build an influential organization supplying domestic goods of high quality, based on Arts and Crafts principles. Hubbard founded the Roycroft community and craft shops in East Aurora, New York, to apply the ideals of William Morris, whom he had visited at Merton Abbey, in book publishing and hand-made domestic goods.

Primarily a charismatic writer and businessman, Hubbard set out the philosophical basis for the design of Roycroft books,[13] furniture and other domestic artifacts in his periodicals, *The Fra* and *The Philistine*. These were evangelical magazines in which the colorful Hubbard lampooned conventional thinking and taste while promoting his craft community and its products. He gathered together a varied group of designers and makers, including carpenters, metalsmiths, illustrators and leather workers drawn from the immediate locality and from around the world. And he brought to Roycroft a steady stream of lecturers including the

sculptor of the Mount Rushmore Memorial, Gutzon Borglum, and Henry Ford to inspire the community. Although he did not design specific objects, Fra Elbertus, as Hubbard styled himself, was the guiding spirit behind the design of Roycroft products. And through his modern marketing and publicity strategies, he attracted a national market for Roycroft goods.

The value of a manager with a highly developed design sensibility was later demonstrated by the career of Florence Schust Knoll (Bassett). A Cranbrook alumna who had worked and studied with Gropius and Mies, Florence Knoll made a major contribution to the development of steel-framed office furniture in the 1940s and 1950s and transformed the company owned by her husband, Hans G. Knoll, into Knoll International, one of the world's most important producers of modern furniture. Florence Knoll ultimately earned a reputation as an interior designer able to adapt the austere International Style to the American corporate clients' preference for luxury and comfort; her aesthetic, often described as the 'Knoll Look', became the most typical style of American corporate interiors in the 1950s and 1960s.[14]

After the early death of her husband, she developed his company by reproducing classics of early modern furniture and introducing innovative new designs by Lella and Massimo Vignelli, Robert Venturi and many others. She employed outstanding designers, such as Herbert Matter, to produce the catalogs, graphics and advertising for the firm, establishing its distinctive corporate style. Thus Knoll gained a uniquely influential position in design both as a creative individual and as a sophisticated manager.

The achievement of a particularly successful design can be as much to the credit of an enlightened and involved entrepreneur as to the trained designer at the drawing board or the CAD station. Henry Ford is probably the best-known example of a designer-entrepreneur. His concept of a standard product was one of the most influential and controversial design premises of the century. And his historical position was just as open to interpretation. The *New York Times* described Ford as 'emancipator, anti-semite, popular philosopher, myth-maker, inventor, moralist, hero of Hitler, multi-millionaire folk-hero of 'grass-roots' Americans, accomplished self-promoter, 'industrial fascist – the Mussolini of Detroit'.[15] Ford appealed to diametrically opposed ideologies, a hero of American free enterprise and a model for Soviet tractor production.

A later instance of the close relationship between management and product design can also be traced to the Ford Motor Company. As Vice-President of Ford under the presidency of Henry Ford II, Lee Iacocca took a primary role in the development and design of the hugely successful Ford Mustang of 1964 (figure 78). According

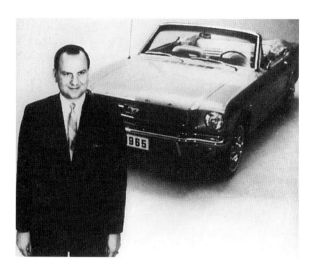

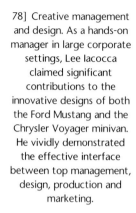

78] Creative management and design. As a hands-on manager in large corporate settings, Lee Iacocca claimed significant contributions to the innovative designs of both the Ford Mustang and the Chrysler Voyager minivan. He vividly demonstrated the effective interface between top management, design, production and marketing.

to Iacocca, his contribution to the design of the Mustang was fundamental. He identified a potential market for a practical sports car in the early 1960s and set up a group of Ford executives, the Fairlane Committee, to develop a product to capture it. In consultation with this group, he defined the nature of the car: 'we had in mind a kind of do-it-yourself car that would appeal to all segments of the market'. He established its production context (the utilization of existing engine and chassis components from Ford's small Falcon) and its cost in terms of both development and sticker price. Finally, Iacocca specified the basic image and visual characteristics of the car: it would have a long hood and a short rear deck, based on the proportions of the original Lincoln Continental of 1939, to give 'an appearance of verve and performance'. It should be 'obviously sporty and distinctively styled with just a dash of nostalgia'. He organized an unprecedented competition among his stylists and selected as the winner a model by the studio of David Ash and Joseph Oros under the direction of Eugene Bordinat.[16] Thus the form of the Mustang was pre-conditioned by high-level management decisions before a single sleek line was drawn.

Later, as President of the Chrysler Corporation, Iacocca stimulated other important automotive design initiatives. Lamenting the abandonment of open-top cars by Detroit in the 1970s, Iacocca 'decided to bring back the convertible', which he did in 1982. Two years later he and a management colleague, Harold Sperlich, spearheaded the design of a new type of family car, the seven-passenger minivan. Like the Mustang, the Plymouth Voyager was a commercial success, widely imitated both in America and abroad. While Iacocca's role in these projects was primarily executive, his claim to creative design input and his colorful promotional activities made these products his in the public mind, confronting the impression

created by much of the literature on design and by many industrial designers that they alone are responsible for products.[17]

In this century of cheap, mass-produced goods, the utility of hand-made products became secondary to their value as symbols for the creative endeavor of individuals. Subtle variations indicated the uniqueness of craft objects and represented the particular preferences or techniques of the maker. Famous or unknown, the craftperson's labor and way of life was communicated through his or her product which became the tangible link between maker and user.[18]

Division of labor and the increasing mechanization of factories had seen to it that craft skills, such as those of the carpenter, the planisher or the upholsterer, were dispensed with as quickly as production technology could introduce an unskilled worker or a robot to do the job. After a century of deskilling the manufacturing workforce, the popular appreciation of skill itself diminished. In the fine arts after 1945, Minimalism, Conceptual Art and Pop Art all deleted the role of craft from the production of art. This was partly due to the prevailing ethos of production in our period, but it also stemmed from a redefinition of the artist as a thinker rather than a maker.[19] That the nature of art had been changed fundamentally in the nineteenth century by the invention of the infinitely reproducible photograph was a fact with which artists had been struggling ever since.[20] As the critic Clement Greenberg wrote in 1962, 'Inspiration is the only factor that cannot be copied'.[21]

Inspiration was inextricably linked to the constant search for something new in the arts. An increasingly fluid culture of art production, emerging after the Second World War, blurred the old distinctions between sculpture, painting, music, dance and theater which were rolled into the new composite arts called Performance and Happenings. This was partly a response to the earlier deconstruction of the fine arts by innovators such as Marcel Duchamp and Joseph Cornell. It was also an opportunity for creative individuals to carve out new territories for self-expression and for imaginative and individualistic production.

Ironically, some of them looked to traditional crafts for alternative means of expression. Like George Ohr, an eccentric early twentieth-century ceramic artist, known as 'the mad potter of Biloxi', they approached craft media such as clay, glass and fiber in the expressive and experimental manner of fine art. However, many of this new breed of professionals also consciously aimed to cross the traditional barriers which stood between the crafts, the fine arts and design. The new generation of post-war craftspeople worked in studios *and* workshops. They called themselves 'artist-craftspeople' or 'object-makers'. And their clients were not the

middle-class householders who had bought Arts and Crafts furnishings or subscribed to *The Philistine*. Instead, they were private art collectors. For them, the new studio-crafts offered an escape from the old value systems which had been associated with painting and sculpture. The crafts were classless and had deep roots in the independent rural traditions of the country.

The great motivator of the studio craft movement was Mrs Vanderbilt Webb, a New York potter who founded America House in the 1940s as an outlet for the work of rural craftspeople. The articles sold there included traditional craft wares and other rural products. The success of America House led to the formation of the American Craftsmen's Council (American Crafts Council) and its official journal, *Craft Horizons*. In 1956 Mrs Webb organized the Museum of Contemporary Crafts to provide an appropriate setting for the exhibition and collection of significant works by the growing number of people who identified themselves as artists working in craft media which were not recognized by the fine art establishment. Later, she founded the World Craftsmen's Council to promote international appreciation of the crafts.

Artist-craftspeople devised a working method in which their product was 'created only in the taste and for the spiritual satisfaction of its maker'.[22] A paradox then emerged by which craftsmanship itself was subordinated in the work to ideas about craft. The glass-blowers Harvey Littleton and Fritz Dreisbach, for example, emphasized expressive, spontaneous and accidental effects in the 'objects' they made, rejecting the controlled and obviously skilful execution of conventional decorative glassware, such as that produced by Steuben. Their work also undermined the traditional utilitarian purposes of glass. Even Native American potters and weavers were swept up in the redefinition of their products as art objects, 'liberated' from traditional forms and uses. During the 1960s the Institute of American Indian Arts in Santa Fe and the Extension Center for Arts and Crafts at the University of Alaska established programs for the education of craftspeople which encouraged them to work in 'personal directions'.[23]

In *Masters of Contemporary Craft*, a 1961 exhibition at New York's Brooklyn Museum, exhibitors represented materials and techniques ranging from textiles to furniture. The show emphasized personal style, defining craft as a 'means of expression'. Nevertheless, Marvin D. Schwartz asserted in his introduction to the catalog that 'the craft movement has been a force fighting for reform in design'. And he supported his view by citing designs for mass production alongside custom work by exhibitors such as the textile designer Marianne Strengell and the woodworker Wharton Esherick.[24]

By the 1960s, makers of craft objects came to reside in an altogether more elevated world than the therapeutic and 'folksy' domain of the rural crafts or the more practical and altruistic Arts and Crafts Movement. The point was made in an exhibition, *Objects: USA*, held in New York in 1970, which surveyed the contemporary crafts including ceramics, glass, woodwork, jewellery and textiles. The organizers made clear their view that the early American tradition of craft, exemplified by the work of the silversmith Paul Revere, had been buried by the Industrial Revolution and that the crusade of the crafts, to re-beautify the home, at the beginning of the century had been cut off by the emergence of modern industrial design.

The catalog text asserted that the crafts had effectively ceased during the inter-war period. True or not, the craftspeople who emerged after the war were of a very different type than those of any previous period.[25] The arrival in America of European *émigrés* as a result of the war stimulated interest in a new approach to craft work. The weaver, Anni Albers, arriving at Black Mountain College in North Carolina, 'taught American craftsmen to re-evaluate the loom as an expressive tool by demonstrating that fibers could be bound in non-functional forms with the probing validity of a work of art'.[26] The new craftsperson was an intellectual, and a number of university and college fine art programs began to encourage the use of clay, glass and fiber as expressive media.

While claiming only 'the most unpretentious of goals', the studio craft or 'object movement' nevertheless sought both recognition by the art world and a trip up-market. Lee Nordness, in the introduction to the catalog for the *Objects: USA* exhibition, stressed the crafts as a new branch of the fine arts, simultaneously disavowing the movement's association with design; 'an art object cannot be designed or contrived out of a piece of clay, metal, fabric: it must be *formed* with the hands and the media shaping each other's direction until a concinnity is reached'. The studio-crafts also severed ties with the rural crafts. In their early days *Craft Horizon* and America House were 'servicing amateur or folk craftsmen', selling seasonal produce, such as cornmeal, along side traditional decorative products, such as corn dollies, and useful wares. The new 'studio artist-craftsmen ... did not wish to exhibit in such an atmosphere – out went the cornmeal'.[27]

Some craftspeople who were associated with the movement in its early years have achieved international reputations. The glass-blower, Dale Chihuly, whose large installation work far exceeded the traditional limitations of craft activities, was one of only three American artists ever honored with a solo exhibition in the Louvre. He founded the Pilchuck Glass School in Seattle in 1971 to

advance the use of glass as a medium for sculpture and to extend its expressive design potential.

Conversely, some fine artists used their design skills and their knowledge of materials and techniques to utilitarian purposes. Another artist who began as a glass-blower, James Carpenter, moved away from the studio-crafts to establish an innovative international design practice which, nevertheless, exploited an experimental, materials-based approach to the creative process. Carpenter developed a range of architectural applications for high-tech, dichroic glass in the form of domes, wall structures and trusses to infuse monumental public spaces - airport terminal, church, shopping center - with ever-changing projections of colored light.

The sculptors Scott Burton and Donald Judd were among a number of prominent artists who, in the 1970s and 1980s, began designing furniture. Burton's massive stone benches functioned both as outdoor seating and as public sculpture, while Judd transplanted the Minimalist principles of his 'specific objects' to practical domestic furniture. His tables, chairs, beds and shelving reconciled the uncompromising rectilinearity and proportional rigor of his sculpture with the practical demands of furniture, effectively bridging the gap between art and design.

Keith Haring also applied himself to art and design activities including mural painting, sculpture, performance, subway graffiti, textile design, and the decoration of pots, T-shirts and skateboards. Haring made and presented his work in the streets and subways, as well as in art galleries; and he ran a boutique in New York, the Pop Shop, where he sold his batch-produced work. The work of Carpenter, Burton, Judd and Haring achieved a rare but genuine integration of fine arts with the designed environment.[28]

The sculptor Claes Oldenburg also moved toward a synthesis between art and design. He is best known for his monumental sculptures based on the enlargement of common objects, such as a lipstick tube or clothes-pin, to heroic scale. Because of the size of his works, Oldenburg designs them while others, often from the building trades, construct them. In this spirit Oldenburg collaborated with Coosje van Bruggen and the architect Frank Gehry in the design of an office building for Chiat/Day advertising agency in Venice California in 1991 (figure 84). The facade is dominated by Oldenberg and van Bruggen's portal in the form of giant binoculars, a metaphor of magnified vision, which transforms the building into a work of public art. In this instance, the relationship between sculpture and architecture and between artist and designer is so seamless as to make the distinction irrelevant.

The influence of Europeans who settled in America between the

LOJA SAARINEN
CRANBROOK ACADEMY OF ART
BLOOMFIELD HILLS, MICHIGAN

79] Through the highly
influential courses they
created at the Cranbrook
Academy of Art, Loja and
Eliel Saarinen revitalized
craft by establishing its
relevance to modern
commercial design.
Cranbrook Textile Studio
logo, 1928.

wars, bringing living craft traditions with them, was particularly strong in the creation of a new breed of hyphenated craftspeople. Schools of design played an important role in supporting *émigré* artists, designers and craftspeople such as the Finnish weaver Loja Saarinen, who established a postgraduate textiles program at Cranbrook Academy of Art (figure 79). Many undergraduate programs were founded to provide a rounded education in the liberal arts while also preparing craftspeople for various types of career. They could become makers of unique art objects; they could set up as production-designers, supervising the making of their designs in batches; or they could work for industry, hand-making prototypes for mass production.

Marianne Strengell, also a member of the Cranbrook community intermittently from 1942 to 1968, achieved prominence in textile design by translating the qualities of hand-made works to prototypes for industrial production.[29] She experimented with combinations of natural and synthetic materials and developed silkscreen printing for the decoration of commercial fabrics at a time when the technique was not in general use. Through her teaching, Strengell imparted to younger designers, such as Robert Sailors and Jack Lenor Larsen, an ability to bridge the gaps between the disciplines of art, craft and commercial design. Over the years, she served as a consultant for many notable architects, industrial designers and commercial clients around the world, designing textile products ranging from unique wall-hangings and carpets to automobile upholstery fabrics.

During the 1950s and 1960s Strengell worked for UNESCO as an adviser on textiles and weaving as a cottage industry. In this capacity she travelled to Japan and the Philippines; and in Jamaica she established a cottage weaving industry by organizing and equipping a studio for local weavers whom she trained personally. Strengell earned international respect as a designer-craftsperson who not only constructed links between art, design and craft, but also moved easily between activities traditionally ascribed to women and the patriarchal domain of manufacturing design.

Strengell's student, Jack Lenor Larsen, combined natural materials, often woven in patterns derived from historical sources, and modern synthetics such as mylar and cellophane, producing textiles in keeping with a tendency emerging in the 1960s to mix the old and the new, the natural and the artificial, the rough and the smooth. Many of his designs were conceived as prototypes for large-scale industrial production.[30]

Like Larsen, the woodworker George Nakashima, helped to reconcile the expressive and experimental use of material with the requirements of commerce and manufacturing. He used power

tools, to achieve highly controlled finishes, in combination with restrained hand-craftsmanship for a natural look. The strong sense of craft values evident in the natural fissures of wood and the rough, 'unfinished' elements of his work were elevated to a level of high sophistication by their juxtaposition with sharply cut lines and smooth surfaces produced by machine. Several of his designs were adapted by Knoll for short production runs during the 1940s. As in the time of Stickley, the use of new production technology allowed Nakashima to make, in small quantities and at relatively reasonable cost, pieces of furniture which bore the marks of craftsmanship and sensitivity to materials normally associated with the purely hand-made. After decades of seeing only perfectly finished machine-made products, many people came to appreciate the imperfections and willful eccentricities of objects such as Nakashima's which revealed the hand of the maker and celebrated the qualities of the material used. And so, in the course of the century the possibility developed of 'a marriage between art and craft and the manufacturing of everyday objects'.[31]

While many histories of the studio-crafts movement and the industrial design profession became indistinguishable from conventional histories of art and architecture, in which star biographies and personal style overshadowed all other issues, craft work in America took new directions which remained largely ignored in 'official' histories. In the leisure culture of the twentieth century, genuine vernacular craft work came to reside in recreational pursuits of ordinary people by the millions. As a release from the tedium of jobs which were routine, uncreative or highly demanding, men and women of all social classes took up manual crafts as hobbies. The exercise of craft skills was partly therapeutic, but it was also a way of achieving a custom-made world in contrast to the uniformity and anonymity of manufactured goods and standardized houses. It also enabled the ordinary person to recapture a sense of resourcefulness and accomplishment reminiscent of the colonial period. The scale of the movement was reflected in the $12 billion annual sale of power tools and DIY accessories by 1960, which rose nearly ten-fold to $110 billion by 1990.[32]

Although the contributions to design by unknown people had been treated historically, most notably in Siegfried Giedion's *Mechanization Takes Command*, the inventors he discussed in the 1940s were involved primarily in manufacturing industries. By contrast, the design and making processes in the Do-It-Yourself movement took place outside the commercial system. The new makers were enabled by their incomes from paid employment, pensions, or even from welfare benefits, and by the increase in their leisure time, to design and make things for their own use and satisfaction.

In a standard, hierarchical view of design, the output of well-known professionals working for large industries or in established institutional contexts comes at the top. Anonymous, team design for industrial production comes next. Then there is an invisible bar, below which design activity is rarely discussed. This consists mainly of design work with no apparent market value, produced by amateurs. Little attention has been paid by historians and critics to autonomous, non-professional designers in modern Western society because their work does not figure in a post-Marxian view of production and consumption. As it has no exchange value, it is not 'serious'. Therefore, modern vernacular design was banished to a murky ghetto inhabited typically by women, ethnic makers, hobbyists and the rural poor. These nameless designers were invisible to most writers as they did not provide the material for riveting and easily researched biography and were therefore unsuitable subjects of study.

The idea that amateurs design has also been unthinkable to most professional designers. And indeed, many home-made products were based strictly on published patterns or used kits of parts supplied by manufacturers with instructions. Many others, however, were conceived and executed by their makers without the benefit of professional plans. 'How-to' articles in magazines were, typically, guides to design and construction rather than specific plans with dimensions. They were inclined to offer the home designer-maker options, suggestions and models for particular types of projects.[33] The construction of a garden fence, for example, might follow entirely conventional lines; but the amateur builder would still have to adapt its layout to a specific site and purpose, then consider its height and color. Choices would have to be made concerning style (stockade, picket, etc.), details of gate configuration and the selection and placement of hardware, the nature of corners (i.e. curved or angled), and the introduction of decorative elements such as scallops, additional trellising or symbolic details such as American eagles. All these would require research, planning, organization, sketching and specification in addition to physical execution (figure 80).

Although much of the promotional literature connected with the handicraft movement has been pitched at men, in reality, design and construction projects often involved women, alone or in collaborations between wives and husbands, sisters, mothers and sons, or friends. Until the rise of the current feminist consciousness in the 1960s and 1970s, the home workbench was normally characterized as an 'altar of masculinity', just as the kitchen was seen as a 'temple of womanhood'. But the universality of literature, broadcasts and courses in 'making over' furniture, carpentry, joinery, and

Where Designs are Born

A furniture maker's sketchbook becomes an archive of design ideas

BY BILL KEYSER

painting and decorating, led both women and men to undertake home-based projects which required design thinking as well as practical craft skills (figure 81).

Magazines such as *The American Home, House Beautiful* and *House and Garden*, with a 'you can do it too' approach, targeted their female readers as the primary specifiers of furnishings, accessories, materials and services for the home. The ability to lay a table with proper structure and inventive ornament was considered a useful skill for women who entertained; and the self-help books of Dorothy Draper ensured that anyone could acquire it. The display of flowers indoors was a minor decorative art form developed to a very high level by many women, but few men. The ephemeral nature of these small creative acts meant that they went unrecorded. Their value resided entirely in the appreciation of the domestic circle.

In recent years, the nuclear family setting for such activities ceased to be the universal standard it once was, but the urge to create an expressive and personally satisfying home remained. The fashion writer Holly Brubach, living alone, described design as the process of arrangement and selection in composing the interior of her home:

my apartment is full of ... souvenirs ... presents from friends ... foundling objects ... I have marshaled all sorts of family

80] This top civil servant was also an expert carpenter, joiner and stone mason whose taste was acquired from contemporary published sources. His characteristically American combination of intellectual and manual skills was appropriate to the practical and aesthetic thinking required in the design process. He is seen here breaking rocks for dry stone walling designed and constructed in his spare time.

81] Magazines such as *Home Furniture* taught basic design principles to readers interested in conceiving and making unique products.

mementos … my Aunt Margaret's carpet, a 1930s oriental, from which I chose the room's colors. The books … are arranged by size or subject or, in some cases, by whim … Edith Wharton entertains Casanova.

Her design decisions reflected a balance between intellect and instinct in the process by which she selected and organized things, investing each item with her own interpretation of its meaning. Ultimately, Brubach confirmed how the private construction of her environment stimulated the professional work she performed at home and reinforced her sense of self.[34]

In Alfred Hitchcock's film, *North By Northwest*, Cary Grant plays an advertising executive running from a false murder charge. He meets the glamorous and mysterious Eva Marie Saint in the stylish dining car of a transcontinental train, and during their flirtatious introductory banter he asks what she does for a living. The startling answer, 'I am an industrial designer' undermines expectations of what job an attractive young blonde woman might realistically do in 1958. In the unravelling plot, it transpires that she is not, after all, an industrial designer, but rather a spy – an altogether more plausible career for a woman at that time, and no doubt easier to get into. But the interchange was a sly indicator of the exteriority of women to the exclusively male design professions.

The marginal position of women to design has been aggravated by an excessively narrow definition of the discipline which placed it exclusively within large industries devoted to mass production. This orientation is typical of much design literature as it makes arguments much neater and issues simpler. Defining design narrowly in terms of commercial products has also resulted in the exclusion of public sector design as it does not cater overtly to consumer demands. Engineers are ignored for similar reasons. Designers of weapons, such as 'stealth' aircraft and hand-guns, have rarely been discussed due to a combination of factors including government secrecy, critical timidity and repulsion to sleaze.

Interior decoration, jewellery design and ceramics provided many women with an outlet for their creative talents and their means of livelihood. Consequently, these fields have received some critical and historical attention. Women also performed outstandingly well as designers for the fashion and textile industries, in which men also competed for leadership. Yet the patriarchal orientation of the business world, professional bodies, the press and the critical establishment have inhibited serious analysis of the achievements of women in design.

This has resulted partly from stereotyping the nature of women's creativity. They were seen to be instinctive rather than intellectual, content with personal satisfaction as opposed to

craving worldly recognition, emotional rather than rational, home-oriented rather than professional, traditional rather than innovative. In short, their abilities were seen to lie outside the thrusting male arena of competition. The emphasis on the tough world of industry and commerce also represented the 'butching' of design, conveniently ignoring a gay perspective central to creativity in a number of design fields. Thus one of the most compelling reasons to broaden the definition of design is to understand the motives of individuals who design outside the White, middle-class, male industrial design profession.

As our social organization has kept women out of paid employment until recent years, except in emergencies, their creativity has been exercised mainly in the home. There they were granted an economically important, design-related role as selective and critical consumers. Yet another way in which women have asserted themselves through design was by shaping their own appearance. While basic dressmaking from patterns was largely supplanted by the universal availability of standard, mass-produced clothing,[35] customization has become a popular means of communicating individuality or signaling associations with subcultures. Although fashion magazines and other branches of the media have established norms of appearance, women throughout the century have found ways of subverting conventions through the selection, combination and alteration of clothing, and through the symbolic manipulation of accessories and make-up.

Young women in the 1920s exaggerated the 'official' shortening of skirts by shredding their hems to expose more bare leg than had hitherto been decorous. Similarly, ripping and tearing T-shirts and jeans recently became a popular technique of customizing standard and relatively neutral garments to evoke an image of savage eroticism by both sexes. As Dick Hebdige pointed out, 'the most mundane objects – a safety pin, a pointed shoe, a motorcycle ... take on a symbolic dimension, becoming a form of stigmata, tokens of a self-imposed exile'.[36] The subversive potential of style was demonstrated by the protagonist of Stanley Kubrick's Viet Nam war film, *Full Metal Jacket*, who wore the slogan 'Born to Kill' on his standard issue helmet and a peace symbol in the lapel of his flack jacket. Asked for an explanation, he replied that 'they represent the duality of man, Sir'. Similarly, in the 1980s and 1990s tattooing and body piercing became signifiers of confrontation with 'official' standards of decorum and with the larger concept of 'civilization'.

The appearance of the first 'street fashion', the counter-cultural 'Beat' style of the late 1940s, coincided with the burgeoning of the suburban Do-It-Yourself movement. Ironically, both groups served

as conduits for individual expression within the acceptable norms of an identifiable social community, one small, the other large. While published patterns provided D-I-Y-ers with general solutions for many common problems, from constructing a breakfast nook to 'finishing' basements and attics, the desire for self-expression and individuality informed countless projects undertaken by amateur designers. Leisure and sporting interests, social and cultural attitudes, class-consciousness, gender and sexual orientation, nationalism, regionalism and ethnicity all contributed to the character of personal designs as they did to dress styles and to the type and color of cars individuals chose to drive.

In home decorating the selection of colors, arrangement of furniture, patterns, textures, decorative artwork and memorabilia acted as signs of a whole way of life. Many Italian-Americans, for example, displayed classical or religious plaster statuary and decorative metalwork on the exteriors of their homes. Inside, they preferred warm Mediterranean colors, rich materials, such as real or imitation marble and gilding, all reminiscent of traditional design and decoration in Italy. Recreation rooms, frequently conceived as a male domain, often imitated bar rooms in their furnishings and included emblems of breweries and sports souvenirs, such as baseball pennants to create a clubby atmosphere.

The aim of American manufacturing and advertising to 'give the customer what he (or more often she) wants' contributed to the development of a role, both real and mythological, for consumers in the design process. By the 1950s refined manufacturing and marketing techniques made it possible for car dealers to offer wide variations of a standard car through the customers' selection of body types, color combinations, ornamental trim, transmission, engine, electrical accessories and so on.

An advertising campaign launched by General Motors' Chevrolet Division in 1959 astutely identified the fact that people believe themselves to be unique and wish to control their image through the things they buy. The advertising copy of the series, written in the first person by the fictional purchaser of a new Chevrolet, always began with the tag line 'I "built" my Chevy …' and went on to describe how a virtually bespoke automobile was fashioned from a basic car and a list of options selected to suit the specific personal requirements of the narrator: 'you can virtually design your own car, tailored precisely to your needs'. Partly true.

While it was possible to fit out any Detroit car to one's own specification, the basic offerings were quite singular. Detroit had only one idea, and it was a big, sculptural showboat: Chevy = Ford = Chrysler = Rambler = Cadillac. From the 1930s through the 1960s

"I 'built' my Chevy to handle like a sports car... for five!"

82] Buyer becomes designer. The increasingly close relationship between design and consumption was signaled by advertisements promoting the bespoke nature of flexible mass production and the potential influence of the end user over the form of the product. When the architect portrayed in the ad says 'built', he means 'designed'.

there was little difference in size, type or style, as manufacturing did not yet have the sophistication to cater to what would later be called niche markets. Thus 'choices' existed within a narrow framework – and at the end of the day, the Chevy was still a Chevy. Yet despite their naivety, these advertisements recognized a legitimate relationship between design and individuals with special interests. The dramatic serial of advertisements included cars 'built by' a chic New York fashion model, a 'swinging' young architect with a family of five, and a county housewife addicted to rural leisure pursuits (figure 82); it omitted cars 'built by' a night-club drag artist or a black civil rights activist, but these too were possible under the terms of the offer.

The idea of a 'build-it-yourself' motorcar carried with it a high feel-good-factor connected with the reclamation of personal identity in an alienating, mass-produced world. 'Finding oneself' through shopping is a central notion of twentieth-century American culture. In the therapy-mad United States, it has also been recognized as a form of neurosis. And related to it is a belief, which dates back to the early years of the century, in the therapeutic function of making things. In 1911 the ceramist, Frederick Hurten Rhead, organized a pottery for Dr Philip King Brown who ran the Arequipa sanatorium in California, one of many experimental clinics of the period which employed craft as therapy. The ceramics workshop gave King's patients, mainly women suffering

from tuberculosis, simple and rewarding work. But Rhead controlled the designs made by skilled throwers and then decorated by the patients. This ensured a consistent quality which enabled the pots to be sold locally to offset the running costs of the clinic. Rhead's own description of the purpose of craft therapy, 'to help people who were nervous and needed rest ... to give these people interesting work', was in keeping with the attitude toward craft held by the caring professions thereafter.[37] Following both world wars the arts and crafts found new purpose in the rehabilitation of wounded and shell-shocked veterans.[38] And as time passed design originality was given increasing importance as part of the therapeutic process.

Just as objects can be vehicles for emotional well-being, or at least a quick fix of happiness, inventing things, making them, acquiring them, organizing them, subverting them and discussing them have become increasingly design-aware activities with emotional significance. The freedom to control one's environment may still be an illusion for most people. But it is at least imaginable and has entered the debate about what design is and who does it.

The cult of the designer flourished from the 1920s and persists to the end of the century. But the great bulk of professional design activity was always team driven, involving people whose names are never known outside consultancies, professional organizations and manufacturing companies. They are social creatures subject to the same basic forces which affect the lives of everyone in society: economics, politics, fashion, tradition. At the end of the century, the designer's function as a form giver is merging with an alternative role as an organizer of situations, collaborating with (other) users and enabling individuals to design for themselves. From this perspective, some types of design have become less attached to the object and more involved in processes.

Stars of the art-design-craft complex have become part of the commodities they take part in creating. And this they share with millions of anonymous designers and makers, professional and amateur, who work toward the definition of a material world which corresponds with their particular goals, beliefs and needs. This was vividly illustrated in the products devised by President Franklin Delano Roosevelt, disabled by polio, to allow him a degree of independent mobility and to create the illusion of physical strength and vigor central to his presidential image. Working with a blacksmith local to the resort he founded at Warm Springs, Georgia, in the 1920s for suffers of 'infantile paralysis', Roosevelt designed improved metal leg braces, crutches, a muscle testing device and advanced hand-controls for his car. His non-professional design expertise was based entirely on severe personal experience

and dedication to purpose, while the realization of his designs resulted from collaboration with a skilled craftsperson. Designing has become part of the process of constructing a life for oneself or for others, for personal gain or public welfare, to express oneself or to impose one's will on others. Designers can be aggressive or benign, elite or populist, profligate or conservationist. A few may be geniuses worthy of public celebration. Many are competent individuals capable of contributing to the solution of modest problems. Others may bungle horribly as a result of their own limitations or due to the conditions under which they work. And there is plenty of empirical evidence to prove that incompetence exists in both the professional and amateur spheres of design. But wherever they operate within the broad range of activities described above, designers are essentially ordinary people contributing to the evolution of their own material world.

Notes

1 Raymond Loewy, *Industrial Design* (London and Boston, 1979), p. 50.

2 Paul Jodard, *Raymond Loewy* (London, 1992), p. 112.

3 Van Doren's *Industrial Design, A Practical Guide* (New York and London, 1940) was the first textbook on the practice of industrial design. Intended as 'a book of method', it stated the main aim of the new profession as 'above all to create in the consumer the desire to possess' (p. xvii).

4 Jeffrey Meikle, 'From Celebrity to Anonymity', in Angela Schonberger, *Raymond Loewy: Pioneer of American Industrial Design* (Berlin and Munich, 1990), p. 54.

5 The Conran Foundation, *Art and Industry* (London, 1982), p. 28.

6 Along with domestic style guru Martha Stewart and deconstructivist architect/designer Frank Gehry, Calvin Klein was among *Time* magazine's '25 Most Influential Americans', 17 June 1996, p. 21. Described as 'fashion's Frank Lloyd Wright … the true American Puritan', Klein has pursued a Minimalist fashion aesthetic over more than fifty collections produced since 1968.

7 Arthur Pulos, *The American Design Adventure* (Cambridge, MA, 1988; repr. Cambridge, MA, 1990), p. 309.

8 Peter Dormer, *Design Since 1945* (London, 1993; repr. London, 1995), p. 24.

9 Buckminster Fuller, *Ideas and Integrities* (Toronto, 1963; repr. Toronto, 1969), pp. 176–82.

10 *Ibid.*, p. 182.

11 Victor Papanek, *The Green Imperative* (London, 1995), p. 48.

12 MBA stands for the postgraduate degree, Master of Business Administration.

13 Hubbard derived the Roycroft name for his press from the seventeenth-century bookbinders, Thomas and Samuel Roycroft.

14 R. Craig Miller, 'Interior Design and Furniture', in Andrea Belloli, *Design in America. The Cranbrook Vision* (New York, 1983), p. 138.

15 James Flink, *The Car Culture* (Cambridge, MA, 1975), p. 104.

16 Lee Iacocca with William Novak, *Iacocca, An Autobiography* (New York and London, 1984), pp. 68–71. Iacocca's pursuit of a personal design vision,

strongly identified with the success of the Mustang, was presented in his autobiography and in countless magazine articles, including cover stories in both *Time* and *Newsweek* following the car's launch on 17 April 1964.

17 *Ibid.*, pp. 295-8.

18 Peter Dormer, *The Meanings of Modern Design* (London, 1990), p. 31.

19 Peter Dormer, *The Art of the Maker* (London, 1994), p. 7.

20 Walter Benjamin, 'The Work of Art in the Age of Mechanical Reproduction', in Stephen Bayley, *Commerce and Culture* (London, 1989), p. 34.

21 Clement Greenberg, from 'After Abstract Expressionism', quoted in Dormer, *Art of the Maker*, p. 7.

22 Lee Nordness, *Objects USA* (London, 1970), p. 7.

23 *Ibid.*, p. 21.

24 Marvin D. Schwartz, *Masters of Contemporary Craft* (New York, 1961).

25 Nordness points out that, according to a US Department of Agriculture Survey carried out in 1938, 1.5 million people were engaged in handicrafts. Seventy-five per cent of them were women or 'girls' and only 20 per cent of their output was for sale. The rest, presumably, was used at home. This would seem to contradict Nordness's earlier assertion that there was 'no craft tradition' remaining in the United States until the 'studio craft revival' of the post-war period. The real significance of his comment is that, of the 1.5 million craftspeople working in the late 1930s, none were famous.

26 Nordness, *Objects USA*, p. 10.

27 *Ibid.*, p. 20.

28 Lisa Phillips, *High Styles: Twentieth Century American Design* (New York, 1985), p. 203.

29 Christa C. Mayer Thurman, 'Textiles', in Belloli, *Design in America*, p. 197.

30 A founder of the Haystack School of Crafts at Deer Island, Maine, Larsen taught and co-authored with Mildred Constantine *Beyond Craft: The Art of Fabric*, first published in 1973, which articulated their approach to craft design. For a fuller discussion of the use of craft works as prototypes for mass production, see Arthur Drexler and Greta Daniel, *Introduction to Twentieth Century Design* (New York, 1959).

31 Peter Dormer, 'The Ideal World of Vermeer's Little Lacemaker', in John Thackara (ed.), *Design After Modernism* (London, 1988), p. 113.

32 Karal Ann Marling, *As Seen on TV: The Visual Culture of Everyday Life in the 1950s* (Cambridge, MA and London, 1994), p. 54.

33 A typical example of the 'How to' guide is provided in Robert Gorman, 'How to Store Your Records in Bookshelf Space', *Popular Science Monthly* (January 1954), p. 227.

34 Holly Brubach, 'Writer in Residence', *House & Garden* (May 1993), pp. 63–4.

35 This instigated the often caricatured paranoiac nightmare of two fashion-conscious women turning up to a social event wearing the same dress.

36 Dick Hebdige, *Subculture* (London and New York, 1979), p. 2.

37 Leslie Greene Bowman, *American Arts & Crafts, Virtue in Design* (Los Angeles, Boston, Toronto and London, 1991), p. 180.

38 Pulos, *American Design Adventure*, p. 170.

II Four case studies

The case of Post-Modernism: a late-century movement

<div style="text-align: right; font-size: 2em;">6</div>

In its broadest form, postmodernism is a cultural theory with implications for all aspects of human activity including science, religion, economics, politics and aesthetics. As with any grand concept which has developed simultaneously in a number of different places and out of a variety of disciplines, postmodernism has acquired different meanings for particular people and groups. Even in the more limited context of twentieth-century American design, there is no unanimity regarding its meaning, just as there was and is no consensus on the meaning of modernism.

Taken literally, postmodernism stands for a system of thought which developed out of and superseded modernism. If modernism attempted to construct a world which was all new, postmodernism aimed to make a world in which the shock of the new could be tempered by an awareness and appreciation of tradition. If modernism is perceived as a singular ideology based on rationalism and machine technology, then postmodernism stands for pluralism in the age of electronics. One of the most often used words in the postmodernist vocabulary is 'eclectic', the selection of ideas and images from diverse periods and cultures: past, present and future, Eastern and Western, highbrow and lowbrow, mainstream and minority.

The general theory of postmodernism emerged since the 1960s as a broad-based assault on the establishment, resulting initially from the Civil Rights movement, feminism, and general cultural fragmentation in the United States. Eventually all forms of institutional authority, including authorities on art and taste, were brought into disrepute. If *they* said it was good for us, then it must be bad - in addition to the government, the police, the judiciary, school, milk, meat and Knoll furniture all came under suspicion. Postmodernism in America could also be seen as a critique of the austerity and uniformity of the Modern movement, imported from Europe and promoted as the International style.

As an aesthetic high style, Post-Modernism[1] began in architecture and quickly spread to other design disciplines including domestic products, fashion, graphics and textiles. It was quickly embraced by the corporate establishment , just as the International

style had been during the 1950s. Its influence in the 1980s and 1990s can be found in the architecture and interior design of the most sober banking houses as well as in elaborate projects of the Disney Corporation.

The origins of postmodern thinking in America can be traced back to commercial and industrial developments of the 1920s. But commentators on taste in the 1960s first identified a shift in cultural orientation which came to be seen as postmodern consciousness. When in 1964 Susan Sontag outlined the qualities of a new taste culture, Camp, she identified a rising appreciation for the vulgar and ostentatious manifestations of mass culture, its latent sexiness and its unintentional humor. Sontag echoed ideas of the English design critic, Reyner Banham, and his colleagues of the Independent Group, which met at the Institute of Contemporary Arts in London during the 1950s. Their publications and exhibitions recognized popular music, film, industrial design and all commercial art as products worthy of serious analysis.

The popularization of Camp from its roots in gay culture formed part of a movement 'to neutralize moral indignation … by promoting playful aestheticism … be(ing) serious about the frivolous, frivolous about the serious'.[2] Like the humor of Lenny Bruce, 'Camp' challenged prejudice by outraging convention. Its visual manifestations were first evident during the 1960s in the art of Andy Warhol, in the flamboyant dress of hip kids, and in an Art Nouveau revival. The styles of the period broke with both conservative and advanced high styles and with middle of the road tastes. What emerged was a self-consciously trashy hybrid of old and new, dull and flashy, traditional and futuristic, formal and casual.

Some observers sought a broader foundation for postmodernism in the phenomenon of mass-produced kitsch. The German art historian Gert Selle criticized camp for its exclusivity as a taste subculture, preferring to appreciate kitsch as 'exaggeratedly beautiful everyday goods designed for everyone'.[3] Selle saw the inclusive taste of popular design as the real product culture of the twentieth century and its universal appreciation as the solution to the problem of social alienation aggravated by positions such as 'Good Design' and Camp. Such attempts to legitimize popular taste have formed a constant refrain in postmodernism.

In his 1968 exposition, *Kitsch*, the Italian design theorist Gillo Dorfles raised a number of issues, related to popular art, which would become significant in the development of the postmodern viewpoint.[4] He addressed themes of myth, morality and tradition represented in domestic artifacts. And by reprinting Clement Greenberg's 1939 article on Nazi kitsch, he introduced a political perspective to the discussion of taste. Serious attention to kitsch

created a modern context for Hume's assertion that beauty is not inherent in things, but rather in the eye of the beholder, thereby raising a question mark over universal standards of taste and the importance of authorship. Although he supported the enthusiastic spirit of kitsch as a phenomenon which is 'partly positive', he objected to the 'kitsch attitude' of sentimental response, rather than thought (figure 83).

Dorfles' chapter on 'Styling and Architecture' asserted that kitsch arrived in American culture with car styling, catering to the popular taste for nostalgia, futurist fantasies, general showiness, and above all, phoniness. Dorfles identified transference of meaning as a key attribute of kitsch (for instance, a clock shaped like a guitar or a car designed to look like a fighter plane). This became a significant element of Post-Modernism exploited extensively in theme-park design and architecture for the Disney Corporation and in furniture and ceramics by the craftsman/ designer Peter Shire who, in the 1980s, appropriated forms from 1950s American car styling.

The worlds of kitsch, camp and elite taste converged in the Pop Art movement during the 1960s. Claes Oldenburg's environmental installation, 'Bedroom Ensemble', portrayed a luridly glamorous interior with geometrically distorted furniture covered in fake-fur, shiny vinyl and turquoise marbled paper. Its amusing and nightmarish atmosphere inspired countless real interiors which delighted in parodying dissolute 1950s taste.

Oldenburg brought genuine Pop Art to Post-Modern architecture through his collaboration with Frank Gehry on the design of the Chiat/Day advertising headquarters in Los Angeles. The gigantic pair of binoculars through which the building is entered signify the 'focus' of its occupants' professional activities (figure 84).

83] Computer kitsch. Baby Jesus turns dragon slayer in the Sacred Heart Mouse Pad – its jumble of religious images introduces sentimentality to the most logical of activities. This belongs to a genre of designed products known as 'novelties'.

84] The collaboration of sculptor Claes Oldenburg and architect Frank Gehry in the design of the Chiat Day advertising agency headquarters (1984–89) in Venice, California, reveals a conceptual link between Pop Art and architectural Deconstructivism. It is also a high-style version of a local design vernacular shown in the bench-press form of the nearby Muscle Beach Gymnasium.

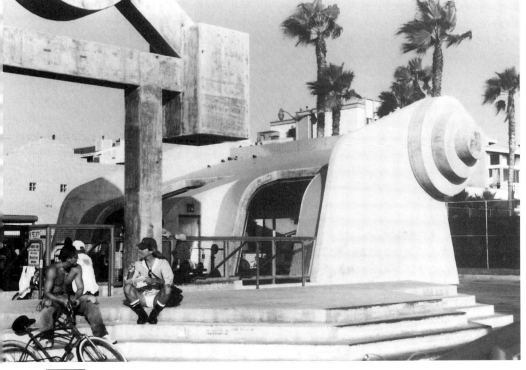

Ultimately, the spirit of Pop Art affected the thinking and the work of designers practicing in all fields from fashion and interiors to graphics, endowing the work with a fresh wit and color as in the 'I (love) NY' symbol by Milton Glaser of Push Pin Studios.

The publication in 1966 of Robert Venturi's *Complexity and Contradiction in Architecture* was the first major step in the formation of a theory of Post-Modern design. Like Johnson and Hitchcock's *The International Style* of 1932, *Complexity and Contradiction* was published by the Museum of Modern Art; and like the earlier book it was mainly a discussion of form, in this sense typical of the writing of its time.

However, Venturi departed from earlier models by establishing a diverse canon of sources which included Michelangelo, the American Shingle Style, colonial classicism, the commercial strip and all anti-rational design. Whereas *The International Style* had presented the works of Gropius, Le Corbusier and Oud as if they were virtually identical, through a highly unified set of images showing austere geometries executed in metal, glass and concrete, *Complexity and Contradiction* emphasized the qualities which distinguished one building, environment or object from another. Dissonant, formal juxtapositions, syncopated rhythms, violent shifts of scale, material, color or texture, all were served up as evidence of human inconsistency and change in the formation of the material world. These ideas were fundamental to postmodernist thought.

Vincent Scully appreciated Venturi's ability to spot the 'life to be found in the common artifacts of mass culture when they are focused upon individuality'. He also credited Venturi with an acute awareness of the nature of life in the United States, both metropolitan and provincial: 'out of our common, confused, mass-produced fabric he makes … an art'. Due to the humanism and devotion to all kinds of art evident in Venturi's text, Scully likened him to Le Corbusier and equated *Complexity and Contradiction* with *Towards a New Architecture* as centrally important texts in twentieth-century aesthetics.[5]

Venturi's achievement was to initiate a new direction in design by combining an enthusiasm for history with a thoroughly up-to-date world view. Trained as a modernist (he had worked for both Kahn and Saarinen), he could criticize modern design with an insider's knowledge. He examined buildings of all styles and periods, and he treated modernism as one of several viable approaches to design in the twentieth century. In this way Venturi injected a new energy into the design discourse and set his observations in a cultural framework which transcended petty squabbles over taste.

Looking in every direction for the seeds of a new design humanism, Venturi advocated design 'based on the richness and ambiguity of *modern* experience'. In sources ranging from the Abstract Expressionists to the Italian Mannerists, he found the quality of ambiguity. He analysed the designs of the Renaissance architect Peruzzi alongside those of Le Corbusier to discover how formal contradictions enhance the life of an artifact. He portrayed vividly how order and disorder work together to enhance a composition: 'A valid order accommodates the circumstantial contradictions of a complex reality'. Describing Le Corbusier's disturbance of the grid of structural columns in the Villa Savoye, to make way for circulation paths, Venturi wrote, 'Le Corbusier today is a master of the eventful exception, another technique of accommodation'. In this way, Venturi established the virtue of 'control *and* spontaneity', 'both-and' rather than 'either-or'.[6] He countermanded Miesian unification and simplification with his often repeated dictum, 'Less is a Bore'.

Venturi's *Learning From Las Vegas*, published in 1971, was mainly a discussion of symbolism in the physical environment. In it, he and his co-authors, Denise Scott Brown and Steven Izenour, demonstrated how the commercial environment communicates effectively with a wide, responsive audience, in contrast with public incomprehension of 'Good Design'. Venturi's designs for his mother's house in Chestnut Hill, Pennsylvania, and the London National Gallery extension (figure 85) manifest the ideas presented in his two books. Of the house, built in 1962, he wrote,

> This building recognizes complexities and contradictions: it is both complex and simple, open and closed, big and little; some of its elements are good on one level and bad on another; its order accommodates the generic elements of the house in general, and the circumstantial elements of a house in particular.[7]

The National Gallery extension represented his 'decorated shed' principle – that an essentially conventional building could signal its specific purpose and its relationship to its neighbors through applied signs or easily understood ornaments (another example being the neon signs of Las Vegas). According to this logic, any standard product could be adapted to specific use in a particular context by customization; a pop-up toaster decorated with wheat sheafs to match a colonial kitchen or with streamlines for a modern decor.

The same idea was applied to a range of chairs Venturi designed for Knoll (figure 86). The bent and molded plywood construction of the chairs employs a technology strongly associated with the most innovative modern American furniture by designers such as

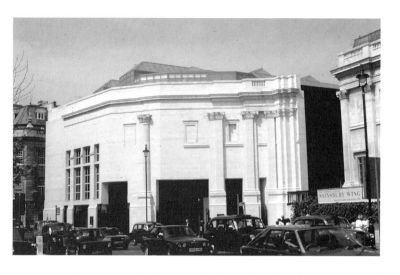

85] Robert Venturi's design for the Sainsbury wing of the National Gallery in London (1986–91) served as a European pulpit for contextualism, an idea at the heart of American Post-Modernist design thinking.

Breuer and Eames. Venturi wrote, 'We see this furniture as part of the tradition of Modern furniture, as an evolution within the bounds of Modern design'.[8] However, he departed from the modernist idiom through the overt historical references employed in the detailing and decoration of the chairs. His sources ranged from eighteenth-century Queen Anne to American Art Deco reflecting the mixture of historicism and nostalgia central to much early Post-Modernist design. Yet the way in which he simplified traditional themes by using flat, cut-out forms in modern materials created a result which was distinctly of its own time. Like his decorated shed buildings, the chairs were standard, functional products with symbols added for differentiation – like a Pontiac and Oldsmobile, sharing the same body shell, but distinguished from one another by ornament (see figure 45).

Postmodernism attacked traditional hierarchical values, seeing modernist tastes and 'Good Design' as forms of elitism. Venturi contributed to this debate in his references to both the 'high and the low', 'the good and the bad'. And he succeeded in crossing the worlds of high style and kitsch in his design for a silver tea and coffee service in the shape of a piazza, commissioned by Alessi in 1983 and produced by them in part-gilded stainless steel since 1985. The tray for the service was inspired by the geometrical paving pattern of Michelangelo's Campidoglio in Rome, producing a result curiously akin to the popular tourist paperweights showing the Campidoglio-Eiffel-Tower-Statue-of-Liberty in snow.

In *Complexity and Contradiction*, Venturi quoted August Heckscher on the developing consciousness in modernity: 'the movement from a view of life as essentially simple and orderly to a view of life as complex and ironic is what every individual passes through in becoming mature'.[9] Likewise, postmodernism

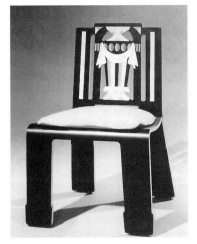
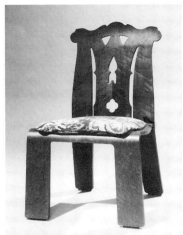

36] Venturi's chair designs, 1984, produced by Knoll International, combined technological and stylistic characteristics of modernist furniture with his Post-Modern fascination for ironic historical references.

represents a maturing process – the brash, progressive culture of the twentieth century re-examining and moderating its attitude toward the past.

The popularizer of Post-Modern design during the 1970s and 1980s was Charles Jencks, who named the movement in his 1977 manifesto, *The Language of Post-Modern Architecture.* Jencks wrote, 'I would define Post-Modernism ... as double-coding: the double voiced discourse which accepts and criticises at the same time.'[10] He based his method on semiotics, the study of signs and signification, drawn from the work of French linguistic theorists and sociologists including Roland Barthes, Jean Baudrillard and Michel Foucault. Jencks applied their methods of understanding literary and visual 'texts' to analyses of architecture and design.

He expressed the spirit of Post-Modernsim as 'radical eclecticism' or more simply as 'pluralism'. In later years, he moved on to promote Post-Modern Classicism as a universally comprehensible

public language of design. However, 'Colosseum Chair and Stool', furnishings he designed for his Symbolic house, suggested so many possible 'readings' – architectural model, cracker barrel, doll's house – that its primary function could be lost in a blizzard of fictions.

An eclectic mix of references also characterized the projects of architect Michael Graves, who converted from Corbusian Modernist to Post-Modernist during the 1970s. His richly ornamented Portland Public Services Building of 1982 and the interiors he designed for the Sunar company showroom include Art Deco and Biedermeier influences combined with Purist and Cubist color and geometry. His Plaza dressing table for the Italian design group, Memphis, was a nostalgic take on Manhattan glamor, while his solid silver 'Tea and Coffee Piazza' for Alessi adapted and mingled signs from classical and Art Deco architecture on a miniature scale for the amusement of a fashion elite – among its prominent admirers was the First Lady, Nancy Reagan. In the mid-1980s, Alessi mass produced Graves's stainless steel kettle which carried Post-Modern humor to a large market on the wings of its bright red, bird-shaped whistle.[11] The Alessi kettle became one of the best-known examples of Post-Modern design.

Graves's semiotic approach to design is also evident in the ceramic coffee service he designed for Swid Powell. To modernist geometrical forms reminiscent of the Wiener Werkstatte and the Bauhaus, Graves added symbolic ornament: a band of wavy lines encircled the body of the coffee pot to signify its liquid contents (figure 87). Much of Graves's furniture was designed for the museum rather than the home, reflecting the postmodernists' attack on the traditional divisions between design and art. One table entitled 'Variations on a theme of Juan Gris', a near replica of a cubist painting, is permanently installed in the Kroller-Muller

87] Michael Graves' semiotic approach to design is evident in this ceramic coffee pot and filter designed for Swid Powell (late 1980s).

Museum in the Netherlands. Like other leading Post-Modernists, Graves crossed easily between architecture and other design disciplines. His 'archaeological' jewellery and watch designs abandoned wit for an almost archaic classical elegance which resulted in an image of exclusivity verified by high prices.

While rejecting the international perspective of the Modern movement, postmodernism looked to local vernaculars as a source of identity. Early American classicism was revived in the architecture and design of Robert Stern. Yet his eclectic carpets, ceramics, metalwork, jewellery and interiors combined the simple luxury of the New England beach house, or the spare elegance of Paul Revere silver with the glamor and gaudiness of Hollywood set design. In Stern's work the polemics of postmodernism were often subsumed by the sheer luxuriousness of form, ornament and quality of execution. According to Michael Collins,

> Stern's work can be read as neo-conservative Post-Modernism, subservient to the most rampant form of capitalism, namely the taste trends of New York … however accomplished his designs are, they simply serve, in a somewhat venal manner, the desires of American consumerism. [12]

The link between Post-Modernism and avarice was explored dramatically in one of the quintessential American films of the 1980s, *Wall Street*, in which themes of moral corruption and personal greed were suggested by the lavish Post-Modern decor of an aspiring young stockbroker's skyscraper apartment.[13] Its gilded classical ornaments, simulated cracked plaster and *trompe-l'œil* patches of exposed brick, combined with spectacular metropolitan views and state-of-the-art gourmet kitchen, would be the perfect setting for an Alessi 'Coffee and Tea Piazza'. In the postmodern world, the antique and the futuristic coexisted comfortably among 'the finer things of life'. But everything was fake, and no price was too high to feed the ego.

In a pivotal scene the anti-hero, Gordon Gekko, delivered to the assembled shareholders of an ailing company the following speech.

> Greed, for lack of a better word, is good. Greed is right. Greed works. Greed clarifies, cuts through and captures the essence of the evolutionary spirit. Greed in all its forms, greed for life, for money, for love, for knowledge, has marked the upward surge of mankind. And greed, you mark my words, will save … (that) mal-functioning corporation called the USA. [14]

Like the Social Darwinist William Graham Sumner, who applauded the new millionaires of the turn of the century as products of natural selection, Gekko affirmed that economic strength was the key to both cultural and personal survival.

In the course of the century, members of many groups within American society who had a history of oppression, Jews, Blacks, gay men, women, sensibly adopted the position that in a capitalist democracy economic power was the most effective defense against their enemies. And conspicuous consumption, or shopping, was the clearest expression of their power. Postmodern design, particularly during the economic boom of the 1980s, aimed to dramatize the diversity of subcultural tastes and to provide 'something-for-everyone' as a badge of empowerment; consumption became a weapon in the war against hegemony. Meanwhile, the venomous tone of much postmodernist literature suggested that a grave cultural struggle was at the root of some of the most ostentatious and frivolous-looking design concocted since the Art Nouveau.

Victor Papanek, however, saw only selfishness in Post-Modernism born of the 'Me' generation of the 1970s [15] and 1980s' Reaganomics;

> The Post-Modern condition can be characterized as a vacuum of conscience in which such socially responsible notions as fair housing, a clean environment, health care or access to services are considered somewhat of an embarrassment. Product culture has been allowed to run wild, and has substituted trendy objects for community values.[16]

The extravagance and obvious impracticality of many iconic Post-Modern products reveals that their intended function was didactic. Jencks's solid silver 'Tea and Coffee Piazza' for Alessi was a superlative expression of Post-Modern Classical aesthetics which would certainly burn its user's fingers. In this sense, it followed in the tradition of Detroit manufacturers' 'dream cars', built to test styling innovations, but not fitted with a motor or brakes.

The fundamental operating principle of postmodern pluralism was choice. Jencks wrote, 'More important than the technologies which allow individualisation are the new alignments in taste, the fragmentation of taste cultures and the wide array of choices the Post-Modern system promotes.' [17] He continued, 'in America in the Modern era, it used to be either a Ford or a Chevy, black or white. Now you can choose from over seven hundred and fifty different models of cars and trucks, and a large, annually changing, number of colours'.[18] Indeed, information, production and marketing technologies of the 1990s ensure that many American consumers are miserably spoiled for choice; and the proliferation of options does allow for a greater expression of minority tastes.

According to Jencks, 'Perhaps the biggest shift in the Post-Modern world is the new attitude of openness ... a new assertion of minority rights, of "otherness" ... the women's movement is characteristic'.[19] This conveniently forgets the long struggle for

independence within the period of modernism demonstrated by the suffrage movement of the 1910s, the social emancipation of women in the 1920s and the feminism of both world wars. It can be argued similarly that in another cultural product, music, the ultra-modernism of Duke Ellington represented blackness as effectively as the postmodern Camp of the Village People celebrated gayness.

Many of the defining texts on Post-Modernism create such artificial historical distinctions in order to clarify their position, just as some early Modernist writings dramatized the breach between premodern and modern culture. Jencks is candid about this process: 'I used this rhetorical formula – Death of Modernism/Rise of Post-Modernism – aware that it was a symbolic fabrication (I invented a false date) and yet was pleasantly surprised to find that nearly everyone (especially the press) accepted it as truth'.[20]

According to the orthodox Post-Modernist view, American design in the the twentieth century was controlled by a German *Zeitgeist* theory and by the dictates of the International Style. Yet the idea that there ever was a single style dominating American design (with the possible exception of 'Colonial') is very hard to make stick in the face of such immense cultural diversity, varied production and voracious hunger for change.

David Kolb warned that facile distinctions between premodern, modern and postmodern conditions should be watched carefully as they imply a periodic framework for a story which is largely mythical and of limited use in gaining insights into either the present or the past. Kolb identified two categories of recent postmodern thought which has considerable influence on design in the last quarter of the century.

The first, including the writings of Jencks, declares the death of modernity and the birth of a new Postmodern Age. Jencks defined Post-Modernism as 'a positive movement'. His definition suggested progress, a crusade carrying moral baggage as cumbersome as that born by the Modern movement. Further, he likened his Post-Modern manifesto to 'the platform of an ambitious political party' and declared its permanence: 'post-modernism is here to stay'. He denounced the Moderns for 'legitimising their position by exaggerating the faults of their opponent', yet employed a similar tactic in constructing a dubious, narrow definition of modernism, emphasizing only its most barren and dogmatic manifestations, to make room for a counter-movement based on openness and pluralism.[21]

While Post-Modern design flourished within the same cultural establishment which fostered the various camps of Modernism, genuine pluralism existed in the homes of ordinary people, in

roadside architecture, amusement parks, street fashion and in the design of popular consumer goods throughout the century. It also existed in museums and within the domain of educated taste as expressed in the 'functioning decoration' central to the interiors, films and exhibitions designed by Charles and Ray Eames. The achievement of postmodernism was to bring this fact to general attention and to create a framework for its appreciation.

Sadly, the defining characteristics of Post-Modernism, which Jencks set out in 'The Post-Modern Agenda' and presented as an improvement on modernism, bear little relation to the realities of life in the late twentieth century.[22] Modernism was described as 'totalitarian', postmodernism as 'democratic', but there is little evidence of any genuine increase in democracy in America at the end of the century. He created an unfavorable contrast between modernist atheism and postmodern 'pantheism'; yet the latter seems distinctly at odds with the growth of religious funda-mentalism and intolerance in the 1990s, both in America and abroad. And his opposition of modernist 'monism' with postmodernist 'pluralism' suppressed the anarchic, spiritual and polymorphic strains of modernism, which provoked debates among its various factions throughout the century. It is difficult, therefore, to avoid concluding that this period-approach to under-standing cultural change is unsatisfactory in the face of messy historical reality.

Kolb described a second type of postmodernist thought as de-construction which attempted to dismantle the certainties and unities associated with modernism while avoiding the myth of a New Postmodern Age. He argued that we have not changed so very much from our premodern condition in that human beings are still a bundle of confusions and conflicts, are subject to widely varied external influences, and are in a state of constant change and development.[23] This view of the evolving human condition freed the historian to assess any episode in history on its own merits, rather than as the product of one or another adversarial 'period'.

The freedom and complexity of deconstructivist thinking was expressed in 'New Wave' graphic design and typography, exempli-fied by the work of April Grieman. Grieman's magazine and poster designs exploited the potential of computer and video to create spatially ambiguous, multi-layered, multi-referential and frag-mented images with richly varied typography to engage the viewer's imagination and invite liberal interpretations. Teaching at the California Institute of the Arts and working for high-profile clients such as Xerox Corporation and the clothing chain Esprit, she became one of the most influential American graphic designers of the 1990s (figure 88).

Deconstructivism, derived from Chaos and Complexity theories, suggested a new direction for postmodern design, addressing the human-nature-machine interface in an optimistic and creative spirit. Less concerned with image than with ecological, spiritual and functional innovation, the deconstructivist approach was demonstrated in Frank Gehry's design for the Vitra Museum in Germany. Vitra's galleries were housed in a cluster of warped boxes, haphazardly piled on one another at odd angles, creating the impression of 'frozen motion'. The complex, dynamic curves of Vitra's interiors alluded to German Expressionist architecture of the 1920s which was intended to inspire the human imagination and feed the spirit. Dramatically vibrant forms and spaces also

appeared in Gehry's Guggenheim Museum (1997) in Bilbao, Spain, where fluttering and undulating metal cladding created an impression of animation consistent with contemporaneous developments in bio-technology and anticipating further blurring of distinctions between the natural and constructed worlds. These projects helped to place American deconstructivism on a world stage and declared that postmodern design had entered a more promising phase at the end of the millennium (figure 89).

Post-Modernism, defined idealistically as pluralism by its founders in the 1970s, became another high style in the 1980s. Yet its theory served to ennoble popular design and to reorder the system of taste. The movement established the idea that all approaches to design have equal validity within their own terms of reference and should be nurtured in respect to particular conditions and requirements. In the 1990s, Post-Modernism appears to be taking a direction which would equip American design of the next century for rapidly advancing demands by the information culture, environmental movements, and higher organizational systems found in nature by ever smarter machines.

Notes

1 I am using the capitalized spelling, Post-Modernism, to describe the design style which emerged from the general cultural orientation of postmodernism.

2 'Camp', *Time Magazine*, 11 December 1964, p. 75.

3 Gert Selle, 'There is No Kitsch, There is Only Design!', in Victor Margolin, *Design Discourse* (Chicago, 1989), pp. 55–66.

4 Gillo Dorfles, *Kitsch, the World of Bad Taste* (New York and London, 1969), p. 9.

5 Vincent Scully wrote the Introduction to *Complexity and Contradiction in Architecture.*

6 Robert Venturi, *Complexity and Contradiction in Architecture* (New York, 1966; repr. London, 1977), p. 48.

7 *Ibid.,* p. 118.

8 Michael Collins, *Post-Modern Design* (London, 1989; repr. London, 1990), p. 107.

9 August Hechsher, quoted by Venturi in *Complexity and Contradiction*, p. 16.

10 A composite definition drawn from two sources; Charles Jencks, *What is Post-Modernism?* (London, 1986), p. 49 and idem, *The Post-Modern Reader* (London and New York, 1992), p. 6.

11 Forty thousand of Graves' whistling kettles were sold by Alessi in the first year of production: Collins, *Post-Modern Design*, p. 127.

12 *Ibid.,* p. 132.

13 The character's blue-collar background allies him with the disadvantaged, if not the oppressed.

14 *Wall Street* (1987): director, Oliver Stone; art director, Stephen Hendrickson.

15 Refers to an article by Tom Wolfe, 'The "Me" Decade and the Third Great Awakening', *New York* 23 August 1976, p. 26.

16 Victor Papanek, *The Green Imperative* (London, 1995), p. 47.

17 Jencks, *What is Post-Modernism?*, p. 49.

18 *Ibid.*, p. 52.

19 *Ibid.*, p. 55.

20 Jencks, *The Post-Modern Reader*, p. 24.

21 *Ibid.*, pp. 6-7. See also the chapter 'Demonizing Modernism' in Jencks, *The Architecture of the Jumping Universe* (London, 1995), p. 31.

22 *Ibid.*, p. 34.

23 David Kolb, *Postmodern Sophistications* (Chicago and London, 1990), pp. 172-5.

Industrial drama: the custom car myth

<div style="text-align: right">7</div>

In the early 1920s it looked to many observers as if mass production would be devoted, indefinitely, to making what Le Corbusier called 'type-objects': perfectly refined, standard products. The Model T Ford (1908–27) was just such a rational product, technically simple and made from interchangeable parts for easy repair and maintenance. It was robust in construction, relatively powerful and high enough from the ground to clear the poor roads of rural areas in the first decades of the century. Thus, it conformed to at least two of the three basic principles of functionalism, strength and utility. As for appearance, this has usually been granted a poor third by historians who have represented Ford's ideas on beauty through the aphorism often attributed to him, a 'customer can have a car in any color he wants, as long as it is black'.

In reality, the Model T was much loved for its characterful shape. Strother MacMinn wrote of the 'new' 1923 model, 'even its bare necessities possessed a sense of grace and logic that endeared it to its loyal customers'.[1] But if the Ford car is granted a modicum of beauty, it is absolutely the result of the way its appearance expressed its fitness to purpose.

The Model T was an exemplar of precision manufacturing, reliable, robust and of unvarying quality. The car proved that simplicity and classlessness could be compatible with commercial desirability. The generic, universal product, a modernist ideal, was suitable for a wide range of purposes, adaptable to customization, and usable everywhere by anyone. Like the earlier products of Colt and Singer, the wide appeal of the Model T also demonstrated the potential universality of the marketplace.

In reality, the Model T Ford was never as thoroughly anonymous as it is often portrayed today. For one thing, the Model T was not a static, unchanging product, even to the extent of the later Volkswagen 'Beetle'. It evolved visibly, keeping pace with most other low-priced cars of its day. It was also produced with every conceivable body type including a snappy four-seater convertible, called the Tourabout, a prototypical wooden-bodied station wagon and an elegant town car which sold well to the carriage trade, although it might have made a better taxi cab than a limousine (figure 90).

90] Part of the mythology of twentieth-century design is the notion that the Model T Ford was unattractive due to its unvarying form and spartan character. The reality was somewhat different. This illustration shows some of the 1917 models including a chauffer-driven Town Car, an aggressively proportioned Runabout and the substantial Coupelet.

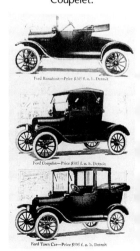

While Henry Ford made a point that the car's low price was the direct result of standardization, the Model T was sold in a range of colors in its early years and again toward the end of its production run.[2] Many owners also bought them in primer finish and painted them to suit their own tastes. When the original factory bodies became dilapidated, the sturdy Ford could be easily fitted with a special body made by the Lehman Manufacturing Company, a Ford subsidiary; their 'Lamcoline' range included sporting, touring and racing bodies designed for the Ford chassis.[3]

The very fact that the standard-type car invited such intimate personalization contributed to the genuine popular affection for the Model T during its nineteen-year production run. Staunchly ascetic in matters of fashion, the writer Gertrude Stein and Alice Toklas left theirs 'in the nude' and defined the car's gender by naming her Godiva. In his novel *Cannery Row*, John Steinbeck called for someone to

> write an erudite essay on the moral, physical and esthetic effect of the Model T Ford on the American nation. Two generations of Americans knew more about the Ford coil than the clitoris, about the planetary system of gears than the solar system of stars. With the Model T, part of the concept of private property disappeared. Pliers ceased to be privately owned and a tyre-pump belonged to the last man who had picked it up. Most of the babies of the period were conceived in Model T Fords and not a few were born in them. The theory of the Anglo-Saxon home became so warped that it never quite recovered.[4]

Such was the emotional bonding of the nation with a standard 'type-object'.

Unlike Ford, Alfred P. Sloan took the view that he could sell the public mass-produced goods which would satisfy their aspirations by employing artistry and illusion in their design. By the mid-1920s, flexible mass-production techniques were creating the opportunity for manufacturers to differentiate their relatively standard products economically, and Sloan quickly spotted the commercial benefit of enticing buyers with an illusion of choice. If, like Walter Mitty, you dreamed of piloting a jet fighter plane, Sloan could sell you a Buick with vestigial wings and a bubble of glass overhead to make you feel like Chuck Jaeger.[5]

The idea of an inspirational 'model' which common goods imitate goes back to the early industrial period. In the nineteenth century, Gottfried Semper observed that the study of art could be based on the identification of 'original type-forms from which … subsequent artistic forms were derived'. According to this logic, the Doric Order exists as a 'model' in the popular imagination, independent of its physical reality. The thousands of suburban colonial

homes built by developers during this century, with Doric porches gracing their entrances, showed a classical allegiance through their decoration.

Jean Baudrillard updated this idea when he wrote, 'the status of the modern object is dominated by the opposition of the unique object to the mass-produced object – of the "model" to the "series"'. Baudrillard saw the model as the essence of the series. Models work best among objects, such as cars, which are widely understood to have both an imaginative and a practical function. Clothes are another good example – the couture item in relation to the ready-to-wear garment. Among such things, our opportunity to identify with the object seems naturally greater than with an object of pure utility, such as a filing cabinet.

91] The model and the series. Ford's 1966 Mustang (bottom) was a people's version of their expensive, hand-built Lincoln Continental of 1956 (top). The Mustang's enormous feel-good-factor was reflected in massive sales; good things come to those who wait.

Comparing a mass-produced car like the original Ford Mustang (1964-66) with a hand-built luxury car such as the Lincoln Continental of 1956-57, shows how the 'series' aspires to the 'model' through its proportions, sculptural articulation and ornamentation

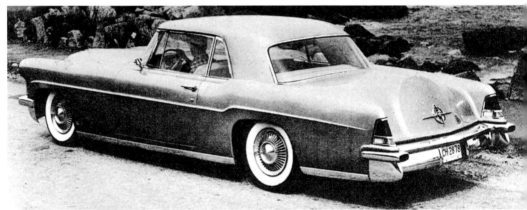

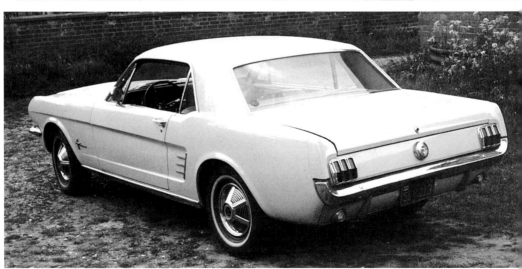

– in its overall character. If the unique personality of the Continental stood for the wealth, prominence and elan of its owner, then it was through the emulation of its visual qualities that the Mustang brought a similar sense of importance and distinction to its driver and passengers (figure 91).

In the American consumer culture identification with manufactured goods became a way of establishing and expressing individuality – a way to make a more comfortable nest and feel

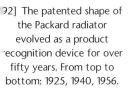

92] The patented shape of the Packard radiator evolved as a product recognition device for over fifty years. From top to bottom: 1925, 1940, 1956.

more at home in society. The historian Tim Benton pointed out that Le Corbusier used images of cars 'in anthropological ways to stand in for people'. His personal Voisin Grand Tourer represented himself in many photographs And in drawings of custom-designed houses, Corbu often represented his clients in the form of suitable types of car: artist as sport torpedo; banker as limousine.

Treating the car as a badge of the individual in society, American corporations built up a highly successful status hierarchy for their products by the 1930s. This class system was well understood by the whole motoring population and served as a representation of self-improvement as one bought one's way up the ladder. Typically, in 1957, the Ford Motor Company produced the standard Ford, the more sophisticated Mercury, the sporty Thunderbird, the prestigious Lincoln, and the exclusive Continental (few outside of Hollywood had one). Similar hierarchies established by European makers such as Fiat were identified less romantically by engine size: 500, 1100, 1500 and so on up.

The motor industry always used ornament and color to distinguish products which were basically alike. At first, product recognition was made easy by dynamic figurative sculpture mounted on the car's radiator. Similarly, the distinctive patented form of Packard's ornamental radiator grill identified that make for over fifty years (figure 92).

Decoration was also employed to signify craftsmanship, prestige or sporting qualities. Car dealers frequently sold standard models ornamented with sporting details such as imitation wire wheel covers, 'continental' spare wheel kits and elaborately simulated convertible roofs, executed with the same conviction as a decorative gas log-fire. Traditional coach craft was suggested by stick-on pin-striping and walnut burl imitated in plastic. Some 'special edition' cars celebrated historical events: 1992 Buicks carrying a 'Presidential' designation commemorated the Clinton election of the same year, making this 'series' automobile the transport equivalent of a 'Bill and Hillary' souvenir mug – a keepsake (figure 93).

A 'model' enjoys both the present, when it sets fashion, and history, when it is revered as a 'classic'. GM styling chief William Mitchell's personal XP-700 of 1958 was such a car. The fantastic forms of this unique 'concept' car inspired the generic futurism of later General Motors' production cars, such as the Chevrolet Camaro. But as the 'series' car follows a 'model', it is already slightly passé by the time it is launched. It is also built to wear out; and so few examples last long enough to become prized antiques.

Marketing was a great beneficiary of the auto industry's technical ability to provide choice. Advertisers urged buyers to express

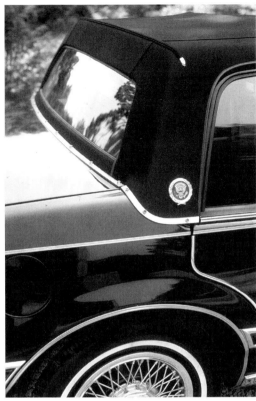

[203] The Buick dealer's 1992 Presidential Special Edition (right) employed simulated wire wheel covers and convertible-type roof details with great conviction to achieve visual distinction from the standard model (left).

themselves through the things they bought. Judith Williamson explained, in 'Decoding Advertisements', how this myth of individualism was promoted. Ads tell us that each of us is unique. She wrote that they

> give us the assurance that we are ourselves, separate individuals and that we choose to do what we do … in an advertisement, we are told that we do choose, we are free individuals, we have taste, style, uniqueness, and we will act accordingly. It is crucial to maintain the myth that this choice is an individual one, that we act in accordance with our 'beliefs' … ours in particular.[6]

As in the fashion world, Detroit's profusion of stylistic choices was an attempt to give customers products which they could easily identify as theirs alone. Devon Francis, an automotive journalist writing in a 1954 issue of *Popular Science* magazine, told his readers how to get a distinctive looking car right off a standard production line by selecting one of 161 different color combinations available for the thirteen Chevrolet models being produced that year. Although the DuPont company had been supplying the industry with synthetic lacquers since the 1920s, it was only after the Second World War that the range of color options expanded to

This Year You Can Buy
161 Chevrolets
...All Different

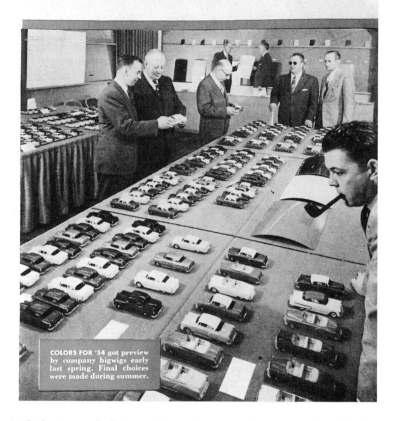

COLORS FOR '54 got preview by company bigwigs early last spring. Final choices were made during summer.

94] Spoiled for choice? Color and trim options offered the Chevy buyer in 1954 an opportunity to acquire a car which looked unique among the millions produced.

include a non-chalking white and an amazing array of pastels, including pink, turquoise and lemon yellow. His speculations took him further into the possible variations of the standard product achievable by ordering factory options such as automatic transmissions, special engines, air conditioning and power-assisted equipment plus fancy wheel trim and white-wall tires (figure 94). The article cleverly recognized the desire of each potential owner to have the perfect, one-off, bespoke automobile – in other words, the 'model'.

A craft industry of traditional coach builders has always catered to the few who could afford to own a genuinely unique car (figure 95). At the turn of the century hundreds of companies across the country were in the business of carriage building. By 1910 many of them had quickly converted to making car bodies on all the high

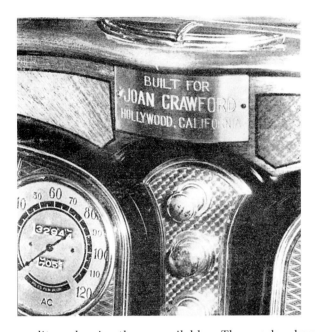

95] The genuine bespoke automobile, especially if it represents a well known personality, has remained the model to which the mass-produced variety aspires. This one was designed and built in the 1930s to the specifications of the Hollywood star Joan Crawford.

quality chassis then available. The early hand-built cars demonstrated the importance of craftsmanship in their careful detailing of wood and metal components, the hand-rubbed paint-work, pin-striping which highlighted the elegant configurations of body panelling, and luxuriously tufted and buttoned leather up-holstery. Among the most prestigious of coach-building firms was Brewster & Company who had been making top quality carriages since 1810. When they turned to automobile bodies, they con-tributed numerous innovations to the improvement of comfort, safety and aesthetics which eventually filtered down to more pros-aic products. They also attempted to express something of the personality of the individual client in each design.[7]

Murray and Briggs were also important early manufacturers of custom bodies who helped to define the professional role of the body draftsman. The body draftsman was the direct ancestor of the automotive stylist, who came to prominence in the major car-making companies during the 1920s and 1930s. The role of draftsmen was to conceive and communicate the complex shapes of the car body to pattern and die-makers. Their skills were de-veloped both on the job and in new institutions such as the Carriage and Automobile Body Drafting School in New York. Like ambitious young American architects who achieved sophistica-tion by attending the Ecole des Beaux Arts in Paris, some aspiring automotive draftsmen were privileged to study at the coach-buil-der's school of Monsieur duPont in Paris.[8] Thus the traditions and innovations of European design were translated directly to Ameri-can automotive styling.

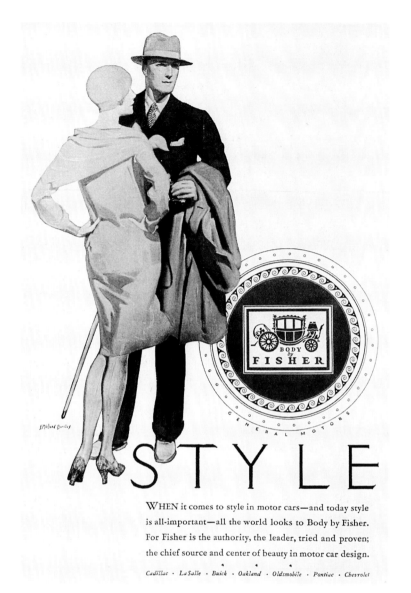

STYLE

WHEN it comes to style in motor cars—and today style is all-important—all the world looks to Body by Fisher. For Fisher is the authority, the leader, tried and proven; the chief source and center of beauty in motor car design.

Cadillac · LaSalle · Buick · Oakland · Oldsmobile · Pontiac · Chevrolet

96] By the mid-1920s, the idea of a stylish automobile was firmly linked to the established notion of sartorial fashion. In this General Motors advertisement of 1928 by McLelland Barclay, style is portrayed as up-to-the-minute and linked to the classical tradition of royal coach building.

Other coach builders, including Brunn, Bohman & Schwartz, and Murphy, flourished even in the climate of high-volume production which increasingly dominated automobile manufacture in the 1920s and 1930s. They survived as design consultants and body builders of top end production models, one-offs for special customers, and unique show cars made by the major car companies. Some were assimilated. Brewster was acquired by Rolls-Royce to build the bodies for their American product lines. The largest American body builder, Fisher Body Corporation, was bought by General Motors and became one of its most important divisions (figure 96). The importance of the coach builders was the

influence their designs had on the production cars of the large manufacturers.

Raymond Dietrich formed Dietrich Incorporated which specialized in luxurious bodies for Lincoln and Packard. He also was a co-founder of LeBaron which became closely associated with Chrysler, producing some of their most elegant bodies on top of the line Custom Imperial chassis in the early 1930s. These sleek behemoths, built at the depth of the Depression, were sold at a financial loss to get them on the road as prestige advertisements for Chrysler's cheaper bread and butter lines which inherited some of the looks of the custom jobs. Similarly, the firm of Howard 'Dutch' Darrin, which created European inspired bodies for many manufacturers, is best known for the line of luxurious Packard 120s and 180s built to their designs in the early 1940s. These were intended to stimulate demand for the cheaper Packard Clipper cars which bore a family resemblance to the elegant custom models.[9]

Among the early coach building firms was the Earl Automobile Works, a name revived by the recent historical interest in the firm's scion and chief designer, Harley Earl, who became the first Vice-President in charge of styling at General Motors. The Earl Automobile Works prospered in Hollywood during the first boom years of the silent movie industry. They built unique automobiles, mainly Cadillacs sold through the Don Lee agency, for the first generation of stars. Clients included Mary Miles Minter and the larger-than-life comedian, Fatty Arbuckle. Aside from their sleekness and expressive coloring, these cars achieved individuality through the addition of personalized bolt-on accessories, such as a saddle and steer horns mounted on the car Earl designed for the cowboy star, Tom Mix. The Earl company also marketed standard accessories, such as specially upholstered seats, with which the ordinary motorist could customize a stock production car.

More widely available to the rapidly growing motoring public in the 1910s and 1920s were the accessories sold by mail order through the Sears Roebuck Catalog. These included ornamental motometers, which sat atop the radiator measuring the water temperature and embellishing the most prominent position on the car's body. Upholstery slip-covers in a variety of colors and patterns, decorative carriage lamps and luggage racks could also be fitted to the standard car to improve its usefulness and personalize its looks.

Modification of standard Detroit cars by small professional workshops began in the late 1930s in the car culture of southern California. 'The Coachcraft Shop' in Hollywood and 'Valley Custom' in Burbank were two of the first, joined after the war by Barris Brothers' workshop in Lynwood. By the early 1950s, customizing

had become a practice with significant influence on the styling directions of the major manufacturers. Yet in a wider sense, it was the private customizer, the hobbyist, who contributed to a nation-wide, popular expression of design and craft skills. The owner-designer would, typically, enlist the services of a variety of specialists including a body shop, upholsterer, pin-striper and performance specialist to achieve the intended transformation of a stock car into a unique custom. Many also developed their own craft skills and home garage facilities to perform the cosmetic surgery.

In 1963 the journalist Tom Wolfe reported on a California Teen Fair at which the Ford Custom Car Caravan appeared along side sellers of guitars, Chris-Craft boats and sports shoes. The Custom Car Caravan was a travelling exhibition of factory sponsored show cars aimed to stimulate the youth market for new Fords.

> These kids are absolutely maniacal about form (in their dances, their dress and posture) ... They have created their own style of life ... (and) they have money ... it is this same combination – money plus slavish devotion to form – that accounts for Versailles or St. Mark's Square. And the kids' formal society has also brought at least one substantial thing to a formal development of a high order – the customized cars ... They are freedom, style, sex, power, motion, color.[10]

The presence of the Custom Car Caravan confirmed that Ford had begun to appreciate the commercial potential of establishing allegiance with teenage interests. Whereas Detroit styling of 1963 may have seemed flamboyant in any rational, adult context (particularly by the standards of the Museum of Modern Art), Wolfe declared somewhat perversely that Detroit styling was austere – 'pure Mondrian, very Apollonian'. He saw California customizing, by contrast, as extravagantly Dionysian, which the kids preferred.

The exuberant custom styles of the 1950s and later had evolved from the relatively conservative pre-war efforts of individuals to improve and personalize the looks, performance and interior comfort of certain, preferred high-volume Detroit automobiles such as the standard Fords and Mercurys of 1939–40. The early customs were classified as either 'mild' or 'wild', depending on the extent of modification. They were essentially simplified versions of the production models, stripped of decoration, de-chromed, running boards removed, bodies lowered by 'chopping', 'sectioning' and 'channeling' to exaggerate their sleekness.

After the war, painted and applied decorations were added as expressive elements. The paint-jobs of the post-war customs featured flame motifs, pin-striping and multi-hued combinations of

aggressively lurid, metal-flake lacquer to give the cars character and to make them stand out in any crowd.[11] The addition of stock or hand-made chromium trimming, 'continental' wheel kits, additional sculptural elements, such as tail fins, and extravagant 'tuck-and-roll' upholstery all contributed to the exoticism of cars conceived as extensions of their makers' egos. This tendency did not go without criticism. The architect, John Brenneman, wrote in 1957, 'It seems to me that customizers do not try to improve the looks of their cars, but instead try to make them more conspicuous … speaking as a professor of architectural design, the most highly customized business in existence – (I) am led to wonder what motivates this frenzy of dedicated activity'.[12]

Tom Wolfe offered some suggestions in his interview with the best-known customizer and authority on amateur customs, George Barris, at his 'Kustom City' workshop in North Hollywood – 'he is absolutely untouched by the bug amoeba god of Anglo-European sophistication that gets you in the East'. A Barris car is like 'one of these Picasso or Miro rugs. You don't walk on the damn things. You hang them on the wall … In effect, they're sculpture.'[13] Indeed, during the 1950s and 1960s, fine artists also began using mass- produced Detroit cars as the raw material for works of art. The assemblage artist, John Chamberlain, welded junked auto parts into dynamic, expressive abstract sculptures, while on a larger scale the environmental art and architecture collaborative, Ant Farm, constructed Cadillac Ranch near Amarillo, Texas, in 1974 as a poetic homage to the tail fin. Ten Cadillacs, buried nose down at sixty degrees to the earth, narrated the history of the Cadillac fin from its first tentative appearance in 1949, through its apogee in 1959, to its final restrained appearance on the rear fender of the 1964 model.

George Barris opened his first shop in Los Angeles in 1945, carrying out accident repairs and modifying standard Detroit products for private clients. As his reputation grew, he went on to produce hand-made one-offs for movie stars and other moneyed Angelinos. And as a publicist for creative car craft, he encouraged a generation of backyard customizers to allow their imaginations free expression through sheet metal, plastic and paint. Wolfe portrayed Barris as one of 'America's modern Baroque designers'. He called his style 'Dionysian Streamline' and compared the aesthetic with that of Eero Saarinen's organic and expressive TWA terminal in New York.'The way people have taken to these models makes it clearer still that what we have here is no longer a car but a design object, *an object*, as they say.'[14] Wolfe's observation reflects a view of the custom car similar to the traditional appreciation for works of the decorative arts, such as a Cellini salt cellar or an Alessi

coffee and tea piazza, for which use is secondary to image and craftsmanship.

Cars by professionals, such as Barris, and those by accomplished amateurs became widely known via shows and magazines.[15] Robert Peterson staged the nation's first custom car show in the Los Angeles Armory in 1948. Customizers learned of new designs and techniques in Peterson's *Hot Rod* magazine, founded in the late 1940s, in *Car Craft, Rod & Custom,* and in more mainstream journals, such as *Motor Trend,* for which Barris was a contributing editor. By the late 1950s, Barris cars were so popular that they were being reproduced by the AMT Corporation as 1/25th scale model kits. Ed Roth, another customizer whose creations were often seen in magazines and on the custom car show circuit, produced designs for similar kits made by Revell.

Tom Wolfe recalled the color studies of Goethe in describing Barris's 'Kandy Kolors' as signifiers of emotions. In the case of custom cars, the appeal of the purples, oranges and metallic blues was both narcissistic and rebellious. Like their outrageous colors, the names of the cars also suggested sexiness and/or alienation: *Miss Elegance, Orchid Flame, Lost in the Fifties, Heartbreak.*

But the customizers had only a small lead on the big car-makers in tapping into the public fantasy. That is why the Ford Custom

97] Custom-designed, hand-built cars continued to be made in small craft workshops for private customers or for the promotional uses of majo car manufacturers. Under construction in the 1990s a 'phantom' roadster, an a new, high-tech car based on the lines of a 1937 For as it might have been customized by a backyar hot rodder in the 1950s. Boyd Coddington workshop, Los Angeles.

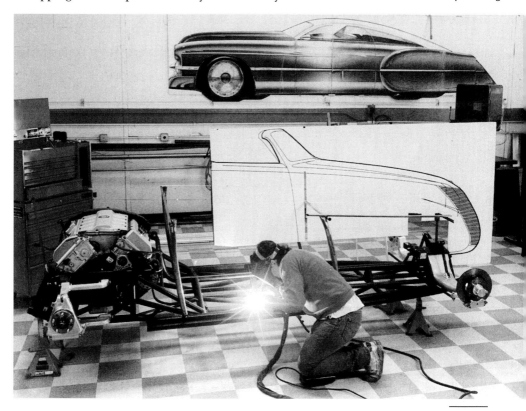

Caravan was at the Teen Fair in 1963. Barris was approached by the Cadillac styling center in Detroit first in 1957 when they wanted to use his Kandy Kolors, initially for show cars to be exhibited in their annual Motoramas and later for use on their production models. Design elements of professional customs often found their way directly into Detriot products via stylists' copying. Barris described this process sardonically as 'lifting'. Inevitably, he and other prominent customizers worked as consultants to car manufacturers of America and the Pacific rim.

In the 1990s, Boyd Coddington's Los Angeles workshop caters to a continuing demand for custom cars measurable in terms of popular interest by the 850,000 monthly circulation of *Hot Rod* magazine. Coddington specializes in building one-of-a-kind hot rods for wealthy extroverts; but Coddington rods are also commissioned as 'concept' cars by American and Far Eastern manufacturers including GM, Mitsubishi and Hyundai, closing the circle between 'model' and 'series' (figure 97).

Car styling proved to be one of the most fertile outlets for design creativity in the mechanistic material world of the twentieth century. From a critical viewpoint, automotive design served as an arena for the ongoing debate between rational design and expressionism. The former represented both 'good form' and a sense of social responsibility. In the latter, symbolic values outweighed all other considerations, and the car was seen as an emblem of the owner's personality and taste. Distinctions existed, however,

98] Modern crafts generated a new type of dream product light years removed from the traditions of wood turning and patchwork quilts. Here, a serviceman redesigned a standard 1940 Mercury, and spent 8,000 of his 1952 dollars transforming it into a rolling cocktail lounge – ultimate date-bait in the post-Second World War period. 'Craftsmen in Uniform' was a series run by *Popular Science* magazine during the Korean War featuring craft products ranging from a copper bas-relief to a sun helmet radio.

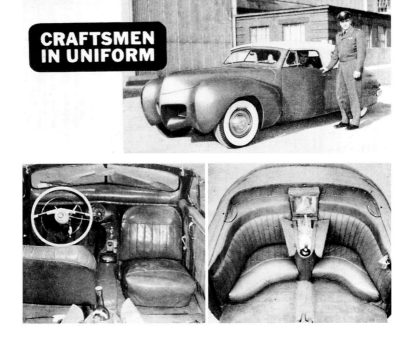

between the illusions of individuality implanted in the design of 'serial' products made by large corporations and the genuine individuality of the hand-crafted car.

Amateur, grass-roots customizing undermined the normal relationship between the 'model' and 'series'. This was accomplished by 'personalizing' production goods through hand-craftsmanship. In customizing, the 'model'/'series' relationship operated not as a marketing ploy, but as a genuine outlet for the imagination. The customizer became a true participant in the production process by

99] Car customizing continues to flourish in the 1990s. An amateur customizer employed his imagination, native design ability and highly developed craft skills to transform his 1951 Ford into this nostalgic show-car, 'Lost in the '50s', c. 1993.

continuing that process beyond the factory gate. Also, customizers interfered with the pre-determined lifespan of the production car. Automobiles which, in the normal order of things, should have arrived on the scrap heap or have found their way into a sculpture by John Chamberlain were resurrected and elevated to the status of the 'model': unique, expressive, finely wrought, immortal.

Using highly developed craft skills, customizers refashioned the standard production car in order to express his or her personality (figures 98 and 99). Like street fashion and D-I-Y home improvement, car customizing combined adhocism with specialist accessories to concoct a 'one-off' of high-image value. The grass-roots customizer was a true subversive in the commercial system of design, production, marketing and use of automobiles.

Notes

1 Strother MacMinn, in Gerald Silk, *Automobile and Culture* (New York and Los Angeles, 1984), p. 219.

2 David A. Hounshell, *From the American System to Mass Production, 1800–1932* (Baltimore and London, 1984), p. 273.

3 Floyd Clymer, *Historical Motor Scrapbook, Number Four* (Los Angeles, 1947; repr. Los Angeles, 1952), p. 142.

4 John Steinbeck, *Cannery Row* (New York, 1945; repr. London, 1958), p. 135.

5 Chuck Jaeger was a record-breaking American test pilot of the post-war period. See Tom Wolfe's *The Right Stuff* for an account of Jaeger's career.

6 Judith Williamson, *Decoding Advertisements* (London, 1978; repr. 1992), p. 53.

7 Silk, *Automobile and Culture*, p. 220.

8 *Ibid.*, p. 218.

9 *Ibid.*, p. 223.

10 Tom Wolfe, *The Kandy-Kolored Tangerine-Flake Streamline Baby* (Toronto, 1963; repr. Toronto, 1987), p. 79.

11 George Barris devised a range of iridescent paints described as 'Kandy Kolors', some of which were bought by Cadillac for use on their production cars during the early 1960s.

12 John Brenneman, 'An Architect Looks at Customizing', *Motor Life* (December 1957), p. 18.

13 Wolfe, *Kandy-Kolored Tangerine-Flake Streamline Baby*, pp. 82–3.

14 *Ibid.*, p. 94.

15 Of 28 custom cars entered in *Motor Life* magazine's annual 'Custom Cars of the Year' contest in 1958, 13 were owner-designed and owner-built. 'The Winning Custom of the Year', *Motor Life*, vol. 8, no. 3 (October 1958), pp. 38–43.

Making American homes: domestic architecture and interiors

<div style="text-align: right">8</div>

Whatever its structure, single or multi-family, condo, mobile, log cabin, tipi, converted barn or warehouse, home is where Americans most clearly define their identity. As in the theater, design of the domestic stage-set involves selection and arrangement of props in an imaginative combination which requires a variety of craft skills. It also involves knowledge – the choice of a model as the basis of the design. Just as the narrative of a play suggests a setting, in the home the self-image of the occupants suggests the model. Tradition-oriented White Anglo-Saxon Protestants (WASPS) have long favored the New England colonial salt-box house. The White House is a perennial source for executive homes. Relaxed suburbanites found a suitable pattern in Frank Lloyd Wright's prairie houses. Even a minimalist glass box, such as Mies van der Rohe's Farnsworth house, has inspired glass-walled homes for middle- and upper-income modernists.

Since Jefferson's time, Americans have aspired to live in a family or extended family group in a private house standing in its own land. As industrialization and urbanization advanced in the nineteenth century and many people became increasingly dependent on the office and factory for their livelihood, the suburban house became the closest facsimile of the Jeffersonian ideal that most people would ever achieve. Later, shortages of city housing and the improvement of roads and rail communications encouraged mass migration to the suburbs of towns where the building industry produced small, modern houses based on the models of Jefferson's Monticello, Washington's Mount Vernon or western, ranch-type dwellings.

From the start of the century, new mass-circulation magazines, such as the *Ladies' Home Journal*, published small-house plans by 'the foremost architects of the country whose services the average house-holder could otherwise never have dreamed of securing'.[1] The *LHJ* promoted the principles of social reform espoused by the Progressive movement, including their campaign for better standards of housing. They staunchly advocated improvement of the

middle-class dwelling through stylistic simplification and rational planning according to needs dictated by the conditions of modern life - in a word, functionalism. To realize their aims, the *LHJ* sold full plans of their model houses by mail order at $5 a set in a form which local builders could construct for relatively modest cost.[2] The *LHJ* had a circulation of 1.7 million subscribers by 1919, making their house plans the most widely circulated designs for individual production. The magazine estimated that 30,000 homes were built to their plans between 1900 and 1916.[3]

The 'ideal' home, as illustrated in commercial literature and the entertainment media, has been contrived to set and raise living standards, to portray the dream lives of Americans, and to promote products. Among the earliest plans published in the *LHJ* (February 1901) was 'A Home in a Prairie Town' (figure 100), designed by Frank Lloyd Wright . Although the estimated cost was under $7,000, the house bore a family resemblance to the Susan Lawrence Dana house, a modern palace designed by Wright and built in Springfield, Illinois, in 1902-04. The Dana house represented the American house in its most advanced and sumptuous form at the start of the new century, while the *LHJ* version brought its essential qualities within the reach of thousands of readers and prospective copyists.

One of the outstanding qualities of both the Dana house and the 'Home in a Prairie Town' was openness. Free flow of space became a desirable feature in American house planning due to the increasing informality of modern family life, while the cheapness

100] The compact, informally planned and mechanically serviced house was becoming the accepted standard for middle-class Americans by the end of the first decade of the century. The *Ladies Home Journal* , 'Home in a Prairie Town', 1901, designed by Frank Lloyd Wright.

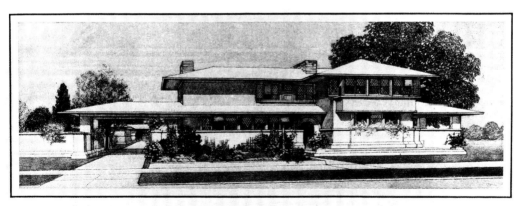

 CITY man going to the country puts too much in his house and too little in his ground. He drags after him the fifty-foot lot, soon the twenty-five-foot lot, finally the party wall ; and the home-maker who fully appreciates the advantages which he came to the country to secure feels himself impelled to move on.

It seems a waste of energy to plan a house haphazard, to hit or miss an already distorted condition, so this partial solution of a city man's country home on the prairie begins at the beginning and assumes four houses to the block of four hundred feet square as the minimum of ground for the basis of his prairie community.

The block plan to the left, at the top of the page, shows an arrangement of the four houses that secures breadth and prospect to the community as a whole,

and broad eaves are designed to accentuate that quiet level and complete the harmonious relationship. The curbs of the terraces and formal inclosures for extremely informal masses of foliage and bloom should be worked in cement with the walks and drives.

Cement on metal lath is suggested for the exterior covering throughout, because it is simple, and, as now understood, durable and cheap.

The cost of this house with interior as specified and cement construction would be seven thousand dollars :

Masonry, Cement and Plaster	.	.	.	$2800.00
Carpentry	.	.	.	3100.00
Plumbing	.	.	.	400.00
Painting and Glass	.	.	.	325.00
Heating — combination (hot water)	.	.	345.00	
Total	.	.	.	$6970.00

and efficiency of new central heating systems made it practical.
The open plan became a fashion applied to suburban houses of all
sizes and costs, from the smallest ranch to the sprawling *Arts &*
Architecture Case Study houses, built in Los Angeles during the late
1940s and 1950s.

Houses generally became smaller as a response to rising building
costs and the ever decreasing size of house lots in developers' sub-
divisions. Smaller families made the three-bedroom house an
adequate standard. The passing of servants abolished the need for
staff rooms and back stairs and led to upgrading and integrating
the kitchen and other areas of the house where domestic jobs
would be performed by members of the family.

One of the primary means of reducing the size of the typical
house was the elimination of dedicated circulation areas, such as
the front hall, and the transformation of the formal parlor into an
open living room which connected directly to the dining area and
often with the kitchen. These were standard features of the Arts
and Crafts bungalows of the early 1900s. The further development
of the open plan came after the Second World War in the form of
tract housing.

The abolition of the parlor was the most difficult aspect of open
planning to achieve in practice. The parlor was despised by hous-
ing reformers of the early twentieth century such as Edward Bok,
the editor of the *Ladies Home Journal*. It represented all that they
thought was wrong with Victorian culture. Progressives ridiculed
it for its pretentiousness and excessive formality. It represented
undemocratic aspirations to class. And it separated children from
family activities. The parlor had to go; and in its place would be a
genuine 'hearth' (in Wright's word) where the family would gather,
eat, work and entertain. A useful model for this multi-purpose
space was the English medieval hall, revived in the nineteenth
century in buildings such as the rambling Newport summer 'cot-
tage' designed for Isaac Bell by the architects McKim, Mead and
White in 1881.

The modern hall, or living room, was used to dramatic effect as
a set in one of the most popular television sit-coms of the 1980s,
The Cosby Show. The Huxtable family gathered most often around
the breakfast bar or large dining table in their kitchen or they would
sit together on a capacious sofa in the living room. The living room
contained three essential features of the English hall: main entrance,
stairs and hearth.[4] All public circulation happened there, ensuring
family interaction, while its fireplace provided a symbolic focus
for family gathering. The stairs offered a dramatic staging for en-
trances and exits. Because the program aimed to encourage family
values, the furnishing of its sets became a glamorized and sanitized

model of security and togetherness. As the affluent family around which the plot revolved was Afro-American, the appearance of their home was also significant in confronting racial stereotypes. The luxurious informality of the television stage-set, however, was more difficult to sustain in reality at the very reduced scale of tract houses. There, the dominant factor was economy rather than community.

The result of open planning was to make the entire public space of the house a stage for the display of wealth and taste, or of mess and neglect. This factor was compounded by the modern insistence on extensive glazing which opened the interior to public scrutiny. Karal Ann Marling compared the modern house front to a television set, the 'picture windows' screens through which the world watched as the occupants performed.[5] The New York tenement setting for the popular 1950s TV series, *The Honeymooners*, provided a comic rendering of the dwellings of the urban poor at mid-century, while *I Love Lucy* offered its audience an image of middle-class home life in the city. These shows revealed the domestic interior with one wall removed, just as the picture-windowed suburban house provided a one-point perspective on the lives of the family within.

Despite the open plan, the lure of a room specifically dedicated to formal display of wealth was difficult to eradicate. Even in smaller homes, people found it desirable to set aside the living room as a 'special' room, off-limits to children and pets. This was made possible by the removal of family activities to TV 'dens' and to large 'recreation rooms' constructed in the spacious basements where Barca loungers and convertible sofa beds provided comfort not found in more decorative living room furniture. With the proliferation of portable and personal audio appliances and televisions from the late 1950s, people living in open-plan homes tended increasingly to retreat into bedrooms for privacy, abandoning the living room to special occasions and museum-like displays.

The open-plan kitchen met with greater success, as its display involved functional equipment. Aside from the family car in the garage, the refrigerator and stove were the two largest and most expensive pieces of hardware in the modern house.[6] Their looming presences in the kitchen symbolized the abundance of food prepared and consumed in the home. 'Family-sized' appliances, the early General Electric 'monitor top' refrigerators and later double-door Amanas, and multi-gageted, chromed and enameled table-top ranges, standard since the 1930s, provided both real and symbolic comfort and made the kitchen a natural focus of family life and a source of pride in ownership.

From the start of the century, model kitchens were promoted

as laboratories for ideas intended to ease the burden of kitchen work. But they also represented the fecundity of American design and manufacturing and the intimate relationship between technology and material comfort. The Libby-Owens-Ford glass company's 'Kitchen of Tomorrow' was widely publicized during the Second World War as a promise of post-war rewards to the generation whose domestic lives were on hold for the duration.[7] It featured state-of-the-art glass technology and a range of futuristic electrical appliances organized for maximum convenience. Food preparation and eating were combined with accommodations for children's play and study, making the kitchen the nucleus of the family home.

In the mid-1950s, the RCA Whirlpool Miracle Kitchen ventured further into the realm of fantasy in its expression of the kitchen as the nerve center of the house. More stage-set than laboratory, its style was a cross between the new straight-lined minimalism of the dawning computer age and the warmer, oiled-walnut Danish modern which was the last word in popular interior furnishing at the time. Whereas the LOF kitchen had concentrated on rational innovation, amusing robotic gimmicks prevailed in the RCA kitchen. The most memorable, a self-propelled vacuum-cleaning robot, scurried about the huge floor acreage consuming invisible debris while the human occupants munched on canapés.

In larger post-war homes, reality was very close to the model, minus its sillier gimmicks. If American home life no longer revolved around formal dining, it still concentrated on eating; the kitchen had become the room which gave the home its primary meaning. The provision of multi-functional amenities such as 'breakfast nooks' and 'island bars' made the 'zoned kitchen' a center for homework and household accounting as well as for informal entertaining (figure 101). Communication appliances, telephones, televisions and personal computers established the kitchen as the 'command post' of the house, like the bridge of a ship. And the common use of the kitchen door by tradesmen and guests alike, plus direct access to garages, porches and patios or decks drew circulation through the room and contributed to its function as the most commonly used reception area of many homes.

But kitchens in the majority of series houses were different – and size was the crucial factor. While kitchens of the LHJ 'model homes' of 1901–02 ranged from 140 to 225 sq. ft., a typical Usonian house, designed by Frank Lloyd Wright in the mid-1930s, showed a kitchen of approximately 70 sq. ft.[8] This corresponded quite closely in size and character to the kitchens of Alfred Levitt's standardized, open-plan two-bedroom ranch houses built by the thousands after the war. These kitchens were often just a bay

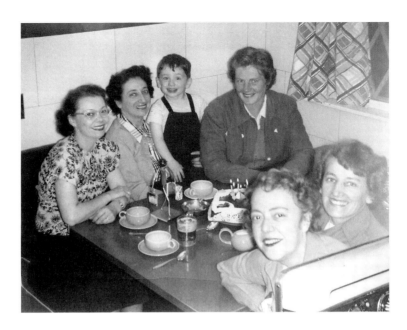

101] The kitchen became the genuine heart of the family house. The 'breakfast nook' was the site of family meals and snacks, homework, and informal entertaining. 'Vitrolite' glass wall tiling, Formica table top, vinyl upholstery, Russel Wright 'American Modern' ceramic ware and cigarette 'porter' establish its comfortable modernity and playfulness. 1949.

separated from the dining-living room by a counter furnished with high stools. Yet they too were showcases of high-tech gadgetry, stages for the display of culinary prowess and observation posts, overseeing the social sphere of family activity.[9]

Perhaps the most radical model home of the century was R. Buckminster Fuller's Dymaxion house prototype of 1927. Constructed mainly of metal, the octagonal house was suspended from a central mast which sat at the center of a service core carrying all the mechanical equipment and ductwork for the provision of modern comforts and internal atmospheric control. The Dymaxion house constituted the most fundamental re-think of the house form to that date and inspired later models of the high-tech, mass-producible house, including Fuller's Witchita house of the mid-1940s. Also inspired by the Dymaxion model, Monsanto's House of the Future was an updated and glamorized version built in 1956 in the Tomorrowland neighborhood of Disneyland. It was made of new synthetic materials to demonstrate their strength and easy maintenance. Hovering above its site, the curvaceous white structure featured four identical picture window facades, like a Flash Gordon version of Palladio's Villa Rotunda. Its interiors were furnished in the most advanced style of Eames and Saarinen and were filled with electronic devices to enable the obsessive house-holder to continuously monitor activities and possessions.[10]

Periodicals in the post-war period continued the tradition of supporting innovations in house design. The California Case Study houses, sponsored by *Arts & Architecture* magazine, were among the most significant of mid-century experimental dwellings. The

'Case Study House Program' was initiated by the magazine's editor, John Entenza, in 1945 to begin 'study, planning and actual design and construction of eight houses ... (to) make a beginning in the gathering of that mass of material that must eventually result in what we know as "house – post war"'.[11] The architects chosen to design the first houses included Eero Saarinen, Ralph Soriano, Gregory Ain, Richard Neutra, Ralph Rapson and Charles Eames.

The Eames house and studio[12] is well known for its clever use of stock, pre-fabricated components (figures 62 and 102). It established a potent model for the post-war dwelling through its innovative method of ad hoc construction and its dramatic spatial configuration. The light steel frame, industrial glazing, Cemesto wall paneling and exposed, corrugated Ferroboard ceilings reflected the utilitarian appearance of the innovative wartime aircraft hangars and factories which enjoyed heroic status following the victory of 1945. But the richness and diversity of its furnishing and decoration pointed toward a merger of high technology construction and the personal values intimately wrapped up in the idea of 'home'. Charles and Ray Eames introduced vivid color, rich textiles, vernacular, period and modern artworks and furnishings, and a profusion of personal objects which they called 'functioning decoration'[13] to

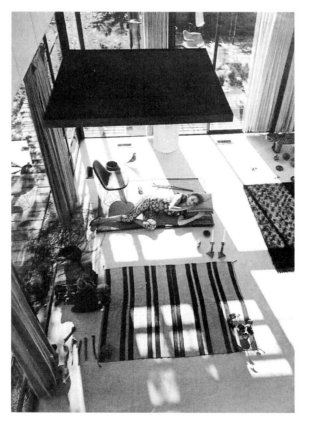

102] With its dramatic spaces and broad views of ocean and landscape, Charles and Ray Eames's Case Study house was an ideal setting for this 1954 'Vogue' cover story on the spread of California style which linked architecture and fashion with regional culture. The house and clothes were casual, practical and oriented to the beach.

give the house a humane, distinctive appearance reconciling post-war affluence with practical efficiency.[14] Thus the simple background provided by high-tech architecture offered an opportunity to develop an entirely new and diverse approach to interior decoration more inclusive even than the eclecticism of the Victorian parlor.

During the housing shortage following the Second World War, the idea of building houses in the manner of mass-produced automobiles was pursued by many manufacturers. But for a variety of reasons, including variations in local building ordinances, changing government legislation and subsidies, uneven demand and cultural traditions, full mass production never achieved as great a success in the housing industry as it did in car-making. Nevertheless, when demand was strong, as it was in the late 1940s and 1950s, houses were produced in very large series using a variety of mass-production techniques, including the assembly line, to achieve economies of volume. In addition to the abundance and relative low cost of materials, the high-volume pre-fabrication of components, ranging from pre-cut timber to all-metal kitchen cabinets and fiberglass shower/bath assemblies, made modern American homes relatively cheap, quick and easy to build.

The failure of Fuller's Dymaxion-Wichita house, intended for mass production by the Beech Aircraft Corporation after the Second World War, demonstrated the unwillingness of post-war Americans to live in a house which looked like a B-movie flying saucer, regardless of the rational economies and comforts it offered – unless it had wheels.[15] The similarity between the failed Wichita house and the contemporaneous, but commercially successful, Airstream trailers and motor homes extended to materials, method of construction, interior amenities, aesthetics and cost.[16] The difference was that the Airstream offered speed, while the Wichita only alluded to it; it bombed mainly due to its attachment to the traditional concept of a stationary house (figure 103). Unlike the Wichita house, the Lustron home of the late 1940s was a 'conservatively modern, ranch-type' house. But it too was intended for mass production, employing the technology and materials of the aircraft industry, and was scheduled to be produced in a recently demobilized aviation plant. Although the Lustron home offered a conventional layout of 1,000 sq. ft. with two bedrooms and open-plan living/dining room, its porcelain enameled steel surfaces, 'available in a choice of colors', lacked the warmth of wood and plaster which prospective buyers expected from a 'permanent' home at the time.[17] And its advanced technology held little potential for aspiring customizers. Federal Housing Association specifications on materials also proved an obstacle to financing.

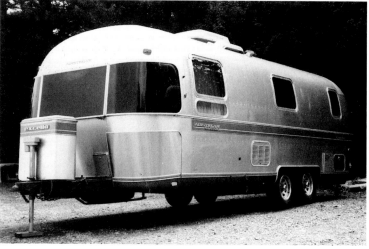

103] Buckminster Fuller's Wichita house and the Airstream trailer shared similar structures, materials, spatial efficiency and visual character. But only the Airstream offered mobility. It succeeded while the site-bound Wichita house failed.

Like the Wichita house, Lustron was a standard product. And despite massive advance publicity, it also proved to be unmarketable.[18]

Although many later 'mobile homes' never left their first site and, like the Lustron house, were often decorated and furnished to imitate traditional houses, their promise of mobility freed a large number of prospective occupants from conventional expectations regarding the way a house should look and/or how it should be made. Modernism was OK, if it signified escape. Small, well appointed with convenient fitted furnishings, cheap, adaptable and movable, mobile homes became the most popular form of low-cost housing in the United States by the 1970s. However, they remained the butt of 'blue-collar' jokes and the target of highbrow aesthetic scorn.

The permanent, traditional house remained the popular favorite, even if its walls were of rendered concrete block or

sheathed in wood-grained aluminum siding. Banks, insurance companies and the federal government agreed. Corporations such as Kaiser Prefabricated Homes, the Texas Housing Company and Levitt Brothers cloaked their advanced building methods and production technology in established styles (Cape, Colonial, Ranch, the latter with contemporary details) to relax their customers into a new way of living in the raw environment of suburban tract developments. And like car makers, they used styling to give buyers an illusion of choice.

The Texas Housing Company removed the mass-production stigma from its homes through flexible manufacturing techniques which enabled them to offer their customers 149 variations of design. As part of their sales service, the Texas company included a unique decorating package designed to personalize the mass-produced home.

> There is no reason why your mass-produced house should be any less individual, any less personally yours than the dress for which you pay $39.50 ... New York's teeming garment industry turns out hundreds of copies of a dress selling at up to one hundred dollars. Yet, enterprising women all over the country make that same dress *individually* theirs by what they wear with it – hat, bag, gloves, shoes, costume accessories. As an example of a completely packaged house that still allows you leeway for your own personal stamp of living, we show you the ER4-7 prefabricated cottage with its packaged decorating charts.

Designed by Beatrice West, the Home Color Service provided charts which specified exterior wall and trim colors, interior surface finishes and advice on curtain materials and upholstery textiles for the ER4-7.[19] Similarly, Kaiser, Levitt and many others offered a basic product with a high standard specification at a relatively low cost. From there on it was the buyers' option to decorate, landscape, customize, or extend the house to suit their changing personal requirements.

By mid-century, craftwork had become productive leisure for the masses. According to Karal Ann Marling, in the 1950s 'Veblens old "leisure class" had expanded to include almost everybody. So many people had joined the ranks, said the *New Yorker*, that the term was obsolete. Leisure was classless nowadays, a textbook example of democracy in action'.[20] Both the owner-built home and the owner-customized home flourished in the growing DIY culture of the century's second half. The old pioneering spirit of building a house was revitalized by the mass manufacturing of power tools, new easy-to-use materials, increased leisure time and a new fashionable image of the white-collar worker with manual skills. The result was a widening interest in the basic principles of

design, its practical functions, and its potential as a means of expression.

Like vernacular crafts, the new DIY movement was more process-oriented than product-based. Victor Papanek wrote of the vernacular house, 'it is usually self-built (perhaps with help from family, clan or builders in the tribe), and reveals a high regard for craftsmanship and quality ... frequently the process of building is more important than or equally important as the end product'.[21] The comparison also included 'strong concern for decoration, ornamentation and embellishment' which applied particularly in the design and making of furniture.

Garages, basements and specially constructed outbuildings served as home workshops, filled with tools designed for use with industrially produced materials. Evening courses at local schools and colleges combined with a massive publishing industry to provide information for aspiring home craftspeople. *Popular Science Monthly* (founded 1872) advertised domestic workshop equipment, easy-to-use materials and plans, encouraging and enabling readers to make their own furniture or even build their own house. From constructing a Rustic-style recreation room in the unfinished basement of a tract house to making a Colonial bookcase, design was applied to all types of domestic projects as an instrument of self-improvement and self-expression.

The most ambitious project, involving designing and making, that most individuals can undertake independently is the house. The owner-built home remains, to many people, a dream which combines a variety of satisfactions, including relative independence from the professional and commercial worlds, genuine economy and creativity. The furniture maker George Nakashima designed his house in response to immediate needs, his background and skills. No plans were drawn (until the house was nearly completed), and its detailing developed from the available materials and the techniques of building employed. Nakashima treated design as a practical, problem solving and organizational activity, based on the tools of building, rather than on pencil and paper. He wrote of his home,

> The fundamental factor in this house is that it was about 90% owner-built, including millwork, cabinet work, masonry, carpentry, roofing, ditch digging, wiring, plumbing, etc. Also it included a large part of the manufacturing of framework, flooring, cabinets, and many odd items from rough material ... Time used was what is generally alloted to entertainment or leisure.

Nakashima's Japanese ancestry was reflected in expressed structure and sliding shoji screens which substituted for curtains over the

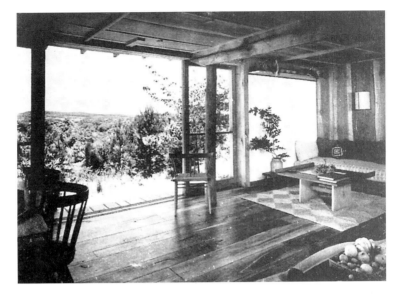

104] The furniture-maker George Nakashima designed and built his California house (1950) without drawings, using both high-tech and traditional materials. The building combines characteristics of Japanese and American domestic architecture. Nakashima's furniture blends primitive sculptural forms with the practical values of the Arts and Crafts to evoke a specifically American modern domestic ambience.

large glass areas and provided movable partitions within the mainly open plan. Rough textures and patterns of wood and stone evoked the character of early colonial homes (figure 104). Yet the form of the building was also American contemporary, featuring long horizontal lines and extensive window walls, plus modern materials such as corrugated transite for roofing.[22]

Nakashima designed and made all the furniture for his house. He wrote, 'Furniture cannot fundamentally be disassociated from building – the problems and precepts overlap ... In a personal sense what we do in furniture is mostly the outcome of a way of life which to us is important.'[23] The idea showed in the hand-hewn look of much of Nakashima's furniture, even those pieces which also revealed his interest in modernist sculptural geometries.

Nakashima's integration of functional simplicity and careful craftsmanship suggested the ideals of the Shaker furniture makers as well as the traditions of Japan.

Whereas Nakashima was a leader of the post-war craft movement, many amateur craftspeople were building houses tailored to

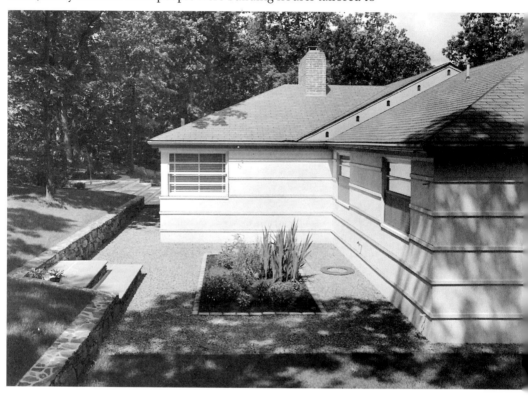

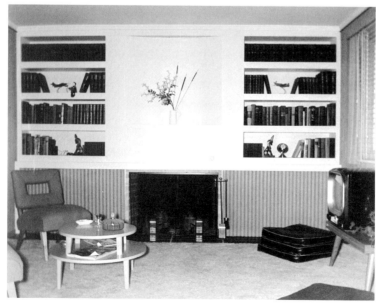

105] This suburban house was designed and built as a leisure-time project by a professional couple. Over the years, its interiors became a *tour de force* of inventive design and high-quality, machine-assisted craftsmanship. The style was contemporary. Tavani house, begun 1947.

their personal definition of a good life – in their leisure time. An airport director, Albert Tavani, and his wife, Lorraine, designed and built their house as an ongoing project beginning in 1947 and continuing for nearly forty years. A single storey open-plan Ranch, with Wrightian, low-hipped roofs and horizontal detailing, rose from a slab foundation incorporating under-floor heating. Rendered concrete block construction, striated plywood paneling, 'Styron' plastic tiling, corrugated translucent fiberglass, linoleum flooring tiles and formica laminates eased construction and contributed to the functionalist character of the house in its early form (figure 105).

In later years, hand-rubbed mahogany paneling replaced the machine-striated plywood inside. Finely jointed blue slate flooring superseded gray linoleum, while hand-cast mosaics supplanted the Styron and formica on walls and counter tops. Contemporary side chairs upholstered in leopard skin patterned fabric and straight-lined, blonde wood Heywood Wakefield lounge furniture gave way to Chippendale reproductions and some genuine antiques. Eventually, utilitarian modernism was thoroughly overtaken by a more luxurious traditionalism as the tastes of the occupants evolved.

Satisfaction gained from the owner's inventive design and high quality machine-assisted craftsmanship were evident throughout the house and particularly in its built-in furnishings. The Tavanis' dining room sideboard/buffet was a *tour de force* of style and convenience. Its frontage followed a sweeping reverse curve fifteen feet in length and incorporated shallow drawers which slid and pivoted effortlessly on a unique mechanism to allow full access to their contents.

Like their house, the Tavanis' seasonal decorations demonstrated an awareness of contemporary design and art and a love of personal invention and surprise. Their typical Christmas trees during the 1950s would be well-selected spruce sprayed eau-de-Nil or off-white and decorated entirely in metalic red, blue or silver. Gifts placed beneath it were wrapped in a concert of solid-colored metalic papers with ribbons, bows and tags matching the tree. Other themed displays could occupy the family for months prior to a holiday. And as the years passed, the typical style developed from abstract modernism to Dickensian narrative.

Other home builders delved further into the realms of fantasy, producing results which were more monument than habitation. Simon Rodia (aka Rodilla), a tile-setter by trade, worked for over thirty years on the construction of an extraordinary set of towers and a surreal, Gaudi-like complex of walls, gates and enclosed structures in the yard of his simple wooden house in Watts, an

industrial suburb of Los Angeles. The Watts Towers, as Rodia's project came to be known, were built of interlaced steel reinforcing rods wrapped in waterproof cement and encrusted with a colorful, shimmering surface of found materials, broken pottery, glass and seashells. The tallest of the towers extended to a height of over one hundred feet, dominating the surrounding community.[24] The site is now protected as a national treasure.

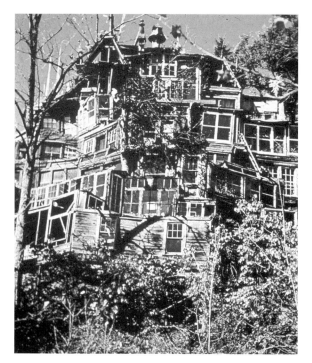

106] Clarence Schmidt's house (c. 1948–71) was a crude but inspired prototype of the bricolage technique used increasingly by sophisticated professional designers at the end of the century. Schmidt's process integrated design, craft and sculpture to create a personally expressive environment which was continually evolving.

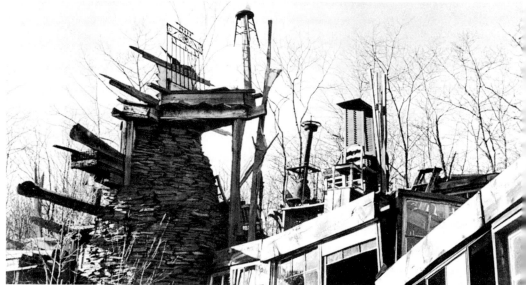

Clarence Schmidt's house at Woodstock, New York, was con-structed and continually transformed by its owner over a forty-year period. In its most grandiose form, around 1968, Schmidt's house was a labyrinthine, multi-storey structure set in an elaborately terraced garden which contained an extensive series of shrines and grottoes. The building was made mainly of salvaged windows and recycled timber from demolished buildings, tar and sheets of aluminum in various thicknesses. Illuminated by fairy lights and decorated with cast-off, chrome-plated automobile parts, the house sparkled from within and reflected its surround-ings in flickering, angular fragments. Shrines were assembled from found and altered objects dedicated to an encyclopedic set of he-roes including Homer, the Lunar Astronauts and the singer Ethel Merman (figure 106). All symbolized human virtues: 'Hope', 'Chari-ty', 'National Pride', 'Guts'.[25]

The works of Schmidt and Rodia occupy the borderland be-tween craft, design and art, in which individuals create their own worlds, sometimes sacrificing comfort and practical considerations for more personally fulfilling aims, attracting public attention, or leaving a monument for posterity. Rodia said simply, 'I had in my mind to do something big and I did'.[26] Schmidt declared, 'It's so immaterial what I do. It isn't what it's made of. It's what it signifies. This is going to make history'.[27] Many people make a life's work of constructing a unique environment, but they are a minority compared with those of us who are content to accept a house more or less as we find it – then choose the curtains.

However, changing needs often require dwellings to adapt. Al-though the majority of post-Second World War developers' houses were designed to be occupied by a nuclear family consisting of mother, father and two-point-two children, many were examples of a 'loose-fit' type of design. Unlike an aesthetically complete, architect designed house, custom-built and meticulously detailed for a singular client such as Susan Lawrence Dana, Levitt or Kaiser houses were designed for unknown, 'typical' groups of occupants and could be easily altered or expanded.

Despite the persistence of the standard model of 'family', in reality the extended family continues to exist in many com-munities, single-parent families are increasing, and countless men and women, many elderly, live alone. Late in the century, houses have to accommodate changing demands such as home working. Many of the 'loose-fit' suburban houses built since the Second World War adapt well to these diverse living requirements. The Raised Ranch house type of the 1970s, due to its direct outside access to both floor levels, has proved to be a particularly flexible form of accommodation for multiple occupancy of the extended

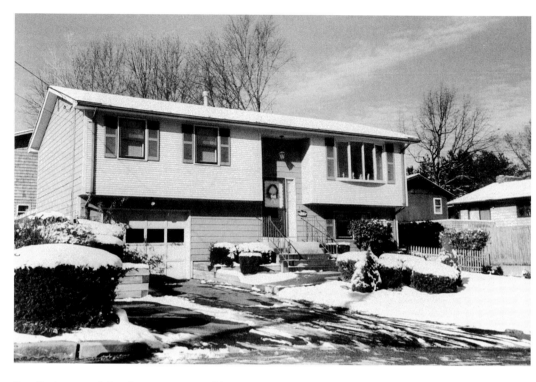

family type and for the provision of home offices and workshops (figure 107).

Whether practical needs or self-expression are their main criteria, ordinary people have engaged at all levels in the process of designing and constructing their homes according to their changing expectations. 'Model' houses have established standards for commercial manufacturers of houses and their contents and inspired individual householders in their efforts to define a space for themselves which protects them from society and presents them as they wish to be seen by the world outside. Whether wildly original or confined by conventional taste, their ability to use design has enabled twentieth-century American householders to create a wider variety of uniquely personalized homes than has been achievable anywhere before.

107] The practical Raised Ranch house of the 1970s proved to be a particularly flexible form of accommodation for multiple occupancy of the extended-family type and for the provision of home offices and workshops.

Notes

1 Kathryn Dethier, 'The Spirit of Progressive Reform: The *Ladies' Home Journal* House Plans, 1900–1902', *Journal of Design History*, vol. 6, no. 4 (1993), p. 251.

2 At the same time, the Sears company was selling pre-fabricated 'Honor Bilt' houses through its catalog. One hundred thousand were sold between 1909 and 1937: Spiro Kostoff, *America By Design*, (New York and Oxford, 1987), p. 57.

3 Dethier, 'The Spirit of Progressive Reform', p. 247.

4 Wright's own 'Home in a Prairie Town', published by the *LHJ* in February of 1901, featured a large reception room, described as the hall, which was entered directly through the front door. It featured an imposing hearth and stairs to the upper floor. The plan was reproduced by Kathryn Dethier in 'The Spirit of Progressive Reform', p. 248.

5 Karal Ann Marling, *As Seen on TV: The Visual Culture of Everyday Life in the 1950s* (Cambridge, MA, 1994), p. 6.

6 Heating, ventilating and air-conditioning units, though expensive, are usually housed as inconspicuously as possible.

7 Donald Albrecht, *World War II and the American Dream* (Washington DC, Cambridge, MA and London, 1995), p. xx.

8 Frank Lloyd Wright, *An American Architecture* (New York, 1955), p. 171.

9 Avi Friedman, 'The Evolution of Design Characteristics During the Post-Second World War Housing Boom: The US Experience', *Journal of Design History*, vol. 8, no. 2 (1995), p. 139.

10 The Monsanto house was designed by MIT architects Richard Hamilton and Marvin Goody in conjunction with Henry Dreyfuss Associates, the Crane company and the Kelvinator Corporation: Arthur Pulos, *American Design Adventure* (Cambridge, MA and London, 1990), p. 53.

11 John Entenza, 'Announcement: The Case Study House Program', in Barbara Goldstein, *Arts & Architecture: the Entenza Years* (Cambridge, MA and London, 1990), p. 54.

12 *Arts & Architecture* Case Study house no. 8.

13 The 'functioning decoration' of the Eames house included abstract paintings by Hans Hofmann, rocks, shells and branches, animal skins, nineteenth-century crystal and Chinese Kites. See Pat Kirkham, *Charles and Ray Eames: Designers of the Twentieth Century* (Cambridge, MA and London, 1995).

14 Albrecht, *World War II and the American Dream*, p. 32.

15 In 'The Great Gizmo' (*Industrial Design* (September 1965), p. 108), Reyner Banham wrote: 'The most typical American way of improving the human situation has been by means of crafty and usually compact little packages'. He goes on to discuss the American love of portable technology set in the imagined pastoral ideal, typified by the Recreational Vehicle (RV) as the logical realization of the American Dream.

16 Motorhomes and car trailers were becoming popular forms of holiday accommodation by the late 1920s. The Airstream company was founded by Wally Byams in 1934 to produce trailers based on a model he had built for his personal use. The aerodynamic form of their stressed aluminum skin is instantly recognizable. Continuous improvements have been made to Airstream's functional designs, and they have remained commercially successful for over sixty years without resorting to stylistic gimmickry or advertising hype.

17 Advertisements for the Lustron Home, *Life*, 19 April 1948 and 13 December 1948.

18 According to Arthur Pulos, some three thousand Lustron houses were built, many of them still in use in the 1980s: Pulos, *American Design Adventure*, p. 53.

19 Dorothy Monroe and James Wiley, 'Must We Resign Ourselves to Living Just Like Peas in a Pod?', *The American Home* (January 1948), p. 16.

20 Marling, *As Seen on TV*, p. 51.

21 Victor Papanek, *The Green Imperative* (London, 1995), p. 118.

22 George Nakashima, 'The house of George Nakashima, Woodworker', *Arts & Architecture* (January 1950), reprinted in Goldstein, *Arts & Architecture*, p. 119.

23 *Ibid.*, p. 121.

24 'Sam of Watts', *Arts & Architecture* (January 1950), reprinted in Goldstein, *Arts & Architecture*, p. 128.

25 Walker Art Center, *Naives and Visionaries* (Minneapolis, 1974), p. 43.

26 Goldstein, *Arts & Architecture*, p. 128.

27 Walker Art Center, *Naives and Visionaries*, p. 44.

9 Nice threads: identity and utility in American fashion

> Gatsby's butler was suddenly standing beside us.
>
> 'Miss Baker?' he inquired. 'I beg your pardon, but Mr Gatsby would like to speak to you alone.' ...
>
> She got up slowly, raising her eyebrows at me in astonishment, and followed the butler toward the house. I noticed that she wore her evening-dress, all her dresses, like sports clothes - there was a jauntiness about her movements as if she had first learned to walk upon golf courses on clean, crisp mornings.[1]

As F. Scott Fitzgerald suggested in this passage from The Great Gatsby, the role of fashion in American life became intimately bound up with leisure and sport. When the Dutch historian J. H. Huizinga wrote of play as a leading influence in the development of modern culture, he acknowledged the importance of the leisure movement which, more than any other social trend, would define American life in the twentieth century.[2] But the image of sport and recreational play which came to dominate American fashion in the second half of the century was only made possible by the liberation of the garment industry from the model of Parisian couture - this was accomplished when the German army occupied Paris in 1940.

Up until that time, American culture as a whole was deferential, whether from necessity or simply from habit, to the model of European culture. The fine arts clung to the traditions of Raphael and Michelangelo and to the modernism of Picasso. French, Italian and English styles prevailed over conservative architecture and furnishing, while modern decoration was linked to the 1925 Decorative Arts Exposition in Paris or to the Bauhaus.

> when Paris started a fashion ... the whole world followed. In 1939 Balenciaga designed a dress with a flounce ... Early in 1940 Schiaparelli, following the trend, was showing them too, and the flounce was launched ... so Vogue says flounces ... and flounces says Fifth Avenue and West Forty-second Street and Seventh Avenue this fall, all the way from approximately $350 to $11 ... Thus does a French designer's whimsey become a 'fashion Ford', worn in Paris, France, and Paris, Arkansas.[3]

So wrote H. Stanley Marcus, Vice-President of the Neiman-Marcus

store, shortly after the fall of Paris. He pointed to painting and architecture as two fields in which the emulation of European models by Americans had led only to second-rate copies. But, he declared that when Grant Wood and Thomas Hart Benton 'painted what they saw and knew' and Frank Lloyd Wright 'tried to meet the requirements of American living', they achieved a standard equal to any work being produced in the capitals of Europe. Marcus went on to argue that only through enforced emancipation from Europe would real creativity flower in American culture. His point was that with the coming of war in Europe the three-billion-dollar American garment industry needed, for the first time, to depend on its own design talent to contribute fresh ideas on which the prosperity of the industry relied.[4] Marcus observed that a global market existed which the huge, mechanized American industry was perfectly suited to service, if its designers could come up with the inspiration which the world's fashion audience expected.[5]

But where would they get their inspiration? Like Wright, Benton and Wood, fashion designers had the American scene as a source – the lives of ordinary people living in a variety of particular landscapes and climates. The culture of the street, its politics, dangers and opportunities offered innovations in dress expressing new identities devised by individuals and groups. They had the nature of work in America, from the factory floor to the cattle ranch. But perhaps the richest source was leisure, for it occupied the greatest amount of time and interest in most Americans' lives. Mass tourism provided contacts with a staggering variety of cultures which captured the imagination of fashion-conscious Americans. Both Hollywood and the publishing industry were central to modern leisure and provided an endless flow of fantasy based on popular narratives which fueled fashion trends throughout the century.

At the turn of the century, the massive popularity of Charles Dana Gibson's magazine illustrations of the physically active American woman contributed to the popularity of the shirtwaist, a form of dress borrowed from men's clothing, which was both proper and comfortable and which, as a universal, mass-produced garment, crossed class lines and ethnic barriers. More than any other garment, the shirtwaist ensured that ready-made clothing, as opposed to couture, became the mainstay of the fashionable American's wardrobe. Subsequently, the economic success of the mass-market United States garment industry, centered in New York's Seventh Avenue, depended on the universal acceptance of the casual model of dressing, not only for sport and relaxation, but for all occasions.[6] Like the Gibson Girl, the Arrow Collar Man of

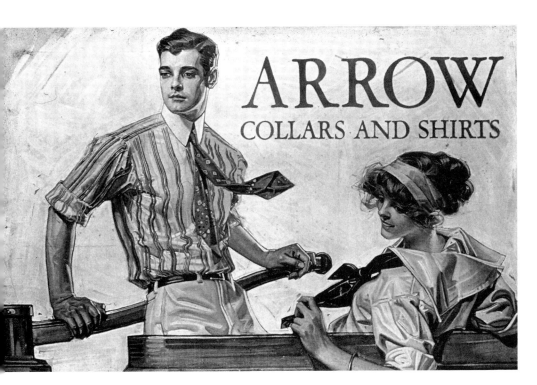

ARROW
COLLARS AND SHIRTS

108] The sporty Arrow Collar man represented the ideal American man. His clothing combined fitness for purpose with casual elegance. Painting by J. C. Leyendecker, *c.* 1920.

the early 1920s was an illustrator's abstraction which embodied the attributes of the ideal young American. Advertising illustrations by J. C. Leyendecker portrayed athletic young men, like those described in the novels of F. Scott Fitzgerald, thoroughly at ease in the casual clothing associated with the relaxed and gentlemanly sports of golf, tennis and sailing (figure 108). The Arrow Collar man was not only a great corporate emblem, but became a symbol of the all-American hero.[7]

Marcus identified the particular strength of American designers in their ability to respond to the developing opportunities of mass leisure and to conceive sportswear with a home-grown, regional accent. The California designers and manufacturers, he wrote, 'succeeded in striking a new note in play clothes. They had a freer range of color, and they have derived inspiration from native sources.'[8] A perfect climate for year-round outdoor activities contributed to the laid-back life of fun in the sun which came to be associated with the south west. The rootlessness and diverse experiences of its new population of immigrants from older parts of the country and from abroad combined with exotic local traditions to create a rich and fluid culture receptive to design innovation. Denim, long associated with western work clothes, Indian hand-made silver buttons, and cowboys' bandanas all made appearances during the late 1930s in suits and dresses by the Santa Fe designer Alice Evans. At the same time, Hollywood stars such as Marlene

Dietrich and Katharine Hepburn were among the first women to wear trousers and trench coats. And it was in California that semi-nudity on the beach first found acceptance.

The importance of sport went beyond its stylistic influence to provide a new model for culture as a whole. It involved the democratization of leisure time and new attitudes toward health, gender and sexuality. It related to manufacturing methods and to the development of new materials. And it required appropriate responses by designers to physical activities originating mainly among young people who were inventing new forms of play and modifying older ones. The development of tennis, golf, water sports, winter sports, cycling, running, as well as spectator sports, such as baseball and basketball, called for continuously creative responses from the fashion world. The real need for comfortable and functional clothing by sportspeople was followed by the creation of sporty clothing for spectators or fans.

Whereas in earlier times and in older cultures, when leisure was thought to be exclusive to the rich, the luxury of free time was signified by styles which inhibited mobility: bustles, corsets and bound feet. These fashion devices were badges of class. But in the American century, design was increasingly devoted to freeing up the human body for movement; and movement was for anyone, regardless of their income or birth. Sports apparel and uniforms were soft and lightweight, with comfort and ease their primary design criteria. Stretch ski pants and loose, down-filled parkas were typical of the practical sports clothing which became ubiquitous fashion items. Sport was one of the great democratizing forces of modern times. Baseball made national heroes out of poor boys who had learned to play the game in vacant city lots. Boxing and track gave international prominence to Black athletes in a time when segregated schools and lunch counters were legal expressions of Southern apartheid. Tennis and competitive swimming brought women under the spotlight of publicity during the 1920s and 1930s.[9]

Sportswear also had a profound affect on the role of the wearer in the fashion system. Whereas couturiers exercised full authority over the way their customers looked through the design of complete ensembles, the sportswear industry of America relied on the production of 'separates' which allowed the purchaser to decide how they should be worn and with what. In the 1930s, the men's sports jacket evolved from the earlier sporting 'blazer'. Unlike the conventional suit jacket, which it resembled closely, it could be worn with dress trousers, casual slacks, khakis, jeans, shirt and tie, turtle neck sweater, polo shirt or T-shirt.

Although garments had been sold individually for decades, the

importance given them by designers, such as Bonnie Cashin in the 1930s and later Calvin Klein, significantly altered the position of the designer, who became the supplier of a kit of parts which offered the buyer considerable choice in constructing a personal look. While the much-vaunted 'death of the designer' has been undermined by the status of Calvin Klein or Ralph Lauren in the 1990s, their role has become less authoritarian and more enabling. The new wearer has been encouraged to be more involved in the creation of fashion by the selection of elements and the composition of an outfit. As a result, the old joke of two horrified women appearing at a party wearing complete, identical outfits is far less likely to occur at the end of the century than it was in 1950.

Sportswear, in its purest form, is the carefully devised response to the needs of modesty under conditions of the most strenuous physical activity. As a result of its connotations of health and its functionalism, sportswear earned a reputation for 'rightness', establishing around it an aura of moral superiority. Nike jogging shoes told us that the wearer valued exercise for physical and mental well-being and knew how to enhance his or her performance by wearing the correct apparel. Like the short tunic worn by Olympic athletes in ancient Greece, modern sportswear attained a classical status through its economy of material and expression of purpose.[10]

In this spirit, Claire McCardell's use of natural materials and free construction produced swimwear and casual dresses which were interpreted as exemplars of functionalism, earning her an exhibition at the Museum of Modern Art in the mid-1940s. McCardell's innovative adaptation of the ease and naturalness of sportswear to clothes for all occasions became known as 'The American Look' (figure 109). Her simple, elegant and unpretentious designs combined the durability of work clothes with the comfort of sportswear; their affordability and classlessness were pure expressions of the democratic principle in modern design. While, in the late 1940s, Dior was reasserting the dominance of Paris as the world's fashion capital with his stiffly constructed New Look dresses, McCardell offered the American woman an equally refreshing change from wartime styles with her range of casual, mid-calf, full circle skirts in soft cotton. Her dresses featured natural shoulders with lithe, close-fitting bodices which gave the wearer the animated look 'of a Martha Graham dancer'.[11]

Perhaps the most distinctive American look to emerge since the 1970s resulted from professional women combining sportswear with business clothing. Typical ensembles would include tailored suits and nylons worn with sport socks, trainers and full-length down-filled parkas. Among the most innovative high-fashion designers of the 1990s, Donna Karan, through 'her invention of the

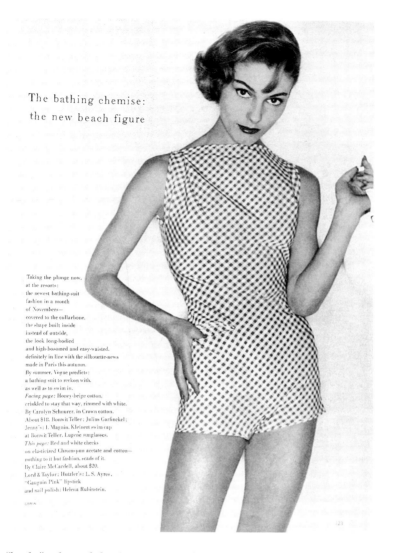

The bathing chemise:
the new beach figure

Taking the plunge now,
at the resorts:
the newest bathing-suit
fashion in a month
of Novembers—
covered to the collarbone,
the shape built inside
instead of outside,
the look long-bodied
and high-bosomed and easy-waisted,
definitely in line with the silhouette-news
made in Paris this autumn.
By summer, Vogue predicts:
a bathing suit to reckon with,
as well as to swim in.
Facing page: Honey-beige cotton,
crinkled to stay that way, rimmed with white.
By Carolyn Schnurer, in Crown cotton.
About $18. Bonwit Teller: Julius Garfinkel;
Jenny's; J. Magnin. Kleinert swim cap
at Bonwit Teller. Lugene sunglasses.
This page: Red and white checks
on elasticized Chromspun acetate and cotton—
nothing to it but fashion, scads of it.
By Claire McCardell, about $20.
Lord & Taylor; Hutzler's; L. S. Ayres.
"Gauguin Pink" lipstick
and nail polish: Helena Rubinstein.

109] Athletic chic – a 1954 chemise-cut bathing suit by Claire McCardell in elasticized Chromspun acetate and cotton. McCardell's designs embodied the relaxed, unpretentious aspect of post-war American life.

"body", adapted the American tradition of easy, sporty clothes into the environment of *Wall Street* (the movie)'.[12] Karan promoted her products through a post-feminist manifesto which encompassed a range of issues from sex and glamour to body type and gender. She presented her clothing as a kit of parts, enabling 'women of character' to create their own personal style. And she exploited her own image, smart, chic and well connected, 'as if she is just her customers, and vice versa'.[13] Karan's monumental DKNY advertisements were an outstanding addition to the commercial mural art of Manhattan and quickly became as familiar around the world as McDonald's Golden Arches or the red and yellow Kodak logo (figure 75).

Sports clothing also claimed the moral high ground as a rational response to the health and hygiene movement initiated in the later

nineteenth century. As the benefits of sun, water, fresh air and exercise became commonly accepted, the clothing which enabled individuals to partake in them became associated with both good sense and a new religion of the body. The new health dieties were also sex gods and goddesses, and the bathing suit was the most effective vehicle for putting their bodies on public display. More than any other form of dress, the bathing suit undermined the virtue of modesty. Exposure on the beach became a symbol of modernity and emancipation for both sexes and a powerful protest against Victorian values.

The modern bathing suit began with the work of Carl Jantzen and his partners John and Roy Zehntbauer who, together, invented the 'elastic stitch' in 1917. Using two sets of mechanical knitting needles in place of the single pair used for ordinary jersey, they created a fabric which could stretch like a 'second skin'. They also introduced a new method of assembling the suit which produced a snug, wrinkle-free fit and streamlined shape which became known as the 'California Look'. The healthy, erotic image made possible by Jantzen's innovations was popularized by slick magazine and billboard advertising which massively increased sales (figure 110). By 1930 Jantzen was the world's largest manufacturer of swimsuits with over one and a half million sold that year.[14]

The development of synthetic Lastex fabric in the 1930s helped to perfect the form-fitting suit, producing a convincing facsimile of nudity. Meanwhile, the bare-chested man had become a respectable sight on American beaches. By the mid-1950s, his loose-fitting 'boxer trunks' had shrunk to tight, minuscule 'briefs'. For women, the two-piece bikini of 1946 was touted to be 'the most explosive fashion event of the forties'.[15] It set a marker on the road to near nudity surpassed only by Rudi Gernreich's 'topless' suit of 1964. The trend toward revealing previously hidden parts of the anatomy persisted into the 1980s, conveying the increased sexual freedom of the period, but also imposing new restrictions, such as the tyranny of slenderness. The modern bathing suit was 'a form of undress which functioned as a symbol of dress' and it combined the eroticism of simultaneous disclosure and concealment. It was said that 'If clothing is a language, then a bathing suit is a telegram.'[16] But in the 1990s, like the newly invented FAX or E-mail, the bathing suit was made to carry much more complex and subtle messages than a telegram could. Changing sexual politics, fear of skin cancer from over-exposure to the sun, and a fashion for historical costume brought with them a Post-Modern cover-up. This first reversal of the modern trend toward nudity was reflected in the modest, Neo-1960s, two-piece suits and 1930s Revival, one-piece streamliners by Norma Kamali and Anne Cole. Men joined in the

cover-up with a fashion for surfers' all enveloping wetsuits and the arrival of loose-fitting, knee-length 'bags' in the 1980s (figure 111).

Conventions of dress and the design of clothing seldom changed as rapidly as they did after the Second World War, when Americans were migrating to the new suburbs and adopting a pattern of life which centered on DIY, and gardening. Leisure pastimes such as fishing and golf and very casual, unplanned socializing with neighbors around the barbecue or the breakfast bar encouraged a relaxed manner of dress which called for new purpose-designed clothing. The men's wash and wear, polyester leisure suit, with matching shirt-tailored jacket and trousers, was designed specifically to distinguish home dressing from office dressing. Alternatively, ad hoc combinations of existing clothing types became popular. These included traditional work clothes, such as jeans and khakis, worn with sports wear, such as short-sleeved polo shirts and tennis shoes. By the 1960s, both were being worn with sports jackets, signaling a new respectability and a relentless rise up-market.

Levi Strauss of San Francisco, the largest apparel manufacturer in the world, have made their blue denim work pants to the same pattern since 1850. Since then, over 800 million pairs of their sturdy, cheap, standard garments have been made and worn. Style-

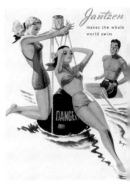

110] Jantzen pioneered the nude look achieved through the use of new synthetic fabrics from the early 1930s. The sleek shapes of their swimwear complemented the streamlining of industrial design products and commercial architecture.

111] Casual clothing accentuates the graceful, fluid movements and gestures of modern sports. Like loose-fitting baseball uniforms and generously cut basketball shorts, the baggy 'jams' and loose tops of the 1980s and 1990s reveal the body through drapery.

conscious men and women began to wear them in the 1930s; but it was not until the 1960s that jeans became a staple of fashionable dress. Their associations with rebellious youth, established in the early 1950s by movie stars such as Marlon Brando and James Dean, and famous motorcycle gangs including the Hells Angels and Amboy Dukes, led them to be adopted as the basis of an ad hoc uniform by the counter-culture generation of the Viet Nam period. Worn skin tight, low-cut and flared, they popularized the sexiness previously connected with sailors' trousers. Yet their proletarian origins and associations with America's historical development established them as a form of national costume. The natural cotton and traditional dyes, from which they gained their durability and good ageing qualities, connected them to the growing ecological consciousness of the 1960s and after. Their unisex appeal also reflected the new gender awareness inspired by the Women's movement. Transformation of jeans from mass utility wear, associated with cowboys and construction workers, to a universal garment appropriate in almost any context, made them the single most prominent item of American apparel.[17]

Designers manipulated the form of jeans to bring them in line with changing fashion trends such as the flared leg of the 1960s and the loose fit of the 1980s (figure 112); they embroidered them

112] Jeans, flared or straight-legged in 1976. Like the shirtwaist at the turn of the century, jeans became a staple garment adaptable to changes in prevailing taste. Similarly, the Adirondak chair was made in many variations on a standard form providing the comfort of the living room outdoors.

and studded them and added their labels to give them class. But individual wearers went further, changing their form, cutting them off short, patching them, slashing them and decorating them by hand to express an infinite variety of meanings, all aimed at personalizing a standard product, mass produced by the millions.

Other articles of functional clothing also found their niches in popular taste. The engineer's boot took its place alongside Indian moccasins, running shoes, sneakers and ballet slippers as everyday footwear. Waxed jackets, riding boots, and denim bib-fronted over-alls, the clothing of farmers and other rural types, were worn with unlikely separates by fashionable men and women to achieve a country look for domestic leisure. Basic cotton knit T-shirts be-came popular with both sexes and all ages for everyday activities and acquired tone to be worn with high fashion suits. They were also adapted by top designers, such as Lilly Pulitzer and Kasper, as full-length dresses. But most commonly, T-shirts were printed with messages using both words and pictures to identify their wearers with places, products, issues and ideas. And like blue jeans, they were subjected by their wearers to all manner of manipulation, from slashing and tearing, to tie-dyeing, in pursuit of the unique example of a standard product.

The century has seen many styles which reflect individual in-terests and tastes emerging from outside the fashion industry. 'Street-fashion' has reflected a belief that creativity was just as likely to bubble up from the native originality of individuals in the lower reaches of society – in other words, those untainted by professional training, commercial motives or educated taste – as to trickle down from high-fashion design houses. In 1969, Rudi Gern-reich declared that 'fashion starts in the streets. What I do is watch what the kids are putting together for themselves. I formalize it, give it something of my own, perhaps, and then it is fashion.'[18] But whether or not Gernreich's 'something' was necessary as a seal of fashion approval is debatable.

From the early 1960s the process of creating fashion often began in the thrift shops which flourished in cities and towns all over the country (figure 113). Like the 'synthetic' assemblage technique of Picasso, later known in America as 'junk sculpture' or as bricol-age, combining cast-off clothing and accessories in new and unexpected ways became attractive to many young people reac-ting against the standardized materialism of bourgeois culture and against the authority of the art or fashion establishment. The in-fluence of the thrift shop look was aped in Ralph Lauren's casually layered and seemingly improvised costumes designed for Woody Allen's 1978 film, *Annie Hall*. The costumes worn by Diane Keaton in the film layered oversized men's clothes with oddly selected

113] Thrift shop chic.
Combinations of old and
new, up-market and down,
formal and casual, all
contributed to the
inventive collage of style
since the 1970s. Originality
and wit were the hallmarks
of this approach to fashion.

women's separates. They accurately conveyed the character's un-
certain, but try-anything brand of creativity. While real Annies
had been out in the street since the early 1960s, Lauren eventually
marketed the look as mainstream fashion in the late 1970s. Thus
the traditional model-series relationship was inverted for fashion,
as it was when Detroit car makers picked up styling details and
colors from grass-roots customizers.

Street styles, inspired by the favored tastes of ethnic groups or
of self-conscious subcultures, such as beatniks, urban gays and new
wave punks, also served as a means of promoting new political and
social agendas. Anti-war students of both genders demonstrated
their political views in the 1960s by wearing military jackets,
boldly decorated with anti-military symbols, in combination with
other distinctly civilian garments, such as psychedelic or flower-
printed shirts, ethnic accessories and the controversial long hair of
the period (figure 114).

Stage and film costumes also reflected the political and subcul-
tural issues bubbling up from popular discontent in the second
half of the century. In 1953, when Marlon Brando wore Levis, T-
shirt, black leather jacket and motorcycle boots in *The Wild One*,
the combination was given an erotic charge which helped to es-
tablished it as a lasting image of sexy alienation. *The Wild One*
became both a straight and gay model, inspiring later underground
films such as Kenneth Anger's *Scorpio Rising*, in which the customi-
zation of apparel, bikes and interior settings all related to themes
of malevolence, sex, death and the individual within a cult. In the
spirit of sexual liberation which had been represented by the bikini

114] Political protest and social outrage found expression in customized garments such as this flack-jacket worn by a marcher at the Anti-Viet Nam War Moratorium, Washington DC, November 1969. The Raised Fist, symbol of the black power movement, became a familiar image on college campuses during the late 1960s.

and the miniskirt for women, the 1970s disco group *Village People* costumed themselves in caricatured uniforms based on gay icons of the period. Their eroticized stereotyping of the work clothes and uniforms worn by hard-hat construction workers and highway patrolmen elevated commonplace appearances to the status of fetishes. Meanwhile, in the bars and bath houses of San Francisco, Key West and New York, similar outfits were being worn as statements of a new, aggressively masculine image for gay men. In contrast, shaved heads, army fatigues and work boots became the austere uniform of both men and women in the darker atmosphere of queer culture following the appearance of AIDS.

From the love of old clothes central to thrift shop style, the fashion industry was reminded of the value of history. But like mainstream furniture and interior design, automotive and fashion design had often responded to earlier styles. The first automobile bodies took their designs from earlier conveyances such as chariots and carriages. And in the 1960s, Detroit looked to its own past for inspiration, offering new takes on pre-war vertical radiator grills, landau roof irons and continental spare wheels, all adapted to the latest projectile body shapes. Similarly, Post-Modern fashion began to combine the modernism of designers such as Bill Blass and the futuristic styles of Rudi Gernreich with historical references, treating history as a dressing-up trunk in which unrelated references

could be combined in challenging and witty ways. Lew Magram's Acrilan turtleneck bodysuit (1974) could be worn with a ruffled tuxedo shirt, unbuttoned, and flared Levis over cowboy boots – and the look was unrestricted by gender or race!

In the 1980s and 1990s, American fashion designers evoked periods ranging from Early Christian to New Frontier.[19] Innovations were based on 'self-conscious and learned archaism and renewals more fundamental than merely nostalgic'. Like Post-Modern architects, fashion designers employed 'a hybrid historicism … arising from a mingling of models and surpassing discrete traditions'.[20] Film fashions played a role in popularizing historical styles such as the archaeological, late 1940s California casuals featured in Roman Polanski's period thriller *The Two Jakes* (1990) and revived as late-century club wear in the 1997 comedy *Swingers*. The return to traditional lines was also promoted heavily by Ralph Lauren in his interpretations of classic American work clothes and sportswear for men and women. Inspiration for his collections included pre-war casual country wear, Native American costume and western pioneer's garb.

The work of Norma Kamali developed from contemporary casual to rigorously archaeological, with some of her designs verging on reproduction. In a similar historical mode, Calvin Klein's 1995 line abandoned the relaxed look of sportswear in favor of highly constructed, minimalist contours refering back to early 1960s designs by Cassini and Givenchy for Jacqueline Kennedy and Audrey Hepburn. Klein featured formality and controlled tailoring intended to re-establish the high standards of an earlier period. But despite such an historicist retreat from casual clothes, the love of sportswear is so deeply a part of the American consciousness, and the freedom it offers its wearers to look and do as they please is so precious, that they will not be sacrificed easily.

Notes

1 F. Scott Fitzgerald, *The Great Gatsby* (first published 1926; repr. London, 1973), p. 57.

2 Richard Martin, *All American: A Sportswear Tradition* (New York, 1985), p. 8.

3 H. Stanley Marcus, 'America is in Fashion', *Fortune* (August 1940), p. 81.

4 The garment industry was the third largest industry in the United States by 1975 according to William Lippincott, President of FIT: Sarah Tomerlin Lee, *American Fashion* (New York, 1975), p. vii.

5 Martin, *All American*: 'Sportswear is a unique American language of style expressing our casual and leisure requirements as well as our informality and truth to mass production' (Marvin Feldman, Introduction).

6 Figures gathered in the 1980s described the garment district of New York as housing over 6,000 clothing manufacturers, producing two-thirds of

American-made women's clothes and half of all American mens wear: Gini Frings, *Fashion From Concept to Consumer* (Englewood Cliffs, 1982; repr. Englewood Cliffs, 1987), p. 119.

7 Martin, *All American*, p. 16.

8 Marcus, 'America is in Fashion', p. 142.

9 Fitzgerald's fictitious character, Jordan Baker, was a tennis champion. See note 1.

10 Martin, *All American*, p. 12.

11 *Ibid.*, p. 39.

12 Correspondence with Helen Rees, 1 September 1996.

13 *Ibid.*

14 Lena Lencek and Gideon Bosker, *Making Waves, Swimsuits and the Undressing of America* (San Francisco, 1989), p. 11.

15 *Ibid.*, p. 90.

16 *Ibid.*, p. 19.

17 Martin, *All American*, p. 16.

18 Gernreich, quoted in Amy de la Haye, *Fashion Source Book* (London and Sydney, 1988), p. 125.

19 New Frontier was the name given to the policies of the Kennedy presidency (1961–63).

20 Richard Martin and Harold Koda, *The Historical Mode, Fashion and Art in the 1980s* (New York, 1989), p. 7.

Critical approaches
to design

Historically, critical approaches to design have evolved and expanded from simple aesthetic appreciation to a much more complex examination of the social nature and purpose of design. As an academic discipline, design history and criticism is still in its infancy, but the methods of approaching and understanding the subject have been growing steadily in sophistication as more study and publishing are undertaken. A widening portfolio of methods drawn from other disciplines, such as art history and sociology, has been helpful in defining and understanding design activities.

Critics and historians have been increasingly interested in a number of issues which arise around the designed object itself.[1] An object will inevitably provide a rich source for analysis of both its utilitarian and symbolic or decorative functions. Study of its designer(s) can reveal much about why a thing looks and functions as it does. Not only its typological characteristics and its style, but the techniques of its manufacture and the materials from which it is made are useful subjects of study. Knowledge of the place, time and conditions in which it was designed and manufactured are also useful. Anthropological and sociological analyses will reveal how a product functioned in the society which made and used it. These approaches are related to the semiotic and structuralist methods of analysis devised in Paris in the 1950s and 1960s. They provide a way of understanding how objects communicate meanings to those who see and use them. Semiotic and structuralist criticism and analysis, first consciously applied to design in the 1970s, have led more recently to a widespread emphasis among critics and historians on the user's relationship with objects. The present volume employs all of the above approaches emphasizing particular methods in certain sections such as chapter 4 which concentrates on a materials and technology approach.

Just as standard art history lectures often feature the comparison of two images, design studies often rely on comparisons of objects to provide the historian and critic with insights on the evolution of style, national differences, and a host of other factors (see figure 93). Raymond Loewy used the method in 'before' and 'after' presentations of his redesigned office machines and household

appliances. The good/bad dichotomy has also been employed by many writers, including Edgar Kaufmann and John Blake, who contrasted restrained European designs with highly ornamented American products to promote their notion of 'good design'.[2]

Some design studies are singular in their approach, for example *Contemporary Classics: Furniture of the Masters* by Charles Gandy and Susan Zimmerman-Stidham (1981). But others combine a variety of methods to provide a broader explanation of developments and events in the history and current practice of design and in the constantly changing interpretations of it. A study of interior design, for example, may consider the evolution of style, the social and economic backgrounds against which changes occur, the relationship to architecture, furniture production, technology and marketing, significant individuals who contributed to change, and singularly important case studies for detailed description and analysis. Such a study might also investigate the political implications of interiors shown at international expositions or the changing public taste for a particular period or style.

Other methods of analysing design concentrate on why, rather than how, things have come to be the way they are. Determining causes leads to further questions. Is the designer pre-eminent in determining the appearance of objects? Or are designers little more than robots whose actions are determined by external forces? Is a design style simply 'in the wind'? Is function the ultimate determinant of form? All of the above have been attempted as means of answering the question, 'why?'; but used alone, each gives an insufficiently clear picture of design as an element of culture.

Karl Popper suggested analysing the 'logic' of situations' as a way forward.'We need studies, based on methodological individualism, of the social institutions through which ideas may spread and captivate individuals, of the ways in which new traditions may be created, and of the way in which traditions work and break down.'[3] In other words, individuals can act creatively and solve problems in their own way given the constraints of the time and place. In fact, the designer can choose to act in accordance with or in opposition to the prevailing conditions. Popper is also suggesting that we question assumptions embedded in the concept of 'tradition'. If tradition and change are two of the central notions of history, our attitudes toward them are signified by words such as 'progress' and 'decay', and by the 'evolution of style'. The way historians and critics view change and the uses to which they put it (for example, as the basis for predictions) are at the heart of their method.

This chapter will discuss the advantages and problems associated with the various methods of design analysis and criticism as

they have been applied to American design. It is hoped that this book, as a whole, will demonstrate to the reader how various methods may be used together to shed light on design practice, products and appreciation. Although criticism and history writing are international activities in which ideas are exchanged freely around the world, it is the American context which chiefly concerns me here. Therefore, my emphasis is on American texts, taking into account writers working outside the United States who have been particularly concerned with issues central to American design and those who have provided models for American design studies.

Scholars have taken design increasingly seriously as a manifestation of culture and society. But design has also become a universal subject of discussion. Boys on street corners chat about the merits and demerits of the latest Corvette and the stylistic implications of Wayfarer sunglasses. Film reviewers often cite the design of a film in relation to story-telling. Shoppers argue the virtues of one dinner-ware pattern over another. 'Coffee-table books' bring the design discourse into the home for entertainment and edification.

The traditions of art history and connoisseurship provided a foundation for early studies of design. Design also featured prominently in social and cultural histories during the first half of the century, from the biting social satire of Thorstein Veblen to Russell Lynes's witty dissections of the American class structure. Critical debate over design has taken place in both professional and popular journals. Articles such as Edgar Kaufmann's 'Borax, the Chromium-Plated Calf', an indictment of American Baroque car styling published in the *Architectural Review* in 1948, and Lewis Mumford's scathing *American Taste*, which appeared as a 1927 special issue of *Harper's Monthly*, communicated the most advanced aesthetic ideas of the American cultural establishment to a broad, educated readership. Not surprisingly, the century has also witnessed a growing interest among the business community in the commercial function of design, examined regularly in the pages of *Fortune* magazine and more recently in the *Design Management Institute Journal*.

Designers themselves have published some of the most influential and memorable texts on design. Norman Bel Geddes combined autobiography and visionary speculations in *Horizons*, published in 1932 when the industrial design profession was barely established. Through his compelling prose and the dramatic illustrations of futuristic buildings, vehicles and other products, he effectively promoted the new profession, of which he was a founder, the streamlined style of design, and himself. From the later vantage point of 1951, Raymond Loewy established himself

as one of the first historians of industrial design in his memoir, *Never Leave Well Enough Alone*. This book was a best-seller around the world and confirmed the wide popular interest in design, a theme addressed throughout this book.

Exhibitions and their catalogs also brought design to a broad public. Beginning in 1917, the Metropolitan Museum in New York launched a series of annual exhibitions of American industrial arts, building up information on design in a structured aesthetic context for manufacturers.

The Museum of Modern Art also added design to its portfolio of interests in the early 1930s. Its early exhibitions on design included *Modern Architecture: International Exhibition*, of 1932, *Machine Art*, in 1934 and *Bauhaus, 1919-1928*, in 1938. These, and the establishment of a permanent design collection within the museum, contributed to the formation of a rationale for an aesthetic favored by the museum. They also served as statements of the museum's mission to improve the taste of American people.

While Museum of Modern Art publications referred to 'the public taste', their main target audience was the metropolitan, art-loving middle class. However, a much bigger and more diverse public came to know design from the giant fairs and expositions, themselves carefully designed, which have been held periodically throughout the century. From the Buffalo Pan American Exposition of 1901, to the New York World's Fairs of 1939 and 1964, these events established a popular awareness of and interest in art, architecture and design. Those designers who worked on them came to be seen as part public servants, part salespeople and part visionary artists.

By the 1920s and 1930s, historical works were beginning to set out a social context for design. A milestone in design history writing, Lewis Mumford's *Technics and Civilization*, published in 1934, described the history of technology in its relation to art, design and human habitat. The book's setting was Western civilization since the Middle Ages; beginning with the monastery and the clock, Mumford divided history into three phases: Eotechnic (based on exploitation of wood, wind and water), Paleotechnic (iron and steam) and Neotechnic (steel, plastics and electricity). In his erudite discussion, Mumford portrayed the history of technology in relation to both ideological and social change and the development of the individual. In this way, he interpreted the modern human condition in relation to mechanization in its broadest sense.

In the more confined historical and cultural framework of American history since the Federal period, Russell Lynes discussed art and design as indicators of cultural change. *The Tastemakers*,

published in 1949, concentrated on the distinction between popular culture and high culture, constantly referring to design as the primary means of communicating the values of each. The importance of books such as *The Tastemakers* and *Technics and Civilization* is that they approached design from a multi-disciplinary viewpoint, establishing its relevance to technology, sociology, history and anthropology, as well as to art.

The publication of reference works by both historians and designers helped to disseminate basic information about the history of design. Ann Ferebee's *A History of Design from the Victorian Era to the Present*, published in 1970, was the first general design history to appear. Although focused on a specific field of design, Philip Meggs' *A History of Graphic Design* (1983), also took a broad view of its subject, including all branches of printed material. Both Ferebee and Meggs followed a formalist method based on the evolution of style. The two volumes of industrial design history by Arthur Pulos were similarly comprehensive within a chosen area and vastly useful in broadening knowledge of their subjects; but they too were not primarily critical works.

Design history developed as an academic discipline since the 1960s mainly within art colleges to give students of practical design courses a historical background, like those offered to fine art and architecture students, against which to assess present and future developments in their fields and, more specifically, in their own work. In the 1970s art history doctoral dissertations began to address design subjects. One of the first was Donald Bush's study of American industrial design in the 1930s, later published as *The Streamlined Decade* (1975).

Monographs

Most design studies emerged from the methods traditionally applied to art, architecture and the decorative arts. One of the oldest, dating back to antiquity, and still most widely used methods is the monograph. 'There is properly no history; only biography', wrote Ralph Waldo Emerson in his *Essays in History*. Throughout this century much design study has been based on personalities (see chapter 5). But monographs focus on the artist's work, unlike biographies which concentrate on the events of the life. According to Mark Roskill,

> The most basic kind of publication that art historians produce is probably the monograph on a particular artist. In it, all the artist's work will be sorted out and catalogued, with illustrations to match; and an interpretive essay will usually be provided to go along with this. There, the development of the artist's work will be dealt with

from different points of view (style, subject matter, technique, and
so on), and the discussion of how the artist developed and of his
total achievement may well shade into criticism.[4]

Monographs are popular among a wide cross-section of readers due
to their charm. They often exploit a range of human emotions,
from humor to tragedy, as a means of engaging the reader's atten-
tion and sympathy. Their chronological structure has the
advantage of providing an easily accessible story, featuring a
smooth development from youth to the old age of the subject.
Monographs are useful in constructing a picture of the individual
creative process within a particular historical setting.

However, the very seamlessness of the relationship between art
and life often generated by monographs leads to the problem of
distinguishing between the personality of the artist/designer and
his or her professional achievements. As a result of their basic
premise, the heroic stature of the individual, they encourage the
reader to admire the central figure, bridging any critical distance
the reader might have from the subject's work or methods. Thus
they can lead to appreciation rather than understanding. Some
'accolades-to-genius-criticism' has inspired deep scepticism. Jules
Langsner described monographs by 'ecstatic acolytes' or 'cynical
publicists' as 'paeans of praise (which) tend to be uncritical, are
weighted with superlatives and quotations from the discourses of
The Master'.[5]

This form of approach is especially problematic as a way of
understanding the work of designers who engage in a collaborative
process within teams and as part of a complex system of corporate
or governmental patronage, production and marketing. In areas
such as automotive design and film design giving individual credit
for the finished product can be particularly misleading. An
example of the problem is found in Stephen Bayley's book on
Harley Earl (1990). The long-serving head of styling at General
Motors, Earl is credited by Bayley with the design of several gener-
ations of GM cars which could be considered, more realistically, as
staff designs carried out by teams under the supervision of divi-
sional styling directors including Bill Mitchell, Bill Porter and Irv
Rybicki.[6] Their designs for a mass market were essentially collec-
tive and social, yet a monograph tends to present them as the
accomplishments of an individual. Such celebrations of design
genius do not satisfactorily explain the genesis nor the significance
of a Cadillac or a Chevrolet in a broader setting of conception,
production, marketing, use or understanding.

Harley Earl belongs to a series of British monographs published
under the general title 'Design Heroes'. In the introduction to an-
other book in the series, *Raymond Loewy*, the series editor, Martin

Pawley, wrote 'the designers of the 20th century *created a world* (my italics) that had never before existed in history ... their lives and their works deliver the essence of design as a vital human activity'.[7] Pawley's statement is true in as much as it applies to anyone who designs. The emphasis, however, on the personal creative act contributes little to an understanding of design as an activity or of the larger 'world' in which design takes place and in which designed products function.

The biography and individual monograph, rather than constructing a balanced history of design, often enshrine their subjects in a professional pantheon, entertain their readers and inspire popular interest in design as an art. Often useful, but also problematic, are monographic studies of design institutions, the Museum of Modern Art or Cranbrook Academy, manufacturing companies such as Knoll International, or consulting firms, for example frogdesign. These have the advantage of acknowledging the collaborative nature of design, unlike studies of a unique genius. However, they often operate on the same level of homage, adopting the self-congratulatory tone of the institutional or corporate viewpoint on which they may rely heavily.

In this vein, Hugh Aldersey-Williams' *New American Design: Products and Graphics for a Post-Industrial Age* (1988), introduced its chapters, each profiling a young design practice of the 1980s, with self-consciously stylish photo-portraits of the members. The dramatic approach of the monograph is applied here to the design teams and the environments in which they work. A chapter on the graphic design firm, Doublespace, begins with the following description:

> The action takes place in a cube of a room with flecked grey walls. Minimal music thrums gently somewhere outside the cube. Enter through a corner door that skews the geometry as it hinges aside; David Sterling, diminutive, neat and nowheresville middle American; and Jane Kosstrin, New York Jewish, larger than life with tumbling red hair.[8]

The limitations of the monograph, particularly as a tribute to genius or style, have been redressed by alternative approaches which intentionally turn away from the creative personality as the subject of study. Scholarly interest in anonymous history dates back to the early twentieth-century work of the Swiss art historian, Heinrich Wolfflin, who called for 'an art history without names', of which more will be said later. But from the 1960s there developed a more politically motivated move away from the creative individual as the center of art and design study. Marxist and feminist critics in particular rejected the elitism and paternalism inherent

in the monographic pantheon, turning instead to the idea that any work of art or design could be analysed more fruitfully as a structure of meaningful signs which were open to interpretation by its user or 'reader'. The dethroning of the creative individual had, however, the in-built danger of reducing the design process to a mechanical act, entirely subject to external forces outside of creative control. A more moderate approach eventually sought the social and historical conditions, and a variety of other factors, which give rise to authorship.

Studies of form

Along with monographs, formal, style-based critiques have made up an important part of the literature on design and have influenced the ways in which works of art and designed objects have been treated by museums and collectors. Style and its evolution came to be seen by art historians and critics as the language through which a person, a historical period or a nation communicated its inner spirit. Heinrich Wolfflin's *Principles of Art History*, published in 1915, established a method of analysing works of art and architecture objectively, avoiding the biographical approach which the author thought encouraged a chaotic, subjective criticism. Wolfflin devised a formula for the evaluation and classification of painting, sculpture and architecture involving five sets of contrasting qualities. With minor adjustments of terminology, they could be applied to any object:

(a) linear to painterly;
(b) plane to recession;
(c) closed to open form;
(d) multiplicity to unity;
(e) absolute clarity to relative clarity of the subject.

A proper elaboration of these concepts is not possible here. It must suffice to say that Wolfflin used them to disclose the characteristics of style prevailing in any time or place throughout the history of Western art. Wolfflin's method was taken up widely by American art historians, such as Bernard Berenson, and eventually set a pattern for the analysis of designed artifacts as well.

Style provided a useful tool for connoisseurship. It helped to date and locate geographically objects of unknown provenance. It also set standards by which objects could be valued; the more closely they conformed to specific, prescribed characteristics of style, and the more perfectly they expressed the 'spirit' of a place and time, the more they would be prized. Style also helped to classify and rank works by known individuals with a large body of work: a

Pollock from his WPA period in the 1930s would have significantly different stylistic qualities and a markedly different value than his drip paintings of the late 1940s. Mass-produced goods are also classified and ranked by style: the extravagantly finned Cadillacs of the late 1950s, made easily identifiable by annual restyling, are more coveted by collectors today than the relatively sober models of the 1960s. In terms of both popular and academic interests, style locates design as a branch of the visual arts.

Professional journals relied heavily on this approach. In 1959 *Industrial Design* magazine described the new IBM Model C 'Executive' office typewriter, by the consulting designers Sundberg-Ferar, as

> the first major design change since 1947, when the Model A came out of the Norman Bel Geddes office ... The most obvious change is the pronounced horizontal organization of the machine and the articulation of the front panel. The typewriter is wider than the former one: the body has been extended to enclose the ribbon spools that stuck out like ears to trouble the blocky symmetry of Model B ... Model C, with its interplay of form and its contrast of material and texture, displays many of the characteristics of a piece of sculpture that is meant to be regarded in the round.[9]

Formalistic design critiques, at their best, include analysis of meaning and symbol as demonstrated in the annual car reviews, written in the 1950s by Deborah Allen, for *Industrial Design* magazine. Of the 1955 Buick, she wrote,

> It is logical, but only by its own standards ... it is perpetually floating on currents which are built in to the design. This attempt to achieve buoyancy with masses of metal is bound to have the same awkward effect as the solid wooden cloud of a Baroque baldacchino. Unless you want to wince a purist wince at every Buick or baldacchino the best recourse is to accept the Romantic notion that materials have no more weight than the designer chooses to give them.
>
> The Buick's designers put the greatest weight over the front wheels where the engine is - which is natural enough - the heavy bumper helps to pull the weight forward, the dip in the body and the chrome spear express how the thrust of the front wheels is dissipated in turbulence to the rear. Just behind the strong shoulder of the car a sturdy post lifts up the roof - that's the actual windshield column there - which trails off like a banner in the air, the driver sits at the dead calm at the center of all this motion. Hers is a lush situation.[10]

Allen wrote of the Buick as the work of anonymous designers, long before Stephen Bayley 'identified' Harley Earl as the author of all GM designs of the period.

While the formal, object-centered approach can be applied to

anything, regardless of its provenance or valuation, such treatments tend to highlight those examples which most purely represent the aspirations of a group, a period, a place or designer. In the history of art and architecture this results in collections of 'masterpieces'. This way of looking at objects relates to the concept of the archetype, formulated by the Swiss scholar C. G. Jung, and to the idea of the model, developed by Jean Baudrillard and expressed in his article, 'The System of Objects' (see chapter 7 of this volume, 'Industrial drama: the custom car myth'). In Baudrillard's ideologically sophisticated system, certain objects, belonging to a social minority, set standards for the mass-produced objects with which the majority live.

Archetypes and models emerge from all design disciplines forming a body of objects to which designers, critics and historians refer repeatedly, ultimately becoming a canon of 'greats' or 'classics'. An example of such a collection is published in *American Design Classics 1960-1985*, by Joan Wessel and Nada Westerman (1985). The book was subdivided into chapters on materials and technology, function, form and human factors; its authors described it as 'an in-depth examination of how great designs evolve'. Its discussion of the elements of 'good design' are underpinned by a moral critique closely bound up with formal/aesthetic preferences, but it has the unusual virtue of describing aspects of the design process and the evolution through redesigns of selected products. This involves a comparative method rare in this type of literature.

Jay Doblin, Director of the Illinois Institute of Technology, identified a similar set of objects through a survey he sponsored in 1959 of 100 judges, all experts in the industrial design field, to select 'the 100 best-designed products of modern times'.[11] The announcement of the top ten of the products chosen (those which were listed most frequently by the individual judges) appeared simultaneously with a MOMA exhibition, *20th Century Useful Objects*, curated by Arthur Drexler, to display 'the most beautiful artifacts of our time'. Together, these 'value collections' provided a format for the presentation of design which continues as a strong favorite of publishers and museums, but which, even at the time, was greeted with skepticism. Jane Fiske McCullough wrote, 'The question that emerged ... was: what do these groups of products say about the world we live in?' Her answer suggested that one could only 'grope for meaning' in such collections.[12] One could also wonder if the selection said more about the judges than the objects.

New technologies

Museums and libraries have traditionally concentrated on the classification of applied or decorative art objects by materials and related techniques. This is primarily intended to facilitate scholarship and examination of artifacts by manufacturers and craftspeople wishing to learn how things have been made. Pottery, glass, furniture (traditionally defined as woodwork, although it was seldom restricted to that material), textiles, wallpaper and costume were then subgrouped by period and country. Monographic studies also came to be grouped under these same headings.

Following Mumford's *Technics and Civilization* and Siegfried Giedion's *Mechanization Takes Command*, a monumental study of the effects of the machine on modern culture discussed below, recent scholarship has merged the study of technology with philosophical interpretation, social history and design analysis to provide a more holistic picture of the ways in which technology has shaped material culture. David Hounshell's *From the American System to Mass Production 1800-1932* (1984) demonstrated how the concept of mass production developed in America, how its nature changed with advances in machinery, systems for production and market demands, and showed the impact of changing production technologies on design.

There are several advantages to such an approach. Using technology as a basis encourages the quantitative analysis of content, thus introducing explicit and relatively objective elements to the discussion. It also has the advantage of redressing an excessive concentration on form, a benefit revealed in Reyner Banham's *The Architecture of the Well-tempered Environment* (1969), in which he cites the innovative mechanical services of Frank Lloyd Wright's Larkin building.

> Historical and critical writing has tended to concentrate exclusively on the felicity of its interior spaces and their relationship to the great monumental volumes of the exterior, without observing that the system of environmental management mediates crucially between interior and exterior form. Not only is the use of a vast single vessel of space ringed with balconies almost a necessity given the then state of artificial ventilation, but it was a flash of inspiration, about the disposition of the services to achieve that ventilation, that gave the magisterial form of the exterior. [13]

Hounshell follows a similar path in discussing the introduction of flexible mass production techniques in the manufacture of Ford cars in the 1920s:

> once introduced, the Model A served to reaffirm and to give an

entirely new dimension to mass production. To some, Ford's work proved dramatically that mass production was not the antithesis of individuality and aesthetics. The Model A was singled out for its beauty, and it was held up as the prime example of what could be achieved by combining mass production methods with art. [14]

Henry Petroski's *The Evolution of Useful Things* (1994) places technological developments within a context of use involving trial and error, improvement and replacement. In this study, the user response to new technologies, such as the introduction of the zipper in the 1920s, is seen in relation to design innovation, marketing and cultural change. Petroski's fundamental principle is 'form follows failure'.

The materials and techniques approach can free the historian or critic entirely from typological boundaries. The Museum of Modern Art's 1995 exhibition and book entitled *Mutant Materials in Contemporary Design* was organized according to materials ranging from wood to synthetic fibers and composites. Exhibits included product design, craft design, sculpture and environmental installations. This approach also enabled the selectors to represent objects in a wide variety of styles, from whimsically organic to geometrically rational. No star system needed to be accommodated within the approach, nor were any of the exhibited objects represented as 'classics'.

It has been argued that the materials and techniques method does not apply well to interiors or complex objects.[15] Yet Banham, in his *Architecture of the Well-Tempered Environment*, used a technical approach to very good effect in analysing the most complex branch of design, modern architecture. Also, by focusing on parts of a design, the *Mutant Materials* exhibition addressed objects as complex as automobiles with little difficulty.

However, a potential danger of the approach is to isolate techniques or materials artificially, creating a fragmented design study, and possibly giving the false impression that designs are subject only to the inner logic and demands of technique or material. This is especially problematic in the crafts. How this can be avoided is demonstrated by Jeffrey Meikle in his article, 'Into the Fourth Kingdom: Representations of Plastic materials, 1920-1950', which reveals the changing cultural meaning of plastics over a thirty-year period.[16]

Beginning in the 1960s as a minority, oppositional movement targeting consumerism, Green Design, advocating alternative technologies, has developed as one of the major approaches to design criticism in the later decades of the century. Victor Papanek's widely read *Design for the Real World* launched a frontal attack on the design profession's unthinking reliance on advanced

technology in the service of mass consumption. Papanek pursued his thesis on responsible uses of technology in design and manufacturing in a series of other books and articles culminating in *The Green Imperative*, published in 1995. Similar ideas were brought to a wider general readership through popular books such as Karen Christiansen's *Home Ecology* (1989), a prescription for an improved Western lifestyle with reduced dependency on technology and consumer goods, and Virginia Dajani's article, 'The Cape Cod Cottage Goes Solar', a consideration of high-tech services for pre-fab houses, published in *New York* magazine.[17]

In the 1990s, the rapid advance of computer-aided design, Virtual Reality, robotics and artificial intelligence has reinvigorated the discussion of design in its relation to technology. Robotic production methods have become central to the debate over global versus national design. For example, the concept of a single global product, sold in every market, as advocated by the American academic, Theodore Levitt, may be overtaken by the increasing ability of manufacturers to produce superficially differentiated products for local markets through the use of flexible manufacturing systems. Discussion of such issues has taken place mainly in literature of the business and manufacturing professions, an example of which is Ramchandran Jaikumar's article, 'Postindustrial Manufacturing', published in the *Harvard Business Review* (1986). However, books such as Hugh Aldersey-Williams' *World Design* have treated the same new technologies more specifically in relation to their design implications.

Even the museum-going public, conditioned to thinking of design in terms of beautiful objects, has been exposed to emerging ideas about the design implications of new technology and materials through exhibitions such as *Mutant Materials in Contemporary Design*, curated by Laura Antonelli. The exhibition and catalog detailed many ways in which scientific discoveries in space and military researches were continuing to alter the design of consumer products and also discussed the potential effects of advanced electronics on the creation of 'virtual' environments constructed from information.

Typologies

Closely related to the materials and techniques approach is the typological approach. It too shares a background with art historical works such as Wolfgang Born's *American Landscape Painting: An Interpretation*, described as 'a history of ideas rather than a biographical account of a school of painters'.[18] John Pope-Hennessy's, *The Portrait in the Renaissance* (1966) and Erwin Panofsky's, *Tomb*

Sculpture: Four Lectures on its Changing Aspects from Ancient Egypt to Bernini (1964) also represent the typological approach as employed by art historians.

Richard Sexton's *American Style: Classic Product Design from Airstream to Zippo* (1987) follows a typological approach derived from the decorative arts (musical instruments, furniture, costume, etc.) But Sexton expands the traditional categories to include mass-produced goods and twentieth-century object types such as the electric guitar, sunglasses and computers. The category of prints is transformed to encompass periodicals. And object types, such as vehicles, which would have been consigned to special collections, are featured prominently under the heading of transport. The author also inserts entirely new categories of object such as photographic products and sports and leisure goods. Similarly, in the present volume chapters 7 and 9, 'Industrial drama' and 'Nice threads', take product type as their starting-point.

Probably the best-known typological work in history of design literature is *Mechanization Takes Command*, written during the 1940s when its author, the Swiss scholar Siegfried Giedion, was resident in the United States and teaching at Yale. The relationship between materials, techniques, typology and use is central to Giedion's method and is represented, for example, in the grouping of new furniture types by material, structural configuration and manufacturing methods. Describing the mass-produced, cantilevered, tubular steel chair, Giedion wrote, 'the modern type is a wholly new one ... conceived according to the laws of bent and welded tubular steel ... in terms of mass-production'.[19] He also discussed the effects of mechanization on taste, food production, housework and bathing, citing the design implications of these developments at every stage throughout a long swath of history.

Giedion followed the approach of his former teacher, Heinrich Wolfflin, in his adherence to a history without names. Thus, *MTC* is subtitled 'a contribution to anonymous history' (refer to chapter 5 of this volume, 'Designers and makers' and 8, 'Making American homes'). As he turned away from great names, he also rejected the canon of great objects.'We shall deal here with humble things, things not usually granted earnest consideration'. The typological method provided an appropriate framework for the creation of the 'bridges' which Giedion wished to construct between disciplines which he thought could not, individually, explain the development of modern life and its specific aspects, such as the modern concept of comfort. Thus an anonymous history of the techniques of mechanization provided a structure for discussing the relationships among various 'departments' of culture, economics, aesthetics, psychology and politics, ultimately seeking a social

context for design. The result was an ambitious multi-faceted work which provided a somewhat rough and ready model for the subsequent development of design history.[20]

Period studies

The vastness of historical information often leads authors, curators and readers to look for a convenient way of limiting their investigations. As in this volume on twentieth-century design, selecting a slice of time is an easy way to cut the problem of history down to a manageable size. While some design studies undertake a huge sweep of time within which to analyse a particular theme, as in *Mechanization Takes Command*, others seek a unifying quality in a particular century, decade or era. Examples of this are *Landmarks of Twentieth Century Design* by Heisinger and Marcus (1993), and Richard Horn's *Fifties Style* (1985), two books which share a belief in the identifiable 'spirit' inherent in any specified period in history. In the first half of the twentieth century, some historians and critics attempted to establish modernism as the dominant force affecting the style of twentieth-century art and design. Similarly, decades have been identified as having significant unifying factors which contributed to the emergence of a cohesive movement or look in particular branches of design. In this manner *The Streamlined Decade* (1975) by Donald Bush significantly expanded the limits of art historical activity to include design and provided a useful model for the emerging design history discipline.

According to Karl Popper, the 'periods' approach, which he calls 'historicist', 'assumes that historical prediction is … attainable by discovering the "rhythms" or the "patterns", the "laws" or the "trends" that underlie the evolution of history'.[21] But Popper rejects the unifying tendency of such an approach which he claims denies the plurality of interpretations which can be applied to any moment in the continuum of history. As a means of avoiding the problems associated with 'historicism' as a method, he advises the historian to 'be clear about the necessity of adopting a point of view … and always to remain conscious that it is one among many'.[22]

Another problem resulting from periodization is its arbitrary nature. What determines the start and end dates. History flows, and circumstances do not change with the pages of a calendar. Just as 1900 is a convenient and arbitrary starting date for this volume, any chosen period will simply be a slice of history and may require an account of earlier circumstances which affect the main discussion. Similarly, it can be useful to look into the subsequent influences of the period, as Richard Horn did in his book, *Fifties*

Style, in which he evaluated the revival of 1950s motifs in designs and fashion of the 1980s. Both Jeffrey Meikle's book *Twentieth Century Limited, Industrial Design in America, 1925-1939* and Thomas Hine's *Populuxe* are models of appropriate selection of a period for study. This is due to the authors' careful identification of time-spans conditioned by identifiable social, political and economic factors which influenced style.

Internationalism, nationalism and regionalism

In the history of art and architecture, national characteristics are commonly used as the organizing method for both books and exhibitions. In this tradition, the Whitney Museum held its blockbuster exhibition, *200 Years of American Sculpture*, in the bicentennial year, a symbolic moment, and billed it as the 'first comprehensive survey of American sculpture'. The catalog discussed at length the aboriginal roots of the art and the diversity of subsequent traditions; it featured essays by a variety of scholars to expose differing interpretations of the work on show. The purpose of the exhibition was to establish the existence of specifically American responses to the practice of sculpture, just as the present volume seeks to identify characteristics of design in America. A similar proposition has been argued in books such as Arthur Pulos's two-volume history of American industrial design, *American Design Ethic* and *American Design Adventure*, published in 1983 and 1990, respectively.

Recently, more broadly-based studies have looked directly at the subject of nationalism and internationalism as they apply to design. Thus the publication of books such as *World Design* (1992), by Hugh Aldersey-Williams, and Jeremy Aynsley's *Nationalism and Internationalism: Design in the 20th Century* (1993). Aldersey-Williams' *New American Design. Products and Graphics for a Post-Industrial Age* examined the practice of design in America during the late 1980s, focusing on the work of twenty-one hip young design practices who were selected to represent a range of issues alive in the design discourse at the time. While the book addresses intelligently a number of potent ideas, the slickness of its corporate monographs suggests that its main purpose was to glamorize American design in the manner of *Dallas* or *Falcon's Crest* (refer to previous section on 'monographs', pp. 255-8).

As in the history of art, a variety of methods have been used to define national design character. Simple stereotypes have been provided to characterize the nation's art and design. More properly, complex sets of conditions are analyzed. Astute historians have recognized that constantly changing conditions alter the products

of a nation. Therefore, prevailing economics, cultural composition
and hegemony, technology and methods of communication all
contribute to such analyses. In *Nationalism and Internationalism:
Design in the 20th Century*, the British writer Jeremy Aynsley sug-
gested that Hollywood, and its packaged glamor, had the greatest
single effect on the formation of the image of American design.
Throughout its history, the movies have portrayed America as a
mythical land of vast space, skyscrapers and streamlined cars – a
unified world of superlative goods made of materials which no
nation ever had before.[23]

Aldersey-Williams observed that the elements of American cul-
ture which most strongly influence its design are the individualism
born of democracy and the continuous immigration which has
made America receptive to ideas from all other cultures. An em-
phasis on the mixed demography of the nation helped him to
avoid a trap into which some national histories fall: the reduction
of national identity to a simple set of clichés.

Patriotism and political motives have figured prominently in
discussions and presentations of design as a national symbol. The
world's fairs held on United States soil have been devoted primar-
ily to boosting American national pride and consumption at
home. American exhibitions at international fairs abroad pro-
moted the American-Way-of-Life as an ideal. Images and objects
on show operated as enticing symbols of the prosperity offered by
a cocktail of democracy and mass production. Karal Ann Marling
wrote about the American National Exhibition held in Moscow in
1959 at the height of the Cold War. She described the vivid slide
shows, designed by Charles and Ray Eames and Billy Wilder, illus-
trating average Americans at work and play; the RCA Whirlpool
Miracle kitchen with its domestic robots buzzing through their
chores (this was the site of a notorious Nixon-Khrushchev debate
over the ideology of consumerism); a complete supermarket
crammed with colorful consumables; and a host of exhibits aimed
at communicating the basic rituals of life in the United States. The
displays, she wrote, 'seemed calculated to arouse envy and discon-
tent at a basic level of appetite, haptic pleasure, and sensory
overload'.[24]

The problem of national pride has surfaced regularly in articles
and books such as Richard Sexton's *American Style*, which aimed
to establish the aesthetic merit of designs produced in the United
States in the face of what the author saw as popular disdain in
America for domestically designed goods. What the book estab-
lishes is the persistence of a 'cultural cringe' which has been
aggravated by the growth of an international marketplace for con-
sumer goods in the later part of the century. It has been a bitter

pill for American pride that the market for high quality imported goods, such as Japanese cameras, has continued to grow steadily throughout the second half of the century (see chapter 1, 'American taste and style').

Yet the influence of imported foreign design ideas on American aesthetics was attracting a negative reaction even before the Second World War. Russel and Mary Wright launched the American Way project in the late 1930s in an ambitious exhibition, held at Macy's department store in New York, to counter the influence of Bauhaus and other European aesthetics by promoting an identifiably American design idiom which they insisted should respond to native methods of production, materials and cultural traditions.

The postmodern climate of criticism has encouraged research on regional design idioms such as the traditional Adirondak buildings and furniture made in rural New York State. Craig Gilborn's *Adirondak Furniture and the Rustic Tradition* (1987) is one of several recent publications about localized design traditions which are being revived as popular tastes and as subjects for academic research at the close of the century. Another is Nicholas Markovich's *Pueblo Style and Regional Architecture*. Yet the geographic and political basis for an appreciation of design in America, particularly in the current century, gives rise to several problems. Homogeneity is the first of them. Although the government of the United States has consistently promoted a strong image of national unity, the divisions between races and ethnic groups, age groups, the regions or states, economic classes, rural, suburban and city interests, and religious or philosophical persuasions have been increasingly apparent since the 1960s. These real differences subverted the idea of the 'melting-pot nation'. At present, any serious analysis of nationalism must take account of a range of attitudes, from national flag-waving and regional 'boosterism' to subcultural and minority values which have design implications. It must also engage with the idea of nation at the level of myth and assess the different interpretations of the myth among various groups. An attempt to demonstrate this awareness is made in chapter 2, 'Theories and movements', under the headings, 'nationalism' and 'pluralism'.

In reality, design has become international. Multi-national conglomerates produce and sell goods across national boundaries and in widely varied markets. The international marketplace, the increase in personal mobility, which has put formerly exotic goods within reach of many people, and the international nature of design practice have tended to standardize the design of goods, environments and the presentation of services around the world. As early as 1932, Henry-Russell Hitchcock's *The International Style* attempted to promote the value of a world view of design as a

front of resistance against the sinister nationalism then rampant in Europe. In the 1990s, Hugh Aldersey-Williams' *World Design* established a useful method of addressing global design and cultural identity. His case study of IBM, for example, considered the relationship between central corporate control and specific market needs in various parts of the world.

Social and cultural analysis

The social approach to design analysis also has roots in art history; an example is Arnold Hauser's *The Social History of Art*, published in 1951, which sets out a framework for analysis of art based on 'connections between social forces and works of art'. Like Wolfflin and others, Hauser pursued an anonymous history of art, but his pioneering method was anthropological, rather than formal, examining both popular folk art and high art in terms of originality and social convention.[25] In a similar vein, Wayne Andrews' *Architecture, Ambition and Americans: A Social History of American Architecture*, published in 1964, stressed the social, economic and cultural aspects of architectural history, rather than famous figures or the history of style.

Anthropological methods of analyzing art and design have been applied within the field of American studies. Founded on a monolithic and synthetic construct called the 'American Mind', American studies was hit hard by the growing recognition of cultural pluralism since the 1960s. Eventually, the field found ways of dealing with the atomization of the old myth of a unified American culture. Jeffrey Meikle's *Twentieth Century Limited: Industrial Design in America 1925-1939* (1979) was the product of a doctoral dissertation in American studies which, by concentrating on a literary analysis of the marketing of industrial design, provided an alternative model.[26]

In 1985 the journal *American Studies International* published 'American Design History: A Bibliography of Sources and Interpretations', demonstrating the relationship which developed between design and American studies. The limitations of this relationship are identified, however, in Victor Margolin's comment that any national focus to the study of design 'determines the kinds of questions that are asked of research material and excludes lines of enquiry that would help to understand design as a practice outside a specific national context ... design historians must still look at their subject in a global framework to fully understand the meaning of design policies, techniques and values'.[27]

In a broader context of popular culture, the anthropological/social approach to design studies has become increasingly popular

as it provides an alternative to singular approaches such as military, political, or corporate histories, which center on milestones. Siegfried Giedion wrote that 'The slow shaping of daily life is of equal importance to the explosions of history'.[28] Many other writers, including Sibyl Moholy-Nagy in *Native Genius in Anonymous Architecture* (1957), have also employed anthropological methods to analyze design as a cultural activity.

As empirical, observational research is one of the basic tools of anthropologists, their method applied to design stresses the direct observation and comparison of artifacts, as opposed to the study of texts as the main source of understanding culture. Comparisons of the changing style of objects are used to disclose trends in popular culture: for example, the evolution of bathing suits reflects attitudes toward leisure, fitness and sexuality, among many other things (see chapter 9, 'Nice threads').

One of the significant advantages of social approaches is that they include groups who have traditionally been left out of the design discourse: women, the poor, ethnic minorities, children, the disabled and the elderly. The feminist view is demonstrated in works such as Cheryl Buckley's 'Made in Patriarchy: Toward a Feminist Analysis of Women and Design,'[29] a direct attack on methods of study which omit or marginalize women from the literature on design. Feminist critiques of design have argued for widening the definition of design to include craft activities, women's roles as consumers and other areas of involvement which fall outside industrial design practice. Such an approach in this volume can be found in chapter 8, 'Making American homes'.

The social analysis of design has also come from within the design profession. Organizations such as the International Design Conference at Aspen and the unofficial Design History Forum of the College Art Association promoted the development of a wide-ranging design debate. At the same time, design history was developing as a self-conscious academic discipline and as an arena for theoretical debate. Designers such as Victor Papanek and Arthur Pulos interested themselves in an ongoing historical and critical discourse which increasingly emphasized the social effects of design in the lives of ordinary people. The profession's intense concern to justify or purge itself morally peppers the literature of the Aspen conferences and the pages of *Industrial Design* magazine. Articles such as Papanek's, 'Creativity vs. Conformity' reflected growing interest among professionals and design educators in a more aggressive debate on the meaning of design.[30] Some observers were surprised to find the design profession examining its navel for symptoms of moral corruption. Reyner Banham, in one of his Aspen papers, repeated the comment of a visitor present at a

particularly acrimonious design debate held in London, 'Do dentists have meetings like this?'[31]

A growing awareness of the relationship between design and other disciplines was reflected in papers published under the auspices of organizations such as the Decorative Arts Society, founded in 1974, and the Society for the History of Technology, founded in 1958. Its journal, *Technology and Culture*, explored the nature and effects of mass production and mechanization, both issues central to the design discourse. Articles in *Technology and Culture*, such as Ruth Cowan's 'The "Industrial Revolution" in the Home: Household Technology and Social Change in the Twentieth Century', linked the study of mechanization in the home with the changing roles of women within the family.[32] This represented one of many ways in which a feminist perspective was wedded with technological analysis of design. An architectural and planning viewpoint was explored in Dolores Hayden's *The Grand Domestic Revolution: A History of Feminist Designs for American Homes, Neighborhoods, and Cities* (1981), a survey of feminist critiques on spatial design in relation to housework and the evolving domestic role of women.

Scholarship in 'material culture' was advanced by the Winterthur Museum's *Winterthur Portfolio*, a journal devoted to the 'interrelation between physical objects and human behaviour'. Historians, turning their gaze from military and political events to cultural history, highlighted design as an index of human aspiration and group dynamics. In fact, cultural studies spawned some of the most lively theoretical debates about what design is. John Thackara's 'Beyond the Object in Design', an introduction to his anthology *Design After Modernism* (1988), posited a redefinition of 'modernism' and a revision of the concept of design in relation to city life, the nature of work and the advance of technology. As its title suggests, this article rejected objects as a focus of attention. Other cultural studies texts of the late 1980s and 1990s have also turned away from observational methods of analyzing design in favor of ideological analyses of its cultural functions; some contain no illustrations as a declaration that these design studies are not about the way things look.

Iconology

A common way of finding meaning in design, as in art, is through the study of symbolic content. Examples of this type of analysis can be found in texts ranging from the profoundly philosophical to the quasi-scientific. Erwin Panofsky's *Studies in Iconology* (1939) established a basic philosophical framework of iconographical

analysis for art historians, whereas Gyorgy Kepes explored the mechanism of symbolic communication in his *Sign Image and Symbol*, of 1965. Among works using more than one approach, *Meaning in Western Architecture* (1975), by Christian Norburg-Schulz, analyzed buildings as cultural, technical and symbolic artifacts, citing examples from antiquity through the twentieth century. With a knowing post-modernist approach, Charles Jencks' *The Symbolic House* (1985) explained in detail the iconographic content of design elements, both spatial and decorative, in the author's own London house. Iconology has become increasingly important in postmodernist criticism and in semiological approaches.

Structuralism and semiotics

In the 1960s, scholars and critics, including Jencks, turned to the French structuralist and semiotic approaches to analyzing material culture. Thus the structure of language became a model for the analysis of objects. Communication was seen to be the primary element in the formation of social and cultural institutions, from the family to the community of nations. Objects formed part of the communication process in that they embodied visual signs which could convey different meanings to different people at different times. The formula 'Sign = signifier + signified' was used to explain how a sign consists of a thing plus its meaning. The Cadillac tail fin (a *sign*) is constructed of pressed and painted sheet metal (the *signifier*) which represents speed (the *signified* quality). At least that is the obvious meaning given it by its designers; but alternatively it might suggest vulgarity, oppression or other images (see figure 49). This system was defined by the French sociologist and literary scholar Roland Barthes in his influential book *Mythologies*, first published in 1957 and translated into English in 1972.[33] A collection of essays on popular subjects, including 'Toys', 'Plastics' and 'The Face of Garbo', *Mythologies* contributed to a significant widening of the appreciation of design in its relationship with the structures of society.

Structuralism relies on the principle that the human mind works according to sets of oppositions in its understanding of the world - good/bad; raw/cooked; feminine/masculine. Judith Williamson employed this system skillfully in *Decoding Advertisements, Ideology and Meaning in Advertising* (1978), a book based on seminars conducted at the University of California in Berkeley. Some critics have objected to the universal nature of this method of analysis which resides outside the historical process, producing 'synchronic' accounts in which phenomena all seem to occur at the same time. As a film-maker and critic, Williamson's acute

sensibility to time protects her from this danger. Objectivity may also be a problem. Empirical evidence of how groups or individuals read objects is difficult to obtain. Quantification is virtually impossible. Consequently, subjective analyses are most common among writers using a semiotic method and can lead to simple assertion – 'this means ...'.

Charles Jencks demonstrated visual techniques of semiotic analysis, clarifying the semiotic approach to a wide audience of designers and students, through his pictorial primer, *The Language of Post-Modern Architecture* (1977). To illustrate the method, he cited a study of movie star homes analyzed in terms of symbols of status, personality, exclusivity and 'home' appearing in their facades and gardens as means of communicating well-understood social values to the broad movie-loving audience who would know the houses from magazine articles or Hollywood tours. The most pragmatic branch of semiotics is concerned with relationships between the producers of signs, the signs themselves and the receivers of the signs. In *As Seen on TV: The Visual Culture of Everyday Life in the 1950s* (1994), Karal Ann Marling described the 'kitchen debate' between Richard Nixon and Nikita Khrushchev, an ideological argument over the virtues and vices of the modern American kitchen. Her discussion of the event demonstrated vividly how everyday objects, such as washing machines and stoves, embody diametrically opposed meanings for individuals holding antagonistic political viewpoints.

Structuralism/semiotics provided a sophisticated means of placing design in an ideological context. It attacked the tradition of universal values and recognized the variety of responses to any design statement.

Consumption and reception

Design studies have taken an increasing interest since the 1980s in how things are used, who uses them and why. Who is the consumer of a product? What determines its value? Is the exchange value the sole indicator of worth? Is the public good a valued commodity? Or are private pleasures or wants the best criteria? This was in marked contrast to the traditional concentration among critics and historians on the production of goods, the process of design and conception, and the making or manufacturing process. Analysis of consumption also differs markedly from formal methods which concentrate on objects themselves.

Consumption theory arose from diverse interests in economics, politics, social criticism, consumer rights, the design profession, and most accessibly from journalism, as represented by Vance

Packard. His studies on the field of motivational research led to publication of *The Hidden Persuaders* (1957) which examined design in its relation to the professional manufacture of want and dissatisfaction through advertising. In The *Status Seekers* (1959), Packard discussed design of homes, cars and clothing as a means of generating symbols representing the structure of rank and class in American society. Packard influenced the 'New Journalism', developed by Tom Wolfe in a series of popular books and articles, beginning in the 1960s, which addressed subjects including abstract painting (*The Painted Word*, 1975), International style architecture (*From Bauhaus to Our House*, 1981), and car customizing (*The Kandy-Kolored Tangerine-Flake Streamline Baby*, 1965), all treated vividly as symptoms of contemporary social trends.

Cinema has also presented popular critiques of consumption in films such as *The Palm Beach Story* (1942) and *Pretty Woman* (1990), both of which used 'shopping-spree' sequences as a means of defining character and establishing plot dynamics. Hollywood has explored shopping as a means of self-expression and fulfilment and also as a way of forming intimate bonds between people. Yet it is the feel-good-factor of such scenarios which have communicated most effectively with audiences. Alternatively, *Scenes From A Mall* (1991) took a more jaded, late-century view of consumption as a metaphor for the dissolution of intimacy and marital fidelity in a culture of such abundant choice that any individual preference is immediately nullified by another option.

If choice is the essence of consumerism, advertising is where the major issues connected with consumerism are portrayed: taste and values, economics, leisure, waste, self-image. Advertisements are designed, and thus they can be viewed in terms of their own formal qualities, aesthetics and iconography. The Doyle, Dane, Birnbach agency's advertisements for Volkswagen in the 1950s and 1960s demonstrated a sophisticated combination of spare graphical qualities with clever and humorous copy eminently suited to selling the particular qualities of the 'Beetle' car in the American market. These advertisements reflected contemporary social concerns such as ethnicity (Jewish humor used to sell a German product), class conflict, gender, urban congestion and waste in a consumer society. Yet the success of the campaign was to make austerity desirable as a chic alternative to extravagance.

The politics of most advertising is to the right of center. And it is the political implications of advertising in relation to consumption which was the subject of Williamson's *Decoding Advertisements*. She detailed the process by which advertisements create misery by inducing cravings which cannot be satisfied by consumption of the products they promote.

On the contrary, one of the main declared intentions of design is to impart pleasure. Of the various forms of pleasure associated with design, desire is possibly the most drawn out. The pleasure of acquisition fulfils desire, but its benefit is of very short duration. The object may give pleasure through use or enhanced status, but may also be a let-down when it malfunctions or goes out of style. The disillusioned user is the central theme of Leslie Weisman's *Discrimination By Design: A Feminist Critique of the Man-Made Environment*. But here, the villain is the designer himself, rather than an intermediary, such as the ad-man.

The magazine, *Consumer Reports*, attempts to provide an objective assessment of user satisfaction. But the essentially subjective nature of pleasure seems to have put scholars off committing themselves to serious analysis of the phenomenon. Thus it is seldom confronted directly in critical literature – although style books sometimes feature it. Richard Horn's *Fifties Style: Then and Now* (1985), emphasizes the sybaritic and amusing aspects of advertisements, their appeal to self-indulgence, the comfort of woven textiles and the tactile and visual pleasures of bejewelled consumer durables produced during the post-war boom.

In the monograph, *Morris Lapidus: Architect of the American Dream*, the architect explains his design intentions in terms of the desires of the patrons who used his hotels to escape from routine and to indulge temporarily in unrestrained luxury at a price they could afford. He said of his work that it was based on the idea of Thomas Jefferson 'who wrote in the Declaration of Independence, "What we want is life, liberty and the pursuit of happiness". Happiness is the word. If you can create happiness for people, that is the American dream'.[34]

Surprisingly little has been written about public sector design in America, where the US government is the largest single client of design for transport, leisure amenities, utilities, communication graphics and military products, perhaps because individuals do not choose these all-pervasive public artifacts and do not purchase them directly. This is unfortunate as almost everyone interacts with public design: mailing a letter, driving on an interstate highway, and responding to campaign advertising in the polling booth. One of the few books to deal with this subject is *The Design Necessity* (1973), by Ivan Chermayeff, which attempted to assess the performance of federally sponsored design from the viewpoint of the public. Chermayeff used time, safety and economy as the primary indicators to gauge effectiveness. He assessed how specific designs saved users' time, improved public safety and created savings for tax-payers through economical production.

Analysing design in terms of its public reception was a method

drawn from literary criticism, which began in the 1960s to recognize multiple interpretations of texts by readers. A dissection of the changing popular reception of the automobile was conducted by John Keats in his 1958 essay, 'Insolent Chariots'. Keats' approach included a study of the 'addressers and addressees', the relationship between the messages designers and manufacturers thought they were sending and the ways in which those messages were being read by consumers. His case study of the Edsel revealed a significant gap between the consumer's apprehension of a product and those revealed by marketing studies.

Methods of design study which emphasize the role of the consumer or user and the ways in which they perceive design sometimes do it at the expense of the status of the 'author' or designer. Structuralism saw the modern concept of the author as a guarantee of exclusivity, individuality and capitalist ownership with regard to all cultural products from literary works to mass-produced products. Michel Foucault asked, 'What difference does it make who is speaking?' He and others wished to see the author concept replaced by a new system of appraisal which asked about the 'mode of existence of an artefact, where it is used, by whom, and how can it be interpreted?'[35] Clive Dilnot wrote that 'designed forms possess no intrinsic value. Their import and significance is not given by their designer status but is achieved because of what can potentially be won from them in terms of evidence and in terms of understanding.'[36]

The user viewpoint is crucial to critiques of conscience. While not, strictly speaking, a method of analysis, the critique of conscience has certain characteristics which define it as a genre of study heavily dependent on analysis of the ways in which things are used. One of the best-known indictments of design and the irresponsible application of design by manufacturers was Ralph Nader's *Unsafe at Any Speed: The Designed-in Dangers of the American Automobile* (1965). In it, Nader compared the aims of management and designers with the experiences of users and others who are affected by the design of automobiles. Case studies of those injured or killed by blade-like fins and chrome decorations were placed in the context of the legal system, economic concerns of manufacturers and publicity. The much admired lines of the Ford Mustang were analyzed in terms of the absolute primacy of aesthetics in the design process over consideration of engineering safety. Every elegant edge profile was assessed in terms of its potential for injury to passenger or pedestrian.

In 1944 Lewis Mumford had made design responsibility his subject of study in *The Condition of Man*. Conservation of the American land had been an issue since Frederick Jackson Turner

announced the closure of the frontier in 1890. Mumford wrote of the need to change attitudes toward consumption in the new era of finite land and resources.

> As a country, we could no longer evade the necessity for settling down and making the most of our resources: it was impossible to overcome the evils of gutting out the forests, mining the soils, annihilating the wild life, merely by pulling up stakes and moving on to a virgin area. Conservation became the price of survival.[37]

Critiques of conscience are inherently antagonistic toward the standard celebratory methods of design analysis, such as monographs or formal analyses. They run the risk, however, of entering the realm of utopianism. This is a complaint sometimes levelled against the most ardent campaigner for design responsibility, Victor Papanek. His aggressive refutations of the priorities of the industrial design profession have drawn bitter responses from the establishment. Yet his books, *Design For the Real World* and *The Green Imperative*, have been widely influential in communicating the need for a more considered approach to design in relation to both production and consumption, as they impact on society and the environment. Similarly, Jane Jacobs' *The Death and Life of Great American Cities* (1961) addressed the condition of modern city planning as a social, economic, aesthetic and personal problem requiring a radical revision of private and public thinking.

Multi-disciplinary critiques

Some design criticism in the 1980s and 1990s has implied that all earlier writing on design was of a primitive, monoschematic type, usually conforming to the monographic or formalist methods outlined above. And while there are many examples of narrowly focused studies among earlier writing, there are also many complex and highly sophisticated works which place design in a wide variety of contexts. Among older American texts, any of Lewis Mumford's mature writing would fit this description. The publication by the British design historian, John A. Walker, of *Design History and the History of Design* in 1989 provided an ambitious introduction to the methods of design history and criticism. By offering alternative concepts for analyzing design, Walker showed how studies could build a rich picture of the widely varied functions and interpretations of design.

Toward the end of the century multi-disciplinary approaches have become more the norm as in the journal, *Design Issues*, founded in 1983 by Victor Margolin and other design historians at the University of Illinois. It is a specialist publication devoted to

the theoretical and critical study of design, and its articles have presented a wide variety of approaches which serve as models for the work of scholars in several fields. Margolin issued a collection of *Design Issues* articles in 1989 under the title *Design Discourse; History, Theory, Criticism.*

Notes

1 In this context, the word 'object' refers also to systems (e.g. transport networks or patterns) and images including kinetic examples such as computer screen displays.

2 Edgar Kaufmann, 'Borax, or the Chromium-Plated Calf', *Architectural Review*, vol. 104, no. 620 (August 1948), pp. 88-93. See also, John Blake, 'Space for Decoration', *Design* (May 1955), pp. 9-23.

3 Sir Karl Popper, 'The Poverty of Historicism' (London, 1961), quoted in Francis Frascina and Charles Harrison, *Modern Art and Modernism: A Critical Anthology* (London, 1982), p. 12.

4 Mark W. Roskill, 'What is Art History', quoted in Wolfgang M. Freitag, *Art Books: A Basic Bibliography of Monographs on Artists* (New York and London, 1985), p. ix.

5 Jules Langner, 'Pocket Guide to Architectural Criticism', reproduced by Barbara Goldstein (ed.), *Arts & Architecture: The Entenza Years* (Cambridge, MA, 1990), p. 206.

6 See C. Edson Armi, *The Art of American Car Design* (University Park, PA and London, 1988).

7 Paul Jodard, *Raymond Loewy* (London, 1992), pp. 7-10.

8 Hugh Aldersey-Williams, *New American Design* (New York, 1988), p. 82.

9 'IBM Redesigns a Typewriter', *Industrial Design*, vol. 6, no. 2 (January 1959), p. 52.

10 Deborah Allen, 'Design Rview: Cars '55', *Industrial Design* (February 1955), and quoted by Reyner Banham, 'Detroit Tin Re-visited', in T. Faulkner (ed.), *Design 1900-1960: Studies in Design and Popular Culture of the 20th Century* (Newcastle upon Tyne, 1976), pp. 130-1.

11 The collection was published by Jay Doblin as *100 Great Product Designs* (New York, 1970).

12 Jane Fiske McCullough, 'Design as Commentary', *Industrial Design*, vol. 6, no. 2 (January 1959), p. 56.

13 Reyner Banham, *The Architecture of the Well-tempered Environment* (London, 1969), p. 90.

14 David Hounshell, *From the American System to Mass Production, 1800-1932* (Baltimore, 1984; repr. 1987) , p. 304.

15 John A. Walker, *Design History and the History of Design* (London, 1989), p. 102.

16 Jeffrey Meikle, 'Into the Fourth Kingdom: Representations of Plastic materials, 1920-1950 ', *Journal of Design History*, vol. 5, no. 3. (1992), p. 173.

17 Virginia Dajani, 'Pilgrim's Progress: The Cape Cod Cottage Goes Solar', *New York* 23 August 1976, p. 57.

18 Wolfgang Born, *American Landscape Painting: An Interpretation* (New Haven, 1948), p. 2.

19 Siegfried Giedion, *Mechanization Takes Command* (Oxford, 1948; repr. New York and Toronto), pp. 489-91.

20 See Reyner Banham's discussion and critique of *MTC* in his book, *The Architecture of the Well-Tempered Environment*, p. 13.

21 Popper, 'The Poverty of Historicism', p. 11.

22 *Ibid.*, p. 13.

23 Jeremy Aynsley, *Nationalism and Internationalism: Design in the 20th Century* (London, 1993), p. 26.

24 Karal Ann Marling, *As Seen on TV: The Visual Culture of Everyday Life in the 1950s* (Cambridge, MA and London, 1994), p. 246.

25 Etta Arntzen, *Guide to the Literature of Art History* (Chicago, 1980), p. 112.

26 Victor Margolin, 'A Decade of Design History in the United States 1977-87', *Journal of Design History* vol. no. 1 (1988), p. 60.

27 Margolin, 'A Decade of Design History in the United States', p. 61

28 Giedion, *Mechanization Takes Command*, p. 3.

29 Cheryl Buckley, 'Made in Patriarchy: Toward a Feminist Analysis of Women and Design', in Victor Margolin, *Design Discourse* (Chicago and London, 1989), p. 251.

30 Victor Papanek, 'Creativity vs. Conformity', *Industrial Design*, vol. 6, no. 3 (March 1959), p. 74.

31 Reyner Banham, *The Aspen Papers* (London, 1974), p. 157.

32 This article was cited by Victor Margolin in his article 'A Decade of Design History in the United States'.

33 Roland Barthes, *Mythologies* (London, 1972), p. 117.

34 Morris Lapidus, interviewed in Martina Duttmann and Friederike Schneider, *Morris Lapidus, Architect of the American Dream* (Basel, Berlin and Boston, 1992), p. 21.

35 Michel Foucault, 'What is an Author?', in Charles Harrison and Paul Wood, *Art in Theory, 1900-1990* (Oxford, 1992; repr. Oxford and Cambridge, MA, 1993), p. 923.

36 Clive Dilnot, 'The State of Design History', in Victor Margolin, *Design Discourse* (Chicago, 1989), p. 240.

37 Lewis Mumford, *The Condition of Man* (New York, 1944), p. 401.

Conclusion: limitations and possibilities

Design has often been portrayed as a panacea for society's problems, the designer a cultural hero. But in the course of the century the limitations of design have become painfully obvious.

Advanced streamlining could not sell the Chrysler Airflow in the depths of the Depression. Baroque car styling of the 1950s could not convince the motoring public to buy Edsels. And automotive design as high art could not save the Studebaker Company from bankruptcy. The contribution of Arts and Crafts furniture to the moral fiber of the nation is questionable. The sack dress proved that fashion design does not ensure personal popularity or sexual attractiveness. And 'Sheer Look' appliances did not free women from domestic labor. MOMA's Good Design program, while informing some areas of public taste, became for others a disturbing symbol of cultural elitism. Green design is widely discussed, but has not yet secured the natural environment.

Designers themselves have come to seem distinctly unheroic; but they have not died out. Instead their role in society has been reconstructed to fulfil more diverse and popular functions. Street stylists produced models for both commercial and private creativity. The professions have been partly un-gendered and de-classed. And rare individuals continue to become stars in the shimmering firmament of design heaven.

Design in the United States has been characterized by a continuing effort to reconcile the influence of ever-changing technology with the preservation of human values. From the poetic analogies to nature in the work of Louis Sullivan and Frank Lloyd Wright to the organic humanism of Mumford, from naturalistic designs by Eames and Saarinen to the fractured organicism of Gehry and the 'smart' furniture cohabiting in an experimental living room at Xerox Parc in California,[1] American designers have persistently aimed to retain the organic spirit within a highly technical culture.

Against the facelessness of design for mass production, individuals have vigorously customized their physical surroundings, subverting the commercial system and presenting a unique appearance to the world. Where politics has seemed to have no

meaningful role in changing the *status quo*, individuals and groups have resisted the function of design as a tool of oppression and a symbol of apartheid as it has been practiced by the cultural establishment. If world's fairs, museum exhibitions and communication media ignored ethnic minorities and women, those groups found their own means of personal expression through music, fashion, sports and the domestic crafts, all having design implications.

At the time of writing, design is increasingly out of hand – it has escaped from the elite design establishment and from the critics. It has evolved beyond the styling of objects. It is out of the bag in all senses. And this is no accident. A struggle has been going on throughout the history of design in America to empower the users of object and environments to tailor their surroundings to their personal needs and preferences, to take over the formation of the material world and focus it to a personal vision.

Design has increasingly been seen as a process of creating experiences rather than objects. It has become a means of expressing different types of order. And we are becoming more aware of its synaesthetic function, to address all five senses rather than just the eye. Architecture, fine arts, music, product design, fashion, eating and sex have merged into a creative dynamic activity informed by an organizational viewpoint that can be called design. The designer, maker and user are often one.[2]

American design, despite its global importance and its assimilation of influences from around the world, has remained relatively immune to orthodoxies which informed design elsewhere. While many designed products of, for example, the European Marxist perspective, its notable practitioners and styles associated with it were imported, its theories had limited effect on the capitalist formation of material culture in the United States.

The American century was born with great promise and a progressive spirit. Fantastic energy and invention characterized the hedonistic 1910s and 1920s when brashness and reckless confidence fueled an explosion of material prosperity. Reality hit in the 1930s, when the full measure of its cleverness was required in a grim struggle for survival. The Second World War tested the strength of America as a cohesive society, 'the arsenal of democracy'. And the outcome was world economic and military supremacy. The richness of the 1950s was accompanied by a middle-aged complacency and indulgence which ate at the fiber of the nation's self-esteem. This led to a terrible identity crisis in the 1960s and 1970s. Loss of confidence and direction was aggravated by a genuine decline in vitality. In the 1980s the elderly culture pulled itself up, dyed its hair and put on shoulder pads, but sank into ever-deepening reveries of a glamorized past. As the century draws to a close,

America seems more reflective, enjoying its wealth while admitting its failures and becoming conscious of its responsibilities, its debts and future uncertainty. But its continued prosperity ensures that it remains the world's greatest exploiter and greatest destroyer. During the twentieth century, the domination of American culture by material goods has made it so.

Notes

1 Kevin Kelly reported on an experimental environment in which microchips were embedded in common domestic furnishings enabling them to serve the human user and to know each other's business: 'The Future is Organic', *Observer Life* 18 June 1995, p. 24.

2 Andrew King, review of 'Redefining Design' by C. T. Mitchell, in *Journal of Design History*, vol. 7, no. 1 (1994).

Bibliography

'25 Most Influential Americans', *Time*, 17 June 1996, p. 21.

Abatemarco, Fred (ed.), 'Best of What's New', *Popular Science* (December 1995), p. 41

Albrecht, Donald (1986), *Designing Dreams*, New York and London.

Albrecht, Donald (1995), *World War II and the American Dream*, Washington DC, Cambridge, MA and London.

Albright-Knox Art Gallery (1930), *Exhibition Commemorating the Twenty-Fifth Anniversary of the Opening of the Albright Art Gallery*, Buffalo, NY.

Aldersey-Williams, Hugh (1988), *New American Design. Products and Graphics for a Post-Industrial Age*, New York,

Aldersey-Williams, Hugh (1990), *Cranbrook Design*, New York.

Aldersey-Williams, Hugh (1992), *World Design, Nationalism and Globalism in Design*, New York.

Antonelli, Paola (1995), *Mutant Materials in Contemporary Design*, New York.

Armi, C. Edson (1988), *The Art of American Car Design*, University Park, PA and London.

Arntzen, Etta (1980), *Guide to the Literature of Art History*, Chicago.

Aynsley, Jeremy (1993), *Nationalism and Internationalism: Design in the 20th Century*, London.

Banham, Reyner (1960), *Theory and Design in the First Machine Age*, New York and London.

Banham, Reyner (1969), *The Architecture of the Well-tempered Environment*, London.

Banham, Reyner (1974), *The Aspen Papers*, London.

Banham, Reyner, 'A Throw Away Aesthetic', *Industrial Design* (March 1960), p. 93.

Banham, Reyner, 'The Great Gizmo', *Industrial Design* (September 1965), p. 108.

Barris, George, '1958's custom Cars of the Year', *Motor Life* (October 1958), vol. 8, no. 3. p. 38.

Barthes, Roland (1972), *Mythologies*, London.

Bartlett, Arthur, 'How To Help Build a House', *Popular Science* (April 1952), p. 151.

Batchelor, Ray (1994), *Henry Ford, Mass Production, Modernism and Design*, Manchester and New York.

Battersby, Martin (1969), *The Decorative Twenties*, London.

Bayley, Stephen (1983), *Taste*, London.

Bayley, Stephen (1989), *Commerce and Culture*, London.

Bayley, Stephen (1990), *Design Heroes: Harley Earl*, London.

Bel Geddes, Norman (1932), *Horizons*, New York.

Belloli, Andrea (1983), *Design in America. The Cranbrook Vision*, New York.

Betsky, Aaron, 'Industrial Chic', *Metropolitan Home* (September 1996), p. 92.

Birnbach, Lisa (1980), *The Official Preppie Handbook*, New York.

Blake, John E., 'Space for Decoration', *Design* (May 1955), pp. 9-23.

Born, Wolfgang (1948), *American Landscape Painting: An Interpretation*, New Haven.

Borth, Christy (1945), *Masters of Mass Production*, Indianapolis and New York.

Bowman, Leslie Greene (1991), *American Arts & Crafts: Virtue in Design*, Los Angeles, Boston, Toronto and London.

Brand, Stewart (1994), *How Buildings Learn*, London.

Brenneman, John H., 'An Architect Looks at Customizing', *Motor Life* (December 1957), p. 18.

Brubach, Holly, 'Writer in Residence', *House & Garden* (May 1993), p. 63.

Bush, Donald (1975), *The Streamlined Decade*, New York.

Cain, James M. (1941), *Mildred Pierce*, New York.

'Camp', *Time* 11 December 1964, p. 75.

Campbell, Colin (1987), *The Romantic Ethic and the Spirit of Modern Consumerism*, New York and Oxford.

Caplan, Ralph S., ed., 'IBM Redesigns a Typewriter', *Industrial Design* vol. 6, no. 2 (February 1959), p. 52.

Chapell, Kevin, 'The New Generation', *Ebony* (November 1995), p. 194.

Chermayeff, Ivan (1973), *The Design Necessity*, Cambridge, MA.

Clymer, Floyd (1947), *Historical Motor Scrapbook, Number Four*, Los Angeles.

Collins, Michael and Papadakis, Andreas (1989), *Post-Modern Design*, London.

Conran Foundation (1982), *Art and Industry*, London.

Consumers Union, 'Safety', *Consumers reports* vo. 23, no. 4 (April 1958), p. 194.

Core, Philip (1984), *The Original Eye*, London, .

Corner, James (1996), *Taking Measures: Across theAmerican Landscape*, New Haven.

Cowan, Ruth Schwartz, 'The "Industrial Revolution" in the Home: Household Technology and Social Charge in the Twentieth Century', *Technology and Culture*, vol. 17, no. 1 (January 1976), pp. 1-23.

Dajani, Virginia, 'Pilgrim's Progress: The Cape Cod Cottage Goes Solar', *New York*, 23 August 1976, p. 57.

Davis, Jeffery (1995), *Children's Television, 1947-1990*, Jefferson, NC and London.

Davis, Mike (1990), *City of Quartz*, New York.

Dethier, Kathryn, 'The Spirit of Progressive Reform: The Ladies Home Journal House Plans, 1900-1902', *Journal of Design History*, vol. 6, no. 4 (1993), p. 251.

Doblin, Jay (1970), *100 Great Product Designs*, New York.

Dorfles, Gillo (1969), *Kitsch, the World of Bad Taste*, New York and London.

Dormer, Peter (1990), *The Meanings of Modern Design*, London.

Dormer, Peter (1993), *Design Since 1945*, London.

Dormer, Peter (1994), *The Art of the Maker*, London.

Drexler, Arthur and Daniel, Greta (1959), *Introduction to Twentieth Century Design*, New York.

Duttmann, Martina and Schieider, Friederike (1992), *Morris Lapidus: Architect of the American Dream*, Basel, Berlin and Boston.

Edwards, Anne, 'Marion Davies' Ocean House', *Architectural Digest* (April 1994), p. 170.

Eidelberg, Martin (1991), *Design 1935-1965: What Modern Was*, New York and Montreal.

Ellis, Bret Easton (1991), *American Psycho*, New York.

Faulkner, T. (ed.) (1976), *Design 1900-1960: Studies in Design and Popular Culture of the 20th Century*, Newcastle upon Tyne.

Fellows, Goodman and Pachner, 'Trends in Dress: These Unchecked Undergraduates', *Esquire* (September 1940), p. 99.

Fisher, Allan C., 'You And The Obedient Atom', *National Geographic Magazine* vol. CXIX, no. 3 (September 1958), p. 303.

Fitzgerald, F. Scott (1926), *The Great Gatsby*, New York.

Flink, James (1975), *The Car Culture*, Cambridge, MA.

Forty, Adrian (1986), *Objects of Desire*, London.

Fouser, Donald B., 'They're Built to Save Lives', *Providence Sunday Journal*, 26 April 1959.

Frampton, Kenneth (1995), *The Twentieth Century American House*, London and New York.

Frascina, Francis and Harrison, Charles (1982), *Modern Art and Modernism: A Critical Anthology*, London.

Freitag, Wolfgang M. (1985), *Art Books: A Basic Bibliography of Monographs on Artists*, New York and London.

Friedman, Avi, 'The Evolution of Design Characteristics during the Post-Second World War Housing Boom', *Journal of Design History* vol. 8, no. 2 (1995), p. 131.

Frings, Gini (1982), *Fashion From Concept to Consumer*, Englewood Cliffs.

Fuller, R. Buckminster (1963), *Ideas and Integrities*, Toronto.

Fuller, R. Buckminster (1969), *Operating Manual for Spaceship Earth*, New York.

Fuller, R. Buckminster (1969), *Utopia or Oblivion*, New York.

Giedion, Siegfried (1948), *Mechanization Takes Command*, Oxford.

Gleick, James (1987), *Chaos: Making a New Science*, London.

Goldstein, Barbara (ed.) (1990), *Arts & Architecture: The Entenza Years*, Cambridge, MA and London.

Gorman, Robert, 'How To Store Your Records in a Bookshelf Space', *Popular Science* (January 1954), p. 227.

Greenhalgh, Paul (1988), *Ephemeral Vistas: A History of the Expositions Universelles, Great Exhibitions and World's Fairs, 1851-1939*, Manchester.

Greenhalgh, Paul (1990), *Modernism in Design*, London, 1990.

Hager, Alice Rogers, 'There's Always a Way Up', *Mademoiselle* (February 1941), p. 88.

Hall, Lee (1992), *Common Threads: A Parade of American Clothes*, Boston, Toronto and London.

Harris, William Laurel, 'Seen in New York', *Good Furniture* (July 1915), p. 54.

Harris, William Laurel, 'Industrial Art & American Nationlism', *Good Furniture* (February 1916), p. 67.

Harrison, Charles and Wood, Paul (1992), *Art in theory, 1900-1990*, Oxford and Cambridge, MA.

Haye, Amy de la (1988), *Fashion Source Book*, London and Sydney.

Hebdige, Dick (1979), *Subculture: The Meaning of Style*, London and New York.

Heskett, John (1980), *Industrial Design*, London.

Hightower, C. (1989), *Graphic Design in America*, New York.

Hildebrand, J. R., 'The Geography of Games', *National Geographic Magazine* vol. xxxvi, no. 2 (August 1919), p. 89.

Hillier, Bevis (1983), *The Style of the Century*, New York.

Hine, Thomas (1986), *Populuxe*, New York.

Hitchcock, Henry-Russell (1932), *Modern Architecture: International Exhibition*, New York.

Hofstadter, Richard, Miller, William and Aaron, Daniel (1959), *The American Republic, Volume 2: Since 1865*, Englewod Cliffs.

Holland, Bernard, 'A Phantom Hall Filled With Discord', *New York Times* Section 2, 28 July 1996, p. 1.

Hounshell, David A. (1984), *From the American System to Mass Production, 1800–1932*, Baltimore and London.

Hughes, Robert (1980), *The Shock of the New*, London.

Huxley, Julian (1943), *TVA: Adventure in Planning*, London.

Iacocca, Lee with Novak, William (1984), *Iacocca, An Autobiography*, New York and London.

Jacobs, Jane (1961), *The Death and Life of Great American Cities*, New York.

Jencks, Charles (1977), *The Language of Post-Modern Architecture*, London.

Jencks, Charles (1986), *What is Post-Modernism?*, London.

Jencks, Charles (1992), *The Post-Modern Reader*, London and New York.

Jencks, Charles (1995), *The Architecture of the Jumping Universe*, London.

Jencks, Charles and Silver, Nathan (1972), *Adhocism: The Case for Improvisation*, New York and London.

Joachimides, C. M. and Rosenthal, N., (ed.) (1993), *American Art in the 20th Century: Painting and Sculpture 1913-1993*, Munich, Berlin and London.

Jodard, Paul (1992), *Raymond Loewy*, London.

Johnson, John H., ed., '50 Years of Style: Dressing Through the Decades', *Ebony* (November 1995) pp. 27, 80, 132.

Johnson, Ken, 'Poetry and Public Service', *Art in America* (March 1990), p. 161.

Jones, J. Christopher (1970), *Design Methods*, London, New York, Sydney and Toronto.

Kardon, Janet (1993), *The Ideal Home: The History of 20th Century American Craft*, New York.

Kaufmann, Edgar, 'Borax, the Chromium-Plated Calf', *Architectural Review*, 104, no. 620 (August 1948), pp. 88-93.

Kelly, Kevin, 'The Future is Organic', *Observer Life*, 18 July 1995, p. 24.

Kent, Rockwell (1939), *Good News For Printmakers, Fine Prints for Mass Production*, New York.

Kirkham, Pat (1995), *Charles and Ray Eames: Designers of the Twentieth Century*, Cambridge, MA and London.

Kolb, David (1990), *Postmodern Sophistications*, Chicago and London.

Kostoff, Spiro (1987), *America By Design*, New York and Oxford.

Krakauer, Jon, 'Dale Chihuly', *Smithsonian* (February 1992), p. 90.

Lambert, Susan (1993), *Form Follows Function?*, London.

Larsen, Jack Lenor with Constantine, Mildred (1986), *Beyond Craft: The Art of Fabric*, Tokyo (first pub. 1973).

Le Corbusier (1925, trans. 1987), *The Decorative Art of Today*, London.

Lee, Sarah Tomerlin (1975), *American Fashion*, New York.

Lencek, Lena and Bosker, Gideon (1989), *Making Waves, Swimsuits and the Undressing of America*, San Francisco.

Lippard, Lucy (1966), *Pop Art*, London.

Littleton, Harvey (1971), *Glassblowing: A Search for Form*, New York and London.

Loewy, Raymond (1979), *Industrial Design*, London and Boston.

'Low-Slung Beauty', *Time*, 2 February 1953

Lucie-Smith, Edward (1979), *Cultural Calendar of the 20th Century*, Oxford and New York.

Lynes, Russell (1949), *The Tastemakers*, New York.

McCullough, Jane Fiske, 'Design as Commentary' *Industrial Design*, vol. 6, no. 2 (February 1959) p. 56.

McDermott, Catherine (1992), *Essential Design*, London.

McLuhan, Marshall (1964) *Understanding Media*, New York.

Marchand, Roland (1985), *Advertising the American Dream*, Berkeley, CA.

Marcus, George H. (1995), *Functionalist Design*, Munich and New York.

Marcus, Stanley H., 'America is in Fashion' *Fortune* (August 1940), p. 81.

Margolin, Victor, 'A Decade of Design History in the United States 1977-87', *Journal of Design History*, vol. 1, no. 1 (1988), p. 51.

Margolin, Victor (1989), *Design Discourse: History, Theory, Criticism*, Chicago and London.

Marks, Robert W., 'Detroit – Motors Operandi', *Esquire* (September 1940), p. 88.

Marling, Karal Ann (1994), *As Seen on TV: The Visual Culture of Everyday Life in the 1950s*, Cambridge, MA.

Martin, Richard (1985), *All American: A Sportswear Tradition*, New York.

Martin, Richard and Koda, Harold (1989), *The Historical Mode: Fashion and Art in the 1980s*, New York.

Meikle, Jeffrey (1979), *Twentieth Century Limited: Industrial Design in America, 1925-1939*, Philadelphia.

Meikle, Jeffrey, 'Into the Fourth Kingdom: Representations of Plastic Materials, 1920-1950', *Journal of Design History*, vol. 5, no. 2 (1992), p. 173.

Meller, J. (1970), *The Buckminster Fuller Reader*, London.

Moholy-Nagy, Sibyl (1957), *Native Genius in Anonymous Architecture in North America*, New York.

Monroe, Dorothy and Wiley, James M., 'Must We Resign Ourselves To Living Like Peas in a Pod?', *The American Home* (January 1948), p. 16.

Morris, Kenneth, Robinson, Marc and Kroll, Richard (1990), *American Dreams*, New York.

Mumford, Lewis (1929), *American Taste*, San Francisco.

Mumford, Lewis (1934), *Technics and Civilization*, London.

Mumford, Lewis (1938), *The Culture of Cities*, London and New York.

Mumford, Lewis (1944), *The Condition of Man*, New York and London.

Nordness, Lee (1970), *Objects USA*, London.

Oestreich, Dieter, 'Some Modern Approaches to the Problem of Form', *Industrial Design*, vol. 6, no. 7 (July 1959), p. 70.

O'Neill, William (ed.) (1989), *Echoes of Revolt: The Masses 1911-1917*, Chicago.

Padovan, Richard (1994), *Dom Hans Van der Laan: Modern Primitive*, Amsterdam.

Papanek, Victor 'An Angry Young Iinstructor Attacks Teaching Practices', *Industrial Design*, Vol. 6, no. 3 (March 1959), p. 74.

Papanek, Victor (1971), *Design For the Real World*, Stockholm.

Papanek, Victor (1995), *The Green Imperative*, London.

Paret, P. (1992), *Persuasive Images*, Princeton, NJ.

Patton, Phil, 'Sleek But Square - And That's Why We Loved the Studie', *The Smithsonian* (December 1991), p. 11.

Pawley, Martin (1990), *Buckminster Fuller*, London.

Petroski, Henry (1994), *The Evolution of Useful Things*, New York.

Phillips, Lisa (1985), *High Styles: Twentieth Century American Design*, New York.

Pile, John (1994), *The Dictionary of 20th-Century Design*, New York.

'Plastics in 1940', *Fortune*, vol. 22 (October 1940), p. 91.

Pontus Hulten, K. G. (1968), *The Machine*, New York.

Pulos, Arthur J. (1983), *American Design Ethic*, Cambridge, MA and London.

Pulos, Arthur (1990), *American Design Adventure*, Cambridge, MA and London.

Rand, Ayn (1947), *The Fountainhead*, New York.

Rees, A. L. and Borzello, F. (1986), *The New Art History*, London.

Reif, Rita, 'Chairs Windows and Other Surprises by Wright', *New York Times*, (13 March 1994), p. 39.

Richardson, Adam, 'The Death of the Designer', *Design Issues*, vol. IX, no. 2 (Spring 1993), pp. 34-43.

Roth, L. M. (1983), *McKim, Mead & White, Architects*, New York.

Rybczynski, Witold (1989), *The Most Beautiful House in the World*, New York and London.

Rybczynski, Witold (1991), *Waiting for the Weekend*, New York.

Schau, Michael, 'The Man Who Created the Gatsby Style', *TWA Ambassador* (July 1974), p. 12.

Schonberger, Angela, (ed.) (1990), *Raymond Loewy: Pioneer of American Industrial Design*, Berlin and Munich.

Schumacher, E. F. (1973), *Small is Beautiful*, London.

Schwartz, Marvin D. (1961), *Masters of Contemporary Craft*, New York.

Sexton, Richard (1987), *American Style: Classic Product Design from Airstream to Zippo*, San Francisco.

Shoults, Worth E., 'The Home of the First Farmer of America', *National Geographic Magazine*, vol. LIII, no. 5 (May 1928), p. 602.

Silk, Gerald (1984), *Automobile and Culture*, Los Angeles and New York.

Simpich, Frederick, 'Chemists make a New World', *National Geographic Magazine*, vol. LXXVI, no. 5 (November 1939) p. 601.

Skipwith, Joanne (1997), *Rhapsodies in Black: Art of the Harlem Renaissance*, Berkeley, Los Angeles and London.

Stansfield, Peter, 'Heritage Design: The Harley-Davisdon Motor Company', *Journal of Design History*, vol. 5, no. 2 (1992), p. 142.

Stein, Gertrude (1934), *The Autobiography of Alice B. Toklas*, New York.

Stein, Gertrude (1934; repr. 1962), *The Making of Americans*, New York.

Steinbeck, John (1945), *Cannery Row*, New York.

Sterling Ready-Cut Homes', *Popular Science* (January 1952), p. 34.

Suisman, Douglas, 'Utopia in the Suburbs', *Art in America* (March 1990), pp. 184-93.

Talmey, Allene, ed., 'The California Idea Across the U.S.A.', *Vogue*, 15 April 1954, p. 60.

Thackara, John (ed.) (1988), *Design After Modernism*, London.

The Lustron Home', *Life*, 13 December 1948, p. 118.

'The Presidency: Measuring Mission,' *Time*, 9 June 1961, p. 9.

'The Reluctant Tastemaker', *Time*, 10 October 1960, p. 81.

'Up From the Egg', *Time*, 31 October 1949, p. 68.

Van Doren, Harold (1940), *Industrial Design, A Practical Guide*, New York and London.

Veblen, Thorstein (1899), *The Theory of the Leisure Class*, New York.

Venturi, Robert (1966), *Complexity and Contradiction in Architecture*, New York.

Venturi, Robert, Scott Brown, Denise and Izenour, Steven (1971), *Learning From Las Vegas*, Cambridge, MA.

Walker Art Center (1974), *Naives and Visionaries*, Minneapolis.

Walker, John A. (1989), *Design History and the History of Design*, London.

Walters, Anna L. (1989), *The Spirit of Native America*, San Francisco.

Ward, James S., '20th Century Design: U.S.A.', *Industrial Design*, vol. 6, no. 6 (June 1959), p. 46.

Webb, Michael, 'Designing Films: William Cameron Menzies', *Architectural Digest* (April 1994), p. 64.

Weingartner, Fannia (1986), *Streamlining America*, Detroit.

Weiss, Jeffrey (1994), *The Popular Culture of Modern Art*, New Haven.

Whitford, Frank (1984), *Bauhaus*, London.

Williamson, Judith (1978), *Decoding Advertisements: Ideology and Meaning in Advertising*, London.

Wolfe, Tom (1963), *The Kandy-Kolored Tangerine-Flake Streamline Baby*, Toronto.

Wolfe, Tom (1968), *The Electric Kool-Aid Acid Test*, New York.

Wolfe, Tom, 'The "Me" Decade and the Third Great Awakening', *New York*, 23 August 1976, p. 26.

Wolfe, Tom (1979), *The Right Stuff*, New York.

Wolfe, Tom (1981), *From Bauhaus to Our House*, New York.

Wolkomir, Richard, 'Boyd Coddington', *Smithsonian* (July 1993), p. 50.

Wollen, Peter (1993), *Raiding the Icebox*, London and New York.

Wollen, Peter, 'Strike a Pose', *Sight and Sound* (March 1995), p. 10.

Wright, Frank Lloyd (1955), *An American Architecture*, New York.

Index

Page numbers in **bold** type are main references to a subject.